An Ocean of Wonder

An Ocean of Wonder

The Fantastic in the Pacific

Edited by *ku'ualoha ho'omanawanui,*
Joyce Pualani Warren, and Cristina Bacchilega

University of Hawai'i Press
HONOLULU

© 2024 University of Hawai'i Press

"Hāloaʻaikanaka: An Origin Story of the Rise of the Third-Born Hāloa" © Māhealani Ahia and Kahala Johnson

"Histories of Wonder, Futures of Wonder: Chamorro Activist Identity, Community, and Leadership in 'The Legend of Gadao' and 'The Women Who Saved Guåhan from a Giant Fish'" by Michael Lujan Bevacqua and Elizabeth Ua Ceallaigh Bowman [Isa Kelley Bowman] (2016) © Wayne State University Press

Ia Ora Taaroa, Paraoa Iti ē (*Greetings Taaroa, Little Whale*) © Sarahina Sabrina Birk

"Ka Hoaka" © Marie Alohalani Brown

Hiti, the Return of the Navigator © Raʼi Chaze

"A Crossing in Dark Waters" © Sosthène Desanges

Līlīnoe © Joy Lehuanani Enomoto

Kanaloa, Nanaue, The Puhi Rider © Solomon Enos

"Across Lewa and Kikilo" © Nicole Kuʻuleinapuananiolikoʻawapuhimelemeleolani Furtado

Ma Waena © Sofia Kaleomālie Furtado

Sina ma Tinirau © Vilsoni Hereniko

Ka Lei Hulu a Kahelekūlani i Hiʻilaniwai (*The Feather Lei of Kahelekūlani at Hiʻilaniwai*) © kuʻualoha hoʻomanawanui

"Te Pō" © Robyn Kahukiwa and Patricia Grace

"Padil o (the Paddle)" © Emelihter Kihleng

"Auntie" and "Hoʻoulu Lāhui" © Victoria Nalani Kneubuhl

"The Wind through Stars" and *Prism Stalker* © Sloane Leong

Hānai ʻAi O Haumea © Naiʻa-Ulumaimalu Lewis

"ʻĀina Hānau" © Brandy Nālani McDougall

"Black Milk" © Tina Makereti

Pouliuli © Selina Tusitala Marsh

Hānau Pōʻele and *Makalei* © Kapiliʻula Naehu-Ramos

She Who Dies to Live © Jocelyn Kapumealani Ng, Kathy Jetñil-Kijiner, Terisa Siagatonu, and Lyz Soto

"Tourists" © Lehua Parker

"The Forever Spam, 2055" © Craig Santos Perez

Momoheaga and *Looking at Motu te fua from the Shores of Fonuagalo* © John Pule

Nakili © Tiare Ribeaux and Qianqian Ye

God of Diaspora: Blood Returns to Water; Mejenkwaad: I Am Made of Teeth; Kanaloa: Into a Stone Sea; When We Become Home Holobiont Ahi Mebachi; and "When We Become Home" © Lyz Soto

"2140AD" and "Ocean Birth" © Robert Sullivan

"Aitu" and *Motu Faʻafafine* © Dan Taulapapa McMullin

"The Fag End of Fāgogo" by Dan Taulapapa McMullin (2019) © Wayne State University Press

"Bowl of Stars" © Kristina R. Togafau, Alexander Casey, Aaron Kiʻilau, Brittany Winland, and Briana Koani Uʻu

"Into the Tupuaga" and *Creatures* © Albert Wendt

"Reconstituting Oceanic Folktales" © Steven Winduo

All rights reserved
Printed in the United States of America

First printed, 2024

Library of Congress Cataloging-in-Publication Data

Names: hoʻomanawanui, kuʻualoha, editor. | Warren, Joyce Pualani, editor. | Bacchilega, Cristina, editor.

Title: An ocean of wonder : the fantastic in the Pacific / kuʻualoha hoʻomanawanui, Joyce Pualani Warren, Cristina Bacchilega.

Description: Honolulu : University of Hawaiʻi Press, [2024] | Includes bibliographical references.

Identifiers: LCCN 2023036608 | ISBN 9780824896171 (hardback) | ISBN
 9780824897352 (trade paperback) | ISBN 9780824897307 (epub) | ISBN
 9780824897314 (kindle edition) | ISBN 9780824897291 (pdf)
Subjects: LCSH: Indigenous authors—Pacific Area—Literary collections. |
 Speculative fiction—Literary collections. | Wonder—Literary
 collections.
Classification: LCC PR9645.5 .O24 2024 | DDC 820.8/0996--dc23/eng/20231204
LC record available at https://lccn.loc.gov/2023036608

Cover art: Kapiliʻula Naehu-Ramos, *Hānau Pōʻele*, 2017. Oil on canvas, 16" × 20".

University of Hawaiʻi Press books are printed on acid-free
paper and meet the guidelines for permanence and
durability of the Council on Library Resources.

Contents

Oceanic Wonder across Tā and Vā (An Alternative Table of Contents) *xiii*
Acknowledgments *xix*

kuʻualoha hoʻomanawanui, Cristina Bacchilega, and Joyce Pualani Warren
 Introduction: Kīauau, Hōauau—Navigating Our Fantastic Sea of Islands 1

Robyn Kahukiwa and Patricia Grace
 Te Pō 16

kuʻualoha hoʻomanawanui
 He Holomoana Āiwaiwa (A Fantastic Voyage): Navigating Wonder in Pasifika Literature 18

Naiʻa-Ulumaimalu Lewis
 Hānai ʻAi O Haumea, **Plate 1**

Solomon Enos
 Kanaloa, **Plate 2**
 Nanaue, **Plate 3**

Albert Wendt
 Into the Tupuaga 39
 Creatures 44

Dan Taulapapa McMullin
 Artist Statement: Aitu Studies 45
 Aitu 47
 Motu Faʻafafine, **Plate 4**

Michael Lujan Bevacqua and Elizabeth Ua Ceallaigh Bowman
 Histories of Wonder, Futures of Wonder: Chamorro Activist Identity, Community,
 and Leadership in "The Legend of Gadao" and "The Women Who Saved Guåhan
 from a Giant Fish" 49
Andrea Nicole Grajek
 The Women Who Saved Guåhan, **Plate 5**

vii

viii Contents

Lyz Soto, Jocelyn Kapumealani Ng, Kathy Jetñil-Kijiner, and Terisa Siagatonu
 Artists' Statement for *She Who Dies to Live:* Lifting the Veil 65
Jocelyn Kapumealani Ng, Kathy Jetñil-Kijiner, Terisa Siagatonu, and Lyz Soto
 She Who Dies to Live 69
Terisa Siagatonu, Jocelyn Kapumealani Ng, and Lyz Soto
 God of Diaspora: Blood Returns to Water, **Plate 6**
Kathy Jetñil-Kijiner, Jocelyn Kapumealani Ng, and Lyz Soto
 Mejenkwaad: I Am Made of Teeth, **Plate 7**
Jocelyn Kapumealani Ng and Lyz Soto
 Kanaloa: Into a Stone Sea, **Plate 8**

Steven Winduo
 Reconstituting Indigenous Oceanic Folktales 83

Selina Tusitala Marsh
 Artist Statement for *Pouliuli* (from the Interstellar Series) 97
 Pouliuli 98

Caryn Lesuma
 Dreaming Indigenous Realities in Young Adult Literatures of Oceania 99

Kristina R. Togafau, Alexander Casey, Aaron Kiʻilau, Brittany Winland,
and Briana Koani Uʻu
 Artists' Statement for "Bowl of Stars" 109
 Bowl of Stars 112

Nicholas Thomas
 Artist Statement: The Art of John Pule 130
John Pule
 Momoheaga, **Plate 9**
 Looking at Motu te fua from the Shores of Fonuagalo, **Plate 10**

Victoria Nalani Kneubuhl
 Artist Statement: Writing from the Vā 132
 Hoʻoulu Lāhui 134
 Auntie 142

Brandy Nālani McDougall
 Artist Statement for " ʻĀina Hānau" 152
 Selections from " ʻĀina Hānau" 155

Joy Lehuanani Enomoto
Artist Statement for *Līlīnoe* 164
Līlīnoe 165

Nicole Kuʻuleinapuananioliko̓awapuhimelemeleolani Furtado and
Sofia Kaleomālie Furtado
Artists' Statement for "Across Lewa and Kikilo" and *Ma Waena* 166
Nicole Kuʻuleinapuananioliko̓awapuhimelemeleolani Furtado
Across Lewa and Kikilo 168
Sofia Kaleomālie Furtado
Ma Waena, **Plate 11**

Bryan Kamaoli Kuwada
An Aloha ʻĀina Imaginary: Kahikina Kelekona and the Fantastic 175

Kapiliʻula Naehu-Ramos
Artist Statement for *Hānau Pōʻele* and *Makalei* 187
Hānau Pōʻele, **cover art**
Makalei, **Plate 12**

Lehua Parker
Artist Statement: Once upon One Time 188
Tourists 191

Solomon Enos
Artist Statement for *Kanaloa, Nanaue, The Puhi Rider* 201
The Puhi Rider, **Plate 13**

Marie Alohalani Brown
Artist Statement for "Ka Hoaka" 203
Ka Hoaka 204

Lyz Soto
Artist Statement for "When We Become Home" 208
When We Become Home 210
When We Become Home Holobiont Ahi Mebachi, **Plate 14**

Pono Fernandez
Nā Mana Moʻolelo, Nā Moʻolelo Mana: Adaptations of Moʻolelo Hawaiʻi to Empower Moʻolelo
through the Generations 218

x Contents

ku'ualoha ho'omanawanui
Artist Statement for *Ka Lei Hulu a Kahelekūlani i Hi'ilaniwai* (*The Feather Lei of Kahelekūlani at Hi'ilaniwai*) 230
Ka Lei Hulu a Kahelekūlani i Hi'ilaniwai (*The Feather Lei of Kahelekūlani at Hi'ilaniwai*), **Plate 15**

Māhealani Ahia and Kahala Johnson
Artists' Statement for "Hāloa'aikanaka" 231
Hāloa'aikanaka: An Origin Story of the Rise of the Third-Born Hāloa 233

Tiare Ribeaux and Qianqian Ye
Artists' Statement for *Nakili* 244
Nakili, **Plate 16**

Dan Taulapapa McMullin
The Fag End of Fāgogo 245

Craig Santos Perez
Artist Statement for "The Forever Spam, 2055" 254
The Forever Spam, 2055 255

Marama Salsano
Ko au tēnei 269
Cyberspace Is an Island in Oceania: A Close Reading of "Te Kuharere Tapes" by @tekahureremoa 270

Tina Makereti
Black Milk 280

Sosthène Desanges
Artist Statement: An Interview with Sosthène Desanges, conducted by ku'ualoha ho'omanawanui, Joyce Pualani Warren, and Cristina Bacchilega 284
A Crossing in Dark Waters 287

Ra'i Chaze
Hiti, the Return of the Navigator 289

Robert Sullivan
2140AD 294
Ocean Birth 295

Sloane Leong
The Wind through Stars 297

Joyce Pualani Warren
Drawing from the Margins: Speculating Pacific Diasporas across Discipline,
Genre, and Form 309
Sloane Leong
From *Prism Stalker*, **Plates 17–21**

Emelihter Kihleng
Artist Statement for "Padil o (the Paddle)" 322
Padil o (the Paddle) 324

Vilsoni Hereniko
Artist Statement for *Sina ma Tinirau* 326
Sina ma Tinirau 329
From *Sina ma Tinirau*, **Plates 22–25**

Sarahina Sabrina Birk
Artist Statement for *Ia Ora Taaroa, Paraoa Iti ē* (*Greetings Taaroa, Little Whale*) 340
Ia Ora Taaroa, Paraoa Iti ē (*Greetings Taaroa, Little Whale*), **Plate 26**

List of Contributors 343
Plates follow pages 44, 108, and 268

Oceanic Wonder across Tā and Vā

An Alternative Table of Contents

Vā

Spaces within and beyond Genre

ku'ualoha ho'omanawanui, Cristina Bacchilega, and Joyce Pualani Warren
Introduction: Kīauau, Hōauau—Navigating Our Fantastic Sea of Islands 1

ku'ualoha ho'omanawanui
He Holomoana Āiwaiwa (A Fantastic Voyage): Navigating Wonder in Pasifika Literature 18

Michael Lujan Bevacqua and Elizabeth Ua Ceallaigh Bowman
Histories of Wonder, Futures of Wonder: Chamorro Activist Identity, Community, and Leadership in "The Legend of Gadao" and "The Women Who Saved Guåhan from a Giant Fish" 49

Andrea Nicole Grajek
The Women Who Saved Guåhan, **Plate 5**

Steven Winduo
Reconstituting Indigenous Oceanic Folktales 83

Joy Lehuanani Enomoto
Artist Statement for *Lilinoe* 164
Lilinoe 165

Bryan Kamaoli Kuwada
An Aloha 'Āina Imaginary: Kahikina Kelekona and the Fantastic 175

Lehua Parker
Artist Statement: Once upon One Time 188

xiv Oceanic Wonder across Tā and Vā

Pono Fernandez
Nā Mana Moʻolelo, Nā Moʻolelo Mana: Adaptations of Moʻolelo Hawaiʻi to Empower Moʻolelo through the Generations 218

Sosthène Desanges
Artist Statement: An Interview with Sosthène Desanges, conducted by kuʻualoha hoʻomanawanui, Joyce Pualani Warren, and Cristina Bacchilega 284

Vilsoni Hereniko
Artist Statement for *Sina ma Tinirau* 326
Sina ma Tinirau 329
From *Sina ma Tinirau*, **Plates 22–25**

Communal Spaces

Victoria Nalani Kneubuhl
Artist Statement: Writing from the Vā 132

Brandy Nālani McDougall
Artist Statement for "ʻĀina Hānau" 152
Selections from "ʻĀina Hānau" 155

Dan Taulapapa McMullin
Motu Faʻafafine, **Plate 4**

Kathy Jetñil-Kijiner, Jocelyn Kapumealani Ng, and Lyz Soto
Mejenkwaad: I Am Made of Teeth, **Plate 7**

John Pule
Momoheaga, **Plate 9**

Lehua Parker
Tourists 191

Marie Alohalani Brown
Artist Statement for "Ka Hoaka" 203
Ka Hoaka 204

Tiare Ribeaux and Qianqian Ye
Artists' Statement for *Nakili* 244

Dan Taulapapa McMullin
The Fag End of Fāgogo 245

Marama Salsano
Ko au tēnei 269

Robert Sullivan
Ocean Birth 295

Sarahina Sabrina Birk
Artist Statement for *Ia Ora Taaroa, Paraoa Iti ē* (*Greetings Taaroa, Little Whale*) 340
Ia Ora Taaroa, Paraoa Iti ē (*Greetings Taaroa, Little Whale*), **Plate 26**

Diasporic Spaces

Lyz Soto, Jocelyn Kapumealani Ng, Kathy Jetñil-Kijiner, and Terisa Siagatonu
Artists' Statement for *She Who Dies to Live:* Lifting the Veil 65
Jocelyn Kapumealani Ng, Kathy Jetñil-Kijiner, Terisa Siagatonu, and Lyz Soto
She Who Dies to Live 69
Terisa Siagatonu, Jocelyn Kapumealani Ng, and Lyz Soto
God of Diaspora: Blood Returns to Water, **Plate 6**

Nicholas Thomas
Artist Statement: The Art of John Pule 130
John Pule
Looking at Motu te fua from the Shores of Fonuagalo, **Plate 10**

Ra'i Chaze
Hiti, the Return of the Navigator 289

Joyce Pualani Warren
Drawing from the Margins: Speculating Pacific Diasporas across Discipline, Genre, and Form 309
Sloane Leong
From *Prism Stalker*, **Plates 17–21**

Emelihter Kihleng
Artist Statement for "Padil o (the Paddle)" 322
Padil o (the Paddle) 324

Digital Spaces

Selina Tusitala Marsh
Artist Statement for *Pouliuli* (from the Interstellar Series) 97
Pouliuli 98

Sofia Kaleomālie Furtado
Ma Waena, **Plate 11**

Tiare Ribeaux and Qianqian Ye
Nakili, **Plate 16**

Marama Salsano
Cyberspace Is an Island in Oceania: A Close Reading of "Te Kuharere Tapes"
by @tekahureremoa 270

Dream Spaces

Albert Wendt
Creatures 44

Caryn Lesuma
Dreaming Indigenous Realities in Young Adult Literatures of Oceania 99

Victoria Nalani Kneubuhl
Auntie 142

Tā

Pasts

Albert Wendt
Into the Tupuaga 39

Kapili'ula Naehu-Ramos
Artist Statement for *Hānau Pō'ele* and *Makalei* 187
Hānau Pō'ele, **cover art**
Makalei, **Plate 12**

Jocelyn Kapumealani Ng and Lyz Soto
Kanaloa: Into a Stone Sea, **Plate 8**

Solomon Enos
Artist Statement for *Kanaloa, Nanaue, The Puhi Rider* 201
Kanaloa, **Plate 2**
Nanaue, **Plate 3**
The Puhi Rider, **Plate 13**

Futures

Victoria Nalani Kneubuhl
Hoʻoulu Lāhui 134

Naiʻa-Ulumaimalu Lewis
Hānai ʻAi O Haumea, **Plate 1**

Nicole Kuʻuleinapuananioliko'awapuhimelemeleolani Furtado and Sofia Kaleomālie Furtado
Artists' Statement for "Across Lewa and Kikilo" and *Ma Waena* 166

Nicole Kuʻuleinapuananioliko'awapuhimelemeleolani Furtado
Across Lewa and Kikilo 168

Lyz Soto
Artist Statement for "When We Become Home" 208
When We Become Home 210
When We Become Home Holobiont Ahi Mebachi, **Plate 14**

Craig Santos Perez
Artist Statement for "The Forever Spam, 2055" 254
The Forever Spam, 2055 255

Sloane Leong
The Wind through Stars 297

Nonlinear and Spiral Times

Robyn Kahukiwa and Patricia Grace
Te Pō 16

kuʻualoha hoʻomanawanui
Artist Statement for *Ka Lei Hulu a Kahelekūlani i Hiʻilaniwai* (*The Feather Lei of Kahelekūlani at Hiʻilaniwai*) 230
Ka Lei Hulu a Kahelekūlani i Hiʻilaniwai (*The Feather Lei of Kahelekūlani at Hiʻilaniwai*),
Plate 15

xviii Oceanic Wonder across Tā and Vā

Sosthène Desanges
 A Crossing in Dark Waters 287

Robert Sullivan
 2140AD 294

Endings That Become Beginnings

Dan Taulapapa McMullin
 Artist Statement: Aitu Studies 45
 Aitu 47

Kristina R. Togafau, Alexander Casey, Aaron Kiʻilau, Brittany Winland, and Briana Koani Uʻu
 Artists' Statement for "Bowl of Stars" 109
 Bowl of Stars 112

Tina Makereti
 Black Milk 280

Māhealani Ahia and Kahala Johnson
 Artists' Statement for "Hāloaʻaikanaka" 231
 Hāloaʻaikanaka: An Origin Story of the Rise of the Third-Born Hāloa 233

Acknowledgments

Our collective mahalo to

all of our contributors;

the Department of English at the University of Hawai'i at Mānoa for the Research Outcomes Support grant for "The Fantastic in Oceania" online events in 2020, as well as for research funds contributing to the production of this volume;

University of Hawai'i Press editor Emma Ching for believing in this project from the beginning and for giving it her careful attention;

our copyeditor, Adriana Cloud.

Mahalo nui loa to my conavigators of this literary wa'a—my longtime mentor and friend, Cristina, and my newer colleague, Pasifika literary word nerd, and friend, Pualani. As always, aloha to my 'ohana for their continuous support, and to everyone else, from my kūpuna to my haumāna, for always sharing stories and instilling a deep love of mo'olelo and culture within me.

—ku'ualoha

I give my deepest thanks to Cristina and ku'ualoha for their abundant knowledge, patience, and kindness. Aloha to my 'ohana, who always encouraged me as a nerdy kid, let me read comics, and supported me as I searched for literary worlds that centered Pasifika and Black folks. I hope this collection is meaningful for the ones before us and behind us. And always and forever, for Juana and Brandon.

—Pualani

I started working on this book before retirement and continued during my *rewirement*. For varying reasons, I am grateful to Grace Dillon, Esther Figueroa, Cynthia Franklin, Bryan Kamaoli Kuwada, No'u Revilla, John Rieder, Dan Taulapapa McMullin, Reina Whaitiri, Aiko Yamashiro, Ida Yoshinaga. I am grateful to my conavigators for their knowledge and inspiration; without you, ku'ualoha and Pualani, I would have never ventured into the Moana.

—Cristina

Introduction

Kīauau, Hōauau—Navigating Our Fantastic Sea of Islands

kuʻualoha hoʻomanawanui, Cristina Bacchilega, and Joyce Pualani Warren

Moananuiākea (the Pacific Ocean) is the largest geographic feature on the planet, comprised of 64 million square miles of ocean and over 25,000 islands that make up only 300,000 square miles of land. It is also one of the most dynamic and diverse regions, containing dozens of countries, many more islands with varied cultures and people, and over 1,300 languages. Our "ancestral ocean," as Hawaiian nationalist, scholar, and poet Haunani-Kay Trask describes it (1993, 51), is one that connects—Tongan scholar and writer Epeli Hauʻofa explains—rather than divides us (1993); I-Kiribati scholar and poet Teresia Teaiwa reminds us that the ocean is within us as well, as "we sweat and cry salt water, so we know the ocean is really in our blood."[1] Storytelling has always been an integral part of human activity and continues in many diverse forms, from the informal sharing between two or more people to global audiences of literature, film, and more. Within Oceania,[2] storytelling has followed these trajectories as well, resulting in a continued dynamic flourishing of our stories in many forms, along with our peoples. As we understand the very essence of life—our koko (blood) is salt water—we understand as well that our frames of reference and relationships with our worlds, our peoples, and ourselves resist imposed colonial ones, and that wonder and the fantastic have always been important elements in Indigenous storytelling in Oceania.

An Ocean of Wonder: The Fantastic in the Pacific brings together writers and artists from across Moananuiākea working in myriad genres of the fantastic across media, ranging from oral narratives and traditional wonder tales to horror, science fiction, and fantasy, as well as scholarly essays about them. Collectively, this anthology features the fantastic as present-day Indigenous Pacific world-building that looks to the past in creating alternative futures, and in so doing reimagines relationships between peoples, environments, deities, nonhuman relatives, history, dreams, and storytelling.

1. This quote from Teaiwa is the epigraph of Epeli Hauʻofa's "The Ocean in Us" (1998, 391); see also Teaiwa, *Sweat and Salt Water*, 13.

2. Throughout the collection, multiple synonyms for the vast Pacific region will be used interchangeably. These include Oceania, the Pacific, Moana, Moana Nui, Moananuiākea, Moananuiakiwa, Vasa, Vasa Loloa, and One Salwara, to reflect some of the diverse linguistic descriptions of our oceanic home waters.

2 Introduction

As artistic, intellectual, and culturally based expressions that encode Indigenous knowledge, the creative writing, visual artwork, and scholarly essays in this collection upend stagnant, monolithic, and often exotic and demeaning stereotypes of the Indigenous Pacific and situate themselves in conversation with critical understandings of the global fantastic and Indigenous studies.

The project began in June 2020 with online events we organized that featured ʻŌiwi (Native Hawaiian) writers Victoria Nalani Kneubuhl and Lehua Parker. Their presentation titles respectively suggested interdependent specificities of the fantastic in Oceania: Kneubuhl's "Writing in the Vā" foregrounded artists' immersion in Indigenous cosmologies and practices to make contact with multiple worlds; Parker's "Roots, Branches, and Stars" set paths for a place-based speculation into the future. From our different positionalities—two Native Hawaiians, one with ties to Hawaiʻi and Kauaʻi islands, the other diasporic with ties to Oʻahu; and one settler of color in Hawaiʻi—we were inspired and became passionately committed to recognizing in print the vastness and multiplicity of Pacific traditions of the fantastic. So we set ourselves to include in our collection reprints and new works that cross linguistic, cultural, media, and genre boundaries and that foreground traditional ways of being and knowing as part of the promise of dynamic and vibrant Indigenous futurity across our Vasa Loloa. These scholarly and creative works trace their genealogies in traditional narratives, genres, and beliefs, and they represent an array of contemporary adaptations and interpretations of the "fantastic" emerging in the region and its Indigenous diasporas. Influences within the collection range across diverse fields, including children's literature, folklore and fairy-tale studies, Indigenous and queer studies, narrative and genre studies, adaptation studies, performance, and creative writing; they attend to issues of social justice, decolonial and activist storytelling, and Indigenous futurities, among others. Thanks to our collaboration with *Hawaiʻi Review,* the book has an online companion located at www.hawaiireview.org providing visual and performance experiences that complement what is on the page and also comment or extend what is in print.

How does one organize an ocean, particularly one as vast and diverse as Moananuiākea? An attempt to do so is both futile and irresponsible; instead, we offer some tā and vā (time and space) coordinates to help navigate these waters.

Nā Moʻokūʻauhau (Genealogies). Origins, familial ties, and relationships are integral in One Salwara cultures. Moʻokūʻauhau (genealogies) are traced to Pō (see Robyn Kahukiwa and Patricia Grace, as well as Tina Makereti), a starting point of te vā (the space between), where art is "a way of resurrecting our atua and reconstituting reality" (Albert Wendt) and where "the intermingling of past and present" develops a sense of reality "that is different from that of contemporary western civilization" (Kneubuhl), "wonder histories" (Michael Bevacqua and Elizabeth Ua Ceallaigh Bowman), the reconstitution of Indigenous Oceanic cultural heroes and their stories (Steven Winduo), "fāgogo [that] are always outside time, in an [I]ndigenous futurism, which can be the same as an [I]ndigenous past, a sutured cleft, an eternal return" (Dan Taulapapa McMullin), songs of "ocean births" (Robert Sullivan), human-nonhuman connections to land and spirit world both (all). The reprints in our collection point to genealogies of the fantastic in Oceania that have multiple locations and draw on culture-specific oral traditions, genres, and beliefs; but they also crisscross like currents moved by the winds and followed by Moana Nui wayfinders who knew

and know "the sea is our pathway to each other and to everyone else, . . . the ocean is in us" (Hauʻofa 2008, 58).

Nā Piko (Centers). Our "ocean of wonder" rejects colonial "-nesia" divisions. Instead, Oceanic stories, ideas, and images embodying the realities of the fantastic in this collection surround and connect to Hawaiʻi. A part of and nestled within this ocean of stories, Hawaiʻi is for the three of us editors, in different ways, a piko (center) of the collection. Not *the* center, but a cultural foundation of the environment and history that ground us, and from which we relate to other traditions of the fantastic in Oceania. We encourage readers to locate themselves in this sea of stories and to experience them rippling in and out of the islands that are the piko for them. Unfortunately—due to our limitations, not their creative or scholarly traditions—some nations and cultures are underrepresented, so we also encourage readers to supplement what's in the book with what you know and experience as fantastic, your streams of stories, images, and Indigenous realities. Furthermore, to acknowledge that *An Ocean of Wonder: The Fantastic in the Pacific* will be put to multiple uses, especially in the classroom, we offer alternative tables of contents. This strategy is effectively modeled within this field in collections such as *The Wesleyan Anthology of Science Fiction* (Evans et al. 2010). In turn, this collection draws inspiration from the intersectional collaborations of BIPOC women who have been theorizing otherwise ways of being and knowing, as articulated in the alternative and innovative tables of contents in anthologies such as *The Woman That I Am: The Literature and Culture of Contemporary Women of Color* (1994) and *This Bridge Called My Back: Writings by Radical Women of Color* (1981). In addition to the alternative table of contents in this collection, readers are invited to contemplate these texts across the many tā and vā that they may inhabit through additional tables of contents, clusters, and digital content in the companion platform available at www.hawaiireview.org.

Nā Pilina (Relationships). So much of colonial thinking about Oceania and its varied cultures is based on comparison or similitude; this is a common strategy in approaching what is foreign or unusual, and it is in most cases also a hierarchical cognitive process that assumes the centrality of western thought and reality, and the subordination of Indigenous ones that are made to fit extraneous categories and patterns. Colonial comparison, then, masks collision and appropriation. Historically, this overwriting cannot be undone but, as Dan Taulapapa McMullin emphasizes in his essay, if "the hybridity" of today's stories "cannot be unwoven," these stories—whether seen, heard, danced, or read—nevertheless "connect our post-monotheistic present to our polytheistic past" and futures. They also connect Oceanic peoples and realities to one another.

Building on both juxtaposition and association, *An Ocean of Wonder: The Fantastic in the Pacific* moves readers to articulate pilina (relationships) across genres, locations, time, and media. It celebrates the multiplicity and relationality of the fantastic in Oceania. And for previously unpublished pieces, it offers statements by verbal and visual artists to foreground self-representation as well as theorizing from within the region. Refusing to regard ʻōlelo Hawaiʻi as a foreign language when we are writing in Hawaiʻi nei and also emphasizing pilina with one's land, stories, and language(s), in this collection we do not italicize Hawaiian words. For similar reasons, we respect the decision of contributors who choose not to italicize words in their Indigenous languages, or italicize only the first occurrence of these words.

Nā Moʻokūʻauhau o ka Palapala (Literary Genealogies)

Prior to the introduction of western literacy (reading and writing text) in the nineteenth century, stories in Moana Maoli (Indigenous Pacific) cultures were oral, material, and performance based. Storytelling, storyperformance (chant, song, dance, theater, and ritual clowning, for example), carvings (statues to storyboards), and body ornamentation such as tātau (tattooing) were some of the ways moʻolelo (histories, stories, narratives) were created, remembered, stored, and disseminated.[3] The introduction of reading, writing, and the printing press enabled a new way to preserve, perpetuate, and share oral and performative traditions. While for colonizers the point of introducing literacy was to further projects of colonization through assimilation to western education systems and religion (Christianity), Moana Maoli peoples seized opportunities to record traditional stories and histories, as did colonial agents such as explorers, travelers, missionaries, ethnographers, anthropologists, and settlers.

In places like Hawaiʻi, where literacy was introduced by American missionaries who established a printing press by 1830, resistance to the prescribed dominant conservative Calvinist Christian settler colonial narrative soon developed. By 1861, independent ʻŌiwi-controlled newspapers were established, and traditional moʻolelo were soon disseminated in print, beginning an intellectual tradition of ʻike palapala (written knowledge) and Hawaiian literature in print. For just over a century (1830s–1940s), nearly 80 Hawaiian-language newspapers comprising roughly 1.5 million pages of writing that included moʻolelo by ʻŌiwi writers were printed, shared, and read; the newspapers that were preserved have become a critical archive of ʻŌiwi knowledge today.

Contemporary Moana Maoli writers draw from our environments, ancestors, and cultures to (re)imagine and (re)tell moʻolelo that (re)inspire and are relevant to our people—our primary audiences—today. One way we do this is to use new media (film, digital technologies) and new (introduced) languages, styles, techniques, and modes to expand upon our own. Examples include writing novels (an introduced western form) (primarily) in settler colonial languages, such as English or French; but also, revisioning traditional moʻolelo āiwaiwa (stories that contain elements of wonder and the fantastic) as Indigenous speculative fiction, or more specifically, Indigenous wonderworks.

Wondering about Wonder—What Do We Mean by "Wonder" and "the Fantastic"?

As editors, we came to this project from different if somewhat overlapping fields and interests: Hawaiian and Pacific literatures, Indigenous studies, and Polynesian religion for kuʻualoha; diasporic interpolations of Hawaiian and Pacific literatures, Indigenous studies, global Black studies, and women, gender, and sexuality studies for Pualani; and folklore and literature, fairy-tale studies, and adaptation for Cristina. Sorting out what wonder and the fantastic mean in and to these contexts and how these understandings impact the practices of the fantastic in Oceania has been

3. See Teaiwa (2010).

a necessary and fun part of our exploration and conversations, leading us to assert the vitality of the fantastic in Oceania against colonial fantasies and, at the same time, to recognize distinctive currents in it and connections with other futurisms.

For many, ideas of "wonder," "the fantastic," and "fantasy" evoke immediate images with strong emotional attachments, memories, and experiences, despite the wide spectrum each represents. "Fantasy can be tiny picture books or sprawling epics, formulaic adventures or intricate metafictions" (Attebery 2014, 1), and the specter of "fantasy" haunts the "fantastic."[4] When approaching the fantastic in Oceania, this specter—depending on who and what defines it—needs either exorcizing or reviving, or both. We wish to exorcise colonial fantasies about the Pacific and its "natives" that misinterpret their stories into expressions of a mythic, monolithic, childish, "uncivilized," and romanticized past. Instead, promoting visibility and power for the peoples, cultures, and beliefs that are often perceived to be only shadows or remnants from the past in such Pacificist fantasies (Lyons 2006), we aim to feature the resurgence of Indigenous cosmologies, wonderworks, and storyperformance, as well as the imaginings of Indigenous futurism that are specific to our region.

Fantasy as applied to Oceania in colonial frameworks has not only resulted in exoticizing and Othering the peoples of Oceania; it has also repackaged and mislabeled Indigenous histories and worldviews as fictional. But if fantasy as a genre creates entire storyworlds, their being "imaginary" need not mean that they are fictional only, and instead can open up possibilities for envisioning an escape from the dominant norms. Indigenous and other futurisms today offer such alternative versions of the worldly: they are "imbued with . . . fantastic modes of thought, narrative connections deriving from the logic of myth, metaphors from magical or religious belief" ("Fantasy" in Clute and Nicholls 1999, 407), and they resonate with Black, feminist, or Indigenous technologies and sciences. In other words, contemporary counterhegemonic works of fantasy are fictions "about the impossible" (http://www.sf-encyclopedia.com/entry/fantasy) that practice thinking otherwise and creatively display the potentiality of possible worlds grounded in all-too-often dismissed cultural traditions and worldviews.[5]

Thus, drawing on recent critical perspectives, we see wonder and the fantastic as a general mode of expression that is not simply mimetic or confined to realism.[6] Therefore, it is generally

4. Fantasy, before coming to mean illusory appearance, hallucination, or a pie in the sky, referred in various languages to the workings of the imagination, broadly speaking. Jack Zipes, scholar of fairy tales and the fantastic, writes of the "loaded meaning" of fantasy: "The word for imagination in French is *phantasie,* in Italian *fantasia,* in Spanish *fantasia,* and in German *fantasie.* In most European languages, 'fantasy' means imagination" (2009, 79). Zipes then turns to Theodor Adorno's discussion of fantasy, identifying "fantasy as a capacity, that is, the module in the brain called imagination, which enables us to transform existing conditions into the negation of material reality; and fantasy as the result, that is, the product of the transformative capacity of the imagination" (80).

5. "In a fantastic cultural work, the artist pretends that things known to be impossible are not only possible but real, which creates mental space redefining—or pretending to redefine—the impossible. This is sleight of mind, altering the categories of the not-real" (Miéville 2002, 45). What interests us about this definition is the "sleight of mind" with which the fantastic redefines what is "not-real" because it has been normalized as such into the "possible" and "real."

6. Here we paraphrase the entry "Fantastic" from the *Encyclopedia of Fantasy* (1997) edited by John Clute and John Grant, as it appears at http://sf-encyclopedia.uk/fe.php?nm=fantastic, where it continues to serve as a reference and resource for users of the updated *Encyclopedia of Science Fiction* (*SFE*).

6 Introduction

accepted that the fantastic encompasses fantasy[7] and science fiction, magic realism, fabulation, horror, fairy tale, utopia, dystopia, and speculative fiction[8]—and we too stand by this broad definition.[9] We include Black and queer futurisms, Indigenous wonderworks, Hawaiian moʻolelo kamahaʻo, āiwaiwa, Sāmoan fāgogo, and other nonmimetic genres defined from within specific cultures rather than in accordance to the dominant one, because we recognize that their refusal to adopt restrictive Euro-American definitions of reality is a core drive of the fantastic. As Daniel Heath Justice asserts, "when 'realistic' fiction demands consistency with corrosive lies and half-truths, imagining otherwise is more than an act of useful resistance—it's a moral imperative" (2018, 142). In the fantastic conceived as such, "making the impossible possible" (Hopkinson and Nelson 2002, 98) is not creating a narrative where we suspend our disbelief, the way we do with fairy tales; rather, it is the creative actualization of long-held beliefs and ways of abiding in the world that patriarchal, colonial, white supremacist, and capitalist modernity have relegated to the past and dismissed, but that nevertheless persist and re-emerge in the present and for the future.

This conception of the fantastic demands that we consider the situated role of belief and place in the creation of storyworlds and the meaning of "possible worlds" in different contexts. For instance, rather than conflating western fairy tales and Indigenous wonderworks, as colonial authorities did (and still do), we seek to articulate meaningful distinctions and overlap between the two that do not subsume the Indigenous into Euro-American thinking and instead consider the fairy tale as *one* of several wonder genres across cultures. Fairy tales are quintessentially fictional; their characters often exhibit "supernatural" qualities—what today we call "superhero powers"—which comes as no surprise to other inhabitants of the fairy-tale storyworld; and this world, while associated with the past and often medievalized, is represented in broad strokes, calling on listeners/readers/viewers' imaginations to visualize the specifics of its landscape, town, or people. Fairy tales, like much genre fantasy, feature magic, especially in contemporary Disneyfied adaptations. But fairy tales across cultures and history also distinguish themselves as narratives that are emotionally associated with hope, meaning they activate personal and social transformation; and with "wonder," which, as one of us put it elsewhere, "is an emotional and active process we negotiate through storied experiences, one that demands change in us and the world" (Bacchilega 2017, 10). Unlike genre fantasy's dependence on drawing a line between the real and imagined, wonder is activated by curiosity, humility in the face of mystery, and engagement with possibilities.

7. Attebery noticeably broadens the definition of fantasy, recognizing that "modern fantasy draws on a number of traditional narrative genres . . . and a wide array of cultural strands, including pre-Christian European, Native American, Indigenous Australian, and Asian religious traditions" (2014, 2).

8. Marek Oziewicz identifies three meanings for "speculative fiction" (2016). We identify it as a genre that is distinct from science fiction and its focus on the future, along the lines of his second meaning. His third meaning coincides with what we prefer to call "the fantastic" because speculative fiction points to a literary medium, and we wish to feature speculative art and wonderworks in the Pacific not only across genres but across media.

9. This understanding of the fantastic stands in stark opposition to an influential and narrow one by Tzvetan Todorov (1975), for whom the term applied only to narrative texts in which the reader experienced an unresolved hesitation between accepting events as natural or perceiving them as supernatural. This view relied on a natural/supernatural binary as well as on the assumption of a universal cognitive reader response founded on that binary.

Thus, moving beyond English-language literary terms and reframing concepts of wonder and the fantastic in Oceania[10] are helpful in understanding how Indigenous "fantasy" is part of who we have always been. For example, the *Hawaiian Dictionary* definitions of "āiwaiwa" include: inexplicable, mysterious, marvelous, strange, amazing, fantastic, fathomless, incomprehensible, wonderful because of divinity; wonderfully proficient or skilled (wehewehe.org). They are similar in scope with the definitions of "fantastic" (dictionary.com), which also range from the marvelous to the grotesque. Yet āiwaiwa also conveys a sense of the unknowable and the divine that connect peoples of Moana Nui to our deities, as described in many creation stories and moʻokūʻauhau. For example, through cosmogonic creation stories such as Kumulipo, Hawaiians trace their lineage back to prehuman ancestors, such as plants and animals of the land and sea, to the very elements of the cosmos. In other Hawaiian genealogies, Hawaiians are related to our archipelago of islands, specific geological formations, such as Mauna Kea, and other elements and deities, such as the volcano goddess Pele. This is expected and not exceptional, as moʻolelo that reflect similar cultural concepts are found in cultures across Moana Nui.

This interconnection of species is described as one of kinship, and as kānaka (humans), we are challenged by our nonhuman relations to be "good relatives" (Justice 2018, 171). Part of how we do this is to continue to honor our nonhuman kin in our moʻolelo, to continue to marvel at our interconnections, transformations, evolutions, and teachings that still influence, entertain, and inspire us today as they have across tā and vā. Understanding our hi/stories as moʻolelo āiwaiwa helps us do this.

For Indigenous peoples, moʻolelo are valuable because they connect us to our environments and each other; they carry our cultures, practices, values, philosophies, epistemologies, ethics, worldviews, and much more, shaped by our environments and experiences across tā and vā, which are embedded in our native languages. Characters are often āiwaiwa—shapeshifters with multiple kino lau (body forms), gods, demigods, and extraordinary humans who educate and entertain us with their remarkable physical and intellectual abilities, achievements, and feats. Even when not immediately visible, our moʻolelo are often political, demonstrating the power dynamics of our akua, some chiefly genealogical lines over others, caution and awareness of nefarious character types (manō ʻaikanaka, or human-devouring shark men, for example), etiological origins of places, beliefs, and practices, and concepts of resistance to evil, injustice, and striving toward pono (justice, balance, harmony). While Euro-American literature is often oriented around specific kinds of conflict (human vs. human, human vs. nature, human vs. technology, human vs. self), Indigenous storytelling expands struggle beyond the human centered (to nature vs. nature, for example), and beyond conflict toward cooperation, such as humans helping humans, and humans and nature helping each other. Indigenous stories thus affirm multispecies kinship and care, which are integral in Indigenous worldviews and cultural practices such as mālama and aloha ʻāina (caring

10. Whereas in *Stories about Stories* Attebery investigates fantasy as "the repurposing of myth in modern culture" (2014, 8) and uses "myth" as the umbrella term for traditional narrative genres across cultures, we strive to situate traditional narratives within their own culture, language, genre, and geopolitics in Oceania.

for the land as family; love for the land; ideas embodying matriotism viewing the earth as mother/grandmother and provider).

Contemporary Moana Nui writers are inspired by and center our own languages, cultures, and values, often drawing from traditional moʻolelo in creating new ones, or new variations on old themes, bringing new meaning for contemporary audiences in ways that are as profoundly political as traditional moʻolelo. Such Indigenous literary nationalism and decolonial thinking, which place Indigenous creativity, aesthetics, and intellectual and cultural values in the center, rather than at the periphery or told from outsider perspectives, is vast in scope.

In recent years, the term "speculative fiction" has been used to describe literature where the setting or theme involves supernatural, futuristic, or other imagined elements.[11] Indigenous speculative fiction is composed by Native authors, where Native characters, cultures, and aesthetics take primacy. It is closely related to Indigenous wonderworks, or, in the context of Moana Nui literatures, moʻolelo āiwaiwa, which highlight—while presenting as normal, reasonable, and expected—wonder and the fantastic.

As Justice explains, "Indigenous wonderworks" is a concept that describes works of art such as literature, film, etc., that "centre [the] possibility" of other worlds and realities existing "alongside and within our own" that are "within Indigenous values and towards Indigenous, decolonial purposes" (Justice 2018, 153). Indigenous wonderworks, then, are a way to understand moʻolelo āiwaiwa as "neither strictly 'fantasy' nor 'realism,' but maybe both at once, or something else entirely, although they generally push against the expectations of rational materialism" (154). Thus, such moʻolelo are "rooted in the specificity of peoples to their histories and embodied experiences. They make space for meaningful engagements and encounters that are dismissed by colonial authorities but are central to cultural resurgence and the recovery of other ways of knowing, being, and abiding. They insist on possibilities beyond cynicism and despair" (154). Moʻolelo āiwaiwa are therefore centered around our own peoples, cultures, hopes, dreams, aesthetics, creativity, and imaginations. They are also grounded in the specificities of our peoples, histories, and experiences.

Justice also states that, as J. R. R. Tolkien wrote in "On Fairy Stories," Indigenous wonderworks offer an escape that "presumes an ongoing engagement with the world, not a repudiation of or a removal from it" (151). For Justice, these narratives are thus "rooted in the land—not generic landscapes but specific places with histories, voices, memories" (155–156), and at the same time they function as transformative speculative fictions. To spell it out further: "For secular, post-Enlightenment readers of the industrialized West, the very idea of spirit beings and little people, individualized and speaking animals, stones, and plants with powers to shape the reality around them and motivations of their own, human actions changing the weather and affecting various elemental forces, and other worlds of beings and kinships with other-than-human peoples, are the

11. In a western context, the English writer Angela Carter, who did wonders herself, revising fairy tales to rethink gender and sexuality in the late twentieth century, gave speculative fiction a more critical edge, defining it as "the fiction of asking 'what if?' It's a system of continuing inquiry" (Katsavos 1994, 14). Daniel Heath Justice, who also emphasizes the critical, unsettling-of-the-status-quo aspect of "speculative fiction," focuses on how this applies specifically to Indigenous experiences and purposes.

stuff of childish make-believe or even pathology, not generally understood as the mature, experiential realities they are in most traditional Indigenous systems" (141). The possible worlds projected by Indigenous wonderworks include what Grace L. Dillon calls "Native slipstream," which, as she tells us in her introduction to the groundbreaking *Walking the Clouds: An Anthology of Indigenous Science Fiction,* "has been around for millennia, anticipated recent cutting-edge physics," and "exploits the possibilities of multiverses by reshaping time travel" (2012, 4). Anticipating the storytelling- and land-based pedagogy of Michi Saagiig Nishnaabeg Leanne Betasamosake Simpson (2017), Dillon proffered in her 2012 anthology that Indigenous futurisms, which for us include Indigenous wonderworks, return Native/Indigenous peoples "to ourselves by encouraging Native writers to write about Native conditions in Native-centered worlds liberated by the imagination" (11).

What is distinctive about the fantastic and Indigenous wonderworks in Hawai'i and across the Pacific? Per Justice's understanding, they are grounded in the specific relationships connecting Kānaka Maoli/Tangata Māori/Ta'ata Mā'ohi, and other Moana Nui peoples to their lands, their histories, and their stories that return us/them to our/themselves, as this collection shows. For us as editors, this also means articulating matters of genre, or more precisely of genre systems, to pursue a decolonial approach to the fantastic.

Within the global fantastic as an umbrella storytelling mode, genres such as science fiction or horror are currently categorized as "genre fiction"—which is popular but subordinate to "literature" in status—and emerged as part of the mass cultural genre system, a set of closely connected narrative and publishing practices based on fostering habitual consumption that emerged in the late nineteenth century (Rieder 2017, 1–64). In contrast, the fairy tale/wonder tale has a much longer and transnational history of shapeshifting, migration, adaptation, colonization, and creolization, leading to its current mainstream role as consumer heteronormative romance (Duggan 2021; Teverson 2019). Like counterhegemonic practitioners elsewhere, authors and artists in Oceania are repurposing—and thus *changing*—science fiction, horror, and fairy tales.

But much of the fantastic in the region emerges from and adapts stories that connect or reconnect its humans, islands, and histories, and that narrate and visualize the world from Oceanic experiences, perspectives, and desires. These are the stories and genres we foreground, as they are culture and language specific, and they do not fit Euro-American genre systems, whether these be literary, mass cultural, or traditional. These land-based narratives inform the contemporary fantastic in the Pacific as they are ancient but not relegated to the past: like all transformative stories, they themselves transform and continue to reorient us in the present and across media, navigating us into the future.

Taking into account the larger understandings of wonder, the fantastic, and fantasy just outlined, and looking specifically at the pieces in this collection, the fantastic across Moana Nui is or includes:

- activation of cultural knowledge;
- the (re)imagining of culture, characters, narratives, and themes in times (tā) and spaces (vā) both old and new, sometimes simultaneously;

- wonder histories and stories (that include elements of wonder, magic, enchantment, the supernatural) that present engagement with the natural and spiritual realms as normal and part of our Indigenous experiences or reality;
- an aloha ʻāina (political) imaginary—the power to dream and imagine an anti-colonial (anti-racist), postcolonial existence as a celebration of who we are, and that he ʻo ia mau nō (we go on) and we are who our ancestors were;
- inherently decolonial resistance to colonialism that resists being typed as a relic of the past irrelevant to modernity and the future (except for continued colonial and settler colonial exploitation);[12]
- insistence on perpetuating our languages, cultures, knowledge, heritage, history, memories, symbolic objects; caring for our sacred places—not just for our own sense of identity, not just to honor our ancestors, but with an eye toward future generations, asking ourselves: What kind of ancestor do we want to be? This is part of what we embrace, celebrate, create, and pass on for future generations to learn from us;
- experiencing what is considered "magic" or "bizarre" or "out of this world" (fantasy, fantastic) in Euro-American worldviews as part of our everyday culture, knowledge, history, understanding. Rather than being "outside" of us/our people/our cultures (with the "supernatural" equating to scary, bad, irrational, unreal because it is not explained by western science), such experiences are part of the fabric of our understanding of our world, a foundation set by our ancestors.

The Power and Potential of the Spaces Between: Oceanic Fantastic and Global Traditions of the Future

The stories, art, and worldviews represented in this collection are laden with mana—intellectual, emotional, spiritual, and political strength and prestige. Some of this mana has accumulated over decades or perhaps even centuries of retelling; some of it has been claimed through innovative and fearless imaginings rooted in our contemporary moment and routed into our most fantastic futures and wondrous pasts. Yet, what these works have in common is their reliance on various and specific genealogies and relationships that serve as manifestations and expressions of that mana. The contexts of those relationships may broaden and shift, as understood through the previously discussed concept of vā. While vā can be literal space, it can also be the figurative space that governs relationships and connects entities (human or more-than-human; secular or sacred), places, and ideas. To nurture a relationship is to ia teu le vā—to nurture the space between parties and all of the potentiality and power that it represents.

If we take seriously the sacredness and power of mana and vā as concepts that structure this collection and undergird Oceanic configurations of wonder and the fantastic, we must then do the work of identifying, tracing, and encouraging their activation beyond the page, canvas, or screen. In this specific context, that means examining the many relationships and genealogies,

12. kuʻualoha hoʻomanawanui (2012) discusses this in more depth.

both figurative and literal, that encourage and sustain the contemporary Oceanic fantastic in communities as well as classrooms. Here we offer a discussion of the intersecting genealogies of the Oceanic fantastic with Afrofuturisms and Indigenous futurisms,[13] and point toward the potential found when we variously inhabit or respectfully maintain the spaces between them.

Since its coining in 1993, "Afrofuturism" has been applied to SF that interrogates the relationship between African-descended peoples and technology (Dery 1994). As Isiah Lavender III describes it, "Afrofuturism is concerned with the impact of black people on technology and of technology on the lives of black people. It explores both the innovative cultural productions enabled by technology and the ways in which black people have been the subjects of technoscientific exploitation" (2009, 190). While the term suggests an emphasis on the future, Lisa Yaszek reminds us that "Afrofuturism is not just about reclaiming the history of the past, but about reclaiming the history of the future as well" (Yaszek 2006, 47). Taken together, Lavender III's and Yaszek's comments reveal a theoretical and critical concept that centers technology and innovation as means to endure and overcome power imbalances in the past and the future, real and imagined.

This potential to rework and ultimately reject structures of power (political, epistemological, or otherwise) across tā and vā is at the heart of Grace Dillon's description of "Indigenous futurism," which she coins in relation to Afrofuturism. In describing Indigenous futurism in relationship to broader, whitestream science fiction, Dillon argues that it "confront[s] issues of 'Indianness' in a genre that emerged in the mid-nineteenth-century context of evolutionary theory and anthropology profoundly intertwined with colonial ideology, whose major interest was coming to grips with—or negating—the implications of these scientific mixes of 'competition, adaptation, race, and destiny.' Historically, sf has tended to disregard the varieties of space-time thinking of traditional societies, and it may still narrate the atrocities of colonialism as 'adventure stories'" (2012, 2). Indigenous futurism, as a term and a field of critical and literary theory, grows out of discussions of Afrofuturism and centers an Indigenous rejection of settler colonial epistemological and literary boundaries. Yet, Dillon is clear that Indigenous futurism is neither derivative nor reactionary. She asserts that Indigenous creators intentionally draw audiences, both Indigenous and settler, into the epistemological and ontological stakes of the text. Indigenous futurisms interrogate what these stakes might mean not just for the audience, but for the many Indigenous bodies as they exist within these texts and beyond the bounds of our most wondrous and fantastic imaginings. This forces audiences to contemplate their own relationships to Indigenous knowledge and traditions across the time and space of the worlds they may encounter and the ones they currently inhabit: "Native authored sf extends the miinidiwag tradition of ironic Native giveaway, of storytelling that challenges readers to recognize their positions with regard to the diasporic conditions of contemporary Native peoples" (Dillon 2012, 6).

13. We use the plural here to mark the many definitions and applications of both of these terms, and to gesture toward their intentional, simultaneous application. We maintain the use of the singular for each term in direct quotations where applicable.

With their emphases on technology, structures of power, storytelling as an ironic and self-aware challenging of subjectivity, and the potential of relationships as they exist across time and space, Afrofuturism and Indigenous futurism offered creators and audiences of the Oceanic fantastic the discursive tools to articulate and analyze Indigenous Pacific perspectives. In the realm of what is becoming collectively known as alternative futurisms, the allied and aligned concerns of various non-white, anti-colonial, non-heteropatriarchal populations represent these concerns as overlapping rather than discrete. Examples include Joy Sanchez-Taylor's analysis (2020) of Tananarive Due's globe-hopping African Immortals series at the intersections of Afrofuturism, Latinx futurism, and Indigenous futurism. Or Aotearoa-based Fijian Gina Cole's coining of "Pasifikafuturism," "a theoretical construct that situates Oceanic science fiction in the afterlife of colonization and seeks to move beyond postcolonialism to create Pacific conceptions of the future," which she locates alongside "Afrofuturism, Indigenous Futurism, Queer Indigenous Futurism, Chicanafuturism, Latinafuturism, and Africanfuturism" (Cole 2020, iii). Cole's theory relies on Indigenous Pacific wayfinding and waka building, and is fleshed out in a comparative project that looks at the Indigenous science fiction space travel stories *Dead of Night* by Witi Ihimaera and *Binti* by Nnedi Okorafor. Cole adds to this growing body of alternative futurisms with her own space-travel novel, *Na Viro*.

In laying out some basic framings of the fantastic across Oceania, this collection offers one more relational space with which other futurisms might engage to cultivate fuller, more inclusive worlds and visions. For instance, if, as Ken Liu asserts, "science fiction is the literature of dreams" (2016, 14), what might broader traditions gain by thinking through an aloha ʻāina imaginary and its power to dream, as Caryn Lesuma and Bryan Kamaoli Kuwada do in this volume? How might Oceania's many forms of partnership, kinship, gender, and sexuality (see Māhealani Ahia and Kahala Johnson as well as Taulapapa McMullin), be placed into conversation with global queer Indigenous futurisms that present Indigenous body sovereignty as a key site of cultural and political sovereignty? This collection gestures toward literatures in Oceania beyond Anglophone Polynesia (Sosthène Desanges, Vilsoni Hereniko, Winduo, Emelihter Kihleng, Bevacqua and Bowman), and asks other futurisms to take into account the ethnic and linguistic diversity of Indigenous Oceania. What might be gained through, say, a Latinx futurist engagement with the Hispanophone legacy within the Pacific? How might Afrofuturism engage with the epistemological, ontological, and temporospatial darkness of Pō? Or with the Black Indigeneity of Melanesia or the Black Indigeneity of Australian Aboriginal and Torres Strait Islander communities, which may not rely on the familiar routes and temporalities of African diasporic blackness? These are but a few examples of the many questions and interventions the fantastic across Oceania may pose in broader futurist literatures.

An Ocean of Wonder is part of a global and intersectional framework of futurist knowledge that is both factual and imaginative. And, because its roots predate the violence of colonial encounter, that simultaneously writes back to as well as before and beyond whitestream understandings of existence, kinship, sovereignty, and even reality. This collection is the relational space of remembrance, recovery, resistance, and the as yet unknowable potential within which Indigenous Oceania encounters our many selves and invites futurists to join us in wonder and speculation.

Interventions in Fantastic Futures: On Reviving and Exorcising Our Literary Aitu

Any understanding of the fantastic in Oceania is haunted by specters that must be simultaneously, variously, revived and exorcised. The promises and the potential of millennia of Indigenous political and cultural sovereignty are woven into the many genres and modes that comprise the Oceanic fantastic. At times, these promises and potential whisper softly from the margins of a narrative; at others, they seem to shout and command our attention from the center of the tale, with all meaning spiraling out from our understandings and recognition of their presence. These are the literary and oratorical specters or spirits, the aitu, that sustain us because they are "woven into [the] flesh" (Wendt 1980, 284) of the living, breathing body of the fantastic in Oceania. There are other specters whose hauntings attempt to snatch the breath from this dynamic body of literature. The ghosts of foreign fantasies of the Pacific as a body to be dominated, eroticized, and violated date back to the sixteenth century, and still haunt contemporary understandings of Indigenous Oceanic authorship and audience, especially where the genres of fantasy are concerned.

This collection disrupts global academic discussions of the fantastic and the speculative through its centering of conversations about how these various aitu have participated in the calls and countercalls that have formed what we now call the fantastic in global literary terms, but what has also been recognized as moʻolelo āiwaiwa within Hawaiʻi, Oceania, and its Indigenous diasporas. The most urgent facet of this intervention is the relational nature of Indigenous Oceanic constructions of the fantastic, which themselves rest on an understanding of reality as relational, contextual, and malleable. In Polynesian contexts, the concept of vā dictates that relationships may broaden and shift as the contexts between the parties evolve. Similarly, because Indigenous concepts of time are nonlinear, or, as "huli ke au" tells us, time is relational, Pacific literature is always already futurist, as our ideas of the future are rooted in our interpretations of the past, and the ways our bodies mediate the present. Genres and storytelling modes are also relational. Thus, what may seem like literature in the realist tradition in one context may become fantastic in another, or vice versa. And writing should not be viewed as discrete from other art forms—which is why we include multimedia storytelling—but as enmeshed with them as different kinds of writing, such as weaving, tātauing, building, crafting, navigating, etc.

As Michael Lujan Bevacqua and Elizabeth Ua Ceallaigh Bowman point out in their essay on Chamorro wonder tales, such literature is "more than fables and fiction"; our traditional moʻolelo are not "empty of meaning, societal delusions," or "lies stripped of wonder and without power." Rather, as they argue, "traditional wonder histories . . . encode social values and systems, which endure in the tales and in culture more broadly and continue to animate present-day Indigenous resistance and sociopolitical activism" (pg. 49). So, while one aspect of moʻolelo āiwaiwa asserts a continuity of wonder, cultural practices, and identity, another ties such an assertion directly to continued resistance to (settler) colonialism. More importantly, rather than purely defensive, such resistance is also an *insistence* on connecting to our fenua—lands, islands, and, by extension, our ocean; and to our kūpuna (ancestors) and our cultural traditions and practices. It is an insistence on remembering, reinvigorating, and creating anew for ourselves and for future

14 Introduction

generations of Moana Maoli peoples in ways that honor our ancestors, ourselves, our descendants, and our world.

Living and writing in the midst of a global pandemic and climate change whose effects are being keenly felt in the Pacific feels as if we are in a particularly bad dystopia, and, at moments, the frustration and hopelessness are overwhelming. Yet our moʻolelo mai ka pō mai (from the ancient past), mai nā kūpuna mai (from the ancestors), spanning tā and vā, have always inspired the imagination through their breadth and depth of āiwaiwa. Imagination and creativity are essential because they allow us to envision a different direction, a new and better reality, and allow us to chart a path toward a brighter, hopeful future. This is how an ocean of wonder sustains Indigenous Oceania and why the fantastic in Oceania matters.

Works Cited

Attebery, Brian. 2014. *Stories about Stories: Fantasy and the Remaking of Myth.* New York: Oxford University Press.

Bacchilega, Cristina. 2017. "Where Can Wonder Take Us?" *Journal of the Fantastic in the Arts* 28, no. 1:6–25. https://www.jstor.org/stable/26390187.

Clute, John and John Grant. 1997. *Encyclopedia of Fantasy.* New York: St. Martin's Press.

Clute, John, David Langford, and Graham Sleight, eds. 2018. *Encyclopedia of Science Fiction.* 3rd. ed. London: Gollancz. http://www.sf-encyclopedia.com/.

Cole, Gina. 2020. "Wayfinding Pasifikafuturism: An Indigenous Science Fiction Vision of the Ocean in Space." PhD diss., Massey University.

Dery, Mark, ed. 1994. *Flame Wars: The Discourse of Cyber Culture.* Durham, NC: Duke University Press.

Dillon, Grace L. 2012. *Walking the Clouds: An Anthology of Indigenous Science Fiction.* Tucson: University of Arizona Press.

Duggan, Anne E., ed. 2021. *A Cultural History of Fairy Tales.* New York: Bloomsbury.

Evans, Arthur B., Istvan Sciscery-Ronay Jr., Joan Gordon, Veronica Hollinger, Robert Latham, and Carol McGuirk. 2010. *The Wesleyan Anthology of Science Fiction.* Middletown, CT: Wesleyan University Press.

Hauʻofa, Epeli. 1993. "Our Sea of Islands." In *A New Oceania, Rediscovering Our Sea of Islands,* edited by Eric Waddell, Vijay Naidu, and Epeli Hauʻofa, pp. 1–17. Suva: University of the South Pacific.

———. 1998. "The Ocean in Us." *Contemporary Pacific* 10, no. 2:391–410.

———. 2008. *We Are the Ocean.* Honolulu: University of Hawaiʻi Press.

hoʻomanawanui, kuʻualoha. 2012. "From Captain Cook to Captain Kirk, or, from Colonial Exploration to Colonial Exploitation—Issues of Hawaiian Land, Identity, and Nationhood in a 'Postethnic' World." In *Transnational Crossroads, Remapping the Americas and the Pacific,* edited by Camilla Fojas and Ruby Guevarra, pp. 229–268. Lincoln: University of Nebraska Press.

Hopkinson, Nalo, and Alondra Nelson (interviewer). 2002. "Making the Impossible Possible: An Interview with Nalo Hopkinson." *Social Text* 20, no. 2:97–113. muse.jhu.edu/article/31932.

Justice, Daniel Heath. 2018. *Why Indigenous Literatures Matter.* Waterloo: Wilfrid Laurier University Press.

Katsavos, Anna. 1994. "An Interview with Angela Carter." *Review of Contemporary Fiction* 14, no. 3:11–17. https://www.dalkeyarchive.com/a-conversation-with-angela-carter-by-anna-katsavos/.

Lavender III, Isiah. 2009. "Critical Race Theory." In *The Routledge Companion to Science Fiction,* edited by Mark Bould, Andrew M. Butler, Adam Roberts, and Sheryl Vint, pp. 185–193. New York: Routledge.

Liu, Ken. 2016. *Invisible Planets: An Anthology of Contemporary Chinese SF in Translation.* New York: TOR.

Lyons, Paul. 2006. *American Pacificism: Oceania in the U.S. Imagination.* New York: Routledge.

Miéville, China. 2002. "Editorial Introduction." *Historical Materialism* 10, no. 4:39–49.

Oziewicz, Marek. 2016. "Speculative Fiction." In *Oxford Research Encyclopedia of Literature.* Oxford: Oxford University Press. DOI: 10.1093/acrefore/9780190201098.013.78.

Rieder, John. 2017. *Science Fiction and the Mass Cultural Genre System.* Middletown, CT: Wesleyan University Press.

Sanchez-Taylor, Joy. 2020. "Alternative Futurisms: Tananarive Due's African Immortals Series." *Extrapolation* 61, no. 1–2:91–108. https://doi.org/10.3828/extr.2020.7.

Simpson, Leanne Betasamosake. 2017. *As We Have Always Done: Indigenous Freedom through Radical Resurgence*. Minneapolis: University of Minnesota Press.

Teaiwa, Teresia. 2010. "What Remains to Be Seen: Reclaiming the Visual Roots of Pacific Literature." *PMLA* 125, no. 3:730–736.

Teaiwa, Teresia Kieuea. 2021. *Sweat and Salt Water: Selected Works,* compiled and edited by Katerina Teaiwa, April K. Henderson, and Terence Wesley-Smith. Pacific Islands Monograph Series. Honolulu: University of Hawai'i Press.

Teverson, Andrew, ed. 2019. *The Fairy Tale World*. New York: Routledge.

Todorov, Tzvetan. 1975. *The Fantastic: A Structural Approach to a Literary Genre*. Ithaca, NY: Cornell University Press.

Trask, Haunani-Kay. 1993. *From a Native Daughter, Colonialism and Sovereignty in Hawai'i*. Monroe, ME: Common Courage Press.

Wendt, Albert. 1980. "Inside Us the Dead." In *Lali: A Pacific Anthology*, edited by Albert Wendt, pp. 284–290. Auckland: Longman Paul.

Yaszek, Lisa. 2006. "Afrofuturism, Science Fiction, and the History of the Future." *Socialism and Democracy* 20, no. 3:41–60.

Zipes, Jack. 2009. "Why Fantasy Matters Too Much." *Journal of Aesthetic Education* 43, no. 2 (Summer): 77–91.

Te Pō

Robyn Kahukiwa and Patricia Grace

I am aged in aeons, being Te Pō, the Night, that came from Te Kore, the Nothing.

First there was Te Kore that could neither be felt or sensed. This was the void, the silence, where there was no movement and none to move, no sound and none to hear, no shape and none to see.

It was out of this nothingness that Increase and Consciousness and I, Te Pō, were born.

I am aged in aeons, and I am Night of many nights, Night of many darknesses—
Night of great darkness, long darkness, utter darkness, birth and death darkness; of darkness unseen, darkness touchable and untouchable, and of every kind of darkness that can be.

In my womb lay Papatūānuku, who was conceived in Darkness, born into Darkness
—and who matured in Darkness, and in Darkness became mated with the Sky.
Then Papatūānuku too conceived, and bore many children among the many long ages of Te Pō.

* * *

Ko au tēnei, ko Te Pō, Te Pō tuauri whāioio, i ahu mai i Te Kore.

Ko Te Kore te tīmatanga—Te Kore tē rawea. Koia ko te hemanga, ko te haumūmūtanga, Kāore kau he oreore, kāore hoki he mea i reira māna e oreore; kāore kau he oro, kāore he mea māna te oro e rongo. Kāore kau he āhua, kāore hoki he mea māna te āhua e kite.

Nā Te Kore, ko te mātātupu, ko te mātāoho, ā, ko au, Te Pō.

No tuaukiuki ahau, ko au Te Pō o ngā pō huhua—te pō nui, te pō roa, te pō kerekere, te pō ara mai, te pō mate atu, te pō tē kitea, te pō whāwhā, te pō whāwhā kore—ko ngā momo po katoa, kei a au a awhi ana.

Previously published: Kahukiwa, Robyn, and Patricia Grace. 2018. "Te Pō." In *Wāhine Toa: Omniscient Māori Women*, translated into Māori by Hēni Jacob, pp. 31–33. Ōtaki, Aotearoa New Zealand: Te Tākupu, Te Wānanga o Raukawa.

Ko Papatūānuku taku kōpū, i whakatōkia ai i Te Pō, i whānau mai ki Te Pō, i tupu ake i te Pō, i aitia e Rangi i te Pō.

Ka mea ā, ka whānau mai ko ā Papatūānuku ake—e hia kē ngā tamariki i whānau mai ki a ia i ngā waenga huhua, i ngā waenga roroa o Te Pō.

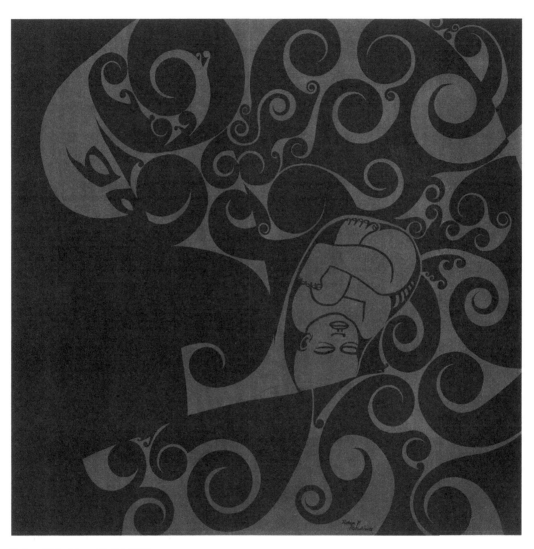

Robyn Kahukiwa, *Te Pō,* 2018.

He Holomoana Āiwaiwa (A Fantastic Voyage)

Navigating Wonder in Pasifika Literature

ku'ualoha ho'omanawanui

Kīauau, Hōauau (Preparing to Sail)

Wonder and the fantastic have always been important elements in Indigenous storytelling, including in Oceania,[1] beginning with oral traditions memorized, performed, and passed down across time mai ka pō mai (from the ancient past) and mai nā kūpuna mai (from the ancestors). Across Moana Nui, mo'olelo (stories, narratives, histories) of the kupua (demigod hero) Māui and his wonderworks—such as snaring the sun with a rope made from his mother's or sister's hair, fishing up islands with a "magical," mana-imbued fishhook, and learning the secret of fire from supernatural firekeepers like a deified ancestress (Mahuika in some Māori traditions) or 'alae 'ula (Hawaiian mud hens) have been passed down across tā and vā (time and space) for millennia. In an 'Ōiwi (Native Hawaiian) context, ancestral figures like Haumea, an akua wahine (female deity) associated with childbirth and warfare (among other things) is described as āiwaiwa (mysterious, fantastic) because of her ability to transform and regenerate across time. In the Kumulipo,[2] Haumea procreates with multiple generations of her own descendants; as Kameha'ikana, she transforms into an 'ulu (breadfruit) tree and saves her partner Wākea from death. Mo'olelo like Māui and Haumea are not unique in terms of the primacy of āiwaiwa abilities or experiences; such representations of wonder and the fantastic are normal and expected in Moana Nui mo'olelo. This chapter explores three expressions of āiwaiwa in Moana Nui mo'olelo (literature and film) in the first two decades of the twenty-first century. Each exemplifies our collective and ongoing genealogies of wonder, demonstrating the value of āiwaiwa in not just our creativity but also our social, cultural, intellectual, and political lives.

Continuity of pilina (relationships and connections) between 'āina (environment), akua (gods), kūpuna (ancestors), and kānaka (the people) of the present and our (future) descendants across tā

1. Oceania, Pacific, Pasifika, and Moana Nui are all used interchangeably in this chapter.
2. Kumulipo (*lit.* deep dark source [of life]) is a Hawaiian account of the universe, flora, fauna, and Hawaiian people, a genealogy that originates as the universe first forms as a big bang and up to the ruling chiefly class of the late eighteenth century, when it is composed by kahuna (priests) for the birth of high chief Kalaninui'īamamao.

and vā is an important theme in Moana Nui moʻolelo. These pilina transcend not just space and time, but the physical and spiritual realms. The seamless connection and pilina between the current "living" generations, past "dead" generations, and the yet-to-be future generations are not rigidly distinct in Indigenous thinking, as the concept of spiraling time—and, by extension, of storytelling—demonstrates. Such Indigenous wonderworks continue to normalize wonder and the fantastic elements of our lives through our moʻolelo. Three specific categories I discuss are:

- **Ke ola nei nā akua, kupua, ʻaumākua (gods, demigods, spiritual family guardians who live among us).** Shapeshifting akua, kupua, and ʻaumākua still live among us—we interact with them, and we embody them, even if we don't realize it.
- **Āiwaiwa, kino lau logic, kaiua, tā and vā (wonder, shapeshifting logic, regeneration across time and space).** Such embodiment and transformation (kino lau logic[3]) is possible because of cultural concepts of tā and vā: time is spiral; things repeat and are renewed.
- **E hoʻomau ka pilina (continuity of relationships).** Without a clear divide between living and dead, ancestors and spirits are with us, communicate with us, guide and protect us, have a relationship with us, and are powerful conarrators of our stories; this pilina includes the yet to be born.

Noho ana ke Akua: Deities among Us

Māori author Patricia Grace's *Potiki* ([1986] 1995) is one of the first contemporary Moana Nui novels to feature an āiwaiwa character who is pivotal to the narrative. The circumstances around the paternal parentage, birth, and raising of the pōtiki (favorite) child, Tokowaru-i-te-Marama (Toko) are a retelling of the story of Māui, which is what designates him as special from other people, including intimate family members. Yet the pōtiki Toko is *not* Māui, representing instead the āiwaiwa ʻano (nature, type). This kind of allusion to and recall of (ancestral) figures and events from the past is indicative of a spiraling storytelling style that is well recognized in Moana Maoli (Indigenous Pacific) narratives in many ways. For example, individuals in one generation often embody character traits, skills, and/or personalities of a kupuna (ancestor), particularly when named in their memory. Another aspect of āiwaiwa is that either by embodying our kūpuna, being named for them, or through encounters with them, whether we recognize them as such or not, our akua and kupua live among us and interact with us.

This kind of representation is perhaps most visible in Hawaiian moʻolelo of kanaka manō, or shapeshifting shark men. Kanaka manō were born from a human mother and a shapeshifting father with shark and human kino lau. Their sons were often born in shark bodies, inheriting the same fierce niuhi (human-devouring shark) predatory character and shapeshifting abilities as their fathers. Niuhi were particularly feared because they were large and aggressive; exceptionally

3. Kino lau logic is a term used by Marie Alohalani Brown (2022) to describe an ʻŌiwi ontology of systematic order (a kino lau system) that is thoughtful, intelligent, and adheres to sound principles of relationship and representation; such ontologies or systems of logical representation are found throughout Moana Nui and the Indigenous world, and are not always recognized or understood by those not fluent in the particular language and culture.

skilled aliʻi (chiefs) and warriors were favorably compared to niuhi sharks. Some niuhi kanaka manō, such as Nanaue, are legendary.

In ʻŌiwi writer Victoria Nalani Kneubuhl's short story "Manōwai" (2003), the main character, Kanoe, who lives in urban Honolulu on the island of Oʻahu, retreats to the rural Kona region of Hawaiʻi Island to escape her unfaithful husband and determine what she will do next. She rents a cottage from Robert and Luisa. Kanoe discovers a tranquil brackish pond among the lava fields at the shore called Manōwai (shark water). Robert and Louisa are uncomfortable with her going there alone, but are vague as to why. All Robert shares is that it is a "place for ʻaumākua. It used to be kapu [sacred, off limits] to everyone but family, big aliʻi. Even today, nobody around here like swim there. Luisa no like that place" (45).

Luisa later tells Kanoe a story about a young woman with a baby who went to pick limu (seaweed) with friends, and left the baby under a tree on a blanket. Later, the women witnessed the baby carried out to sea by a shark. Kanoe remarks, "How awful to have your baby eaten by a shark," to which Luisa replies, "I never said the shark *ate* the baby . . . I said the shark *took* the baby" (46). Kanoe doesn't react, and doesn't seem to understand the significance of Luisa's clarification.

Kanoe ignores their warning to stay away from Manōwai. One day, she sees a young man offshore on a surfboard; he retrieves her sun visor, which has mysteriously moved down the sand and into the water. He introduces himself as Kapuaokekai (the flower of the sea), and the two begin spending time together, especially when Robert and Luisa leave for a few days. The night before they depart, Luisa has a dream about a boy and a girl swimming with sharks.

While the story is never clear, Kneubuhl intimates that perhaps Luisa is the mother of the baby that was taken, that the shark who takes the baby is a kanaka manō, probably a family ʻaumakua, and that Kapuaokekai is the baby raised as a shark who can shapeshift into a human. Kanoe also has a dream involving sharks, which turns into a nightmare. But Kapua is there to soothe her, and tells her not to worry, as that night "will be a special night. The moon will be as full as it can be and together they will watch it rise . . . The two of them will be alone with the moon, the water and the light" (49).

The scene shifts to Kanoe recovering from an injury after she is found by Robert and Luisa by the Manōwai pool. Kanoe has no memory of what happened to her, but tells Luisa about a dream she had; the "dream" suggests what happened to Kanoe, and that it is a reiteration of a kanaka manō story, in which Kanoe is impregnated by Kapuaokekai and gives birth to a manō, which is then lovingly carried off into the sea by Kapuaokekai, all in hyperreal time that seems to span mere seconds.

Several āiwaiwa elements include the extraordinarily quick sequence of events of impregnation, gestation, and childbirth. There is also a suggestion of collapsed or spiralized time in which Kanoe is back in ancient Hawaiʻi, or perhaps ancient Hawaiʻi has come to the contemporary world, on the night of the Akua or full moon, as she notices she is surrounded by "torches all around" held by unseen figures (49). She is also suddenly "leaning on the rocks," which suggests traditional pōhaku hānau (birthing stones) used by aliʻi women in childbirth. She hears "a series of snapping sounds," which recall the sound of animated shark jaws, indicating the birth of a

child in manō (shark) form, before everything turns into "a silent movie in slow motion" (49). At that point, Kanoe recalls she is "tenderly carried by invisible hands, washed in the pool and placed back on the rocks which are clean and smooth again. The torches begin to go out one by one and I watch the young man [Kapuaokekai] walk away . . . He turns away and enters the sea" (49). In the end, the reader is left wondering if Kanoe's experience is real or imagined. But how can it be purely imagined when such events have occurred mai ka pō mai to current times?

Dreams are an important form of communication between kānaka, akua, and kūpuna across Moana Maoli cultures, and the dreams Luisa and Kanoe have are important meiwi (culturally based ethno-poetic [literary] devices) that function not only as foreshadowing (Luisa's dream), but also as a storytelling device that adds depth, background, and details to the narrative in a seamless, organic way. Dreams as communication are prevalent in cultural practice and oral story performance that long predate writing, and not simply a plot device. Kāne o ka pō (dream lover, *lit.* man [who comes] in the night) are a commonly recognized dream; women who became pregnant by a dream lover often birthed keiki ʻeʻepa, "a strange and wondrous child" (Pukui, Heartig, and Lee [1972] 2014, 171). Hōʻike o ka pō (revelations in the night) are another known category of dreams in which messages from ʻaumākua could be direct or symbolic (172–173).

Another twenty-first-century moʻolelo āiwaiwa takes shapeshifting and the life-death cycle of kanaka manō in another direction. ʻŌiwi writer Bryan Kamaoli Kuwada's short story "All My Relations" (2017) is an original moʻolelo featuring the renowned kanaka manō Nanaue. Nanaue is a shapeshifting shark of Waipiʻo, Hawaiʻi, son of the manō Kamohoaliʻi and a human mother, Kalei. He develops a taste for human flesh after his maternal grandfather feeds him meat so he will grow up to be a strong and fierce warrior. When his true identity is discovered, he is killed. Like other kanaka manō, in his human form, Nanaue has a shark mouth on his back, which he conceals with a kīhei (cloak).

"All My Relations" is set in modern Hawaiʻi, narrated by Nanaue, who is both proud and surly, easily annoyed by a young boy at the beach who talks incessantly, and addresses him as "Uncle," a term of respect in modern Hawaiian culture, but one the akua manō (shark deity) finds insulting. Nanaue has been relegated (or demoted, in his view) to his human kino lau, a state he reviles. He recounts the defeat he and his fellow manō ʻaikānaka (human-devouring sharks) suffered in a battle two centuries ago at Puʻuloa (Pearl Harbor), Oʻahu, with the human-protecting sharks led by Kaʻahupāhau and her brother (or son, depending on the version) Kahiʻukā. Kaʻahupāhau declared no manō should consume human flesh again, and Nanaue begrudgingly complied.

Nanaue begins taking the boy (whom he nicknames Uncle, since he hates being called "Uncle" by the boy) diving and teaches him how to dive and fish responsibly, despite the boy's nīele (incessant questioning; overly curious) character, which Nanaue finds mahaʻoi (rude). As months go by, the boy becomes adept at spearfishing, although Nanaue is concerned and warns him about overfishing, especially for profit, and taking more than he needs, thus promoting a very practical and respected environmental stewardship practice recognized across Indigenous cultures. Nanaue remarks, "I sometimes think that he doesn't understand why we do this. Why we hunt for our food. Why I say the ritual words before I feast. I don't mean some hippie crap about us being one

with the ocean or whatever drug-addled notions they peddle at their Puna retreats nowadays. I mean that there is a responsibility to being in the ocean, swimming in the salt blood of this planet. There is a weight to being predator or prey, and it is something you gutbags [humans] have forgotten" (112). Nanaue's ire grows when he takes the boy out into deep water, and the boy clumsily shoots an 'ahi (tuna) and is more concerned with getting good video than quickly dispatching the 'ahi and ending its suffering. Nanaue is furious when the boy ignores his order to return to the kayak when he sees a group of sharks arrive, drawn by the death throes of the tuna, and is incredulous when the boy aims his camera and speargun at a tiger shark and shoots. The other manō attack the mortally wounded tiger shark; the apex predator of the sea has been reduced to shark bait. Nanaue is so enraged he can no longer contain his true nature, and shapeshifts into his manō 'aikanaka niuhi form.

> I lift the wetsuit hood off of my head, and as I begin to work my way out of the wetsuit top, I feel the tips of my teeth emerging from the tattoo on my back. They tear through the black triangles on my skin and push their way forward, becoming a ring of jagged teeth around uliuli.
>
> Gills tear open on my neck and denticles rise on my skin. Bones crack and soften, reshaping and elongating, fins pushing out from my torso. The neoprene stretches and shreds into little pieces. I arch my back with the pain of the transformation and roar soundlessly as it completes.
>
> With the return to shark form, so too comes the freedom of hunger. And there is only one prey. (114)

There is no escape for the boy once Nanaue transforms into his true self, as they are alone in the kai uliuli, the deep blue sea, far from any help for the boy, but well within the home of Nanaue. Too late, the boy realizes Nanaue is a manō 'aikanaka, and the reader realizes the possibility (or probability) that manō 'aikānaka still live, swim, hunt, and interact among us. We just might not be aware of their presence.

A point of irony reflected in the title and repeated by Nanaue throughout the short story is that while many 'Ōiwi acknowledge kinship with manō, not all kānaka are related to manō. On the one hand, "all my relations" references the Lakota philosophy *Mitakuye-Oyasin,* all living things are connected to each other and to a creator or higher power. In Hawaiian thinking, it acknowledges a kuleana (responsibility) we all have to each other, and underpins the philosophy of mālama and aloha 'āina. On the other hand, Nanaue repeatedly denounces the boy calling him "Uncle," sneering, "as if we could be related" (104, 115). While the boy calls Nanaue "Uncle" as a sign of respect for him as an adult, demonstrating a sense of pilina despite not being immediately related, Nanaue recognizes the boy's disregard for the sanctity of life in being greedy and careless, and thus Nanaue "disowns" the boy for being an irresponsible fisher/hunter and not caring for all his aquatic relations.

Sometimes life lessons and the consequences of our actions are harsh and can result in death, as in the case of the boy. At first glance, "All My Relations" is a horror story. According to

Sigmund Freud's psychoanalytical approach, we are attracted to horror because it taps the fears, negative urges, and desires buried deep in our subconscious; horror stories that involve predatory, human-devouring sharks, such as Peter Benchley's *Jaws* (1974), spawned a subgenre of shark horror films after the movie version was released in 1975. But rather than simply tell a Hawaiian horror story, Kuwada presents a traditional 'Ōiwi theme of mālama 'āina and kuleana: care for the environment and resources, or there will be consequences. When viewed through this lens, the consequence the boy faces is a reiteration of a classic Moana Maoli theme of environmental restorative justice on at least two levels: he is punished for his greed, selfishness, and senseless taking of life, and Nanaue's true nature and full mana are restored through his shapeshifting back into his manō 'aikanaka/niuhi form. The mo'olelo leaves us with the sober lesson that Nanaue, in his shark and human forms, is out there, watching, waiting, interacting with us when and how we might least expect it.

Embodiment and Transformation—From Squid Gods to Pig Gods

Pasifika literature reveals our cultural worldviews, that our akua, 'aumākua, and kupua ancestors and heroes of the past still live amongst us in the present, and we reflect and embody them. The two poetry collections of Pasifika poet Daren Kamali (Fijian, Wallisian, Futunan), *Tales, Poems, and Songs from the Underwater World* (2011) and *Squid Out of Water: The Evolution* (2014), feature a narrator (presumably Kamali) descended from a kuita atua (squid god), who also embodies the god Kuita. The atua and narrator can shapeshift into each other, embodying the other's kino lau. There are myriad examples throughout Kamali's work, so I will touch upon a few.

In sharing kino lau, the squid god and the human each represent the other. However, kuita atua also represents language, culture, and traditions of the past, while his human body represents modernity, the past, present, and future, of tā and vā, and also native Oceanic and introduced languages, cultures, and experiences. A kai loma (half caste)—half human, half fish—who travels the world "from the sea / to the streets," he represents multiple identities in one, binding memories of the past and experiences of the present with an eye toward perpetuation, preservation, and innovation into the future (2011, n.p.).

In the poem "Giant Squid," Kamali fleshes out the physical transformation of the sea god as one

> you'd love to meet
> jandals between webbed feet
> tentacles become dreads
> all dressed up in island threads
> goggles become shades
> emerging from his ocean cave. (29–32)

In "Eight Tales of the Giant Squid," his physical transformation from cephalopod to human involves "dreads" replacing "tentacles," "brown skin" emerging from "silver scales," and "gills

disappear[ing]" as he is now "breathing fresh air" (45–48). Cultural and psychological negotiations of Kuita's identity in a modern human world also occur—he arrives "culture-shocked / Suffering from severe mind block / islander mentality," as a "half-fish, half-man / caught in between two lands / in transit from the ancient / adapting to the new" (32).

The continuity of moʻokūʻauhau, connecting us to the past through our ancestors, as well as to the future through our descendants, and our ability to navigate different worlds is conveyed when he emerges from the sea, "his family following close behind" (48). This theme is affirmed in the poems "He Has Superpowers" (54–56) and "The Shark and the Turtle" (66–67).

"He Has Superpowers" introduces Grandmother Duna, an eel, representing Kanaka kinship with ocean life, and, by extension, all of nature. A visual art piece "Grandmother Eel" (53) by Lehna Gill, which precedes the poem, and a graphic comic illustration of the poem after it (57–62) frame the poem in ways that visually represent the continuation of genealogy and kinship connection. Moreover, as elder women, grandmothers hold positions of wisdom and power in many Indigenous cultures, and Grandmother Duna is the one who knows the source of Kuita's superpowers, that he is a shapeshifting kupua with wondrous abilities, "an unsung superhero / in the village" who "can fly / breathe underwater / walk on hot lovo [earth oven] stones" (54). As an atua, he doesn't get sick or grow old, and as time passes, he worries about how to hide his youthful appearance, finding it easier to fake being ill in his human kino lau. Yet, rather than revel in his abilities, he worries about his grandmother's advancing age, and wants to know how he can transfer his āiwaiwa superpowers to her to keep her alive. The familial connection and cooperation of nature (and perhaps nature and its elements) is evident in their intergenerational love, respect, and caring for each other, a foundational cultural value of kinship connection with (nonhuman) ancestors.

The "evolution" of the squid deity as kai lomo is extended and explored in more detail in *Squid Out of Water: The Evolution* (2014). Here, the squid god/human Kuita acquires additional names, each with its own persona—Teuthis (adapted from Architeuthis, the scientific name for "giant squid"); Taitusi (an indigenized form of Teuthis); and Inkfish (a play on squid ink and ink for writing/printing [poetry]). Thus, the narrator is indeed a "squid out of water" living beyond his natural oceanic environment/comfort zone. An epigraph to the collection states that "the giant squid is interchangeable . . . from squid, to octopus, to Kuita, to Teuthis (as a man) changing like the climate of the Pacific" (n.p.). But still he explores the world as a heʻe (octopus) human bedecked in dreadlocks, traveling ocean to ocean by airplane—from the Pacific to England, Dubai, Ukraine, and home to the Vasa Loloa again.

The complexities of these identities and experiences are provided in poems such as "Octopast" (41–42), "Na Dua" (48–49), and "Teuthis in Brixton" (50–51). "Octopast (How He Came to Be)" provides some cultural-historical description of Kuita's experiences across tā and vā, "cannibalized by history / once eaten by his own" (41).

> Kuita roams the vasa [ocean]
> licking blood off
> his half human tentacles

belly filled with human meat
he lies on a mat
under a coconut tree
for an afternoon nap. (41)

Kuita is awakened by Lapita people (1600–500 BCE), whom he describes as cannibals,

trying to find a place to rest
navigating ocean graces
to a space
where va doesn't exist. (41)

The narrative shifts to Burotukula (Pulotu), a paradise underworld; in Tongan cosmology, Pulotu exists from the beginning of time, and is the homeland of deities. In Tongan and Sāmoan culture, Pulotu is considered a real place believed to be located "somewhere in the Lau group," as the poem also expresses (41). There are multiple metaphors at play with Burotukula/Pulotu and Matuku in the next line that all reference "an underwater island" (41). Makutu is a volcanic island located in the Yasayasa Moala group in the Lau Islands, Fiji. Makutu is also a Māori word meaning "witchcraft, magic, sorcery, spell," to "inflict physical and psychological harm and even death through spiritual powers,"[4] as well as magical, bewitching, and supernatural. In Māori culture, Mākutu lived with Miru, a female atua of the underworld; her home was called Tātauotepō ("door of night") (Tregear 1891, 200, 488). Thus, multiple concepts of supernatural āiwaiwa deities, particularly those associated with sorcery, female power, and the underworld, are woven together, suggesting immense mana, particularly when the female Mākutu's

sharp sparkling teeth
[are] used as an octopus lure
to fish the underworld up
to weave the myths of Burotukula to Pulotu. (Kamali 2014, 41–42)

In effect, Mākutu is able to "pull the giant [squid] out of his comfort zone / out of the ocean," to her world,

onto mountain top
where she sits
looking out to the Moana
covered in stars. (42)

4. *Te Aka Māori Dictionary*, s.v. "mākutu." https://maoridictionary.co.nz/word/3559.

"Teuthis in Brixton" encapsulates the "squid out of water" theme as Teuthis tries to navigate the foreign land by airplane and then bus, unsure of who is trustworthy when seeking assistance and directions. The narrator remarks,

> Never has he seen so many squidlums
> in a patch of foreign land before
> black faces with stretched English accents
> tainted by centuries of suffocation
> by the oppressor
> tentacle like dreads hang over
> wandering eyes. (50)

Despite recognizing kindred squid folk of other places who are also brown-skinned and suffering in the land of the colonizer far from their homelands, he is also wary, because Brixton (representing colonial oppression) "makes people / hungry and tired / causing them to lose their minds" (51).

Calling upon his physical, cultural, and spiritual connections to home (Fiji), he removes a "lucky vatu [stone]" gifted from an aunt in Honiara in the Solomon Islands, "kisses it and whispers to the gods," and, "like magic," a "middle-aged African lady appears out of nowhere / walks up to him and offers" him assistance (51). Is it a mere coincidence that the narrator receives help from the woman when he does? Or does the helpful woman appear because of the narrator's use of a talisman and appeal to his atua? Her timely intervention reinforces our Maoli beliefs in the guidance and aid offered by our atua, ʻaumākua, and kūpuna; that the appearance is sudden is āiwaiwa and purposeful, and that she is female resonates with Kamali's evocation of powerful akua wahine throughout his work. That she has no name (the narrator forgets to ask, and she doesn't offer it) adds to the āiwaiwa nature of her identity, in that it is intimated she is an atua, ʻaumākua, or kūpuna of the narrator, despite their different ethnic and cultural backgrounds. After all, Kuita travels the world for millennia, and perhaps represents not just a Moana Nui genealogy and identity, but a global one with kinship connections of the oppressed around the world.

Kamali's poetry performs how Moana Maoli people embody our ancestors and are the regeneration of our kūpuna. We, too, are āiwaiwa, with our own shapeshifting abilities, as we navigate modernity, mixed heritage, and trans-Oceanic migration in new ways, but continue to celebrate and practice our culture roots as we travel routes old and new.

The protagonist of ʻŌiwi writer Keola Beamer's short story "Ka ʻOlili, the Shimmering" (2002) is Kenneth Weir, a haole (white) volcanologist from New Mexico who is working as a scientist at the Hawaiʻi Volcanoes National Park Observatory on the island of Hawaiʻi in the mid-1990s. His initial supervisor, Nicholas Granger, suggests he learn about Hawaiian culture and language as a way to enhance his knowledge about the Hawaiian volcanoes he is studying. Weir's new supervisor, Willard Drakes, however, demonstrates racist, condescending disdain toward Hawaiian culture, including traditions about the volcano and its active akua wahine,

Pele. All three men are haole Americans from different parts of the United States, and represent different western viewpoints toward Hawaiʻi, Hawaiian culture, and Hawaiians. Weir follows Granger's advice, enrolling in Hawaiian-language and hula classes to learn more about and (ultimately) respect the culture. Through his studies and practice of Hawaiian language and culture, specifically hula, Weir begins to transform, and Pele begins to communicate with him through his work computer, recognizing him as her lover Kamapuaʻa. Kamapuaʻa is the famous pig kupua representing the lush, rain-laden forests of the islands, a fertile male symbol, dualistically paired with the fiery, tempestuous volcano goddess associated with the drier, lavascape of the active, land-birthing volcano Kīlauea Weir is studying. Weir is at first frightened, convinced he is going crazy or nefarious hackers or practical jokers are toying with him. But with his growing knowledge of and experience with Hawaiian culture, language, metaphors, and symbols, he begins to embrace his communication with the volcano deity and his newfound identity.

The moʻolelo opens with Weir as Kamapuaʻa in his pig kino lau fleeing from hunting dogs. After he collapses from exhaustion, the hunters are confused to find a nude haole man unconscious in the forest, unsure why their dogs tracked a human. As the sole narrator, first in Kamapuaʻa's voice, then in his own, Weir begins telling how he came to work in Hawaiʻi, and the fantastical experience that transforms him into Kamapuaʻa. The moʻolelo concludes with Pele assisting Weir in overcoming his nemesis, Drakes. Drakes, a pillar of western science, demonstrates complete contempt for Hawaiian culture and Weir's embrace of it, even though Weir's new understanding helps him as a scientist and person, allowing him new insights. At Pele's suggestion, Weir lures Drakes to a molten lava lake under the pretense of showing him a new discovery. As they approach the fiery kino lau of Pele, the molten lava that is ʻolili, shimmering from the intense heat, Weir shapeshifts into Kamapuaʻa's pig form and throws Drakes into the molten fire, which consumes him. In a note to the text, the author shares that he was inspired by the descriptions of Kamapuaʻa in traditional moʻolelo such as Kumulipo as "ka haole nui maka ʻālohilohi" (the important/large-framed foreigner with sparkling [light colored] eyes). "What would happen," the author muses, "if after all this time, Pele longed for her old lover?" (26).

While containing elements of western horror and science fiction, the story is clearly a twenty-first-century iteration of traditional moʻolelo āiwaiwa, beginning with the author's inspiration, Kumulipo. While some readers might bristle at the idea of Pele's lover as a haole scientist, Kamapuaʻa—like Pele—were considered malihini (visitors, foreigners) from Kahiki, simultaneously Tahiti and all foreign lands outside of Hawaiʻi. Thus, Beamer's interpretation of the Kamapuaʻa and Pele tradition is firmly rooted in Hawaiian moʻolelo, as is its original incorporation of āiwaiwa elements.

For example, mele and hula are always prevalent in traditional moʻolelo, functioning for Pele and Kamapuaʻa as a form of heightened communication in storyperformance (similar to how arias are featured in opera). In "Ka ʻOlili," Pele and Weir/Kamapuaʻa's use of mele heightens their communication with each other, resulting in tangible outcomes. In the first instance, Weir as Kamapuaʻa chants a traditional mele to Pele, asking for her help as he is pursued by hunting dogs through the rainforest—

Kekē hoʻi ka niho	*The teeth are exposed*
ʻAneʻana nanahu mai	*Ready to bite*
Moku au lā	*I am bitten,*
Moku au lā.	*I am bitten.* (2)

Upon hearing his chant, Pele responds with temblors, and the dogs, now frightened, back away, which saves Weir's life.

After three years of studying Hawaiian language and hula, Weir's hālau (hula academy) begins studying hula kahiko (ancient hula) and a series of mele for Pele, including the well-known "Aia lā ʻo Pele i Hawaiʻi" (Pele is present on the island of Hawaiʻi)—

Aia lā ʻo Pele i Hawaiʻi ʻeā, ke haʻa maila i Maukele ʻeā

ʻŪhīʻūhā mai ana ʻeā, ke nome aʻela i nā Puna ʻeā

Ka mea nani ka i Paliuli ʻeā, ke pulelo aʻela i nā pali ʻeā. (6)

There is Pele on Hawaiʻi, yes, dancing at Maukele, yes

Rumbling and blowing volcanic smoke, yes, munching up Puna, yes

The beautiful one is at Paliuli (dark cliff), yes, rising up over the cliffs, yes.[5]

Weir thus demonstrates respect for Pele through the performance of this hula composed in her honor. Even when not performed or included in the text, references to chanting and hula are also described, particularly through Pele and Kamapuaʻa/Weir's interaction through the computer. In one message to Weir, Pele types, "I chant from deep within—your name so sweet / Kama—my own" (9). In another instance, the seismograph produces the definitive kahiko beat of a drum, rendered as "U U—UTETE / U U—UTETE," a way of describing the traditional drum beat rhythm in hula kahiko (11, 15). Thus, auditory imagery evoking the sound and beat of hula kahiko is another āiwaiwa element, as both Pele and Kamapuaʻa are associated with mele hula.

As the narrative progresses, Weir is able to interpret Pele's messages in ʻōlelo Hawaiʻi, demonstrating his increasing fluency in Hawaiian language and culture through practice (exhibited in the ʻōlelo noʻeau, or poetic saying, "Ma ka hana ka ʻike," knowledge is gained through experience). As he gains cultural knowledge and linguistic fluency, his identity shifts as well, embodying more and more his Kamapuaʻa alter ego, which simultaneously deepens the pilina between him and Pele. Later, another message from Pele appears on Weir's computer monitor in Hawaiian, a mele chanted by Pele to her younger sisters that demonstrates she recognizes the true animal (pig) nature of the handsome man who has appeared at the rim of their volcanic crater home of Halemaʻumaʻu. In response, Weir says, "I understood these words," and then flawlessly translates them (12).

5. The English translation by kuʻualoha hoʻomanawanui. For an alternative translation, see https://kaiwakiloumoku
.ksbe.edu/article/mele-aia-la-o-pele-i-hawaii.

Familiarity with the original Pele and Kamapuaʻa moʻolelo deepens the allusion to it: while Pele's younger, more naive sisters swoon over Kamapuaʻa's attractive human kino lau, Pele is annoyed that they don't recognize his true pig nature. She chants a longer version of the lines provided in "Ka ʻOlili" that references his moʻokūʻauhau (an important meiwi). But in her chant she also chastises him, accusing Kamapuaʻa of coming to her volcanic home to fight with her. Kamapuaʻa replies with an equally derisive chant for Pele, and the two battle. But in Beamer's moʻolelo, the mele fragment is repurposed as a romantic enticement from Pele to her beloved, highlighting their relationship as loving and sensual, not simply sexual.[6]

As his cultural knowledge grows, Weir becomes aware of his transformation from human to pig deity and back.

> That night, I chanted in the soft moonlight and smacked my thin, black lips. I danced, ʻai haʻa [an old, traditional-style hula with knees bent and body lower to the ground], beneath the wooden floor of the small cottage until my legs were leaden and my ankles were weak from exertion. Again, I felt her embrace in the deep darkness, as she favored me with silk, shreds of lehua, and tiny fragments of fresh, white ginger. These tender ministrations of sweet aloha eased the loneliness in my heart. The ache that had haunted me for so many years was finally gone. For the first time since the death of my parents did I again feel loved. I closed and ended the kahiko and my tears fell, streaming through the coarse, black hair of my face. (18)

The final chant in Beamer's story describes Weir/Kamapuaʻa "chant[ing] vibrantly into the heavenly darkness" (24). The lines he chants are from a mele inoa (name song) composed for Kamapuaʻa before his birth and addressed to his mother, Hina. In the original moʻolelo, it is chanted by his grandmother Kamaunuaniho, providing him the strength to escape capture, and here it similarly celebrates his āiwaiwa nature.

While the first chant in the story includes an English translation, the remainder do not, speaking to the main character's increased fluency in Hawaiian language and cultural competency. It also centers an ʻŌiwi worldview through our heritage language and evokes the original oral tradition. The chant can be interpreted as a warning that Kamapuaʻa is not a mythic being of the ancient past, but a dynamic, shapeshifting, and living one in the present—

> He miki, he miki
> A i hānau mai ʻoe e Hina
> Ka maka o ka puaʻa
> E lele ana i ka lani
> E lele ana i ke kuahiwi
> ʻEwalu maka o ke keiki puaʻa a Hina. (24)

6. For the longer version of the chant, see Fornander (1918, 336–338).

Be alert, pay attention
When you give birth, Hina
The eyes [or face] of the pig
Look to the heavens
Look to the mountains
The pig child of Hina has eight eyes.[7]

On the one hand, the reference to eight eyes is metaphoric, meaning he is ever alert. On the other hand, one kino lau of Kamapua'a is an abnormally huge pig with four sets of eyes and tusks. The number eight is used in reference to Kamapua'a and similar godly, warrior, and hero figures, such as one of Kamapua'a's rivals, Lonoka'eho, and the bat kupua Pe'ape'amakawalu (*lit.* eight-eyed bat). Thus, Kamapua'a's wondrous, fantastic, āiwaiwa nature was prophesied before his birth. With the story ending on this note, it promises more wondrous adventures, particularly since Weir's human adversary has been killed.

Mo'olelo Āiwaiwa as Storyperformance in Film: *Kava Kultcha* (2003)

Āiwaiwa is found throughout film texts, both those adapted from literature (such as Māori writer Witi Ihimaera's *Whale Rider,* 1987; 2002) and original films (Rotuman filmmaker Vilsoni Hereniko's *Pear ta ma 'on maf: The Land Has Eyes,* 2004, and Māori filmmaker Himiona Grace's *The Pa Boys,* 2014). Film is both a return to and showcase for storyperformance, a way to preserve and disseminate the oral and theatrical beyond an immediate, live audience. Elements of āiwaiwa lend themselves to visual transformation by engaging multiple senses as well as the imagination of viewing audiences.

The 2003 short film *Kava Kultcha,* written by Tongan artist Misa Tupou and directed by Leah Kihara ('Ōiwi), is "set in a futuristic world dominated by [a global] enforcement agency intent on eliminating cultural diversity," as "a peaceful Polynesian resistance group dares to practice their own traditions, including the drinking of kava."[8] That the "future" world is 2015 from the perspective of 2003 is irrelevant, as the core theme that (Moana) Maoli peoples live and enjoy their lives and escape colonial assimilation through practicing their culture is certainly not new, nor is their resistance.

The film opens with the sound of Polynesian music playing, a group of presumably Indigenous Pasifika adults of different ages accompanied by one young boy sitting on the ground in a faikava (kava circle). A large tub of kava is being prepared to share among this gathering of the Faikava Underground Resistance, who are defying the colonial Global Enforcement Agency (GEA) by practicing their native culture, symbolized by the faikava. An ensemble of musicians play, and a young woman gets up to dance a tau'olunga (Tongan dance). The mood is relaxed and happy.

The narrator is the young boy, Samu, reflecting back to this memory as a grown man. He introduces us to Kupe, the leader of the Faikava Underground (played by 'Ōiwi actor Moses

7. Translation by ku'ualoha ho'omanawanui. For another variant, see Fornander (1918, 314).
8. Pacific Islanders in Communications, "Kava Kultcha," https://www.piccom.org/programs/kava-kultcha-1.

Goods). Kupe carries the name of the ancestral aliʻi and navigator "of Polynesian myth" who "discovers new land throughout the Pacific" (00:18–00:22). Samu sets the scene by explaining that a global war in 2015 ravaged the earth; thus, the GEA "intervened to establish world peace" and subsequently "abolished countries, religions, languages, and traditions; they tried to assimilate our people and suppress our stories" (00:25–00:44). He then shares, against this bleak dystopian setting, "but I still remember Kupe, not the hero of myth, but my own legendary hero. He was the man leading the underground resistance [and] our only hope for survival, our only hope to perpetuate our culture" (00:45–01:01).

The first scene after the title credit is the GEA, an austere, generic white office environment, with men in black huddled around a desk; artificial, digital tech sounds are audible, a stark contrast to the warm, vibrant opening scene of the faikava. A hologram image of Kupe appears, with the label "Wanted." The second scene shows Kupe relaxing in the Faikava Underground hideout, located "somewhere in the South Pacific" (02:07). He sees his "Wanted" image printed in the newspaper he is reading. Upset, Kupe pulls out a packet of dried kava root and begins to prepare it for consumption. He is interrupted by an alarm sounding, and grabs a weapon. But it is friends who enter. "Fix Amnesia," a contemporary Pacific hip-hop song by Aotearoa-based King Kapisi (Sāmoan) plays. The music then shifts to steel guitar music, lūʻau (party) style; the friends (and relatives?) greet each other with smiles, warm hugs, and kisses, and they prepare and share kava together in faikava. Close-up shots of the preparation demonstrate the cultural care and respect for kava. Music, song, and dance are shared, including practicing movements that demonstrate the preparation of kava by a father with his son.

But the GEA agents raid the Faikava Underground hideout; the Faikava Resistance fights back, but they are all captured or overcome. In the melee, Kupe grabs the ʻumete kava (kava bowl) and throws the kava in the faces of the GEA. As Kupe and the boy are surrounded, Kupe hands the ʻumete to the boy, who grabs it and runs outside; Kupe is handcuffed and taken away. The boy hides in the field and places the ʻumete on the ground. He immediately begins to make the motions for the kava dance he had been practicing inside with his father. The scene cuts to Kupe, who is forced to kneel before the head GEA agent. Looking up at the agent, Kupe defiantly speaks in a Polynesian language, and then delivers the penultimate line, "You will not stop this kava kultcha" (07:24–07:31).

The scene shifts back to the boy, who is observing Kupe's arrest from a distance in hiding, while he continues to practice the ritualized kava dance moves. He concludes, "I was the last one to see Kupe. But it was all of our tears that filled the ʻumete that day. The motions of the faikava told of more than just kava making. They told of the legends of all those who came before us, as well as the stories that we lived every day. Kupe had already set the course for us to navigate our future. I vowed to follow that path. And I knew then that I would be the one to perpetuate our kava kultcha" (07:33–08:22). The closing credits feature more dancing that is celebratory and joyous, leaving the audience with a sense of triumph that Kupe's proclamation has or will come to pass, and that the boy, Samu, has been or will be successful in perpetuating kava kultcha, and all that accompanies it—language, music, dance, kava preparation and consumption, and the social and familial pilina supported and affirmed through it.

There are many visible elements of āiwaiwa in the film, starting with the central character, Kupe. A high chief and excellent navigator from Hawaiki, the ancient Polynesian homeland (sometimes considered to be Tahiti, or, more specifically, Ra'iātea), Kupe is credited by some Māori tribes with discovering Aotearoa (New Zealand). Naming is a critical part of Polynesian cultural practice, as names provide a foundation for one's character and identity, and thus it is no surprise or accident that the Faikava Underground's leader is named for the famed chiefly ancestor Kupe. Because of this, the film's protagonist carries the mana, knowledge, and skill of the ancestral Kupe into future generations, and focusing on his as the only name in the film highlights that ancestral connection. The narrator Samu (Samuel), who is never identified by name in the film, later assumes Kupe's leadership role. His character is akin to the Biblical Samuel, a seer, prophet, priest, judge, and military commander—roles also intimated in the hero Kupe's leadership.

A fearless voyager, the original Kupe sailed the vast Moananuiakiwa,[9] and encounters the fierce Te Wheke o Murutangi (the octopus of Murutangi[10]), who pursues Kupe to Aotearoa.[11] Because the octopus continuously steals the bait off the fishing lines of Kupe's fishermen, Kupe asks Murutangi to call off the wheke, but when his requests go unheeded, Kupe kills the wheke and hides his body so that Murutangi cannot revive him. In the film, the GEA is a colonialist wheke, its snaking tentacles reaching everywhere, prying into Native peoples' lives. Kupe, the fearless Faikava Underground leader, resists colonial assimilation through the perpetuation of the integral cultural practice of faikava, sacrificing his freedom (and perhaps life) for his people.

While the faikava is a specifically Tongan practice, it resonates in similar kava-centered practices across Polynesia and arguably the wider Pacific. The purpose of the faikava is to affirm the importance of personal relationships, interpersonal interaction, and the intersection of family and community. As part of a living culture, it has also undergone adaptations in modern times, particularly in the diaspora. However, as the primary symbol of the film, the faikava ensures continuity of an integral cultural practice as part of Moana Maoli identity into the future, wherever Moana Nui people may be.

Faikava has evolved from traditional practices across tā and vā, especially in the diaspora, but faikava is still "about bringing people together, and it is also about learning, and maintaining a Tongan and Moana identity" (Tecun 2017, para. 14). In interviews with Arcia Tecun, young adult diasporic Tongans shared the sentiment that kava is "just a part of who we are, you can't separate Tongans from Kava," and "it doesn't matter what your background is, there's lots of religions and ethnicities that can be represented in one Kava circle, indicating that a diverse set of people can be unified through Kava" (para. 14). This is reflected in *Kava Kultcha,* as a diverse range of Polynesian faces comprises the Faikava Underground, all sharing a sense of Moana Nui unity through the faikava. Tecun writes, "The Kava bowl and process of gathering to drink, dialogue, and sign was and is a vessel of cultural knowledge that in many cases today has compressed various

9. Moananuiakiwa is a Māori concept of the vast Pacific; *lit.* Great-ocean-of-Kiwa (Kiwa being another famous navigating chiefly ancestor).

10. Murutangi was another skilled navigator.

11. Aotearoa—*lit.* land of the long white cloud, named by Kupe's wife.

elements of previous practices into one. Therefore, I suggest that the Kava bowl is a vaka (canoe) of Tongan and Moana identity that journeys back and forth through time and space between tupuʻanga (ancestors), Tonga, and where Tongans reside" (para. 13). Thus, despite the group being underground and in hiding, the kava symbolically connects them to their homelands through a metaphoric ocean; as S. G. Aporosa explains, "kava is a transportable fonua/vanua [land], and Moana peoples in diaspora are able to maintain Indigenous connections to their identities of the land and to the lands themselves whether they were born in ancestral places or not as they bring their land with them and continue to ingest it, despite their distance from place" (quoted in Tecun 2017, para. 16). As Tongan anthropologist Tēvita Kāʻili explains, fonua "carries the meaning of placenta, land, people of the land, and grave" and also "encompasses the spiritual and genealogical oneness of the land and its people and the reciprocal performance of fatongia [reciprocal social obligations] among people on the land" (2017, Kindle loc. 1059).

Metaphorically, kava is the ocean, and the dregs are the sand that connects the liminal space between land and sea; when stirred, kava resembles the sea churning near the shore, "being stirred into a homogeneous consistency" (Tecun 2017, para. 16). Thus, the partaking of kava is a cultural communion and commitment to affirming relationships between ʻāina and kānaka, and among kānaka. By throwing the kava in the face of the GEA agents about to capture him, Kupe symbolically baptizes them with an integral and ritualized product that is a symbolic act of transformation, not only about resistance, but also about the insistence on cultural continuity despite strict colonial assimilation enforcement.

Performance in Polynesian cultures, centered on storytelling, singing, and dance, is also central to the film. More specifically, kava itself "facilitates various forms of artistic performance" (ʻOkusitino Māhina, quoted in Tecun 2017, para. 19). Such artistic performance often includes music and dance, and, within the faikava, have a cultural purpose: "These spaces are sites where one can refine these particular arts and skills and in turn develop a Tongan and Moana identity through that process. Additionally, this development of identity . . . prepares many participants to participate in life events and Tongan ceremonies" (para. 19). There is a political purpose as well, as cultural continuity is a resistance against colonialism. This is conveyed in the passing of the kava preparation rituals to Samu to continue after Kupe is captured. It is also conveyed through kaona (metaphor) and the selection of songs.

The song for the tauʻolunga, "ʻŪpē ʻo Siuʻilikutapu," was originally composed as an ʻūpē (lullaby) by Tonga's queen Sālote Tupou III in 1948 for her granddaughter Mele Siuʻilikutapu (b. 1948).[12] In 1975, Princess Siuʻilikutapu became the first woman elected to the Tongan Legislative Assembly. The ʻūpē is also considered a hiva kakala, a beloved Tongan genre of poetry. Ethnomusicologist Adrienne Kaeppler writes:

> *Hiva* of various kinds usually give voice to honouring individuals, social values, and places. Today, the most popular kind of *hiva* is *hiva kakala,* sweet ("sweet" here refers to smell and especially to perfumed flowers (*kakala*)) songs that have modern musical

12. The lyrics and a translation of the lullaby can be found in Tupou (2001, 5–6).

settings performed by stringbands made up of two to ten men and/or women . . . this type of song originated with King Tupou (Queen Sālote's father) [who] began adding melodic enhancement to *pō sipi,* short poems recited during informal kava drinking gatherings on behalf of a young man interested in the female kava mixer or a woman being courted. *Hiva kakala* include true love songs (*hiva sō*), complaining love songs (*hiva hanu*), songs that honour individuals or place (*hiva 'ofa*), and aristocratic "lulla-bies" (*'ūpē*), songs that honour aristocratic children. (2004, 33)

As with many Polynesian poetic compositions, metaphor and imagery are essential elements of lyrical beauty. Kaeppler describes the 'ūpē as including "significant social and cultural informa-tion in an artistic form that can be understood only by unravelling layers of *heliaki* [metaphor]. The values embedded in these compositions include the importance of ancestry (especially in the royal lines)" (37). When included in a context of cultural resistance to insist upon cultural conti-nuity, the mele takes on additional layers of kaona and political meaning. The 'ūpē is often described as popular, and "the one for Siu'ilikutapu is best known" (39). Misa Tupou conveyed to me that the Faikava musicians chose the mele to perform in the film, perhaps an indication of its popular status (personal communication).

The inclusion of the tau'olunga performance is another layer of kaona that reaffirms the tā-vā connections between the Faikava Underground members, the genealogies they embody, and the larger Moana Nui communities they represent. In the documentary *Taualuga* (2014), Sāmoan and Tongan dance practitioners discuss the symbolism of the tau'olunga dance form. Tongan choreographer Sesilia Pusiaki describes the dance as one that perpetuates culture from the ances-tors passed on through the dancer, connecting genealogies and generations across time. Tu'u'u Mary Autagavaia (Sāmoan) notes the dance is "a guide on how to live and behave in society," while Mary-Jane McKibbin Schwenke (Sāmoan) explains that "it's about more than being Sāmoan, it's about humanity, it's about serving others" (Taouma 2014, 0:17–0:30).

Between the two traditional mele is the contemporary King Kapisi hip-hop song "Fix Amne-sia." Released in 2001 on the album *Savage Thoughts,* it was a brand-new track at the time the film was made, and speaks directly to Pacific youth and diasporic experiences. The chorus of the song, repeated (and thus emphasized) throughout, states: "Fix Amnesia of Polynesia / Been trapped in this damn game for this I feel ashamed."[13] The "game" is colonization and the constant need to engage with settler colonial institutions—religion, education, capitalism—and its negative effects on Indigenous identity. The "amnesia" that needs fixing is the forgetting of traditions—language, culture, connection to the 'āina and nonhuman kin. Thus the message of the mele reinforces the main theme of the film: the need to resist colonization and expected assimilation through the insistence on continued cultural practice, which is the only way forward into the future, and on connection with all our relations across time and diaspora.

13. Lyrics transcribed from the CD. The complete song is found on the album *Savage Thoughts* (New Zealand: Festival Mushroom, 2001). "Fix Amnesia" is composed by Bill Urale, who performs by the name King Kapisi.

The heart of the narrative is that it is within our Indigenous identities, solidified through cultural practices, that we can and will survive and thrive as peoples of Moana Nui. Our shared heritage, built from generations of moʻokūʻauhau and moʻolelo, strengthens and inspires us, as we move through tā and vā standing on the shoulders of our ancestors. This is reflected in the seamless mixing of different Polynesian traditions, languages, practices, and people, visible at every level of the film. Despite dystopian oppression, he ʻo ia mau nō, we endure by maintaining our culture.

Navigating the Vāsā Loloa of Wonder in the Twenty-First Century and Beyond

In *Indigenous Storywork* (2008), Jo-Ann Archibald (Qʻum Qʻum Xiiem) discusses the Sto:lo and Coast Salish storytelling baskets as a metaphor for "learning about stories and storytelling" that incorporates the fundamental storywork teachings of "respect, reverence, responsibility, reciprocity, holism, interrelatedness, and synergy" (2). She points out that "basket makers are often identified by their designs," and that "even though the design may be attributed to a particular person, her designs reflect her relationship with family, community, nation, land, and nature" (2).

Indigenous literary narratives function as storytelling baskets in that they incorporate our fundamental cultural values, such as respect, responsibility, relationships, and reciprocity. They are often identifiable by their author, but they also reflect the author's relationship with family, past, present, and future; with the larger community and lāhui (people, nation); and with ʻāina (land, environment, nature). Their individual aesthetics simultaneously embody a unifying commonality across Moana Maoli moʻolelo. Discussing the Sāmoan concept of vā, Albert Wendt describes it as the space between that symbolizes our relationships to one another: "Va is the space between, the betweenness, not empty space, not space that separates but space that relates, that holds separate entities and things together in the Unity-that-is-All, the space that is context, giving meaning to things. The meanings change as the relationships/the context change . . . A well-known Samoan expression is 'Ia teu le va.' Cherish/nurse/care for the va, the relationships. This is crucial in communal cultures that value group, unity, more than individualism: who perceive the individual person/creature/thing in terms of group, in terms of va, relationships" (1999, 402). Similarly, Sosthène Desanges notes that "peoples of the Pacific exist as a collective. Legends clearly show that a cultural unity prevails among all islanders, from one side of the Pacific to the other. Stories vary little, if at all; they are universal" (pg. 286).

Āiwaiwa—wonder and the fantastic—is what binds these aspects of our Moana Maoli cultures, practices, lives, and relationships—past, present, and future, in this and in other worlds, real, spiritual, and imagined, in ways that are political in that they insist on a thriving, self-determining future free from colonial oppression, one that remembers, celebrates, and carries on the knowledge, teachings, and traditions of our ancestors mai ka pō mai, mai nā kūpuna mai.

Two Pasifika publications worth noting that bookend Moana Maoli moʻolelo āiwaiwa and its future possibilities take us thousands of millennia into the spiraling vā of the past on one end, and propel us even further into the future on the other. These are New Caledonia writer Sosthène Desanges's *Ash & Vanille,* and ʻŌiwi artist Solomon Enos's *Polyfantastica.*

Ash & Vanille is a five-part fantasy series set thousands of years in the past on fictional islands in the vast southern Pacific. *Les guerrières du lézard* (The lizard's warriors) (2014), and *Le chant du mana* (The song of mana) (2017) are the first two books in the series. The first book opens with an unusual and concerning dilemma: no female children have been born for thirty years to any of the six tribes who comprise the Clan of Chiefs. If this curse isn't rectified, all will perish. The primary character, Ash, is fifteen, and the sole remaining member of the War-Club clan of the cannibal tribes. As the author shares in an interview (in this book), he decided to work with powerful stereotypes about the Pacific, instead of resisting them, in order to turn them on their heads. One example is how the cannibals are depicted as fully developed characters with souls, compassion, and flaws, rather than just "savage," "uncivilized" beings. Ash is unhappy with an important decision made by Gawadi, the Clan of Chief's religious elder, and so he runs away and sets out on a quest to find a solution to the Clan's dire situation. Along the way, he acquires unusual companions (a talking skull he believes is that of an important ancestor, a friend banished from the Clan who has been transformed into a talking poypoy bird, an enchanted child from another people whom the Clan has adopted but described as a witch), and his counterpart of the series title, Vanille, a young, intelligent, bold warrior woman of the Vaaï Clan. Each has their own āiwaiwa abilities, and along their journey, they battle terrifying enemies, all wondrous and fantastic āiwaiwa figures filled with mana.

Desanges sets *Ash & Vanille* so far in the past, the tā and vā of that world are beyond the cultural memory (and oral traditions) of specific Moana Nui peoples and cultures today. One description of the work refers to it as "a fantasy world inspired by Oceania . . . an insular world beyond time."[14] In a complementary but opposite framing of time, Enos's *Polyfantastic* (2006) moves 40,000 years into the future, envisioned as "Pacific Science Fiction and Fantasy. Its main manifestation is as visual time lines that span 40,000 years . . . in a parallel universe. In this paraverse, the 40,000-year timeline follows a para-Polynesian society, as it overcomes death, destruction, and war; connects all human consciousness while retaining individual identity; expands around its planet; and finally, communicates with and explores the mysteries of the galaxy."[15] The project has evolved through several artistic forms, starting with a comic in 2006 (*Honolulu Advertiser*), which was followed by graphic novels, sculptures, and images, with visual images as the primary mode of storytelling of each iteration. These have been exhibited across the Pacific and the United States in their various forms.[16]

The digitized writing and illustrations available on Enos's website are divided into four 10,000-year epochs, each dedicated to one of the primary Polynesian male akua: Kū (Tū), Rono (Rongo, Lono), Tanaroa (Taʻaroa, Tangaroa, Kanaloa) and Tāne (Kāne). Kū is associated with warfare, Lono with healing, agriculture, and arts, Kanaloa with the ocean, and Kāne with fresh water, sun, and agriculture. *Polyfantastica* begins with the earth ravaged by a pandemic in which Hawaiʻi

14. Écrire en Océanie, "Ash & Vanille de Sosthène Desanges," https://www.ecrire-en-oceanie.nc/actualite/ash-vanille-de-sosthene-desanges/.

15. Solomon Enos, "Polyfantastica," https://www.solomonenos.com/polyfantastica.

16. Similarly, *Ash & Vanille* was originally conceptualized as a collaborative comic strip project between Desanges and the illustrator JAR. The story progressed as a novel (then series) as a way for Desanges to further develop the story, characters, setting, and themes to best represent the complexity of such a creative, āiwaiwa-filled world.

is spared due to its geographic isolation. Ten thousand years of warfare ensues before people finally realize the futility of violence, so the narrative turns toward peaceful, positive, and unifying solutions.

A hundred thousand years of peace prevails, as ʻŌiwi share their knowledge around the honua (planet). Art, music, theater, and other creative endeavors flourish in the time of Lono. Expanding beyond Papahānaumoku (Hawaiian earth mother) into the realm of Wākea (Hawaiian sky father), pushing out past the edges of our solar system, kānaka return to shapeshifting forms "with symbiotic superpowers and organic spaceships" (Lo 2005, 1). The end result is that "a healthy society develops the consciousness to comprehend and navigate the galaxy" (1). In a 2005 interview, Enos explained that the purpose of *Polyfantastica* was a desire to "shift our current critically unsustainable and horribly violent state of co-existence on Earth by diverting mainstream media away from crippling societal icons of fear, greed, inadequacy and insecurity, and towards media that ask us as a collective human organism, Wasn't there something we were working on before we got distracted by organized religion and war and plastic?" (quoted in Lo 2005, 1).

In creating such timeless and Indigenous worlds built on an almost inconceivable extension of tā and vā, both Enos and Desanges essentially demonstrate the limitless possibilities of Indigenous Oceanic wonderworks. Rather than follow linear western time, both use Indigenous concepts of tā and vā to map out expansive visions of Indigenous wonder and resistance. In an interview with the editors of this book, Desanges shared: "I speak of a Pacific from the past. Yet, despite various works, research, and theories, no one fully knows what the ancestral Pacific was like. As its content became unclear over 200 years. The first evangelists contributed to this loss of memory. We can imagine ancestral history went through evolution and change. It is a black hole for historians. But for writers, obviously it is a blank page to be diligently filled in" (pg. 286). Simultaneously, both artists expand Moana identities that are still specific but also interwoven in ways that reach back—and forward—across myriad generations to a unified interconnected Oceania, expressed in the Papua New Guinea concept One Salwara (one ocean, one people). Viewed collectively across the Vasa Loloa, the pride and joy expressed through individual cultures and practices—from faikava to singing and dancing to reaffirming genealogical, familial, and social relationships—are shared by all Moana peoples. Such pilina, protecting the common good and resisting a shared enemy—from Xodras and giants in prehistoric times (*Ash & Vanille*) to colonial oppression in the present and the future (*Polyfantastica, Kava Kultcha*)—is in itself a form of āiwaiwa, particularly when our nonhuman and nonliving kin join us. Thus, the vague location of the Faikava Underground "somewhere in the South Pacific," and the unspecified but very mixed cultures and artifacts in the world of *Ash & Vanille,* and the worldwide travels of the shapeshifting Giant Squid in Daren Kamali's poetry, and the extended journey beyond the boundaries of our honua in *Polyfantastica* aren't "pan-Pacific" merging of cultures that flatten one another out. Rather, they are exquisite examples of Indigenous solidarity and strength, as we have always valued.

Moʻolelo āiwaiwa are just one form of artistic expression our Moana Nui peoples have always engaged in. We still talk story, tell story, write story, sing story, dance story, and value story. Now we do it in newer media as well, in an ever-expanding, spiraling, creative universe of pō, which itself is the birthing place of āiwaiwa, and more.

Works Cited

Archibald, Jo-Ann. 2008. *Indigenous Storywork: Educating the Heart, Mind, Body, and Spirit.* Vancouver: University of British Columbia Press.

Beamer, Keola. 2002. "Ka 'Olili, The Shimmering." In *Ka 'Olili, the Shimmering, Island Stories.* Lahaina: 'Ohe Books.

Brown, Marie Alohalani. 2022. *Ka Po'e Mo'o Akua: Hawaiian Reptilian Water Deities.* Honolulu: University of Hawai'i Press.

Desanges, Sosthène. 2014. *Ash & Vanille: Les Guerrières du Lézard.* Noumea: Les Trois Chouettes.

Enos, Solomon, and Meredith Desha. 2006. *Polyfantastica.* www.solomonenos.com.

Fornander, Abraham. 1918. "Ka'ao no Kamapua'a (Traditions of Kamapua'a)." *Fornander's Collection of Hawaiian Antiquities and Folklore,* vol. 5, pp. 314–363. Honolulu: Bishop Museum Press.

Grace, Patricia. (1986) 1995. *Potiki.* Honolulu: University of Hawai'i Press.

Kaeppler, Adrienne. 2004. "Queen Sālote's Poetry as Works of Art, History, Politics, and Culture." In *Songs and Poems of Queen Sālote,* edited by Elizabeth Wood-Ellem, translated by Melenaite Taumoefolau, pp. 27–65. Nuku'alofa, Tonga: Vava'u Press.

Kā'ili, Tēvita. 2017. *Marking Indigeneity, the Tongan Art of Socialspacial Relationships.* Tucson: University of Arizona Press.

Kamali, Daren. 2011. *Tales, Poems, and Songs from the Underwater World.* Auckland: Anahera Press.

———. 2014. *Squid Out of Water: The Evolution.* Honolulu: Ala Press.

Kihara, Leah, dir. 2003. *Kava Kultcha.* Honolulu: Punk Productions. https://www.youtube.com/watch?v=xs8ZdpuBQ7g. Accessed July 24, 2021.

Kneubuhl, Victoria Nalani. 2003. "Manōwai." In *Oiwi: A Native Hawaiian Journal,* edited by ku'ualoha ho'omanawanui, pp. 43–50. Honolulu: Kuleana 'Ōiwi Press.

"Kupe." *Te Ara.* https://teara.govt.nz/en/first-peoples-in-maori-tradition/page-6. Accessed July 24, 2021.

Kuwada, Bryan Kamaoli. 2017. "All My Relations." In *Pacific Monsters,* edited by Margrét Helgadóttir, pp. 104–116. Fox Spirit Books.

Lo, Catharine. 2005. "Planet Enos." *Honolulu Weekly,* October 12, 2005.

Pukui, Mary Kawena, E. W. Haertig, and Catherine Lee. (1972) 2014. *Nānā i ke Kumu.* Vol. 1. Honolulu: Queen Lili'uokalani Children's Center.

Taouma, Lisa, dir. 2014. *Taualuga.* Auckland: Creative New Zealand. https://www.youtube.com/watch?v=J0whEX-NMd8.

Tecun, Arcia. 2017. "Tongan Kava: Performance, Adaptation, and Identity in Diaspora." *Performance of the Real* 1. https://doi.org/10.21428/b54437e2.350e0b75.

Tregear, Edward. 1891. *Maori-Polynesian Comparative Dictionary.* Wellington: Government Printers.

Tupou, Queen Sālote. 2001. *Hiva Kakala Fakatu'ungafasi, Ngaahi Maa'imoa 'a Kuini Sālote mo e Ni'ihi.* Nuku'alofa, Tonga: University of the South Pacific Centre.

Wendt, Albert. 1999. "Tatauing the Postcolonial Body." *Inside/Out, Literature, Cultural Politics, and Identity in the New Pacific,* edited by Vilsoni Hereniko and Rob Wilson, pp. 399–412. Lanham, MD: Routledge.

Into the Tupuaga

Albert Wendt

Our individual journeys are a process of discovering where we have come from, constructing, discarding, inventing, dreaming, and then redoing it all in relation to what we discover at epiphanic moments of crisis or revelation in our lives. But most of us arrive at where we are at any given time without meaning to. Or as Arona, one of the main characters in my novel *The Mango's Kiss,* says:

> Not many of us end up where we intend our selves to be at any given stage in our miserable lives. Look at me: when I left Samoa I intended to explore the Seven Seas and the papalagi world, becoming a devout Christian captain commanding my own defiant ship and returning triumphant to my loving aiga. An alcoholic Dutchman in one of my crews once said that we are our circumstances and the choices we made— or should've made but didn't . . . Most of us end where we are and who we are without meaning to. Profound, eh? (*The Mango's Kiss,* 2003)

Arona's parents wanted him to be a pastor; he wanted to be a great sea captain but turned out to be a gangster without meaning to.

We assume that our children, through a natural process of osmosis, learn our histories of aiga, region, and country without our teaching them. I suppose in pre-Papalagi Samoa, in the pre-European world, where educating the young was part of everyday life, you could say that was so to some extent. But I was born in 1939 into a society already saddled with a formal colonial education system where you actually went to school, a place separate from your home and set up especially for that purpose.

The school was called Leifi'ifi School, established by the New Zealand administration exclusively for their children and other "Europeans." Because we have a German surname, the Wendts were considered "European" and able to enrol [*sic*] in Leifi'ifi. Many of our "non-European" cousins adopted our surname and were able to enrol as well. In that school, little was taught of our Indigenous ways of life. The culture of the colonizer was substituted for ours. So I ended up knowing little about pre-Papalagi Samoa. What I knew I learned from listening and watching our

Previously published: Wendt, Albert. 2015. "Into the Tupuaga." In *Out of Vaipe, the Deadwater: A Writer's Early Life,* pp. 18–28. Wellington: Bridget Williams Books.

elders, especially my remarkable grandmother Mele and Aunt Ita, my father's oldest sister. Much later in life, when I attended university, I researched and learned much more.

So looking back at my writing life, you can say it has been a process of learning, through my writing, the depths of Samoan history and culture; the writing has been an attempt to discover it and to shape it my own way.

You can also say it has been a process of reading, researching and viewing, from my first remembered memory to now. I believe that my first remembered memory is:

> Around her suddenly, the warm familiar smell of the man she'd later come to know as her father, and, as usual, she moved into it, letting it envelop her like a second skin. Down-pressing round coldness on her right cheek, radiating across her face and down through her body to her tingling toes. She jerked away from it, hands clasped to the wet spot on her cheek. In her father's hand, at the centre of her seeing, was a round green-orange object. (A mango, she'd learn later.) From the object to his hand, to his face, she looked, recognizing he was smiling. She moved closer to him, her hand taking the object, the fruit, which assumed the shape of her grip: solid, fitting, apt, balanced. Her father nuzzled his forehead against hers. (*The Mango's Kiss,* 2003)

All the books I've read, all the films and TV I've seen, all that I've heard, from my mother singing the lullaby I first recognized as a song, that is the sum total of my experience. This book is about how that has infiltrated my writing, and how I've deliberately selected from my life's experience for my work, and how in that process I've learned how to explore further the real world and the world of the imagination—if there is such a thing. The total sum of your work is a mirror of your life that helps you to read your life—but is not your life. Or, as I've said before: we are what we remember or want to remember, the rope that stretches across the abyss of all that we've forgotten. Even what we remember becomes a story, a deliberate, ordered sequence that gives meaning to our lives. For we are all shit scared of having no meaning or worth.

What we prefer to omit is just as important as what we include. The actions we meant to take but didn't are as important as those taken. They are in the Vā, the space between, which holds everything together in Vā-Atoa, the Unity-that-is-All.

Whenever I've looked back at my work, over the past fifty years or so, I've been surprised by the constancy with which I've used my growing knowledge of things Samoan, especially of pre-Papalagi Samoa. And as I've discovered and imagined and created my own version of that world, I've used that in my new work. From my first collection of short stories, *Flying-Fox in a Freedom Tree,* through my first novel, *Sons for the Return Home,* to *Pouliuli, Leaves of the Banyan Tree,* and even to my futuristic novel, *Black Rainbow,* and my latest novel, *The Adventures of Vela,* that holds true. When Arona, the son of the Aiga Sa-Tuifolau, dies tragically in New Zealand in *The Mango's Kiss,* his sister, Peleiupu, brings his ashes back to Samoa. Their family bury him secretly in the Aiga Sa-Tuifolau's secret burial place, Niuafei, that began with their aiga's pagan Atua Fatutapu, and where his father, the staunch Christian pastor, insists that he too be buried.

Throughout my work, the spiritual world of ancient Samoa that was banned by the missionaries—and is still banned by the Christians today—lives and grows and is respected. That world is now appearing in the work of other Samoan and Pacific writers and artists. Art ain't life, but for me it's a way of resurrecting our atua and reconstituting reality.

So I want to open with:

Le Tupuaga
I le Amataga na'o Tagaloaalagi lava
Na soifua i le Vānimonimo
Na'o ia lava
Leai se Lagi, leai se Lau'ele'ele
Na'o ia lava na soifua i le Vānimonimo
O ia na faia mea uma lava
I le tūlaga na tū ai Tagaloaalagi
Na ola mai ai le Papa
Ma na sāunoa atu Tagaloa i le Papa, 'Pā
loa'
Ma ua fānau mai Papata'oto
Soso'o ai ma Papasosolo
Ma Papalaua'au ma isi Papa ese'ese
Ta e Tagaloa i lona lima taumatau le Papa
Fānau mai Ele'ele, le Tamā o Tagata
Na fānau mai ai fo'i Sami lea ua sosolo
I luga o Papa uma lava
Taga'i atu Tagaloa i lona itū taumatau
Ola mai le vai
Toe sāunoa o ia i le Papa, 'Pā loa'
Fānau mai Tuite'elagi ma Ilu
Ma Mamao, le Tama'ita'i
Ma niuao, ma Luaao, le Tama
Na fa'apēnā ona fausia e Tagaloaalagi
Mea uma lava
Seia o'o ina fānau mai Tagata, Loto,
Atamai, Finagalo, ma Masalo
Na i'u ai i'inā le fānau a Tagaloa ma le
Papa

In the beginning there was only Tagaloaalagi
Living in the Vānimonimo
Only He
No sky, no land

Only He in the Vānimonimo
He created Everything
Out of where He stood
Grew the Papa
Tagaloa said to the Papa, Give birth!
And Papataoto was born
And then Papasosolo
And Papalaua'au and the other different Papa
With His right hand Tagaloa struck the Papa
And Ele'ele was born, the Father of Humankind
And Sea was also born to cover
All the Papa
Tagaloa looked to His right
And Water was born
He said to Papa, Give birth!
And Tuite'elagi and Ilu were born
And Mamao, the Woman,
And Niuao, and Lua'ao, the Son
In that manner Tagaloa created
Everything else
Until Tagata, Loto,
Atamai, Finagalo, and Masalo were born
There ended the children of Tagaloaalagi and the Papa.

(*The Songmaker's Chair*, 2004)

Tupuaga literally means ways of growing, origins or how and where things grow from. The above version of the Tupuaga was recorded by the London Missionary Society missionary George Pratt from two tu'ua, keepers of the knowledge.

It is interesting that in the Beginning there is only Tagaloaalagi, the Supreme Creator, existing in the Vānimonimo, the Space-that-appears-and-disappears, and that it is from where He stood that the first Papa, the Rock, grows. And it is that Rock that he orders to give birth. The myth has some "scientific" truth in that volcanic islands came out of fire and molten lava, and solidified lava (the Rock) eventually breaks down into eleele, soil, earth. (Our words for blood and soil are the same: toto, eleele, and palapala. So when you bleed, you are bleeding earth, soil.) Then Tagaloa-alagi created water, the source of all life, which covers and "mates" with the various types of rocks, which in turn give birth to other elements and creatures.

Growing up in Samoa, we were never told this genesis narrative because it was considered "pagan," belonging to the Aso o le Fa'apaupau ma le Pogisa, the Days of Paganism and Darkness. Even our beloved grandmother Mele, who had enormous respect for that banned knowledge, did not tell us. We were fed on the Christian Genesis every evening lotu and Sunday service, and at pastor's school. Once in a fale-aitu, we watched a faifaleaitu parodying part of the Tupuaga,

playing on what he (and his fundamentalist Christian audience) deemed the hilarious incredibility of atua mating with rocks that then begat other rocks. It wasn't until the 1960s, while I was researching the Mau movement, that I came across a written version of the Tupuaga, but I didn't think it important to my life then.

When I was Director of the University of the South Pacific Centre in Apia from 1976 to the middle of 1982, our historians Malama and Penny Meleisea and I received money from the UNESCO Pacific Cultural Project to finance the writing of the first history of Samoa by Samoans. We decided to begin the history with the Tupuaga: a bold declaration that our history was *our* history and was to be told *our* way, respecting oral history and traditions and our indigenous beginnings as much as Christians believe that in the Beginning was the Word and the Word was God . . .

And as I thought about the meanings of the Tupuaga, it began to root itself deeper in my psyche. I would find over the years that as I learned more, through my research and writing about the pagan Samoan world, that knowledge and the atua and aitu and other beings who inhabited that world would assume compelling presences in my writing and imagination and dreaming.

In the late 1990s, when I decided to write my first full-length play, *The Songmaker's Chair,* I made those atua the heart and soul of the play. The play opens with them at the back and edges, at the periphery; but by the end, they are at stage front, carrying the body of Peseola, the Head of the Aiga Sa-Peseola, away to Pulotu, the spirit world. In the play, there is no difference between the Christian God and the atua of Samoa.

While I was revising the play, I was advised that it was too didactic, and that I should cut out most of the historical, cultural, and anthropological information in it. I ignored that advice, and used the play to teach our young people and non-Samoan audiences about our ancient religion and beliefs. I think it worked with most audiences. I was also keeping true to the traditions of Samoan storytelling, to the way knowledge and values were handed on.

The Songmaker's Chair took me seven years to write and get onto the stage. It was first performed in the first Auckland Arts Festival in September 2003, directed by my cousin Nathaniel Lees; he also played Peseola. The play sold out for its long season, and received standing ovations.

For me, it was moving, emotionally uplifting, and so joyously fulfilling to watch our young moko really enjoying the play. They were sitting with Reina while I hid and watched from the corner—some of them even jumped to their feet and joined the rap being performed by the actors.

When it played in Hawai'i, it also sold out.

I was especially moved by the enthusiastic reactions of the New Zealand–born Samoan and Pasefika audiences. As one of them said to me: "I loved it because it is about my grandparents and parents. It's the first time I've seen their lives on the stage. And it is about being Samoan in another country. I've also learned much from it about our religion, beliefs, and ancestors."

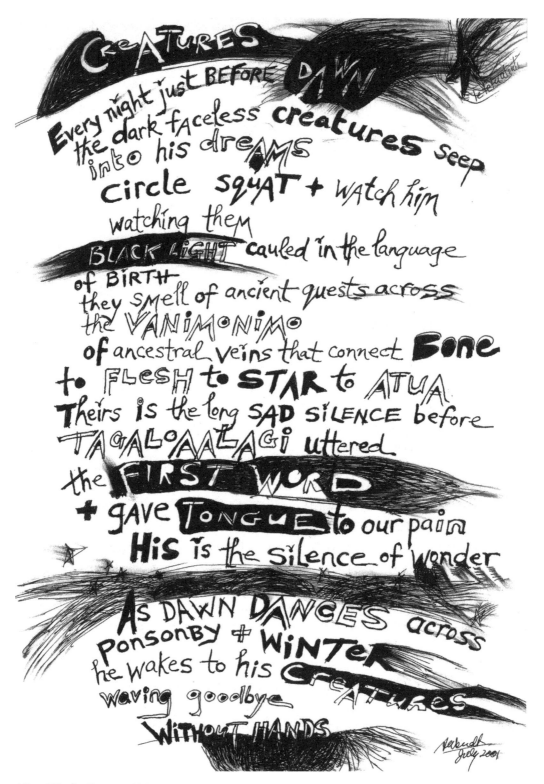

Albert Wendt, *Creatures*, 2001.

Previously published in *The Book of the Black Star* by Albert Wendt, n.p. Auckland: Auckland University Press, 2002.

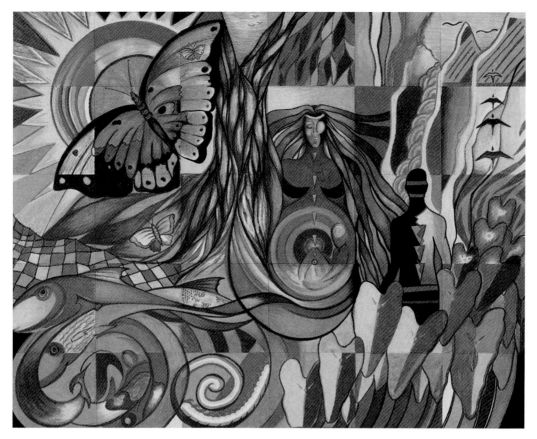

Plate 1 Naiʻa-Ulumaimalu Lewis, *Hānai ʻAi O Haumea,* 2018. Paper, colored pencil, and acrylic paint, 18" × 24".

Plate 2 Solomon Enos, *Kanaloa,* 2021. Acrylic and graphite on Bristol board, 9" × 12".

Plate 3 Solomon Enos, *Nanaue,* 2021. Acrylic and graphite on Bristol board, 9" × 12".

Plate 4 Dan Taulapapa McMullin, *Motu Faʻafafine*, 2019. Photo collage print, 10" × 10".

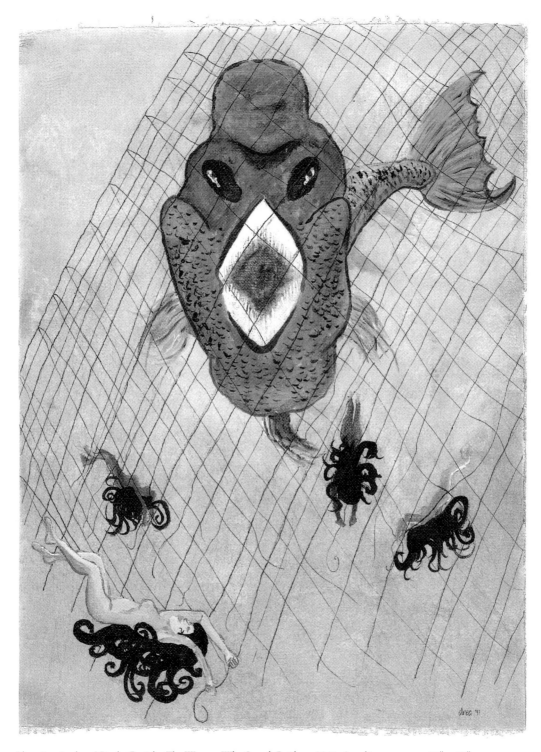

Plate 5 Andrea Nicole Grajek, *The Women Who Saved Guåhan,* 2011. Acrylic on canvas, 11" × 17".

Plate 6 *God of Diaspora: Blood Returns to Water,* representation by Terisa Siagatonu, transformation makeup by Jocelyn Kapumealani Ng, art and photography by Lyz Soto, 2020. Digital photograph collage with watercolor, 3264 × 4341 pixels.

Plate 7 *Mejenkwaad: I Am Made of Teeth,* representation by Kathy Jetñil-Kijiner, transformation makeup by Jocelyn Kapumealani Ng, art and photography by Lyz Soto, 2020. Digital photograph collage with watercolor, 3264 × 4928 pixels.

Plate 8 *Kanaloa: Into a Stone Sea,* transformation makeup by Jocelyn Kapumealani Ng, representation by Jocelyn Kapumealani Ng, art and photography by Lyz Soto, 2020. Digital photograph collage with watercolor, 3264 × 4928 pixels.

Artist Statement: Aitu Studies

Dan Taulapapa McMullin

Aitu is a noun in the Samoan dictionary: Aitu or ghost, spirit. *Na ʻe vaʻai ʻea ʻi se aitu?* Have you ever seen a ghost?

Aitu o le sami, or, ghost of the sea, is a polite way of saying "turtle."
We used to say in Apia, Samoa, when two faʻafafine (transgenders, queers) made love, Laumei! Turtles!

Faʻaleaitu, *faʻa le aitu,* adjective, ghostly. To make the ghost.

Faleaitu, noun, comic turn, comedy, clownery. A once, so recently, popular form of entertainment, all the parts played by men; often the faʻafafine were played by men—the women and the nonbinaries.

Faleaitu. So often conflated by anthropologists with faʻafafine, the way of a woman, nonbinary, queer, to queer, to nonbinary. Anthropologists and drag shows, anthropology is a drag show.

Taulāitu, *taula aitu,* noun, spirit medium. *ʻO le taulāitu le loʻomatua.* The old woman is a spirit medium.

I was living in Minneapolis, I had become a playwright, a poet, people said, Daniel John McMullin, that doesn't sound Samoan. When I was a child in America, teachers would say on the first day of school, Ha-ha, you don't look like a Daniel John McMullin, you don't have red hair. Like a fairy.

I loved the word Taulaitu. I called my mother, I'm changing my name, or, since in those days she called me every other day, maybe she called me, and said, No, no, no, no, not Taulaitu, don't call yourself Taulaitu, let me think about it. The next day she called, and said, Taulapapa, your middle name is Taulapapa not Taulaitu. But Taulapapa is another story.

Taula, noun, obsolete, priest[ess] (used only in reference to the old religion of Samoa).

Fa'ataulaitu, noun, witch, magician; adjective, magical. *O le mana fa'ataulāitu o le tamāloa na moe ai 'o ia.* The [wo]man's taulāitu power is what sent him to sleep. Adverb, magically, by magic. *Fōfō taulāitu,* to cure magically.

Are fairy tales for fairies?

And what's so fair about fairies? Not fair but fate, the fairies were the fates, our past in the future.

The trouble with the archive is it tells us nothing about the past. But the conversation here is imaginary, except in the sense that I sat so many times at Epeli's desk, and this is what I remember. What is remembered is what happens in the present.

This is the beginning of Aitu studies. Not fairy tale studies, wrong language.

Arioi! Arioi!

The arioi, banned by missionaries, were like fairies. They brought the fair to town, island to island, village to village.

In the sunlight.

O lo'omatua, the old ladies. *O le taulāitu le lo'omatua.* The old woman is a spirit medium.

Papatea was known for its fairies, its aitu, but I thought it was far to the east, and then, after writing the story, I began to think it was an old name for Manu'a, the eastern islands of Samoa.

In Papatea, I once saw Aitu, not saw but knew, one night, among us.

Aitu

Dan Taulapapa McMullin

Aitu are holes in the universe
we appear out of aitu
we disappear into aitu

Now they're ghosts of ghosts
Someone told us to bite and swallow and we did
They were a fish, a butterfly, a stone, a small tree
They were a place in the rainforest, in the house, the battlefield

We are connected by machines now, artificial intelligence
But our flesh is so weak, it dies like a flower, like friendship
Our friendship with these ghosts is tied to our flesh
But we have no flesh here

Aitu of aitu, ghosts of ghosts,
how do we mourn them? as photographs, files, numbers

Epeli was a tagata aitu, half human half spirit
his nodding staff first rising over the ridge from his hillside garden
ankle-length sulu, shirtless
a pumpkin under his arm, an aitu

while Seiuli scolded her dancers around the corner
the past Epeli said is the future
The archive tells us of the present, I said
almost nothing of the past!
the past is not the past anymore
It never was, said Epeli

This rope of love of alofa, this alley between you and your aitu
This rope plunging deep into the sea
pulls you to your aitu

Trembling on the wall of this machine
ghost less
soul less
Let me be my Aitu
my hole into the whole past
and future, with dirt, blood, air, fire, love, darkness

Histories of Wonder, Futures of Wonder

Chamorro Activist Identity, Community, and Leadership in "The Legend of Gadao" and "The Women Who Saved Guåhan from a Giant Fish"

Michael Lujan Bevacqua and Elizabeth Ua Ceallaigh Bowman

More than Fables and Fiction

In 1671, the Chamorro maga'låhi (male leader) Hurao of Hagåtña on the western Pacific isle of Guåhan (Americanized to "Guam") delivered a speech to several hundred warriors, rallying them to defend their homeland against Spanish colonizers. Hurao was the first Chamorro to formally organize resistance to their colonizers. Part of his ire stemmed from the claim that "ma na'huyong kumu kado'kado' yan dinagi i fina'pos-ta," or "they treat our history as fable and fiction" (Chamoru Language Commission, n.d.). The derogatory terms kado'kado' and dinagi would have been used by the Spanish to suggest falsely that the Chamorro tales of marvels and wonders were empty of meaning, societal delusions, lies stripped of wonder and without power. However, traditional wonder histories, such as those evoked by Hurao, do encode social values and systems, which endure in the tales and in culture more broadly and continue to animate present-day Indigenous resistance and sociopolitical activism.

The war that Hurao helped launch in 1671 ended by 1695, after which the process of colonizing Chamorros began in earnest (Rogers 1995, 52–53). Significant aspects of Chamorro culture were prohibited and replaced with Catholic rituals and cosmological framework, which affected not only the sociopolitical agency of Chamorro masculinity, as demonstrated in the life of Hurao and the wonder history of the great maga'låhi Gadao, but also the equally significant Chamorro sociopolitical agency granted to femininity and ancestry or family elders, as demonstrated in the wonder history of "The Women Who Saved Guåhan from the Giant Fish." The patriarchal, white-supremacist Spanish church and military sought to diminish the power of Chamorro men, women, and elders alike as the Spanish infiltrated and colonized both the land and the culture of

Previously published: Bevacqua, Michael Lujan, and Isa Kelley Bowman. 2016. "Histories of Wonder, Futures of Wonder: Chamorro Activist Identity, Community, and Leadership in 'The Legend of Gadao' and 'The Women Who Saved Guåhan from a Giant Fish.'" *Marvels & Tales* 30, no. 1:70–89. https://digitalcommons.wayne.edu/marvels/vol30/iss1/6/. Reprinted with the permission of Wayne State University Press.

the Chamorro people. As a result, the fears that Hurao expressed in his speech began to manifest, because Chamorros began to believe that their ancient past was filled with nothing more than empty fables and fiction. The 4,000-year-old traditions, histories, and stories and social organization of Chamorro men, women, and elders slowly came under threat of disappearing.

For several hundred years, under Spanish and later Japanese and American colonial rule, Chamorros lived without that same unquestioned sense of Indigenous marvel and wonder, losing their grasp of the ancient legends that could inspire them and propel them to seek their former sovereignty and move toward decolonization. In this essay, we discuss two tales of wonder: first, the legend of Gadao, a maga'låhi who ruled over all of Guåhan; and, second, the legend of the women who saved Guåhan from a giant fish. In recent years, these two tales have had a significant effect on contemporary Chamorro decolonization, demilitarization, and ecosovereignty activism, which seeks to prevent pollution and destruction of the environment by foreign investors, corporations, and militaries. The tales have been used to animate forms of resistance to American colonialism and militarism, each manifesting in different ways and helping to form a discursive bridge between being histories of wonder and inspiring futures of wonder. These histories and futures of wonder challenge the various constricting colonialist legends by proposing alternative narratives by which Chamorros can activate themselves, inspiring their resistance and giving character to their activities for political change. As these two tales reveal, Indigenous wonder tales can be based on a single great figure but can also be diffused into more communal, gender-egalitarian tales of wonder future, which are stronger and capable of enduring beyond one great figure or dynasty, beyond hierarchies of gender or class.

Decolonizing Indigenous Wonder Histories

Wonder tales of Indigenous people have often gone underexamined or unmentioned in the Eurocentric lens of scholars such as Jack Zipes or Bruno Bettelheim, or they have been presented as part of a global mishmash of variations on some tale familiar to U.S. or Western European eyes, when addressed at all. This infantilization of Indigenous tales is similar to how European folktales and fairy tales have been recast as simple stories for children rather than echoes of old folk traditions and religions. Postcolonial Indigenous scholars such as Paula Gunn Allen have presented an important corrective and reminder of the vast cultural differences between the Indigenous and the colonizing minds. However, contemporary scholarship is lacking in much sustenance for this topic because of the overall lack of attention to Indigenous narratives, and so in this essay we call for more grounded engagement and collaboration between the fields.

For a Chamorro, histories of wonder, or wonder histories, may be wondrous not only because they are ancient or culturally distinctive and *(un)heimlich,* but also because they are steeped so profoundly in a fundamental structure of place: dramatic limestone cliffs and plateaus, sharp southern hills, lakes deep within ancient caves, coral reefs that ring serene bays around the island. The Chamorro concept of wonder may best be described as histories of wonder, stories of greatness in the past that construct an Indigenous narrative of eco-identity tied intimately to the island of Guåhan. These histories of wonder are stories whose substance can still be found in the tåno'

(land) and tåsi (ocean) that sustain the Chamorro people of today, offering a potential counterco-lonialist structure to society in order to restore Chamorro Indigeneity at the forefront of current conceptualizations of the past, present, and future. In the activist, reclaiming sense of Nasion Chamoru (Chamorro Nation) and more recent groups, such as Our Islands Are Sacred or Fuetsan Famalao'an, these histories of wonder flow seamlessly into the promotion of visions of futures of wonder that counter colonialism and promote ecosovereignty, the political and cultural self-deter-mination of an Indigenous people.

Histories of wonder suggest a new cartography of futures of wonder, activism, and literary criticism—a new Pacific and Indigenous meaning-making map. Selina Tusitala Marsh suggests that our conceptual framework for approaching literature not only should be based in European American colonialist thought but also should be "Pacificized and indigenized to each island con-text" (1999, 339). Similarly, Monique Storie points out that "literature is simultaneously a cultural artifact (a product of a culture) and a cultural agent (an influence on a culture)" (2009, 75). We must decolonize and demilitarize our intellectual performances of these histories of wonder in order to separate the Eurocentric lens of the colonial past from the ancient tales themselves and from Indigenous identity and power.

Colonization as a process is meant to turn the past of the colonized, including histories of wonder, into a wasteland, filled with poverty and inadequacy. A colonized Indigenous person is meant to look into that past and see not strength but weakness, to look into the past and see the need for continuing colonization into the future. As a byproduct of this colonial elevation, the world of the colonized becomes deprived of color. The very histories of wonder that once gave profound meaning can become mere husks of life, covered in an empty, shallow pallor that makes us believe that the colonizer must be there to color them. The histories of wonder, the futures of the wonder, and the desire for ecosovereignty that feed into the local become minor, limited, small.

This overdetermined colonialist narrative can be found in the way that local stories that were once central to the formation of Chamorro culture have become supplanted and replaced by tales that give the colonizer a sense of power and necessity. The arrival of Ferdinand Magellan, the first European to reach Guåhan, in 1521 and of Diego Luis San Vitores, a Jesuit missionary, in 1668 marked a period in which the Chamorros were viewed from the perspective of European moder-nity and cartography, from a "Christian" context, and seen through racist, Eurocentric eyes. Although many native tales survived this colonization, they became distorted and repurposed to fit within a colonial framework: Catholic, Eurocentric, and bourgeois. Chamorro psychologist Patricia L. G. Taimanglo Pier recounts how these colonial realities and histories of dispossession have led Chamorros to question their current status and eventually to seek to change it: "The bot-tom line is that we're only Americans as the United States government wants us to be. To the extent that it is necessary to the government. So we're not actually human beings, but tools. We're no different than the piece of land up at NAS or Anderson Air Force Base. We are to be used and not recognized as humans" (1998, 151, 155).

The two histories of wonder mentioned at the outset of this article—Maga'låhi Gadao and the women who saved Guåhan—have each played a different formative role in helping the Chamorros

imagine and organize their resistance to the American militarization of Guåhan. Resistance or the formation of nationalist identity has also been a function of some fairy and folk tales, or tales of wonder, in contrast to the way that they are disfigured or co-opted in many ways today. Similarly, the Chamorro legends have for millennia helped the Indigenous people of Guåhan imagine what that activism might look like, empowering them to reject the colonial logics that said they were incapable of determining the destiny of Guåhan for themselves.

Both tales deal with ways that Chamorros have been organized to deal with larger-than-life threats from the outside. For the first history of wonder, "The Legend of Gadao," the person of a legendary maga'låhi from a southern village on Guåhan became iconic among male Chamorro nationalist activists during the recent Nasion Chamoru period of decolonization and demilitarization activism and helped to encourage contemporary Chamorros to embrace their ancient past. However, the focus on Gadao ultimately came to symbolize an individualistic and masculine concept of leadership, which is quite different from what history tells of ancient Chamorro communal harmony, egalitarianism, and respect for women's power and leadership alongside men. The second tale of wonder, "How the Women Saved Guåhan from a Giant Fish," recounts an attack on Guåhan by a giant fish. When men are unable to deal with the problem alone, women, guided by their mañaina (elders) and manganiti (ancestral spirits), intercede to capture the fish and save the island. This ancient tale has become iconic for the present generation of Chamorro activists by providing a narrative infrastructure for contemporary demilitarization activism.

The Spear of the Chamorro Nation

Nasion Chamoru was the first contemporary direct-action Chamorro activist group. In the early to mid-1990s it was a serious ideological force on Guåhan and had a tremendous effect on reshaping the contours of Chamorro consciousness. Nasion Chamoru was also successful in lobbying for land rights legislation to help Chamorros displaced by militarism. Nasion Chamoru asserted the Chamorro people's existence through a platform of native nationalism and asserted themselves as a nation older than the United States, with the internationally recognized rights to self-determination and independence. Their ranks were composed of Chamorros of all classes, although most of them were former U.S. military veterans. Much of the group was held together by a shared sense of displacement over land, because their families had lost land to the immediate post–World War II navy and air force expansion.[1]

As anthropologist Ronald Stade notes (1998), before Nasion Chamoru, the local community was often loath to consider any future for Guåhan except as a U.S. colony. But after the heyday of Nasion Chamoru activism, it became standard to imagine a "decolonized" future for Guåhan, one in which the island deserved to be more than just an American possession, where it would be either integrated into the United States (most likely as a state) or recognized as an independent

1. Per Debbie Quinata, interview with Michael Lujan Bevacqua, January 4, 2006; Aguon (2008); Flores (2004); Monnig (2007); and Camacho (2011).

country. Anghet (or Angel) L. G. Santos, the first tribal spokesman for Nasion Chamoru and their first maga'låhi, became the most enduring icon of the movement.[2]

By the twentieth century, the term "maga'låhi" had become unmoored from its ancient cultural significance as the male leader of a clan or a village and was being used commonly to refer to the governor of Guam, regardless of his race. With the rise of Anghet Santos and Nasion Chamoru, the term shifted in meaning once again to regain its ancient connotations of a strong and powerful male leader, similar to the image introduced earlier of Maga'låhi Hurao leading his people into battle against the Spanish. There are many legends of great manmaga'låhi from Guåhan's past, but in terms of power, Maga'låhi Gadao, from the southern village of Inålåhan (Inarajan), stands above the rest.

Members of Nasion Chamoru reimagined the term "maga'låhi," using it for their male leaders, whom they initially referred to as tribal spokesmen. They did more than simply use the word "maga'låhi." Significantly, they also reached into Chamorro history to take on the iconic appearance and personal virtues of their ancient warrior ancestors, whether legendary spirits such as Gadao or historical figures who defended the Chamorro people against Spanish encroachment in the seventeenth century. Members of Nasion Chamoru sought to embody the masculinity of Hurao, even going so far as to dress in ways that were reminiscent of ancient chieftains, wearing loincloths and going shirtless in public and donning the Kepuha hairstyle, consisting of a long topknot of hair at the crown of the head, with the rest shaven. Nasion Chamoru did not look to the past with the poverty of imagination that colonization can breed, where one has to be discovered in order to matter, where one has to be recognized and approved by the colonizer in order to mean anything. Nasion Chamoru saw the Chamorro past as a source of strength. The defiance of those who came before could also animate their defiance in contemporary times.

Nasion Chamoru offered a powerful and much-needed impetus for Chamorro men to become empowered, to fight back, to stand up, to lead, countering the long-standing Tropicalist colonial portrayals of Chamorro men as effeminate, useless, lazy, and uninterested in anything other than sex, food, and revenge for petty grievances. This push to reinvigorate Chamorro masculinity through ancient identifications as strong, successful in providing for a family and helping to hold a community together, and loving and kindhearted caught the imagination of the public. As international relations scholar Miyume Tanji points out: "Military service as an expression of loyalty to Uncle Sam constructs an important part of contemporary hegemonic Chamorro masculinity. Being a good 'warrior' is also associated with past historical images in the Spanish-Chamorro wars (1670–1700). Chamorro men often reconstruct their militarized masculine images taken from notions of Pacific 'savagery' and 'warriorhood' from the past for example, those associated with a legendary Chamorro warrior Gadao of Guåhan" (2012, 103–104). The iconic image of a powerful, honorable ancient Chamorro man was so stirring that even the local U.S. military, arbiters of aggressive and dominant forms of white masculinity, found themselves trying to co-opt it in order to make Chamorro military service appear more Indigenous and natural. At the same

2. See M. Perez (2001); Diaz (2001); and Peterson (2015).

time, however, the matrilineal avuncular organization of ancient Chamorro society and the socio-political power of ancient Chamorro women were not so celebrated by the group. As Indigenous masculinity was deservedly honored, Indigenous femininity too often remained underacknowl-edged. We argue that the ultimate failure of exclusively male and individualistic leadership in the legend of Maga'låhi Gadao warns against such an approach that discards the significance of women, elders, and communality to the ancient Chamorros.

Gadao's Tale and Its (Dis)Contents

Maga'låhi Gadao traveled to the southernmost point of Guåhan to assist the people of the village of Humåtak (Umatac), who were starving. He helped them fish and, in the process, defended the fishermen from a massive shark by stabbing it in the mouth. The manmaga'låhi met, and some proposed that Gadao should be the sovereign over them all, to unify the Chamorro people against foreign threats. For all the manmaga'låhi to accept him as their ruler, Gadao was assigned three impossible tasks. These tasks vary in different versions of the tale, but they center around the fol-lowing legendary labors: first, to swim multiple times around the island without stopping; second, to crack and grate coconuts using only his bare hands; finally, to level the highest peak on the island. Once he succeeded, Gadao instructed his sons to defend the island from foreign invasion by taking the massive boulders from the leveled peak and building a huge fence around the island; he told them to return before daybreak. His sons carried huge rocks to many of the island's bays, but, unfortunately, at the reef between Piti and Asan, they were tricked by a twinkling star into thinking it was the rising sun, and they rushed home, leaving a boulder out on the reef. Because the sons failed, foreigners came soon after, conquering the island.

Nancy Bo Flood, who has compiled and adapted many Indigenous legends from around the world, including Hawai'i and the Navajo Nation, wrote a version of the tale of Gadao in which Gadao of Inalåhan must prove his strength against a challenge by Maga'låhi Malaguana of the northern village of Tomhom (Tumon). They enter the same canoe and paddle as hard as they can, each in an opposite direction: Malaguana north toward Tomhom and Gadao south toward his village of Inalåhan. Both men are too strong for either to triumph: the canoe splits in half, and Malaguana flies north, landing far out in the ocean and becoming the present-day island of Luta, just north of Guåhan. Gadao is shot into the reef off Asgadao Bay, becoming the island of Asgadao.

Gadao represents a matatnga (valiant) and taiå'ñao (fearless) leader, who is able to wield great power and unite his people. In terms of providing a portrait of Chamorro culture and society in either its ancient or contemporary forms, however, the Gadao legend is lacking. The tales of Gadao convey division and competition among Chamorro men, *without the presence or input of Chamorro women.* This reflects not an ancient Chamorro cultural inheritance but the Spanish erasure, Mar-ianization, or demonization of women in Chamorro wonder tales, or the Spanish (re)presentation of Chamorro women in ways that only reinforce the white-supremacist Catholic heteropatriarchy.

The lack of women in most of Gadao's tales brings up the possibility of why his tales seem to feature great power but ultimately result in disunity, as between himself and Malaguana, or fail-ure, as among his sons. Is it possible, given the way these tales are at odds with the shared power

between Chamorro men and women in ancient times, that the failures of Gadao are a satirical gesture toward male arrogance or androcentrism and a reminder of the need for communalism and gender equality?

The legend of Gadao suffers from a glaring lack of female presence and female power, which should have been essential in a portrayal of ancient Chamorro culture. In ancient times, governance of each Chamorro clan featured a balance of power between the maga'låhi and the maga'håga'. Maga'låhi, in this context, does not just mean "male leader" but, more specifically, "the highest son." Maga'håga', though sometimes glossed today as a term for an empowered woman, literally means "the highest daughter."[3] Each clan was governed not by an individual man but by a brother-sister team. This omission is common in both the context of tales of wonder that survived the Spanish colonization and the historical accounts of Spanish officials, explorers, and priests that inform our visualization of that era today. Using Catholic cosmology and Hispanic cultural norms, the Spanish sought to put Chamorro women under the authority of their fathers, brothers, and husbands. It is possible that many tales of wonder have been shorn of their female elements, such as the case with Gadao's quest. The maga'låhi mystique obscured the essential role that women played in ancient Chamorro society.

During the 1990s, the heyday of its direct-action protests, Nasion Chamoru had several hundred members, and women played essential roles in, for example, organizing acts of civil disobedience. However, officially and externally, the public face of Nasion Chamoru was dominated by images of proud and strong Chamorro men only, in traditional loincloths and shell jewelry, such as the giant clamshell sinåhi. This perception was internal to the group as well. Although the group did recognize some of its members as being maga'håga', there were serious disagreements over how power should be shared, and many argued that only Chamorro men should have formal power. Because most male members of Nasion Chamoru saw themselves locked in a battle with the male-dominated hierarchy of the U.S. federal government and military, they felt that their public actions fell likewise within the work of Indigenous Chamorro men. In this mindset, women were to play only supporting roles, maintaining the home or the camp, while the men directed and conducted public activism.

A number of female members of Nasion Chamoru saw this division of gendered labor as being not so much sexist only but colonial. Debbie Quinata, a former maga'håga' of the group, thought that the relegation of women to supporting services and not central leadership was not in line with ancient Chamorro values and was no way to decolonize. In an interview, she stated, "If we are talking about decolonization, that means you have to have a maga'håga' with a maga'låhi. And they have to be equal, they have to work together. One can't be the boss, while the other does the dishes." Quinata and other female Chamorro activists of the era found the gender politics of the Nasion Chamoru difficult to navigate sometimes. Even though male activists would invoke the figure of the proud and strong manmaga'håga' of the past to build support for their activities and would designate female figureheads, they had trouble actualizing ancient Chamorro gender roles within the group itself.

3. See Cunningham (1992, 115, 180, 183); Kasperbauer (1996); and DeLisle (2015).

For a variety of reasons, including these problems with gender and distribution of power, since the 1990s, Nasion Chamoru has declined in power and prominence. It still exists as a group today but no longer commands the symbolic or real political power it once did. However, women who felt affected by the lack of respect for female roles in Nasion Chamoru have gone on to form other groups, often with just a handful of members. For example, Trini Torres, who, though never officially recognized as a maga'håga' of Nasion Chamoru, was often thought of as one by the community because of her fierce and fiery rhetoric, left the group in disillusionment and went on to become the Pilong Maga'håga' (great or champion maga'håga') for another activist organization, the Taotaomo'na Native Rights Task Force.

As we look at Chamorro activism from 1990 to the present, we can see this trajectory toward the egalitarian focus of the story of the women who saved Guåhan. Whereas the momentum of Nasion Chamoru was largely male focused, today Chamorro women routinely take center stage alongside men in new articulations of native activism to fight for Chamorro rights and defend Guåhan against potential threats.

Shift in the Activist Consciousness: The Women Who Saved Guåhan

The tale of Gadao has certain differences from the tale of the women who saved Guåhan from a guihan dångkolo (giant fish), most noticeably in Gadao's emphasis on individuality and a unifying masculinity. In addition, Gadao's history of wonder ends on a note of doom for the future, for Gadao's reign is ruined by the arrival of Europeans. By contrast, the tale of the women who saved Guåhan focuses on female power, the importance of cooperation, and respecting one's mañaina (elders) when tackling a significant problem. Since 2000, when the U.S. military announced plans to increase its military presence on Guam, this tale of wonder has become more prominent and has been invoked in Chamorro activist discourse as something that both describes the potential damages of militarization to Guam and the possibilities for resisting it.

Fuetsan Famalao'an, Famoksaiyan, the Guåhan Coalition for Peace and Justice, and other groups are all activist Chamorro groups that have come into existence since the apex of Nasion Chamoru's effectiveness. In these more contemporary groups, Chamorro women as well as men have been among the primary leaders and the most active and visible members. The formation of these new groups was closely tied to attempts by the United States to increase its military presence on Guåhan, just as Nasion Chamoru was formed in response to previous military increases and also the large-scale taking of Chamorro lands after World War II.

Guåhan has been a strategically important base to the United States since World War II. In 2005, because of ongoing protests and social problems relating to the U.S. military presence in Okinawa, the United States announced that as many as 8,000 marines and 9,000 marine dependents would be transferred from Okinawa to Guåhan. In the initial proposals, the population of Guåhan was estimated to increase from 60,000 to 75,000 in just five years: 42 percent of the population would be U.S. military, up from 33 percent. Historical places of great cultural significance to Chamorros, such as Litekyan and Pågat, were named as locations the U.S. military could colonially commandeer in order to build firing ranges, test weaponry, and conduct other permanently environmentally damaging maneuvers.

Young Chamorro activists, artists, and scholars picked up on the tale of the women who saved Guåhan as a resonant inspiration for their protests against proposed military increases to the United States' already sizable holdings on Guåhan. With their plans for new barracks, a new berth for nuclear-powered aircraft carriers, and their firing ranges, the U.S. military would need to dredge more than 70 acres of coral reef and acquire more than 1,000 acres of new lands. At present, the U.S. military controls 28 percent of Guåhan's 212 square miles. Andrea Nicole Grajek, a Chamorro artist who opposes these military increases, made a clear metaphorical connection between a ferociously hungry fish and the U.S. military, which seemed to have its own insatiable appetite for Chamorro land:

> The reason this legend has been on my mind is because I've been looking at many maps of Guåhan recently. Yes, our island is narrow in the middle, but I've also noticed that there are many parts of our island that [are] inaccessible to the people of Guåhan [due to U.S. military land theft]. It's as if the big fish has returned. This big fish is feasting on the graves of our ancestors and land that is lush and beautiful.
>
> Sometimes this big fish spits out the land, returning it to us, but by that time much of the land is contaminated. . . .
>
> We must gather together, like the women in the original legend, to defend our home, before there is nothing left to defend. (2010)

Both Grajek and another Chamorro artist, Baltazar Jerome "BJ" Bell, have created artwork surrounding this narrative of demilitarization and ecosovereignty. One of Bell's works portrays six young women with long dark hair weaving a rippling ocean of a black net that takes up half the composition.[4] Bell's image emphasizes the young women's communal action and burns with the energetic deep reddish orange of the Pacific spondylus shell associated with the ancient Chamorro color agaga' and often interpreted today as "feminine" jewelry. Grajek's artwork, *The Women Who Saved Guåhan* (**Plate 5**), features the monstrous glimmering blue-green of the palakse' (parrotfish) itself, with a menacing open mouth shaped like the traditional åcho' åtupat, or slingstone. The palakse' symbolizes the island of Guåhan, yet it is ensnared in a still more enormous net controlled by four smaller female human bodies spiraling around the palakse' through the water, their hair curling out like the tentacles of octopi. They are spinning and weaving futures of wonder in defiance of a giant threat to their sovereignty and self-determination.

The fish eats Guåhan and changes its geography, its shape. The military does the same, claiming and taking land. For more than a century, the U.S. military has consumed Guåhan; at one point, after retaking the island from the Japanese after World War II, they occupied close to two-thirds of the entire island. As a result of the closing of bases, lobbying by officials from the government of Guam, and the protests of such groups as Nasion Chamoru, that number has been reduced to 28 percent. Despite the reduction of Chamorro land claims in Guåhan, the bases still have an indelible impact on the visual appearance of the island.

4. See Baltazar Jerome Bell's *Young Maidens That Saved Guam,* 2011, at www.hawaiireview.org/.

The U.S. military proposal would take more than 1,000 acres of land from the government of Guam and private landowners in order to build barracks and a firing range. The firing range proposal was particularly unpopular because the range would be in an area filled with historical artifacts and the remains of Chamorros from ancient times. Pågat, on the northeastern coast of Guåhan, is an area that is popular as a hiking destination and a field trip location for viewing an ancient Chamorro village. It was to be closed off to the public so that a massive training range for marines could be built.

Craig Santos Perez, a Chamorro poet teaching at the University of Hawai'i at Mānoa, was among those who compared this military buildup to the tale of the giant fish: "The apocalyptic beast of U.S. colonialism, capitalism, and militarism has been destroying our island, our culture, and our people for too long. Look and listen: It has been lured out into the open and is violently beating its tail. Can you feel it? Can you feel the strands of our different songs being woven into one voice? Can you feel the net of our voice strengthening?" (2011). These voices of a new generation of Chamorro activists draw on a familiar legend, a commonly understood tale of wonder and Indigenous power, in order to inspire a community to resist and defend itself against what they perceive to be a serious threat to the island. By connecting the mouthfuls of the land that guihan dångkolo' took out of Guåhan, forever changing its landscape, to the intentions of the U.S. military, which might have similar drastic and permanent effects, these activists inspire a sizable portion of Guåhan's community to question and challenge this military buildup.

A future of confronting such a leviathan as the U.S. military and colonial government indicates the discursive possibilities to which this legend is being put. The story of the women who saved Guåhan challenges not only the European American colonial patriarchy but also the Catholic hagiography superimposed on the ancestral palimpsest. In addition, it encodes political resistance itself in radically different ways, from the perspective of a culture built around unity.

Untangling the Cultural Construction of the Histories of Wonder

As the practical geospatial and societal cartography of the Chamorro people has changed over centuries of colonization by the Spanish, Japanese, and Americans, so too has the reference to female empowerment in the tale of the young women who saved Guåhan. Reflecting the heavy Catholic influence on Chamorro culture, a mid-twentieth-century version by military spouse Mavis Warner Van Peeble ([1945] 2009) makes the protagonist Santa Marian Kamalen, who is the patroness of Guam, the local version of the Virgin Mary. Other versions have the women of Guam aided by the Chamorro version of mermaids, named for Sirena, who, in another famous Chamorro legend, was torn between her mother and her godmother, a disobedient daughter who turned to the sea. An account from the Viennese world traveler Christoph Carl Fernberger in 1632 anomalously describes human sacrifice to the giant fish (Wernhart 1972).

As part of the power sharing in ancient Chamorro society, i tasi (the sea) was divided between the men and women in a clan. The area inside the reef belonged to the women, and beyond was the domain of men. In the story, when the men argue that defeating the fish is suited for their

gendered labor, they are encroaching on what rightfully belongs to their sisters.[5] It is possible that the buffoonish failure of the men can be attributed to their lack of respect for the social rules that kept a sense of harmony for the ancient Chamorros; it marks a transgression of the division of i tasi, a lack of respect for the counsel of their sisters, and an inability to recognize women as fellow leaders in confronting life's challenges.

Chamorro literature scholar Robert Tenorio Torres has addressed three main versions of the tale's adaptation: (1) a mermaid motif from Eve Grey's anthology (1951) in which women lure the fish; (2) "Why the Central Part of Guåhan Is Narrow," which focuses on the role of women and more on the geographic effects of the fish's visit; and (3) "A Hair of the Virgin," by Van Peeble, in which the Virgin Mary rescues the island. Torres describes the monstrous guihan dångkolo as a common Micronesian literary motif. He also points out that these tales reflect syncretism with Spanish Catholic mythology and that the precontact folklore has clearly been altered severely (2003, 15). We must investigate further these recent changes to the tale of the women who saved Guåhan to see the greater potential the tale has for community organizing.

The tale also emphasizes the importance of listening to i manfåyi (those with wisdom), especially if they are mañaina (elders). Flood's version suggests that the arrival of the hungry guihan dångkolo is tied to a general depression and lack of respect that the Chamorro people have been feeling with respect to their ancestors and to their land. The disrespectful behavior of the men toward the women is a symptom of this larger issue. Flood writes: "Disrespect for people, land, or sea makes the spirits that are within everything angry. . . . Disrespect brings drought, famine, and an island-eating fish" (Flood, Strong, and Flood 1999, 6). An elder maga'håga' reinforces this warning: "The spirits are angry. . . . The people no longer show respect. They take from the earth, take from the sea and give nothing in return. Nothing! No respect for the earth. No respect for the sea, the water or each other. The spirits are angry. Our punishment will come from our selfishness" (15). Eventually, the men join with the women to destroy the fish, after it is caught in the net and the community is restored, thanks to the wisdom of the maga'håga'. *Hemplon Nåna Siha* (Mothers' Tales) focuses on the actions of Sirenas who lived on the island, mermaids or naiads of Hagåtña Springs, and an atmosphere of supernaturalism. In this collection, the social importance of retelling the story is emphasized; the tale explains "the shape of our island, the spirit of *inafa'maolek* (interdependence) among our people, and the role of Chamorro women in our society" (Department of Chamorro Affairs 2001, vi).

Unity and Community

The position of the maga'håga' has been under attack for centuries because of the power that Chamorro women were believed to wield, which did not sit well with Spanish or American colonial administrations.[6] The female-focused tale of the women who saved Guåhan represents a continuity, a narrative through which the Chamorros have kept alive the notion of female power and

5. See Leon Guerrero (n.d.).
6. See Souder (1987).

cooperation between genders, despite centuries of colonial militarization and patriarchy. The young Chamorro activists who cite this tale are not only resisting contemporary threats to their island but also reclaiming their own histories of wonder, forming maps for the future. In doing so, they are decolonizing, in the sense of perpetuating or reconstituting aspects of their culture that colonizers have long worked to erase. In the tale of the women who saved Guåhan, what is emphasized is not the superiority of one gender over the other but rather the need for women and men to work together. Furthermore, the tale underscores the need to respect one's elders and one's heritage. Finally, we see in the women who work together to subdue the guihan dångkolo the potential power of a community that organizes itself around a strong commitment and purpose and also a respectful unity. This is evident in the climax of this tale of wonder: a gathering of women, each sacrificing her long hair so that the hair can be woven together, who become literally connected to each other in a new sisterhood. Symbolically, this represents the wonder of unity in society and culture and the potential for inter- as well as intracultural unity.

Chamorro scholar Keith Lujan Camacho discusses the tale of the women who saved Guåhan in a more expansive context. He situates the tale so that we can gain a sense of its function throughout history as a sustaining story of wonder, meant to empower and inspire:

> As I understand the story, the "fish" is a metaphor for both human-made conflicts and such natural disasters as earthquakes and typhoons, which are frequent in Guåhan. On the other hand, the net made of women's hair accounts for the cooperative and reciprocal power of women in Chamorro society. . . . Likewise, Chamorro women still exert much authority in their everyday lives. In many ways, the U.S. military is the fish that presently confronts and confounds our futures. We, too, are also a part of that fish. Its scales, its organs, and its fins permeate our lives in the Pacific Islands, as much as it might influence the lives of many others in the wake of 9/11. (2010, 11)

The tale is meant to help Chamorros rediscover their core values, to find them again in new settings with new purpose. Chamorros again return to the social foundation inherited from their mañaina, to find inafa'maolek, balance between maga'låhi and maga'håga', and respect for wisdom and elders.

As we saw through the actions of Nasion Chamoru, the contemporary reimagining of the grand masculine warriors of old can create new heroes, larger-than-life individuals whom we can admire. Gadao is reborn today as an icon like Anghet Santos, who becomes a banner for rallying people against oppressive forces. The tale of the women who saved Guåhan offers a more communal approach, one that may be more sustainable and effective given the serious problems that the Chamorro people face today.

Guåhan's history of exploitation as a result of colonization, capitalism, pollution, and the military combined may take the form of a guihan dångkolo, menacing the island, massive in its form and seemingly impossible to stop. For a single maga'låhi, this might be true, because defeating a massive beast like this is surely beyond the ability of any solitary hero. But if we imagine the structure that the women in the tale follow, if they gather together around a shared love of the

island and a commitment to protect and defend it, if they bring their individual skills and capacity like strands of hair to offer to the growing weave, if the song they create is one drawn from the wisdom of their mañaina and a desire to restore a sustainable balance to the island around them—then, as we see in the tale, they can accomplish the impossible.

Reinscribing Stories

Both of the tales of wonder analyzed here have played an integral role in raising the consciousness of the Chamorro people beyond colonial limits. The story of Gadao provides a narrative vehicle for finding empowerment in a specifically masculine context. Its focus on only individualist male agency, however, means that the wonder it can inspire, the sense of political possibility it can engineer, does not promote a sustainable gender-egalitarian society reminiscent of precolonial Chamorro social organization. This individualist male focus is often too attached to particular individuals to survive beyond their deaths, and it does not offer an inclusive framework for community action. The stories of Gadao alone, as we have seen in the case of Nasion Chamoru, can lead to internal divisions and discontent, because in this framework for envisioning political action the elevation of the maga'låhi may require the subordination or marginalization of the maga'håga' instead of establishing a balance between them.

The story of the women who saved Guåhan fills in so many of the gaps that the Gadao stories creates. Where the Gadao story is the genesis and odyssey of a hero, the defeat of the guihan dångkolo is accomplished through the formation of a linahyan, a multitude that grows and hums with life and purpose, born from the shared sacrifice of the masses to seek the greater good. The use of these tales of wonder in tandem with Chamorro activist movements is part of a larger momentum in Chamorro culture to escape the confinement of colonization. The legacy of colonization tends to continue to impose traumatic feelings of inferiority, of smallness or stagnation, on the people colonized. Colonization continues to force Indigenous identity into sociohistorical silence. Colonial discourse and practice come together to hold up the colonizer's culture as the key to advancement and prosperity, whereas that of the colonized is viewed as an endless source of social problems; relatedly, the language of the colonizer becomes one that holds the key to educational and economic success, whereas the language of the colonized is perceived to be nothing but gibberish and jokes and a marker of low socioeconomic status. For the colonizer, colonial (European or American) culture represents official history, a "universal" language and civilization, whereas the culture of the colonized is characterized by its supposed lack of history, supposedly inferior language and literature, and supposed barbarity: nothing but "fables and fiction."

Both of the tales of wonder considered here have helped Chamorros break down those binary oppositions and see themselves as more than shadows in the colonizer's gaze and more than effects of the colonizer's power. Both tales provide the narrative material for Chamorros today to see more and more the open possibilities of their existence. Such narratives can provide Indigenous peoples with a sense of history, of cultural maturity, of epistemological fullness. These stories can help the Chamorro people see and feel the sagacity of their culture. These wonder histories are not

insignificant narratives but forms of knowledge developed over most likely millennia; they hold memories, values, the voice of the land itself, all of which are bound and woven together as a message for future generations.

These tales are not just histories of wonder. They also help us to perceive our futures of wonder. These tales explicitly offer strength and support for activists remaking, remapping, and reweaving their island's future. Gadao's story gave strength and voice twenty years ago to the radical spirits of Nasion Chamoru to break the illusion of white supremacy and military dominance on Guåhan by revitalizing the ancient figure of a Chamorro maga'låhi who sought to protect his land from foreign invaders. The legend of "The Women Who Saved Guåhan from the Great Fish" has inspired and driven ecosovereignty activists to work against U.S. military plans to degrade the environment of Pågat, Litekyan, Pågan, and Tinian. As Camacho suggests, these stories, these figures, may be timeless, yet at the same time they appear at certain historical moments to offer empowering messages.

For young activists, these tales offer an opportunity to conceptualize cohesion among multiple groups in the common struggle against the U.S. imperial hegemony, a terrifyingly large and destructive predator that, in the words of many, is destroying their island and their children's future. The multiple nodes of the web of women's weaving and Gadao's effort to remake or remap the island of Guåhan against invasion suggest that many small individuals, many narratives, when working together, can create something large and flexible and strategically opportune to ensnare and defeat even a monster. However, this requires that everyone must work well together and support one another, with wisdom from elders and insight and leadership from both men and women. The Chamorro histories of wonder are revived again and again in the social imaginary with each telling: an egalitarian, communal nation-state with members working in unity to create their own Indigenous-centered and self-determined future of wonder.

Postscript (January 15, 2021)

Kado'kado' yan dinagi, fables and fiction: so the invaders dismissed CHamoru wonder tales. And yet, the Spanish priests and soldiers themselves propagated neocolonial "alternative facts" in the CHamoru isles, by means of brute force and death, as their apologists still do today from deans' seats and Jesuits' pulpits. If these apologists do not use swords and whips, their parallel and competing histories of cruelty are no less destructive. Indigenous histories and futures of wonder must never be used superficially to obscure these material exertions of neocolonial authority. We have experienced in our bodies, in the loss of home, land, vocation, every security, how authority marked as white, male, and wealthy seeks to overbear the very existence and resistance of Indigenous people and women. Whether this is the Sisyphean task of Indigenous delegates to the United Nations, or a lone Cassandra shrieking over sexual harassment and rape, as noted by Derek Walcott, "the classics can console. But not enough" (1997, 111). The wonder of Indigenous traditional stories and their revolution through the workings of each new generation is an enactment of compassion in the face of cruelty. Our histories and futures are written in blood—in loss, and in reproduction. We are small fish in a huge wave, but we are also the weavers of nets, the heavers of

stone, the creatures of Fu'una. We believe in a future for our children, if not ourselves. Our stories are for them. I tasi-ta: our stories, our ocean.

Works Cited

Aguon, Julian. 2008. "Other Arms: The Power of a Dual Rights Legal Strategy for the Chamoru People of Guam Using the Declaration on the Rights of Indigenous Peoples in U.S. Courts." *University of Hawai'i Law Review* 31:113–154.

Camacho, Keith L. 2010. *Fuetsan Famalao'an: Chamorro Women's Activism in the Wake of 9/11*. Los Angeles: UCLA Center for the Study of Women.

———. 2011. *Cultures of Commemoration: The Politics of War, Memory, and History in the Mariana Islands*. Honolulu: University of Hawai'i Press.

Chamoru Language Commission, Government of Guam. "Chief Hurao of Hagåtña Ancient Speech of 1671 as Recorded by a French Priest Charles Le Gobien." Accessed October 17, 2014. https://ns.gov.gu/hurao.html.

Cunningham, Lawrence J. 1992. *Ancient Chamorro Society*. Honolulu: Bess Press.

DeLisle, Christine Taitano. 2015. "A History of Chamorro Nurse-Midwives in Guam and a 'Placental Politics' for Indigenous Feminism." *Intersections: Gender and Sexuality in Asia and the Pacific* 37 (March). http://www.intersections.anu.edu.au/issue37/delisle.htm.

Department of Chamorro Affairs. 2001. *Hemplon Nåna Siha: A Collection of Chamorro Legends and Stories*. Hale'ta Series. Guam: Department of Chamorro Affairs.

Diaz, Vicente M. 2001. "Deliberating 'Liberation Day': Identity, History, Memory, and War in Guam." In *Perilous Memories: The Asia-Pacific War(s)*, edited by Takashi Fujitani, Geoffrey White, and Lisa Yoneyami, pp. 155–180. Durham, NC: Duke University Press.

Flood, Nancy Bo, Beret E. Strong, and William Flood. 1999. *Pacific Island Legends: Tales from Micronesia, Melanesia, Polynesia, and Australia*. Honolulu: Bess Press.

Flores, Judy. 2004. "Artists and Activists in Cultural Identity Construction in the Mariana Islands." In *Shifting Images of Identity in the Pacific*, edited by Toon van Meijl and Jelle Miedema, pp. 119–134. Leiden: Brill.

Grajek, Andrea Nicole. 2010. "Sleepless in Wonderland: The Real Big Fish." *Waiting for Wonderland* (blog), January 20. http://www.waitingforwonderland.blogspot.com/2010/01/sleepless-in-wonderland-real-big-fish.html.

Grey, Eve. 1951. *Legends of Micronesia*. 2 vols. Saipan: Trust Territory Literature Production Center.

Kasperbauer, Carmen A. 1996. "The Chamorro Culture." In *Kinalamten Pulitikåt: Siñenten I Chamorro/Issues in Guam's Political Development: The Chamorro Perspective*, pp. 26–38. Hagåtña: Political Status Education Coordinating Commission.

Leon Guerrero, Victoria-Lola. n.d. "Chamorro Women's Legacy of Leadership." *Guampedia*. Accessed May 12, 2014. www.guampedia.com/chamorro-womens-legacy-of-leadership/.

Marsh, Selina Tusitala. 1999. "Theory 'Versus' Pacific Islands Writing: Toward a Tama'ita'i Criticism in the Works of Three Pacific Islands Women Poets." In *Inside Out: Literature, Cultural Politics, and Identity in the New Pacific*, edited by Vilsoni Hereniko and Rob Wilson, pp. 337–356. Lanham, MD: Rowman & Littlefield.

Monnig, Laurel Anne. 2007. " 'Proving Chamorro': Indigenous Narratives of Race, Identity, and Decolonization on Guam." PhD diss., University of Illinois, Urbana-Champaign.

Perez, Craig Santos. 2011. "Our Sea of Voices." *Marianas Variety*, December 19.

Perez, Michael. 2001. "Contested Sites: Pacific Resistance in Guam to U.S. Empire." *Amerasia Journal* 27, no. 1:97–114.

Peterson, John A. 2015. "Co-Opted Heritage: Political Action, Identity, and Preservation at the Pagat Site, Guam." In *Identity and Heritage*, edited by P. F. Biehl, D. Comer, C. Prescott, and H. Soderland, pp. 117–127. New York: Springer.

Pier, Patricia L. G. Taimanglo. 1998. "An Exploratory Study of Community Trauma and Culturally Responsive Counseling with Chamorro Clients." PhD diss., University of Massachusetts, Amherst.

Rogers, Robert F. 1995. *Destiny's Landfall: A History of Guam*. Honolulu: University of Hawai'i Press.

Souder, Laura Torres. 1987. *Daughters of the Island: Contemporary Women Organizers of Guam*. MARC Monograph Series 1. Mangilao: University of Guåhan, Richard F. Taitano Micronesian Areas Research Center.

Stade, Ronald. 1998. *Pacific Passages: World Culture and Local Politics in Guam*. Stockholm Studies in Social Anthropology 42. Stockholm: Department of Social Anthropology, Stockholm University.

Storie, Monique R. Carriveau. 2009. "All Fifty Kathousand Cousins: Chamorro Teachers Responding to Contemporary Children's Literature Set in Guam." PhD diss., University of Arizona.

Tanji, Miyume. 2012. "Chamorro Warriors and Godmothers Meet Uncle Sam: Gender, Loyalty, and Resistance to U.S. Military Occupation in Postwar Guam." In *Gender, Power, and Military Occupations: Asia Pacific and the Middle East Since 1945*, edited by Christine De Matos and Rowena Ward, pp. 98–117. New York: Routledge.

Torres, Robert Tenorio. 2003. "Pre-Contact Marianas Folklore, Legends, and Literature: A Critical Commentary." *Micronesian Journal of the Humanities and Social Sciences* 2, no. 1–2 (December): 3–15.

Van Peeble, Mavis Warner. (1945) 2009. *Chamorro Legends on the Island of Guam*. Vol. 4. Mangilao: Micronesian Area Research Center.

Walcott, Derek. 1997. "Sea Grapes." *Wilson Quarterly* 21, no. 4:109–114.

Wernhart, Karl R. 1972. "A Pre-Missionary Manuscript Record of the Chamorro, Micronesia." *Journal of Pacific History* 7:189–194.

Artists' Statement for *She Who Dies to Live*

Lifting the Veil

Lyz Soto, Jocelyn Kapumealani Ng, Kathy Jetñil-Kijiner,
and Terisa Siagatonu

It is an honor to be able to share this work with you. *She Who Dies to Live* (*SWDtL*) is a multidimensional show that has allowed us, as collaborators, to evolve and transform with each of its various iterations. From a performance in an old meat locker to a museum in Australia and now to this page—a new iteration—a new form. This form is without the voices, lights, movements, projections, and adornments of live theater, and *SWDtL* was born within the ephemeral cauldron of performance. In this way, the title of the piece becomes integral to the process of its making: the last version of the work dies so a new version might live.

In the three years since its original conception, *SWDtL* has continued to be an experiment in transformation, identity, performance, visual arts, and spoken word. Its first iteration was a ten-minute live performance piece, as part of the Smithsonian Asia Pacific American Center 2017 curated event 'Ae Kai in Honolulu, Hawai'i. An expanded forty-five-minute version of *SWDtL* was performed at the Queensland Art Gallery of Modern Art (QAGOMA) in Brisbane, Australia, in March of 2019, and now we are here. Perhaps it is fitting to have this world come to live in print in the middle of a global pandemic.

The performance of *SWDtL* originated with the desire of Jocelyn Kapumealani Ng, Kathy Jetñil-Kijiner, Terisa Siagatonu, and Jahra Wasasala to show powerful Pacific Island stories through spoken word, transformation makeup, movement, and sound. All four are spoken word artists. Jahra and Jocelyn are also a professional dancer and a transformation makeup artist, respectively, and each brought these skills into the original world-building of *SWDtL*. When we were invited by Adriel Luis and Kalewa Correa of the Smithsonian Asia Pacific American Center to bring *SWDtL* to QAGOMA, we knew we wanted the piece to grow into something new. We invited Lyz Soto to be the dramaturg and director of this next iteration, which continued on with Jocelyn, Kathy, and Terisa. Jahra was unable to collaborate in this version, but her contributive spirit continues to live on in this work. The version we invite you to read in these pages is transmuted from this latest scripted performed version.

Two Gods and a Demon

What happens when the sun explodes inside you? Whom do we pray to when our gods have been taken from us—or we have abandoned them, so our children might survive in a different world? How do we survive when all worlds apparently want to swallow us? Who are we when we struggle to remember the culture and history of our ancestors? Why do our women continually pay such a high price for survival in all societies?

These are some of the questions that served as seeds for *She Who Dies to Live*. These questions became fundamental to the creation and recreation of the writings/transformations/performances for this work in part because of all the voices held within its boundaries, which shifted and grew as we built a world where gods and stories of the Pacific might speak to each other across time, place, and experience. While *SWDtL* was written and performed by Jocelyn, Kathy, and Terisa, within the world of *She Who Dies to Live,* they are transformed. Jocelyn personifies Kanaloa, Kathy turns into the Mejenkwaad, and Terisa becomes the God of Diaspora—difficult manifestations, each of them embodying a Pacific ravaged and resilient and struggling to find a path into a future that holds space for us—that believes, even after everything, we will still be here.

Kanaloa and the Mejenkwaad are also profound representations of the cultural past. In Hawaiʻi and other parts of the Pacific, Kanaloa is frequently understood as a god of the ocean and is most often represented as male when appearing in human form. The Mejenkwaad is a demon of the Marshall Islands. Typically gendered female, the Mejenkwaad was a woman who was drowned by her village as a punishment. In her death, she is reborn as a demon with a shark's mouth embedded into her back and she consumes pregnant women and babies. Terisa's becoming the God of Diaspora was born out of many, sometimes painful, conversations between all of us grappling with the reality of what it means to be disconnected from the culture of your ancestors. And these are not ancestors lost into the distance of centuries past, but parents and grandparents—so that sense of disconnection is not far removed, but rather it sits between intimate familial generations who love one another, but cannot always understand the differing perspectives produced by divergent cultural experiences. As the God of Diaspora, Terisa wanted to personify a figure that better encompassed her full lived experience as a Samoan woman, who grew up in California and is also deeply committed to Pacific Island communities living in diaspora, particularly in the continental United States.

Jocelyn and Kathy found themselves asking if they had the right to take on the figures they wanted to inhabit, or rather the figures that might inhabit them. They wondered if they had the right to imagine into the stories of their cultural past. Jocelyn grew up in Kaimukī on the island of Oʻahu. Her grandparents carried and passed down ancestral trauma. They did not teach Hawaiian to their children. They did not pass on cultural traditions, and, in the following decades, her working-class family did not have the capacity to relearn and embrace their Oceanic identity.

Carrying this legacy, as a queer femme Hawaiian womyn, Jocelyn asked, "Am I enough? Do I have the right to say this? To do this? To imagine this?" She wondered, as a person still learning

and with so much more to learn about her ancestors and her heritage, "Do I have the right to personify Kanaloa? Do I have the right to imagine Kanaloa female-formed, gendered queer and reeking of grief and rage? Is it okay to conjure this god in my own perspective and within this imagined realm we've built?"

As a Marshallese woman who spent much of her formative years in Hawai'i, Kathy echoed many of these questions. The Mejenkwaad is often considered a monster—a demonized woman—a figure many of us could find sympathetic; perhaps we might even empathize with such a person, just as Kathy did when she revisioned the Mejenkwaad into an avenging persona, whose strongest desire is to protect her people from the worst parts of the world.

Transformations

The physical manifestations and visual aesthetics of *SWDtL* performances were highly influenced by Jocelyn's identity and imagination as a writer, performer, adornment fabricator, and makeup artist; Jocelyn is a queer femme womyn of Hawaiian, Japanese, Chinese, and Portuguese descent. As a transformation artist, she transforms not to erase but to elevate. Much of her work is driven by wanting to see how poetry could exist visually. We hope you notice in the visual components of this publication the intentionality of each detail of adornment and body art.

In the Marshallese story of the Mejenkwaad, a woman is drowned, rocks tied to her arms and feet. And she is reborn as a monster. Ropes, paint, shark jaws. How do you imagine a monster? How do we humanize a monster? What is a monster? Perhaps black with shades of dark blues and greens to symbolize the depth of the sea. A pale white face as an echo of bleached coral, rising sea levels, and the ghosts that haunt climate change. Rope to shibari the shark's jaw to her back. To imagine what killed her is what helps to turn her into this "demonic" form.

When thinking of Kanaloa, we ask, what does Kanaloa look like? Male-bodied? In a malo? As an octopus? Does Kanaloa appear in these forms in other parts of the Pacific? In the world we built, Jocelyn imagined Kanaloa naked, taking human form borrowing from the physical materials surrounding them. In its most recent performance iteration, she used the ropes that were used to kill the Marshallese womyn as shibari, thus binding Kanaloa's story to that of the Mejenkwaad. She used seashells and coral head adornment as an otherworldly status symbol.

When thinking of a new god, the God of Diaspora, we thought of assimilation. The God of Diaspora would blend in and not try to stand out. They would look exactly like the mortals walking around on earth. In the performance, Terisa wore a red jumpsuit as a nod to the previous iteration of the show, when Terisa personified the Samoan god Nafanua. The red is an echo of the blood clot from which Nafanua was born. The simple crown adornment was to show an attempt for a new god to possess a status symbol, fluctuating between human and god representation.

In *SWDtL*, we ask, do we allow our gods to be transformed as we transform? Do they change with us? Would they want us/allow us to change? Do we want/allow them to change?

Who are the gods you believe in?

We hope this work leaves you with questions. We did not write this work to offer monolithic answers. We wrote this work to explore questions we did not have the answers to—or we have too

many answers—too many possibilities. In these performances, in this writing, we offer our perspectives. We offer you these stories and invite you into the worlds we are building.

Perhaps we can imagine a better future together.

Lyz, Jocelyn, Kathy, and Terisa
January 2021

Some of the Stories We've Read/Written That Inspired *SWDtL*

Avia, Tusiata. 2009. *Blood Clot*. Wellington: Victoria University Press.

Jetñil-Kijiner, Kathy. 2017. "Monster." United for Peace Film Festival. https://www.youtube.com/watch?v=m8OJulGi1Rg.

———. 2018. "New Year, New Monsters, New Poems." Kathy Jetñil-Kijiner, January 25. https://www.kathyjetnilkijiner.com/new-year-new-monsters-and-new-poems/.

———. 2019. "Anointed." Pacific Storytellers Cooperative. https://www.youtube.com/watch?v=hEVpExaY2Fs.

Performance/She Who Dies to Live. 2019. Queensland Art Gallery of Modern Art. https://www.youtube.com/watch?v=HuRS-lHfmHI.

Tobin, Jack A. 2002. *Stories from the Marshall Islands: Bwebwenato Jān Aelōñ Kein*. Honolulu: University of Hawai'i Press.

Wendt, Albert. 2009. *The Adventures of Vela*. Wellington: Huia.

She Who Dies to Live

Written and performed by Jocelyn Kapumealani Ng,
Kathy Jetñil-Kijiner, and Terisa Siagatonu

Scripted and directed by Lyz Soto

I. Before We Became Underwater
In 300 years, your descendants
will turn into a mushroom clouding
foreigners' memory of paradise.

In 300 years, your daughters
will give birth to something
like the eggs of a sea turtle.
They will birth something
like intestines.
Your children will call them jelly babies.

My daughters, you are staring down
the barrel of 300 years of greed wrapped in shrapnel
shoved down throats in our bodies of islands.

In 300 years, invocation will be irony.
These foreigners, who crush your people,
our ancestors, your future to ash,
will tailor your misery into adornment.
Name their destruction after praise.
Name their desire after an island turned crater.

In 300 years, you will see their lust
and their devastations
as the same kind of prayer.

II. Kanaloa from the Deep

Her call shakes me from the Ocean's deep—perhaps I had been sleeping.
Some rage is a building tide. Her very own people—they judge her. They lash her as if she
could be food. Bound. Anchored to the ground. Her wrath trembles
the earth to reach me. So climbing the currents of the sea, all I can do
is listen—

Is this my hair in my hands? Sinking. Where are my lovely scales? Their hair fell
from their scalps floating—a dance to the seafloor . . . Nerik gave birth to something
like the eggs
of a sea turtle. Flora gave birth to something
like the intestines.

They screamed at her—are screaming at her—still screaming—are you a hearing thing?
You stand trial!
Mark the chest . . .
A red and painted thing . . .

As if I am before her, before them, an unwanted witness. Her chest is carved meat, as if all her
body is teeth. And still they scream—

Rivers run back into you, daughter.
Your blood returns to water.
Your punishment: Drowning knowing no one will save you.

All those men . . . all that certainty. They have already decided on her womb and cursed . . . Give
birth to nightmares, daughter. Show the world what happens when the sun explodes inside you.
In your blood there live monsters.

III. Mejenkwaad before Nerik

She drowned. She drowns in their twisted trees. She cries for me, I think. Mejenkwaad does not
thrash. No fighting for breath—she knows I wait for . . . she knew. She will know my limbs
around her.
Nerik gave birth . . .

Give birth to nightmares, my daughter.

Flora gives birth . . .

When the sun explodes inside you . . . you are already a monster.

I am saving the best part of myself. I had forgotten this, hadn't I?
I am forgetting I am made of teeth.

IV. Kanaloa Is a God

You still hear me. You are asking from behind your melted sand. You will ask me—
Am I merciful? I ask you— Who came for you? Who came for me?
Who comes for us? Who will come for her? Who are your gods?
Are they merciful? Do they grow teeth of chrome and lacquer? Were my teeth folded
a thousand times by a hammer? Who are your gods? Do they jumble your name into a backwards
prayer? Am I merciful?

She lives because you drowned her body but forgot she is made of salt.
Were you merciful? Mejenkwaad, I fashioned you
into a god made of flora and ash. Some gentle fragment of the past blooming.
Would you let me build you an altar fashioned from laudable mistakes; can I come for you?

V. Mejenkwaad Is Made of Teeth

I am saving the best part of myself.
This is what I think
as I sink to the bottom, boulders at my feet
wrapped in a woven tomb.

So I turn away from the men in their canoe
and sink willingly in darkness.
I feel a welcoming embrace.

This ocean feels my pain.
This ocean knows this rage.
Does a god taste my rage the same way a child tastes—
sweetness?

In our legends
lives a monster called Mejenkwaad
and I am made of teeth.

VI. Gods Made into Monsters

Mejenkwaad, let the wayward within, the one who bears the world in a body.
To all the gods who still live listen as my witness. In 400 years, our prophets have learned
to speak drowning. Your granddaughter's granddaughter's daughter will sacrifice
your names to us.

In legends you are a woman demon-unhinged jaw swallowing canoes, men, babies. Whole.

 Shark teeth in the back of your head. Neck stretched around an entire island, bloodthirsty.

 Hungry for babies and pregnant women. Monster.

As our children become massacred, I peel the god from my body only

to find more gods beneath. Daughter, remember you are made of teeth.

They will tell stories later about how they saw a slit, from your head

down your back, open shark teeth lying in wait, sharp edges for consumption.

VII. An Unhinged Jaw

 My jaw unhinges. The shapeshifter climbs out.

 Whatever has been quietly bruising me begins to soften.

 The memory of how I was built reckons.

 I beg for a pause in never-ending ruptures.

 It is in the darkness

 I feel your welcoming embrace.

 I only remember

 I am cursed

 by women

 I thought were my own

 by men

 who could have been my sons.

 Cursed me monster.

 Let me watch my child die, alone.

 In 300 years Nerik will give birth

 to something like the eggs of a sea turtle. Flora

 will give birth to something like the intestines.

VIII. A God Could Taste like Revenge

Daughter, you smell of fear. A half-bitten eulogy—gagged and fighting. I am here

because you named me.

Mejenkwaad, I helped birth your islands. Your atolls cradled you in my blue.

Survival

is

Not

gentle.

Let us show them a new world of true hunger of mourning of loss.

Remember who turned you into darkness who shapeshifted you into animals—
an octopus climbing up coconut trees—whispering nightmares to the women you thought
were your own.

IX. The Stories We Should Tell Our Children

<div align="right">

In our legends lives a woman.
Turned monster from loneliness.
Turned monster from agony and suns exploding in her chest.
She gives birth to a child that is not so much a child
but too much a jellyfish.
Struggling for breath.
Struggling in pain.
She wants to bring the child peace.
Bring her home.
Her first home.

</div>

X. As a Colonized Body

Look at this body—my body—filling with blood. Skeletons of all my children.
Infants came from a distant land still making love with destruction.

Look how you steal my children. Make promises of a better life. A better world.
Then fill their throats with poison. Make them dream with no water.

Watch a new god born from yesterday's ash.

XI. A God of Diaspora

All of this tracing and tracing and mapping and naming and owning
And mine and mine and mine
and home and home and home
and for what?
What ancestors? What if I have none?
How did I become?

At birth, I was discarded as a blood clot
thrown away/deemed "premature"/deemed "not of this world"
But this world made me a god of exile, so this body
becomes an asylum seeker.

Do all of us descend from ancestors?
All I've ever known has been taken away from me.
Displaced me.
Moved on without me.
Disowned me.
Does not recognize me.
Will not claim me as kin.
Is that an ancestor?
I've known panic more than I've known "home";
is that an ancestor?

XII. Kanaloa as a Tongue

Child of Worlds Burned to Ash, how this world consumes you. Parts of you are ghost
become kava caught between molars. You find your joy chewed
in a foreign mouth. You reek of conquerors and colonists. You have not realized
you are not human. You are nothing but a fucking shadow—of my lost children's desire.

Where is your voice? Where is our language? Where is the ocean in your tongue?
Did you lose it on some accidental shore, or did you bury it in a dry land?
Have you never looked this way home? Have you never longed for a closer sun?
Have you no salt in your body? How can you love my children while speaking
 in that tongue?

XIII. A God of Worlds Burned to Ash

I once thought I belonged Somewhere
until Somewhere became Nothing.
Do you know when I became Nothing?
Became Nothing they could claim as citizen.
Do you have a word for citizen in your language?

What if my blood returns to water?
What if I am that country?
What if home is the longing?
Who's really lost, then?
If I am speaking, then I am surviving.

XIV. Mejenkwaad Could Taste like a God

I know a story
of the ocean enacting revenge
for women like me.
One sister violated

by an uncle, later
ripped apart by sharks.
Ancient justice
delivered between teeth.
What does it mean
when the men
who rip you apart look just
like you—who is the monster
really?

XV. When Gods Talk Story

I've been invaded too. People have violated me, drained me
of my resources, took what was mine.
Am I country too? Are you my blood too?

If I am blood
then you have become water.
Should we grip
each other at the neck?
Pour death
into each other's mouths.
My jaw unhinges.
The shapeshifter climbs out.

Sister, you have witnessed the greed of men worshipping you to a
drowned body. But you are carved of the sea.
You are the blood clot stain. You are the dislocated
jaw of a mother. I am they who died to live.
You are death living in body.
We live because they try to drown our bodies, but forget
we are made of salt.

Sister—why do they pretend
we are not nursing
the same wounds?
Why do you come to me speaking
tongues, uttering guttural
sounds echoing the fists of men?
Why did they call
for my destruction?

When the men came
they wrapped
me in a woven mat,
tied boulders to my feet
paddled to the end
of the horizon. Threw me overboard.
Demanded that I drown.

 Sister, how many women have been sacrificed like that?
 How many have been forced to drown?
 Simply for being a woman. When you bleed
 your body says—
 I remember everything that happened to me
 Your body says—
 We remember all of the wars we have been bled for.
 The war on women was created by scared men
 frightened men—afraid
 you are stronger / smarter / better than they want
 you to be. How threatening
 is your feminine body . . . How bloody is our womanhood . . .

 Sister, why do you sit in this darkness?
 . . . why embrace the deep?

Because
the Ocean heard me
and cried.

 And the Ocean is a safe place?

The Ocean understood my rage.

 And raged with you.

And fed my hunger.

 And made you hungry. Sister, 300 years ago, she became the whisper
 at the back of the neck. She murmured them into frenzy—

 —I made it possible
for her to swallow our world before the foreigners swallow us!
The sacrifice of a few for the survival of the many. I bore her the teeth of a shark

so she might eat the children forced to flee. So they might never forget who they are.
In her belly, they are always home. Daughter! Devour the men who try
to claim these islands as theirs. Look at their small stories! Look at how they still only
know how to crawl into me and vomit their discontent.

> When the sun exploded,
> I crawled out from the depths
> —watched our women
> give birth to nightmares.
> I watched Nerik give birth to something
> resembling the eggs of the sea turtle
> and Flora give birth
> to something like the intestines.
> I watched them bury
> their nightmares in silence
> And where were you, Ocean?
> Where were you to protect us?
>
> And now, you wash up on island shores
> trying to consume them—
> consuming me!
> Your justice smells
> like a rotting corpse.
> How are you different
> then the invaders?
> Who are you
> to call me blood?
> Who are you
> to claim your tears
> fall for me?
> For us?
> For my islands?

XVI. Kanaloa Has Been Crying

My daughter, of course I cried for you. They brought their God and tried to turn us into
myth, but I see you. I see us. One god to erase the 5 the 50 the 500 the 5,000 the
500,000
Gods you carry inside of you. And they say he saved us. From what?
From ourselves?

They came here to chop parts of us into pieces. They took. They sterilized. They dissected.

And placed you in glass cases for all the world to see. They called it preservation.
They said, they say they are still saying we will only be destroyed if we go back
to our home.

You want to live in their homes, pray to their God
 with that face
 with that skin
 with that hair
 with that body?

You will become nothing more than a body I turned into a story told and retold.
I only reminded a monster of her teeth.

I only reminded you of your teeth to keep all of our children home. I made you a world in my
heart, daughter. But I don't know where to put all this grief crashing inside of me.
How can I just watch you navigate the unknown when all I can foresee
is a future of hurt and loss and fire?

XVII. Gods like Water
 Have you ever built a boat while on it?

 Have you ever trusted the unknown
 —fastened your faith to a something to a promise to a hope you will not drown in that
 promise?
 You, jawless woman with no peninsula for your swallow,
 no limit to your gnawing, feast and feast and feast, as they did, as they do. On you.
 On us.

 At least as you swallow you do not aim to kill . . .
 wallowing for hunger or swallowing for home.
 They drowned you—swallowed you—consumed you
 While they were already full. You were you are

 full as a basket fallen from the sky. Full as a coral reef—an accidental island—a deliberate
 home.
 Do you not know what you're made for?

 Just because something is cultural, doesn't mean it is sacred.
 Take it from my own becoming:
 How can I be a God yet belong to nothing? How can I be a God
 of the unwanted? How can I be a God—an unwanted God?

You may arrive into an unknown, but there: See? A sense of belonging grows despite all—
despite you, as water takes the shape of everything:
As do I: everything that embodies
unbelonging: an impossibility to take root, anywhere.
You were drowned?

You said so yourself—
I am cursed by women who I thought were my own
by men who could have been my sons.

Did your people betray you? Or did the betrayal make you realize
who your people could be?

Sister, I know what it feels like to ache for belonging to a place
that doesn't know what to do with you. In our displacement, in the diaspora we find a way
for our resilience. We, the women who cry
for God's mercy, moments before becoming her. We, the women
discarded and displaced, dis-located and dis-owned. Dis-assembled '
and dis-appearing . . .

But we never truly disappear, do we? We never truly die ever, do we?

Either something was sacrificed for me to be a God or I am the sacrifice that made it
possible to believe in a possible me.

It is easy to want to belong to a people who rely on our submission
for their pulse, rather than declare our survival as divine
to this diaspora. If you say that you dwell in this darkness
because the Ocean heard you: then it's because she did.
If you are looking for salvation: search nowhere else and rest.

XVIII. Kanaloa in the Dark

Does anyone ever ask of the ocean, how does it grieve? Grow eight legs and three hearts
to hold the tender wounds unfurling. Mourn a king tide reaching for land to hold onto. Anything
to hold onto.

In all of my vastness I give you 20,000 leagues
of how we've lost parts of ourselves in this world of how lonely the endless feels
of how much we carry because that is all we know. Do you know what it is like when everyone
floods you with tears but then gives you no one to cry with?

80

What if I told you that I have cried myself into a stone sea? How much god is left of me then—
when I am nothing but shoreline where everything ceases to grow.

Here is what I know:
Our beginnings are roots reaching beyond a realm conjured intangible.
We are end-less. But our middle is where you leave. Me.

Someday: is a prayer gods make to ourselves. Someday: is a long exhale within infinites
You are a someday kind of blessing. Here's a secret: Our greatest fear:
being forgotten. Or rather: Forgetting. If you leave, what will you forget?
What will I fail to remember?

Here's another secret: In the leaving, we could hold onto
our greatest light: memory. Or rather: Here is what I remember:

All the prayers you ever shared with me.
Here.
 Here.
 Here. I
 saved all
of my blue for you.

Here.
 Here.
 Here is what I know:

in all my power in all of my love:
I can't make you stay.

Here is what I know:
It is hard being the one who stays when so many have already gone.
Accepting you leaving. Waiting for the return.
Hoping for the return that may never come.
Here.
 Here is a home you can always return to,
 if you choose.

XIX. Mejenkwaad Swallows the World for All of Us

 Here is what we know: In 100 years, we will carry
 two worlds in our gut.
 One in the journey beyond

the unknown
and the other
in the return home.

Home.
In 100 years, we will retreat
from the stage of the living
and find a home
beneath the reef
where we will tend to our rage.

In 100 years, our god prayers live on, as you become a god story. As you arrive here, an invocation, we give you a blessing to take into the future. What good are these words without the bodies that listen to them—without the voices to tell and retell them—without the minds that reimagine our futures together? We can make the heavens fall, the sun explode, and birth nightmares. Or we can listen. We can be quiet and we can listen and we can do better.

300 years ago, I watched my child die.
In the eons that followed
I filled my pain with rage. I know
it is hard being the one who stays.
But here
is what I know.
I know I am weary.
I know my belly will never stop being hungry.
But I choose the seed.
I choose the earth that feeds
our growth. I choose a vast path—
not just a narrow bridge.

In 100 years, I will re-emerge
when this world rebirths our islands
draws the sea from our shores
and returns to worship the soil. I am a someday
kind of a blessing
a world in your heart
and I am ready to be buried. I am ready
to be the blood clot buried in sand.
I am ready to retreat to the island of demons.
I would take all the children with me
the ones with no homes

the ones with no lineage
the ones cast out and discarded
the ones with no bones to cling to.
I will bury them with me in my garden of skulls.
I will bring with me the salt
and blood that bore me.　　　　　I release
myself from　any unchosen bindings.
And I
emerge.　　　　　　　　　　Whole.

Reconstituting Indigenous Oceanic Folktales

Steven Winduo

Indigenous communities in Oceania have always used folktales to explain their social, psychological, political, and cultural environment. This tradition continues today in the cultural productions of many Pacific writers, artists, and filmmakers. Their "texts" are often saturated with social and political discourses that challenge ideology, tradition, and power. I explore how scholars in various discursive traditions have used folktales as structures for viewing culture, society, and events, and I do so in order to review folktales within an Indigenous cultural production in Oceania.

Folktales as Sociocultural Texts

If we are to see folktales as "text," then we need to consider the definition of "text" as a sociocultural production of society. We need also to attend to the specific demands of theory that address the existence of "text" as a constituting product of social and cultural imaginings. The first place to begin this inquiry is to consider text as a structure of feeling or experience as expressed by Raymond Williams in his discussion of the various discourses we produce in society to explain our thoughts, feelings, beliefs, utterances, and experiences. According to Williams, "a 'structure of feeling' is a cultural hypothesis, actually derived from attempts to understand such elements and their connections in a generation or period, and needing always to be returned, interactively, to such evidence" (1977, 133). As a cultural text, folktales include "unusual anecdotes, initiations, wonder stories and animal tales" (Zipes [1979] 2022, 28). They are affective in nature and cannot be reduced to belief systems, institutions, or explicit general relationships. As "structures of feeling," folktales encompass much more than this, including elements of social and material experience not covered by concepts like ideology or worldview (Williams 1977, 133). Folktales contribute to the general folklore of a kindred group or people in a given time and space, where folklore is taken to mean stories of a kindred group or people who have at least one thing in common.

Previously published: Winduo, Steven. 2010. "Reconstituting Oceanic Folktales." In *Folktales and Fairy Tales: Translation, Colonialism, and Cinema,* edited by kuʻualoha hoʻomanawanui, Noenoe Silva, Vilsoni Hereniko, and Cristina Bacchilega. ScholarSpace at the University of Hawaiʻi at Mānoa. http://scholarspace.manoa.hawaii.edu/handle/10125/15609.

Folklore consists of artistic expressions that are "heavily governed by the tastes of the group" that performs or represents them (Toelken 1996, 266). In folk performances, we see "a continual tableau or paradigm more revealing of cultural worldview," and thus it is possible some of these expressions were created independently by their creators: "Nonetheless, as students of culture have shown, in terms of world view the distinctions between formal culture and folk culture are not as sharp as one would have imagined; apparently, little is exempt from functionings of cultural worldview" (266). Independent emergence of folktales allowed the existence of a distinct repertoire of folktales in Oceania. Our discussions will consider some of these folktales told within certain groups but not in other groups, as is the case in a number of societies in Oceania.

The second consideration here is to think of folktales as texts in the Bakhtinian sense, as an unending object of possibilities, with their own internally constructed structures of producing and reproducing meanings that are themselves open to further possible interpretations of meaning. Thus we have to consider folktale texts as existing within the social and political sphere of heterogenous commingling of worlds and peoples, of ideas and perspectives, of beliefs and experiences, of private and public discourses, and of new and old ways of knowing. A folktale text is a "subjective reflection of the objective world" and it is "an expression of consciousness" out of which we hold our reflection of the world as our reality (Bakhtin 1996, 113). It is through the notion of text that we take our departures in our various kinds of knowledge productions: "Proceeding from the text, they wander in various directions, grasp various bits of nature, social life, states of mind, and history, and combine them—sometimes with causal, sometimes with semantic, ties—and intermix statements with evaluations" (113). We could also relate this view of texts to Julia Kristeva's notion of text as a "mosaic of quotations," by which she means that "any text is the absorption and transformation of another" (Kristeva, cited in Hafstein 2004, 307). As Valdimar Hafstein notes, Kristeva's notion of text is close to "Roland Barthes's conception of the text as plural" (Hafstein 2004, 307) where the text is "woven entirely with citations, references, echoes, cultural languages (which language is not?), antecedent or contemporary, which cut across it through and through in a vast stereophony" (Barthes, cited in Hafstein 2004, 307). The evocation of Kristeva and Barthes in this discussion is to highlight the easily recognizable link of the notion of text to their various discussions on text and intertextuality around objects of cultural analysis such as folklore in their written as well as verbal forms of utterance. Thus, folktales are also the final product of a mosaic of utterances and various commingle of texts and metatexts that are ever present in different societies.

Indigenous authors, artists, scholars, and filmmakers have constructed contemporary works firmly within the influence of their own Indigenous oral traditions. The European difference and separation between high and low cultures is absent in Oceania in that folktales have remained very much part of the cultural knowledge system of the people. But this does not make folktales any less structural and contextual in Oceania than elsewhere. It does, however, call to mind the need to be clearer about where folktales fit into the generic term folklore. Toelken makes clear the distinctions by dividing folklore into three categories: "verbal folklore (that is, expressions people make with words, usually in oral interchange), material folklore (expressions which use physical materials for their media), and customary folklore (expressions which exist through people's action)" (1996, 9).

Our interest is to consider verbal folklore, which "includes genres like epics, ballads, lyric songs (lullabies, love songs), myths (stories of sacred or universal import which people, cultures, religions, and nations believe in), legends (stories of local import which people believe actually happened but they learnt about from someone else), memorates (culturally based first-person accounts and interpretations of striking incidents), [and] folktales and jokes (fictional stories which embody cultural values) . . . to name only a few of the most common" (9). As stories that embody cultural values, folktales occupy the central textual function in the contemporary literature of Oceania.

Indigenous Oceanic Folktale Structures

For a long time, I have been influenced by folktales, especially those that I learned as a child and read over the years. As a child growing up in an oral society, the stories I heard were folktales from my Nagum Boiken society in Papua New Guinea. One of my favorites was the folktale about Lomo'ha, who unplugs a rock that is the doorway to the world of the spirits. The doorway opens into a passage leading to the spirit world. Lomo'ha follows this passage. He travels deep into the spirit world. In the spirit world, Lomo'ha is treated with the highest honor, learns their language, and returns, some years later, to his people. By this time, Lomo'ha has lost his human language. He is unable to communicate with his people. It takes the whole village to perform a ritual that lifts the spirits' influence and brings him back to human society.

I explored the Nagum Boiken culture hero Lomo'ha in my poetry collection, *Lomo'ha I Am, in Spirit's Voice I Call* (1991). I used one among many folktales from my own society to explore, reframe, and restructure the experiences of journeys outside of the village. The Lomo'ha folktale is used to capture the experience of journeys out of the village, learning European languages, manners, behaviors, and culture. The loss of voice to the spirits meant Papua New Guineans have lost their cultures, languages, and attitudes to those of European cultures. In my exploration of Lomo'ha in my poetry, I discovered that I could use the folktale structure to view my experiences and those of others.[1] The folktale structure served the purpose of framing experiences that involve the life of being born in a forest society, journeying into the depths of the western world, gaining education, and participating in intellectual engagement, where I discovered the source of inspiration was always the experience of growing up in a world rich with folklore and mythology.

The use of folktales as poetic structures and frameworks for constructing literary works is not unique to my work. Other Pacific writers have also used folktale structures in constructing their writings.[2] Literary reproduction of Oceanic folklore proliferates in the writings of many Pacific Islanders. Pacific writers such as Patricia Grace, Caroline Sinavaiana-Gabbard, Sia Figiel, Robert Sullivan, and Haunani-Kay Trask have used Indigenous culture hero or heroine models to structure their own creative oeuvre. Grace makes references to female mythical figures such as Papatuanuku, Hine-Nui-te-Po, and Mahuika in her novel *Potiki* (1986). Sinavaiana-Gabbard evokes the goddess Nafanua to restructure her experiences in *Alchemies of Distance* (2001).

1. See my interview with Briar Wood (2006).
2. See Michelle Keown's discussion on the influence of culture heroes and heroine (2007, 181).

Robert Sullivan retells the stories of Maui, Tane and Hine Titama, Tawaki, Rata, and Kupe in his book *Weaving Earth and Sky: Myths and Legends of Aotearoa* (2002). Sia Figiel, like Sinavaiana-Gabbard, also approaches the Samoan war goddess Nafanua as a role model to capture the experiences of young Samoan girls growing up in a male-dominated society. Haunani-Kay Trask invokes the volcano goddess Pele to capture the burden of her experience. The active presence of culture heroes or heroines in the work of these writers attests to the influence of folklore structures in the writings of Pacific Islanders.

From the early writings of Pacific Islanders to the present transfigurations of Pacific stories in films, myths, and folktales have remained an important element, creating a "dialogue between the oral and written traditions in Pacific discourse" (Keown 2007, 182).[3] The folktales transferred to the written form are either translated from vernaculars or are infused with other Pacific folktales and with "Western mythologies and ontologies, exploring the syncretic nature of postcolonial subjectivities" (183).[4] In transferring folktale narratives to the literary form, writers use folktales as the frame of reference to reconstruct their experiences in a complex world with its postmodern tensions and anxiety.[5] The incorporation of Oceanic folktales in writing, art, or film makes Pacific Islanders view themselves through their own lenses. Through folktales, Oceanic peoples view their histories, learn their cultures, and maintain a conscious link to the past, to the traditions of their ancestors, and to the geographies of their psychology, landscapes, and peoples.[6]

If in imaginative literary or artistic works from all over the world, writers, artists, and filmmakers have drawn inspiration from "folktale motifs in the formation of enduring cultural creations" (Zipes [1979] 2002, 9), in Oceania folktales have been infused with other texts to produce multifaceted literary, artistic, and cinematic representations, the frameworks of which are drawn from Oceania's folk motifs. From major writers such as Albert Wendt, Witi Ihimaera, Patricia Grace, Vilsoni Hereniko, Epeli Hau'ofa, Russell Soaba, and John Kasaipwalova to little-known writers such as Ambrosyius Waiyin and Paschal Waisi, the influence of the folktale motifs in their literary works is undeniable.

Reconstituting Oceanic Folktales

Through the creative reconstitutions of culture heroes like Maui, Pele, Sina, or Kulubob, Manup, and Lomo'ha, Pacific Islanders are able to reclaim their authority through the framework of discourses generated by the mythical heroes in Oceania. Patricia Grace blends the elements of the Maui myth with the life of Jesus Christ to constitute the experiences of Maori struggles to maintain their identity and land under pressures of modernization and acculturation in New Zealand (Keown 2007, 179). Similarly, Witi Ihimaera explores the whale rider mythology with contemporary others in urban Maori societies (see Ihimaera [1987] 2003; Caro 2002). I have discussed such

3. See also Sullivan (2005).
4. See also Subramani (1985); Sharrad (2003); Vaai (1999).
5. See Winduo (2000).
6. Cristina Bacchilega (2007) highlights how such traditions have been used to market a certain image of Hawai'i to Americans, but also how Hawaiians continue to draw intellectually, creatively, and politically on them.

themes elsewhere, thus will avoid repeating such analysis here. However, I wish to look at certain aspects of the film *Pear ta ma 'on maf: The Land Has Eyes* as an example of the cinematic use of the folktale motif (Hereniko 2004; see also Howard 2006, 74–96).

Retelling the story of Tafatemasian, the mythical warrior woman goddess, Hereniko drives the narrative of Viki, the young Rotuman girl, through the rite of passage, her growing up in a society fractured by age-old sibling rivalry, colonial history, and postmodern inroads in the lives of ordinary Rotumans rooted in the land of their ancestors. *The Land Has Eyes* is about the Rotumans—or, by extension, other Pacific Islanders'—deep connection to land, which they claim through the telling of myths and folktales about their ancestors. Rotuma, as a storied place, symbolizes the eyes of the ancestors, spirits, and the peoples of Rotuma. The evil deeds, the injustices, the denials, and the difficult times faced by people are all recorded through the eyes of the spirit of the warrior woman. The male brothers abandon the warrior woman on the island of Rotuma. In the absence of the male structures of authority and power, the warrior woman weaves her own world and gives birth to a community that responds through the feminine maternal schema. That is, Rotuma is a creation within itself, and through that imagery, the soul and heart of every Rotuman are discovered. Not through lies, deceits, and betrayal, but through hard work, independent spirit, and socially productive relations cultivated with the land, the social relations, and the community.[7] *The Land Has Eyes* "is significant for the many ways it attempts to make invisibles visible, to show the deceased, weather, sea, and land, can be conscious participants in everyday Rotuman life" (H. Wood 2008, 170).

Folktales and Fables of Oceania

The image of the young protagonist diving into the sea to discover her warrior goddess, in *The Land Has Eyes,* reminds us of the image of turtles and their symbolic power within island communities. In *Folk Tales and Fables of the Americas and the Pacific,* Robert Ingpen and Barbra Hayes retell the Fijian story of the Giant Turtle. The story is told by Fijians to explain how people from Tonga came to live among them. A fisherman from Samoa named Lekabai, saved from drowning in the rough sea, had managed to climb a rock into the realm of the Sky King. The Sky King helped Lekabai return to earth on a turtle: "Lekabai thanked the Sky King. He was climbing on to the back of the huge turtle when the Sky King added. 'If you wish to thank me, give the turtle a coconut and a mat woven of coconut leaves to bring back to me here in the sky. We have no coconuts and I have heard that they are delicious. Send me one and we will grow trees. Send me a mat and we will learn to weave our own by copying yours'" (Ingpen and Hayes 1994, 79). At that, Lekabai left with the mighty turtle back to Samoa with the instruction that he was not to open his eyes at any time. Through the journey to Samoa, Lekabai was teased by dolphins and seabirds for being foolish in closing his eyes. This was the instruction from the Sky King. A feast was staged to celebrate Lekabai's return from the dead. Hungry fishermen speared the turtle when it returned to the reef to feed after it got tired of waiting for Lekabai. On learning this, Lekabai told the villagers

7. See Howard (2006) for further details on how the movie was made and the reasons for making such a movie.

that they would be punished. The villagers got scared and buried the turtle in a deep hole with a coconut and a mat of woven coconut leaves. In the process, the Sky King sent a bird to find out what was happening. The bird touched a young boy called Lavai-pani, who would live in perpetual youth for generations to tell the story to a group of young men from Tonga sent by their king to find the shell of the turtle. The Samoans laughed at the Tongan men and said, "We all know that old legend," smiled the Samoans, "but it is only a legend. No one knows where the turtle was buried, or if there was a turtle at all!"

The Tongan men returned home, only to be sent back by the king. It was Lavai-pani who helped them dig up the turtle shell. They found thirteen turtle shells, but gave only twelve turtle shells to the king. The king sent them back to Samoa to get the thirteenth shell. The young men set sail again, but decided against returning to Samoa, so they set sail until they arrived in Kadavu, one of the Fiji Islands, which was then ruled by King Rewa. He was kind to the weary young men and gave them land on which to live. They built houses and took wives and were happy. These were the first people from Tonga to settle in Fiji (Ingpen and Hayes 1994, 78–83).

This folktale reflects the relationships between Tongans, Samoans, and Fijians, as well as those between humans and their supernatural worlds. The volatile relations, the differences between various groups, and their historical indifference or friendship toward one another are highlighted. Interisland travels and cultural items of value like coconuts and mats woven with coconut leaves are items featured in this folktale. This is a remarkable folktale that resembles those told elsewhere in Polynesia, but features turtles, coconuts, coconut-strewn mats, whales, dolphins, and seabirds. In documented evidence, the oral literature of western Polynesia supports the Fiji-Tonga-Samoa-Futuna-Uvea interconnection: "Interaction continued even when people had acquired a sense of Island-centred identity, as oral literature shows occurred" (Scarr 1990, 66).

Elsewhere in the Pacific, say in Melanesia, the story of turtles takes on a different role and function. Imanuel Nigira (2004) writes a folktale about a turtle and an eagle in the Zia language group of Waria River in the Morobe Province of Papua New Guinea. The story involves a young girl tricked and abandoned to die out in the sea. She swam to an island. To survive, she ate fruits and nuts on the island. One day she hit her hand with a stone when attempting to crack beach almonds. Blood came out from her. She collected the blood in a shell and covered it with another shell. From the blood, two eggs were formed until they hatched, giving birth to an eagle and a turtle. She looked after the eagle and the turtle until they matured. The turtle and the eagle helped her catch fish, bring fire, a clay pot, and a house to the island. The eagle brought the first and second items. The third item was carried on the turtle's back to the island where the woman lived. The shared relationship between the first man or woman and animals in the folktales is the bond that ties them together in a symbiotic relationship. Usually in this type of relationship the animals serve as the link between the human world and the spirit world.

The turtle and the eagle feature prominently in the two folktales presented above. Blood from a cut from the woman in the Waria story gives birth to the eagle and the turtle, legitimating her as the original birthing human spirit. Kamene writes that to the Zia of Waria River "living means being aware of, and having knowledge of, and the ability to manipulate the relationship between other living persons, the dead (the spirit world) and the eco- and aqua-systems of the surroundings

thus reassuring the renewal or continuation of life. The significance of the interdependence of part and whole of the cosmos is clearly manifested in the social structure of the Zia community" (1995, 87–88). As in the folktale given above, the eagle features as a totemic symbol of one of the tribes. In his explanation of the four totem names used in Zia, Kamene has this to say: "The *bego* is associated with the hornbill, the *yewa* the bird of paradise, the *sakia* with the white cockatoo, the *wapo* with the eagle. These clans form the recognizable social badges that cement the extended kin affiliations of each village, which in turn gives its distinct communal sense. This thus gives rise to mutual and reciprocal respect between villages and within individual members which enhance and furthermore, maintain internal social cohesion and harmony in the Zia community" (88). The Zia are also centered on the community (*dubu*) and work at strengthening the interdependent relationship through various social activities such as fishing, gardening, feasting, dancing, and storytelling.

It is worth mentioning that various Indigenous Pacific writers and scholars have used folktales to tell their own histories by tracing the link to the past. Among these Indigenous writers and scholars are John Puhiatau Pule, Kauraka Kauraka, Teresia Teaiwa, Nora Vagi Brash, Rexford T. Orotaloa, and Vincent M. Diaz.[8] History, culture, art, and the study of these are launched from a particular perspective: "History and culture—historiography and ethnography—can be conceptualized in different ways . . . One always sees only a slice, at a given time, from a particular vantage point, of a fluid and uncontainable history or cultural practice" (Diaz 2000, 143).

Reconceptualizing Indigenous Folktales

The reconceptualization of a folktale in Indigenous spaces has intrigued scholars to investigate the phenomenon in new ways. For example, the cassowary woman story is not entirely unique to Papua New Guinea, as it occurs elsewhere in the world. In this framework, the anthropologist Donald Tuzin (1997) investigates its powerful religious political influence in an Indigenous community in Papua New Guinea. Tuzin's study of the cassowary woman Nambweapa'w's story in Ilahita village of the East Sepik Province makes interesting connections of this story to a universal folklore motif of the "swan maiden," which is said to be the oldest and earliest known love story on earth (Tuzin 1997, 71; Lessa 1961, 16). In Asia Pacific folklore, this motif proliferates in many communities. Scholars such as Dixon ([1916] 1964) and Lessa (1961) trace thematic similarities and known historical contacts of folktales and fairy tales as they appear in the Asia Pacific region: "Swan maidens are found in cultures of Philippines and Micronesia; along the north coast of New Guinea; in Vanuatu, New Caledonia, southern and Eastern Australia; and in New Zealand, Samoa, and elsewhere in central Polynesia" (Tuzin 1997, 73). Considering the diffusion of this folktale in Oceania as extensive, it is useful for our purpose to consider the possibility that other folktales have also emerged elsewhere in the Pacific. Some of these may have independent emergence while others may have a long genealogy of diffusion around the world.

8. See Teresia Kieuea Teaiwa (1995); John Puhiatau Pule (1992); Kauraka Kauraka (1989); Nora Vagi Brash (1996); Rexford T. Orotaloa (1996); Vincente Diaz (2000).

As in Europe, where folktales and fairy tales preceded the medieval period, the telling of these tales in Oceania preceded the contact period, and soon after, some of these tales were written down (Silva 2004). Even when education and literary culture in Oceania had established themselves, many of these societies have continued to transmit their traditions through verbal performances, oratory, storytelling, artwork, craft, canoe prows, totem poles, and through song and dance. There is "recovery and reimagining of traditional oral storytelling forms, not just in high literary but in more popular modes of creation and distribution" (Wilson 1999, 6). For example, a conference on Reimagining Oceania dovetailed with the Pacific Artists and Writers' Festival held in Suva at the University of the South Pacific campus. The conference began with a high key address from Subramani touching on some of the developments and challenges Oceania writers, artists, scholars, and filmmakers face: "A kaleidoscope of oceanic cultures, tracing diverse and complex forms of knowledge—philosophies, cartographies, languages, genealogies, repressed knowledges—blurring the usual disciplinary boundaries, including the divisions of oral speech from written materials, visual imagery from music and performances, and juxtaposing the popular, commonsensical and personal with the scientific would certainly make this a mammoth project. Such work would treat Oceania as a complicated palimpsest in which we would reinscribe the new epistemologies, our epistemologies" (Subramani 1999, 3). Indeed, seven years after this discussion, another conference on Indigenous epistemologies of Oceania was organized at the University of the South Pacific, again to reinforce the ongoing scholarship and new developments in the visual and artistic arenas around the Pacific. By this time, a number of Indigenous filmmakers such as Vilsoni Hereniko and Urale were present to discuss the use of Indigenous knowledge of Oceania in their films.

Political Functions of Folktales

The political element of a folktale is how it affects the thoughts of listeners and how they act upon it. The respect accorded to folktales in Oceania says a lot about the importance of locally specific stories. The performance of a folktale "exemplifies how, consciously and not cultural actors engage with modified myths and other folktales and how contingent circumstances can move cultural actors to defend against or preempt that which is foretold" (Tuzin 1997, 98). This is a factor that inspires the reproduction through performance of a folktale in its varied and modified form that is easily misunderstood by scholars or outsiders encountering the folktales of Oceania. This is the observation reflected in Tuzin's study of the cassowary's revenge in the Ilahita society of Papua New Guinea: "The vicissitudes of belief and action that surround myths, their varied and changeable significances, are often overlooked by anthropologists and folklorists, who, following their own habits of inquiry generally take these tales as they are, as things to collect and exhibit, as butterflies of culture" (98). A tacit consideration of folktales is that the form a tale takes at the time of performance is influenced both by time and sociocultural environmental changes that tend to influence the content. The sociocultural space fills its content.

Space influences the way in which power is constructed within cultural frameworks and social interactions. We can analyze space as a sociocultural factor influencing the operation of power

through temporal and spatial structures (Diamond 2008, 100). These are, as some would have it, the foundations for the emergence and consolidation of Indigenous epistemology and Indigenous knowledge. David Gegeo explores the Kwara'ae case in point: "In adopting and modifying practices and knowledge from the outside, Kwara'ae people theorize about rural development and integrate traditional knowledge with introduced knowledge, thereby creating a new form of knowledge" (2000, 65). Gegeo explains further that epistemology emerging out of the Indigenous societies "refers to a cultural group's way of thinking and of creating and reformulating knowledge using traditional discourses and media communication (e.g., face-to-face interaction) and anchoring the truth of the discourse in culture" (65).

How are folktales used as texts to represent the worldviews, local perspectives, and responses of Indigenous peoples to social change and political development? A notable example of how folklore influences the political decisions of the colonized world in Oceania is the experiences of the West Papuan society in Indonesia. Under the Indonesian rule, bloody conflicts emerged partly as a result of militarization and the policy of Javanization in that province. In the effort to promote the "Irianese" provincial culture, Jakarta instituted the creation of a museum, which saw Arnold Ap, a New Guinean, in charge. Ap used the opportunity to document and promote Papuan folklore, songs, and culture as a way of differentiating Papuans from Javanese peoples and culture. He recorded songs and folktales from various tribes and played these on radio in Papuan languages, rather than in Bahasa Indonesia. The project was equally powerful in making Papuans become aware of themselves more as they wrestled with the 1963 referendum that saw them clustered with Indonesia. Ap's position was viewed by the Indonesian military as supporting the anti-Indonesian guerrilla organization Organisasi Papua Merdeka (OPM) (Anderson 1983, 173). To sabotage Ap's work, the military kidnapped him, took him to the Freeport Copper Mine site, and executed him. The elimination of Ap meant the Indonesian authorities could continue to control and force Papuans to accept the Indonesian state control and colonization. The execution of Ap, however, added salt to the wound experienced by Papuans as colonized by people different to them in culture, language, and racial composition.

Folktales and Nationalism

During the period leading up to Papua New Guinea's independence in 1975, students used folktales to enforce the agenda of nationalism. Institutions such as the University of Papua New Guinea, the Administrative College, the PNG University of Technology, and the Goroka campus of the University of Papua New Guinea were hubs of cultural and political consciousness. Students at the University of Technology in Lae contributed their folktales to the student yearbook called *Nexus* between 1970 and 1971. Seven years later, in 1978, Donald S. Stokes published a representative of these stories as retold by Barbara Ker Wilson in *The Turtle and the Island*. Oxford University Press published a later edition as *Legends from Papua New Guinea: Book 2* (1996).

These young writers heard their Indigenous folktales as they grew up in their villages. To negotiate with others, they used stories from their own societies to explain their cultural background and explanations of the world. They also learned from each other the importance of

cultural diversity, cross-cultural fertilization, and multiple explanations of the world. The students wrote their stories from memory. These stories give explanations, moral lessons, and descriptions of the natural beauty of landscapes, cultural values, explanations of the mysteries of nature of things, and the intricate relationships humans have with the natural, physical, and spiritual environment.

As role models and future leaders, these students realized the importance of cultural maintenance, self-explanations, and collective consciousness made up of different cultural and language backgrounds. If they are to live together as a society, they need to teach each other their own cultures. Cultural nationalism begins when those who comprise it consider it important enough to privilege it against the dominant culture. In Papua New Guinea, these students recognize the need to provide their own cultural explanations of the world, their social relationships with each other, and the natural and spiritual environment inherited from their ancestors.

One of the stories in *Legends from Papua New Guinea* is of interest to this discussion. "The Great Flood," written by Adam Amod, from Ali Island near Aitape, in the Sandaun Province, explains how the Ali Islanders settled on the island and their relationships to Tumeleo and the mainlanders of Aitape (1996, 95–99). The flood story had survived the test of time and has spread across the Sepik region, though the flood myth is also a universal one. The Ali Island version begins with the villagers killing a talking eel who had warned the villagers to remove the fish poison (*Walamil*) used to kill fish for a mortuary feast in the village. The eel was carved up and distributed among the villagers. The head part of the eel was given to a young boy. The head of the eel warned the boy not to eat it and instructed him to tell his parents what to do. The father planted the eel's head near a tall coconut tree, and dug a hole near the tree so that the boy and his mother could take shelter from the flood commanded by the eel. The flood destroyed the entire village, except for a neighboring village tribe known as Yini Parey, on the way to the feast, who were swept away by the flood on a breadfruit tree, ending up on a reef that became known as Ali Island. The boy's father had climbed the coconut tree as instructed by the eel. The boy and his mother remained sheltered in the pit near the tall coconut tree. The father, Kairap, ate coconuts to remain alive in the tree. To see if the flood had receded, he threw three coconuts down from the tree. The first two coconuts sank into the water. The third coconut touched the hard surface of the earth. The smoke rising from the pit where the boy and his mother took shelter confirmed that the flood has subsided.

The flood myth is about the arrogance and foolishness of villagers in observing the link between humans, the natural world, the animal kingdom, and the spiritual worlds. Knowing and respecting this link is the key to a balance in nature and the world. Human carelessness and lack of respect of nature lead to ecological catastrophe in the world. Another key element in this story is about the genealogies of a people and the migration of people across vast land, sea, and rivers. In the Ali Island version, we come to see how the Ali Islanders had moved from the mainland to settle on the island. It also tells the story of how the survivors of the flood had come to form the basis on which generations of people from this ancestral place had come about. The myth is told with the intent to instill knowledge in younger generations about cultural taboos, their cultural heritage, and the foundational principles and rules younger generations have to

follow. The eel symbolically represents the ancestral wisdom and spiritual forces that guide and direct people's lives. Finally, the flood myth is the exploration of the metaphor of humans' relationship with nature and through which the complex relationship of man against nature and nature against man occurs.

Using folktales to define their identities, Papua New Guinean students successfully carved out a sense of nationalism. Regis Stella discusses the proliferation of literary productions based on folklore during the early years of Papua New Guinean writing: "The importance of indigenous tradition, culture, and identity for Papua New Guineans, and particularly shared custom (*kastom*), is highlighted through the incorporation of orature into textual discourse. Oral literature has always been an integral part of traditional Papua New Guinean cultures in rendering myths, chants, poetry, song and dance, and drama" (2007, 174). To prove this point, Stella considers Arthur Jawodimbari's play *The Sun* as an example of how a folktale was used to highlight the issue of nationalism and independence: "In the play, the incorporation of a legend validates the people's cultural values and connection to place, while at the same time the use of orature provides cultural authority. . . . Like many stories in Papua New Guinea, the legend of the sun represents the ideals of communality and sharing in Indigenous cultures" (175).[9] Cultural narratives and use of Indigenous folktales serve as the backbone of national narratives in a postcolonial society.

Translation and Power in Folktales

In the process of working with folktales during my study of the Nagum Boiken medicinal knowledge system, I encountered another important relationship between translation and power. I had collected a version of a folktale earlier in my research, but on further analysis, I was told that the version I had collected earlier was "not a serious version" compared to the one my collaborator wanted me to collect. At that time, without knowing the complex nature in which various versions of folklore texts are structured and layered in terms of their power and authority, we disagreed. What did we disagree on? First, we disagreed because the version I had collected earlier was the popular version. My collaborator argued that my research lacked any seriousness. The popular version is heard and performed in public for a general audience. The version that he wanted me to collect was a sacred version. He is the only person to know the sacred version. He felt it was time for me to know the sacred version and wanted me to document both the sacred and popular versions.

So what does this tell us about folktales, translation, and power? The truth is that within different societies, there are different texts lodged at different levels within a culture. Each society views public and sacred texts or folktales in different ways. My collaborator held the view that the sacred text itself is the source of his power and authority. He refused to surrender it through the process of translation from the primary oral culture to the secondary print technological culture. His insistence on maintaining two versions of the same folktale meant he could maintain his control and power of the sacred version over the popular version. This lesson has taught me to

9. See also Jawodimbari (1980).

consider folklore texts, whatever they may be, as existing at two different levels of power in the Indigenous knowledge world.

The first level is that power is sanctioned by the rules governing the performance and recitation of sacred texts. Denying access to the sacred knowledge constituted within the magic utterances and narratives in the sacred text is a refusal to transact any powers outside of the rules that govern performance of sacred texts. Power is maintained within the jurisdiction of sacred texts. The second level is the authority to perform or narrate folktales. One gets to be an authority on performative narratives and magic utterances through inheritance or through a long process of learning under the influence of great elders and authoritative mentors in a society. Individuals with such authorities are considered powerful in Nagum Boiken societies.

The Nagum Boikens have two mythical figures named Haiwanga and Yarawali. Most magic utterances evoke the names of Haiwanga and Yarawali. The two culture heroes began the *wali kombo* (spirit illness) among other magic utterances. The folktale of the two brothers is dispersed in the northern New Guinea mainland. The two brothers are seen as either gods or friends, and their mythology appears as the Manup and Kulubob myth in the Rai Coast area or as Andena and Arena in the Murik society. David Lipset discusses the story as sibling rivalry and also to explain the construction of masculine power and authority (1997). The folktale of the rivalry between the two brothers has implications for the ways in which we view the closely connected tribal or ethnic groups in Papua New Guinea, and elsewhere in Oceania. And a critical look at this folktale reveals the site of the construction of masculine power and authority in societies where this folktale appears (Winduo 1998). My point is that there are folktale types that occur across cultures but are also Indigenous to the region. Specific elements in Oceanic folktales can be teased out and their functions in sociocultural and political development explained in detail. Translations of folktales have political potential as well as challenges in defining power. Power is constructed in folktales by those who recite or perform the unique local folktale. Various models of power often constructed in folktales are adequate enough as models of social political articulations. Members of a society use folktales to reinforce socially productive relations in society.

Conclusion

Translations of folktales, viewed from the perspective considered here, relate to the ways in which we read and study the traditions within the sociocultural contexts and of such texts in the magico-religious world of Oceania. We are concerned with power embedded within the text and its performance as defined within the limits of sacred and secret knowledge. We also consider the literary and scholarly interpretations of Oceanic folktales in their appearance as cultural motifs infused into literary constructions. The folktales and their motifs serve the function of grounding the literary, artistic, or cinematic work within a localized concrete Oceanic space. They also consolidate the expression of feeling of a people at the highest level of expression in Oceania. The final issue is whether the process of translation from one language to another or from one medium to another affects the authenticity of the original folktale. Every performance, every translation, or every transfer of oral folktale is different from the last time it was performed, told, sung, translated, or

transferred. It does lose its originality, but then it also gains its popularity and acceptance. The folktale survives because of the renewed interests it gains through new performances, new literary translations, and transfusion in literary works, and its transfer from one medium to another powerful medium such as novels, theater, and films.

Works Cited

Amod, Adam. 1996. "The Great Flood." In *Legends from Papua New Guinea: Book 2,* collected by Donald S. Stokes, retold by Barbara Ker Wilson, pp. 95–100. Melbourne: Oxford University Press.

Anderson, Benedict. 1983. *Imagined Communities.* London: Verso.

Bacchilega, Cristina. 2007. *Legendary Hawaiʻi and the Politics of Place: Tradition, Translation, and Tourism.* Philadelphia: University of Pennsylvania Press.

Bakhtin, M. M. 1996. *Speech Genres and Other Late Essays.* Translated by Vern W. McGee, edited by Carl Emerson and Michael Holquist. Austin: University of Texas Press.

Barthes, Roland. 1977. "From Work to Text." In *Image, Music, Text,* pp. 155–164. New York. Hill and Wang.

Brash, Nora Vagi. 1996. *Which Way, Big Man?* Port Moresby: Oxford University Press.

Caro, Niki, dir. 2002. *The Whale Rider.* South Pacific Pictures.

Diamond, Heather A. 2008. *American Aloha: Cultural Tourism and the Negotiation of Tradition.* Honolulu: University of Hawaiʻi Press.

Diaz, Vincente. 2000. "Simply Chamorro: Telling Tales of Demise and Survival in Guam." In *Voyaging through the Contemporary Pacific,* edited by David Hanlon and Geoffrey White, pp. 141–170. Lanham, MD: Rowman & Littlefield.

Dixon, Roland B. (1916) 1964. *Oceanic.* Vol. 9 of *The Mythology of All Races,* edited by Louis Herbert Gray. New York: Cooper Square.

Gegeo, David Welshman. 2000. "Indigenous Knowledge and Empowerment: Rural Development Examined from Within." In *Voyaging through the Contemporary Pacific,* edited by David Hanlon and Geoffrey White, pp. 64–90. Lanham, MD: Rowman & Littlefield.

Grace, Patricia. 1986. *Potiki.* Auckland: Penguin.

Hafstein, Valdimar T. 2004. "The Politics of Origins: Collective Creation Revisited." *Journal of American Folklore* 117, no. 465:300–315.

Hereniko, Vilsoni, dir. 2004. *Pear ta ma ʻon maf: The Land Has Eyes.* Honolulu: Te Maka Productions.

Hogbin, Ian. 1970. *The Island of Menstruating Men: Religion in Wogeo, New Guinea.* Melbourne: Melbourne University Press.

Howard, Alan. 2006. "Presenting Rotuma to the World: The Making of the film *The Land Has Eyes*." *Visual Anthropology Review* 22, no. 1:74–96.

Ihimaera, Witi. (1987) 2003. *The Whale Rider.* Orlando, FL: Harcourt.

Ingpen, Robert, and Barbara Hayes. 1994. *Folktales and Fables of the Americas and the Pacific.* New York: Chelsea House Publishers.

Jawodimbari, Arthur. 1980. "The Sun." *In Voices of Independence: New Black Writing from Papua New Guinea,* edited by Ulli Beier, pp. 113–128. New York: St. Martin's Press.

Kamene, Sakarepe Keosai. 1995. "Literacy With/Without Roots." In *Critical and Developmental Literacy,* edited by Otto Nekitel, Steven Winduo, and Sakarepe Kamene, pp. 79–92. Port Moresby: University of Papua New Guinea Press.

Kauraka, Kauraka. 1989. *Oral Tradition in Manihiki.* Suva: Institute of Pacific Studies.

Keown, Michelle. 2007. *Pacific Islands Writing: The Postcolonial Literatures of Aotearoa/New Zealand and Oceania.* Oxford: Oxford University Press.

Legends from Papua New Guinea: Book 2. 1996. Collected by Donald S. Stokes. Retold by Barbara Ker Wilson. Melbourne: Oxford University Press.

Lessa, William A. 1961. *Tales from Ulithi Atoll: A Comparative Study in Oceanic Folklore.* Berkeley: University of California Press.

Lipset, David. 1997. *Mangrove Man: Dialogics of Culture in the Sepik Estuary.* Cambridge: Cambridge University Press.

Nigira, Immanuel. 2004. "Trosel Wantaim Tarangau." In *Zia Writers of Waria: Raitim Stori Bilong Laip,* edited by Sakarepe Kamene and Steven Edmund Winduo, pp. 56–57. Port Moresby: Melanesian and Pacific Studies.

Orotaloa, Rexford T. 1996. "Raraifilu." In *Nuanua: Pacific Writing in English Since 1980*, edited by Albert Wendt, pp. 343–349. Auckland and Honolulu: Auckland University Press and University of Hawai'i Press.

Pule, John Puhiatau. 1992. *The Shark That Ate the Sun*. Auckland: Penguin Books.

Scarr, Deryck. 1990. *The History of the Pacific Islands: Kingdoms of the Reefs*. Melbourne: Macmillan Company of Australia.

Sharrad, Paul. 2003. *Albert Wendt and Pacific Literature: Circling the Void*. Auckland: Auckland University Press.

Silva, Noenoe. 2004. *Aloha Betrayed: Native Hawaiian Resistance to American Colonialism*. Durham, NC: Duke University Press.

Sinavaiana-Gabbard, Caroline. 2001. *Alchemies of Distance*. Honolulu: Tinfish Press.

Stella, Regis. 2007. *Imagining the Other: The Representation of the Papua New Guinean Subject*. Honolulu: University of Hawai'i Press.

Stokes, Donald S. collected by. 1978. *The Turtle and the Island Folk Tales from Papua New Guinea*. Sydney, Australia: Hodder and Stoughton.

Stokes, Donald S. and Barbara Wilson. 1996. *Legends from Papua New Guinea: Book 2*. Melbourne: Oxford University Press.

Subramani. 1985. *South Pacific Literature: From Myth to Fabulation*. Suva: Institute of Pacific Studies.

———. 1999. "The Oceanic Imaginary." *SPAN* 48/49 (April & October): 1–13.

Sullivan, Robert. 2002. *Weaving Earth and Sky: Myths and Legends of Aotearoa*. Auckland: Random House.

———. 2005. "The English Moko: Exploring a Spiral." In *Figuring the Pacific: Aotearoa and Pacific Cultural Studies*, edited by Howard McNaughton and John Newton, pp. 12–28. Christchurch: Canterbury University Press.

Teaiwa, Teresia Kieuea. 1995. *Searching for Nei Nim'anoa*. Suva: Mana Publications.

Toelken, Barre. 1996. *The Dynamics of Folklore*. Rev. and expanded ed. Logan: Utah University Press.

The Turtle and the Island: Folk Tales from Papua New Guinea. 1978. Collected by Donald S. Stokes. Retold by Barbara Ker Wilson. Sydney: Hodder and Stoughton.

Tuzin, Donald. 1997. *The Cassowary's Revenge: The Life and Death of Masculinity in a New Guinean Society*. Chicago: University of Chicago Press.

Vaai, Sina. 1999. *Literary Representations in Western Polynesia: Colonialism and Indigeneity*. Apia: National University of Samoa.

Williams, Raymond. 1977. *Marxism and Literature*. Oxford: Oxford University Press.

Wilson, Rob. 1999. "Introduction: Toward Imagining a New Pacific." In *Inside Out: Literature, Culture, Politics, and Identity in the New Pacific*, edited by Vilsoni Hereniko and Rob Wilson, pp. 1–16. Lanham, MD: Rowman & Littlefield.

Winduo, Steven Edmund. 1991. *Lomo'ha I Am, in Spirit's Voice I Call*. Suva: South Pacific Creative Arts Society.

———. 1998. "Knocking on Ancestors' Door: Discourse Formation in Healing Ritual Utterances and Narratives of Nagum Boikens in Papua New Guinea." PhD diss., University of Minnesota.

———. 2000. "Unwriting Oceania: The Repositioning of the Pacific Writer Scholars within a Folk Narrative Space." *New Literary History* 31, no. 3:599–613.

Wood, Briar. 2006. "In Spirits' Voices: An Interview with Steven Winduo." *Journal of Postcolonial Writing* 42, no. 1:84–93.

Wood, Houston. 2008. *Native Features: Indigenous Films from around the World*. New York: Continuum.

Zipes, Jack. (1979) 2002. *Breaking the Magic Spell: Radical Theories of Folk and Fairy Tales*. Rev. and expanded ed. Lexington: University Press of Kentucky.

Artist Statement for *Pouliuli* (from the Interstellar Series)

Selina Tusitala Marsh

The digital images in the Interstellar Series were made as part of a poetry performance set to taonga puoro (traditional Māori wind instruments), played by Rob Thorne (Ngāti Tumutumu) for the United Nations' seventy-fifth anniversary. I created these images following what I call a "Led by Line" praxis where I connect a number of lines—blood lines, written lines, drawn lines and spoken lines—to recreate a pouliuli genesis of the Void. If "in the beginning was the Word," then so too, words, breath, air, story are there in the ever-present end. Pouliuli, the Samoan word for "darkness" is a flourishing, vibrant, dynamic void in which key elements hang: Ra, our Sun-Star; Māhina, our Moon-Planet; Pouliuli, our VA-Void, Tāwhirimatea, Wind-Spirit, all held in the universe of our imagination making by their own gravitational pull toward Tusitala, the storyteller. Each word is made from a taonga puoro wind instrument—the sacred vessel for mauri ola, the breath of life.

Selina Tusitala Marsh, *Pouliuli*, 2020.

Dreaming Indigenous Realities in Young Adult Literatures of Oceania

Caryn Lesuma

In early 2020, my mother shared a dream with me that she had recently experienced, after her father's unexpected passing at the end of the previous year. In the dream, she saw my grandfather comfortably sitting and engaged in an animated conversation with two unfamiliar young boys, one slightly older than the other. She told me that it was clear in the dream that the boys were brothers, and that they were descendants of her father. She felt certain that the children were mine, and that her father was preparing them to join our family in the near future. Soon after she shared what she called her "true dream" with me, I learned that I was pregnant and subsequently delivered a healthy son in April 2021. Events like this are a common occurrence on the Samoan side of my family, and similar dream practices are evident across Indigenous Oceanic cultures. In a 2020 talk entitled "Writing in the Vā," Hawaiian-Samoan writer Victoria Nalani Kneubuhl explained that Pacific Islanders "have an expanded sense of reality that includes things we can't see," emphasizing that dreams and dreaming comprise a reality where Oceanic peoples have traditionally interacted in "powerful and important" ways that shape identity.

As a scholar of young adult literatures of Oceania (YALO) and as a Samoan with personal and familial dream experiences, I was inspired by Kneubuhl's address to examine how Pacific Islander beliefs about dreams and dreaming are employed in YALO texts; as YA literature, they are already fundamentally engaged in identity formation, and as Pacific literature they are also decolonial (Lesuma 2018, 27). In my experience reading YALO, a significant number of novels include dream sequences. What I examine in this essay is how those dream sequences function—for example, do Pacific Islander writers portray an Indigenous understanding of dreams in their YA novels, and if so, what is its significance for adolescent readers? I argue that the function of dreams and dreaming in many YALO texts aligns with Kneubuhl's assertion that dreams are a critical plane of reality for Pacific peoples. I will show this by analyzing the roles that dreams and dreaming play in the development of youth protagonists in Matthew Kaopio's novellas, Lehua Parker's Niuhi Shark Saga trilogy, and Rangi Moleni's *Terewai Island Dreamer,* particularly in terms of how dreams experienced by the protagonists help to solidify and recover Indigenous identity, genealogies, and worldviews, reversing what are often sites of struggle and insecurity for many Pasifika youth. For 'afakasi and diasporic Pasifika youth especially, YALO models Indigenous

ways of knowing and being, and representations of protagonists as dreamers help to expand their understanding of themselves, their cultures, and their potentials.

Contemporary conceptions of dreams and dreaming in western societies have largely been shaped by the work of psychologists seeking empirical methods for dream interpretation. Sigmund Freud (1999) argued that dreams are a form of wish fulfillment, expressing a distorted version of our unconscious desires. Thus, the content of dreams is taken from an individual's experiences and desires. Carl Jung (1974) posited that dreams are a kind of psychological compensation mechanism, whereby an individual is able to regulate imbalances between the conscious and unconscious mind. Despite slight differences in focus, both base their theories on the assumption that dreams are psychological in nature, reflecting an individual's mental state and desires. Sage (2017) provides a helpful overview of western contemporary dream theories, all of which have emerged through attempts to study and interpret dreams empirically. Over the past century, psychologists have built on Freud's and Jung's theories to hypothesize that dreams can function as a way to increase the dreamer's self-awareness, to reflect symbolically on the dreamer's waking life, or even to help dreamers "practice" recognizing and facing threats that might crop up in their lives; much of the current research on dreams is also focused on therapeutics for mental health issues (Sage 2017, 7). These examples again underscore an underlying assumption that dreams are fundamentally interior, complex manifestations of an individual's psychological condition.

Indigenous conceptions of dreams and dreaming are diverse and have characteristics and functions specific to each culture, but generally tend to be more expansive in function and purpose. Rather than simply a method for measuring an individual's mental state, dreams provide access to knowledge and experiences beyond the individual. Plains Cree/Saulteaux researcher Margaret Kovach (2009) points out that Indigenous knowledge acquisition in many First Nations traditions is "born of relational knowing" between an individual's inner self and the outer world, with one method for this being dreams (57). Dreams often function as a method for connecting the dreamer and the spiritual realm (Battiste 2016, 116; Moʻa 2014, 100), which extends the reality of the dreamer beyond the physical world and their own interiority. In other words, a dreamer can acquire knowledge and develop relationships through spiritual means that are not empirically measurable. Because of this, "Indigenous knowledge dwells beyond what the Western knowledge paradigm can or will accommodate" (Kovach 2009, 180).

In Pacific Islander cultures specifically, dreams and the knowledge gained from them have many functions. They can offer guidance from ancestors and/or gods (Efi 2018, 212; Lindsay et al. 2020, 4; Pukui, Haertig, and Lee 1972, 169) and provide access to "visions of another reality, parallel to those seen in the waking world" (Kanahele, quoted in McDougall 2016, 112). The expanded reality accessed by dreams is significant enough that Māori tohunga (spiritual practitioner or "interpreter of signs") Māori Marsden asserts that "ultimate reality is for Māori the reality of spirit" (Marsden, quoted in Lindsay et al. 2020, 3). While dreams can certainly benefit the dreamer exclusively, they are often also meaningful in a communal sense—knowledge obtained from dreams can have implications for entire families and communities (Handy and Pukui 1998, 127; Efi 2018, 212). Indigenous dream interpretation often also requires assistance from elders or spiritual leaders (Battiste 2016, 116; Handy and Pukui 1998, 126). Because dreams and dreaming

impact both temporal and spiritual spheres, it is unsurprising that they play a prominent role in Indigenous Pacific Islander cultures.

For many Pasifika and Indigenous peoples, however, the cultural significance and traditional practices surrounding dreams and other diverse connections to a spiritual reality "have been lost to environmental conditions, colonization, and neglect" (Battiste 2016, 116). The impact of these losses is felt most keenly among Pasifika youth, who often grow up struggling to reconcile conflicting identities far from their ancestral homelands and immersed in western cultures (Ioane 2017, 39; Mila 2010, 16–18). Julia Ioane (2017) argues that "for the survival of Pasifika youth and their identity . . . they still need to understand fundamental traditional values and culture that are historically and theologically bound. Pasifika youth are proud of their ethnic identity, however a more comprehensive understanding is needed that will still allow them to advance and progress positively in a Pālagi and western dominated society" (40). For many of these youth, direct access to cultural knowledge is minimal or nonexistent, especially if they are several generations removed in diaspora or part of a mixed-race family.

Despite these challenges, opportunities for Pasifika youth to learn more about their cultures is becoming increasingly available. One of these avenues is the small but growing field of YALO, which provides positive literary representations of Pacific Islander adolescents and cultures. Mandy Suhr-Sytsma (2019) outlines the role that young adult literature can play in helping Indigenous youth to navigate identity issues in colonized contexts: "YA books are centrally concerned with young people finding their place vis-à-vis 'the system.' That both resonates and strikes a discordant note when Indigenous subjects are involved, because they are operating in multiple systems—their Indigenous societies and the colonial systems imposed on those societies" (xviii). As literature concerned with identity formation and decolonization, YALO novels are uniquely situated to expose Pasifika youth to Indigenous characters, concepts, and worldviews, normalizing cultural practices that are often downplayed or erased in westernized societies. In the sections that follow, I offer examples and analysis of how a handful of YALO texts provide representation and normalization of Indigenous Pacific Islander dream practices. As the youth protagonists interact with the expanded spiritual reality of their dreams, they gain access to Indigenous knowledge and healing from colonial trauma, modeling pathways for healthy, empowered identity formation.

Written in the Sky and *Up among the Stars*

Dreams and dreaming play a central role in Matthew Kaopio's novellas *Written in the Sky* (2005) and *Up among the Stars* (2011). The books' Kanaka Maoli youth protagonist ʻĪkauikalani frequently experiences both sleeping and waking dreams that connect him with an expanded reality that allows him to develop meaningful relationships with ʻāina, ancestors, ʻaumākua, and eventually beings from across the galaxy. These relationships help him to establish confidence and purpose, demonstrating that the recovery and practice of Indigenous knowledges is a key aspect of identity formation for Pasifika youth.

ʻĪkau's dreams have several functions throughout the novellas, most notably communications with ancestors and ʻaumākua. In *Written in the Sky,* dreams initially provide one-way

communication from his recently passed grandmother, who sends him comfort in the form of memories of their life together, provides instructions, and warns of danger. ʻĪkau notes that "his dreams of Grandma were always so vivid. They seemed real, and his real life the dream" (92). Each of the dreams involving his grandmother does, in fact, have direct implications for his life in the temporal world. Her warnings help to keep him safe from dangerous situations, and her recurrent instructions to find Mariah Wong provide an example of "the *pili mai ka pō mai,* the 'relationship coming in the night.' Hawaiʻi called it 'spirit relationship,' for the spirit received clues or direction in the dream. Follow the dream direction, and a meeting of relative with relative would follow. Such a dream . . . carried an absolute obligation: the family relationship thus revealed must be cherished and family ties strengthened by meetings" (Pukui, Haertig, and Lee 1972, 173). ʻĪkau's efforts to find Mariah Wong, who ends up being his great aunt, not only lead him to find her before her death, but also help him to recover the meaning of his name and his moʻokūauhau, or genealogy, and as McDougall (2016) points out, "the recovery of ʻĪkau's moʻokūauhau is what leads to his healing and his understanding of his own mana and purpose" (112). Later on in *Up among the Stars,* ʻĪkau experiences an extended dream sequence where he travels back in time to the Honolulu of his great-great-grandfather and namesake ʻĪkauikalani. Unlike the one-way communications that he receives from his grandmother and ʻaumākua, he is able to converse with his grandfather, who teaches him the divisions of the sky to help him carry on the legacy of his priestly ancestors (2011, 66–68). Applying this knowledge allows ʻĪkau to grow from an unsure, houseless orphan into a confident teen committed to carrying on his family legacy: "He now knew that he was really somebody, not just the gawky kid that everybody teased and made fun of at school. And not just the boy with the funny name. He was ʻĪkauikalani, a direct descendant of ancient Hawaiian chiefs and powerful priests. And nothing anybody said or did would change that fact. As long as he lived, his ancestors lived. As a descendant of chiefs, he had a responsibility to care for those around him who were in need, and he accepted this calling and vowed to honor the legacy" (2005, 134). ʻĪkau's identity transformation is a direct result of paying attention to and applying knowledge received from his ancestors while dreaming.

Importantly, his dream experiences lead ʻĪkau to build a relational web of connections across time and space that empower him to develop the spiritual talents he has inherited in order to serve others. These mentors help him to navigate both temporal and spiritual realms. In addition to his grandmother and great-grandfather, ʻĪkau's houseless friend Hawaiian provides wisdom and survival strategies briefly in person and subsequently through dreams and the journal that he gifts ʻĪkau before his death (2005, 35–36). Hawaiian's guidance leads ʻĪkau to find Gladys Lu, an elderly woman who offers him food, shelter, friendship, and access to a mailing address and a telephone. This in turn helps him to find not only his estranged aunt, Mariah Wong, but the entirety of his extended family from the island of Kauaʻi (2011, 158). Each of ʻĪkau's mentors teaches him about reciprocity and service, ultimately helping him to solidify his own identity and purpose.

ʻĪkau's most important spiritual mentor, however, is Dr. Owlfeathers, a Native American "Dream Professor" (2005, 68) who teaches ʻĪkau how to navigate and manipulate the dream realm. They meet initially in an extended dream sequence where the professor visits him as an owl and teaches him the names of important constellations and how to travel through the dream realm (2005, 51–54). Upon waking, ʻĪkau initially laments that the dream "wasn't real," but

changes his mind upon finding "a fresh pile of bird droppings with . . . fur and bones in it" and "several large owl feathers" near the place where he slept (2005, 54). He later meets the professor in person at a university lecture, and Dr. Owlfeathers gifts him a book with a note in it that says, "Wasn't that some dream last night? I'll come back to visit again soon" (2005, 82). McDougall emphasizes that this incident is "not an instance of 'magical realism,' as perhaps it would be framed within a Western literary critical context" (2016, 112). Instead, it is an example of overlap between the realities of the physical and dream worlds. 'Ikau's dream experience with Dr. Owlfeathers is arguably an example of moe 'uhane, or "spirit sleep," a dream practice characterized by the belief that "while the body slept, the *'uhane,* one's personal, immortal spirit or soul, wandered . . . the spirit went traveling, seeing persons and places, encountering other spirits, experiencing adventures, and, most important, passing on messages from the ancestor gods, the *aumākua*" (Pukui, Haertig, and Lee 1972, 170). Dr. Owlfeather's appearance in the dream as an owl is significant because the owl is one of 'Ikau's family 'aumākua. While Dr. Owlfeathers does not reappear in the novels in person, we learn in *Up among the Stars* that 'Ikau has enrolled in the professor's university, which appears to be spiritual in nature: two brief dream sequences show 'Ikau developing his ability to manipulate the dream realm through midterms and sports competitions as Dr. Owlfeathers looks on approvingly (Kaopio 2011, 96, 138).

As the intensity and power of 'Ikau's dreaming increase, he experiences an extended dream sequence in which he is sent into the galaxy to help lead other dreamers "from across the known universe" on a mission to secure "fragments of the core of our existence" and "save the very essence of our survival" (2011, 112–114). Referring to this dream sequence and 'Ikau's earlier visit with his great-grandfather, Kelsey Amos (2016) argues that "although these episodes could be explained as mere dreams, their importance to 'Ikau and to the plot encourages us to consider that they are forms of time and space travel or travel to alternate realities. 'Ikau's dreams disturb the linear progression of time . . . and [collapse] the distance between the dead and the living" (201–202). 'Ikau's dreams emphasize the connection between the physical and spiritual worlds, and that both are navigable when individuals are imbued with the appropriate knowledge. His ability to communicate with and receive guidance from ancestors underscores the expansion of his relational knowing, and these experiences also emphasize that dreams are an extension of 'Ikau's reality rather than fantastical or psychological episodes.

Through an understanding of his genealogy and with the guidance of spiritual mentors, 'Ikau is able to reach his potential in the physical world as well as the spiritual realm. Kaopio's portrayal of dreams and dreaming in both novellas reflects a uniquely Kanaka Maoli perspective that underscores the overlapping and relational realities of the temporal and physical. For 'Ikau, it is the embracing of both realities that empowers him to establish a confident identity and reach his full potential as a Kanaka youth.

The Niuhi Shark Saga Trilogy

Lehua Parker's Niuhi Shark Saga comprises three novels that follow the coming of age of Zader Kaonakai Westin, who is half-kanaka, half-niuhi (human-devouring shark demigod). Over the course of the trilogy, recurrent dream experiences help Zader to negotiate his mixed identity, in

addition to navigating conflicts between his niuhi birth family and his adopted human family. While Zader is not a gifted dreamer like ʻĪkauikalani, his dreams nonetheless help him to maintain relationships and embrace his human-niuhi identity. Zader's eventual understanding that dreams are another plane of reality gives him the ability to stay connected with his estranged family members despite his complicated identity and family situation.

Throughout the story, dreams play an integral role in keeping Zader connected to his family members. Like ʻĪkau, Zader is initially unaware of his moʻokūauhau; raised as a human and told that he has an "allergy" to water in order to keep him away from the ocean, he is unaware of his niuhi heritage and his niuhi family members. Throughout *One Boy, No Water* (2019), however, he experiences recurring dreams where he spends extended periods of moe ʻuhane adventuring with someone he calls "Dream Girl": "Dream Girl and I did crazy things like fly and chase each other through fields of grasses and trees I'd never seen in real life. Those kinds of dreams I liked, but sometimes the dreams made me afraid. There was a dark shadow figure, a man we sometimes spied on, a Man with Too Many Teeth, who never did anything to us, but made us deeply afraid" (2019, 33). While he does not initially understand the significance of the dreams or that they are more than just his imagination, Zader recognizes a direct relationship between his dreams and the physical world; for example, he experiences dreams with Dream Girl after eating raw meat or when he is wearing his shark-tooth necklace (2019, 33). Zader eventually learns that Dream Girl is his twin sister, Maka. When he is finally able to meet Maka in person, she helps him to reframe his understanding of dreams as an expanded reality rather than fantasy or imagination:

> "I used to dream about you . . . we had amazing adventures."
> "Not dreams. Reality. . . . you came to me in your ghost shark form in Hohonukai. It was the only way for you to be a shark."
> "I thought it was a dream."
> "It was. It was also real."
> "That's impossible," I said. "Things are dreams or they are real. They can't be both."
> "Why not?" Maka laughed.
> "The world doesn't work that way."
> "You mean you never imagined it could," she said. (2016b, 47)

His positive experiences with Maka in dreams throughout his childhood allow him to develop and maintain a relationship with her despite being unable to interact with her in the physical world.

Zader's dreams also function as warnings to avoid the Man with Too Many Teeth, who turns out to be his vengeful uncle, Kalei. In addition to observing Kalei from afar in his dreams with Maka, Zader also experiences an extended dream sequence where he is able to observe a past interaction between Kalei and Pua, Zader's birth mother. The dream teaches him Kalei's name and some of the rules governing niuhi and their interactions with humans. It also humanizes Kalei: Zader observes that in this dream, "Kalei's not a monster with too many teeth; he's a guy looking out for his sister" (2019, 67). These dreams prepare Zader for a surprise encounter with Kalei in

the physical world; despite his initial shock at seeing Kalei in the flesh, Zader's dream knowledge helps him to know that he must stay out of sight. After this incident, Zader begins to understand that his dreams are not "a figment of my imagination" (2019, 103) and that his dream encounters are "all more real than I thought" (2016a, 24). Unfortunately, Zader lacks a reliable mentor to help him make sense of these dream experiences. While his Uncle Kahana understands what is happening and has the ability to interpret his dreams and guide him through the danger, he chooses not to share this knowledge, ostensibly in order to protect Zader's innocence. When Zader shares his dream experiences about Maka and Kalei, Uncle Kahana pretends that there is nothing to worry about, and that the dreams are "classic teenage fantasy" (2016a, 24); as a result, Zader does not fully understand the danger he faces when Kalei comes hunting for him, and only narrowly escapes with his life.

Zader's later dream experiences help him to stay connected with his human family after his banishment from Lauele town in *One Truth, No Lie* (2016b). With his family situation now reversed, Zader lives with his niuhi family and becomes estranged from his human family. Despite his anguish over the forced separation, Zader is able to stay connected with his human brother Jay through shared dream experiences. In the dreams, which they experience simultaneously, they spend time together in activities from the past such as flying kites and counting stars, but the tone of the dreams reflects the state of their relationship. Jay is initially confused by the dreams, but Uncle Kahana tells him to "listen to the dreams, Jay. It's the only way to connect with Zader now" (2016b, 151). Zader also experiences a one-way dream where he is able to "see" Jay training to strengthen his new prosthetic leg (2016b, 165–168). These dreams make it possible for Jay and Zader to stay connected to each other despite being separated.

The dream world's ability to help Zader maintain connections with both his birth and adoptive families contributes to his realization that his mixed identity is expansive rather than limiting. By the end of the series, he has "figured out how to bridge the Niuhi and human world" (2016b, 251). Rather than having to choose between his two families, he accepts them both, and by extension, accepts his mixed identity: "Zader's new understanding of his identity recognizes that choosing to be either human or Niuhi limits his ability to enact meaningful change in the world; to fully activate his power, he must embrace both parts of his identity by interacting with both sides of his family" (Lesuma 2018, 111).

Like ʻĪkau, Zader is only able to achieve his full potential and power through acceptance of himself and his genealogy. In doing so, he successfully brings both sides of his family together while simultaneously mending a centuries-old conflict between humans and niuhi. The Niuhi Shark Saga is ultimately a story about healing broken relationships, and Parker powerfully demonstrates how dreams can create, mend, and maintain relationships that endure in the physical world.

Terewai Island Dreamer

The first book in an as-yet-to-be-completed trilogy called The Children of Maui Series, Rangi Moleni's novel *Terewai Island Dreamer* places dreaming and the dream world at the center of the plot. As the protagonist Malia Ika discovers and develops her gift as a Māori matakite, or spiritual

leader, she acquires skills while in the dream realm that help her to protect her family from danger and to heal estranged relationships.

Initially unaware of her gift or how to use it, Malia is unable to prevent family tragedies that she foresees in her dreams. After hesitation from her Tongan father, she is allowed to join a Māori performance group, and the group's chief elder, Koro Rāwiri, tells her that she is a matakite. He explains that "matakite are spiritual leaders. Through impressions, visions, or dreams, they are shown the past, present, and future. With this power, they guide the lives of their families and people" (2015, 142). According to Lindsay et al., "matakite also often see, hear and communicate with tūpuna (deceased ancestors). . . . Communication with tūpuna is often described as a regular occurrence, with many matakite reporting lengthy, ongoing contact with tūpuna or kaitiaki (spirit guides) throughout their lives" (2020, 4). Without immediate mentorship, however, Malia is unable to interpret two of her dreams, which symbolically foresee her parents' divorce (Moleni 2015, 198–220) and grandparents' untimely deaths (loc. 1596). Malia expresses frustration at being unable to act to prevent her parents' separation: "This was like my dream! It was all there. . . . How cruel, how disturbing! I had been warned of this horrible scene before it had actually happened" (384). Malia's frustration causes her to vow never to remember a dream again, arguing that "if I buried my dream, no one else would get hurt" (407).

It isn't until Malia has a near-death experience in the aftermath of a storm that she is visited in her dreams by Koro Rāwiri, who reveals that he is also a matakite. He explains that as matakite, she has the power to separate her wairua, or spirit, from her body in order to travel the spirit realm; after providing her with knowledge about how to safely do so, he encourages her to "embrace who you are and what you can become" (1449). Similar in concept to moe 'uhane, "some reference wairua as a spirit entity with the capacity to separate from the physical body, particularly during altered states of consciousness. The physical body, rather like a shell or container, could be temporarily departed from allowing the wairua to visit others while dreaming or sleeping, sometimes warning them of impending danger" (Lindsay et al. 2020, 4). Malia experiences the spirit realm as a direct overlay of the physical world; the two realities are inextricably connected. When she separates her spirit from her sick body, she explains that "my spirit, Wairua, with my mind and emotions intact, hovered in the air over each person who stood or sat, panicked, around my bed. . . . [F]rom the hearts and minds of my family, I was soon able to feel what they felt, see what they saw, and understand what they thought" (Moleni 2015, 1473). The knowledge that she gains in the spirit realm of her family's love and concern for her makes her determined not only to heal, but to fix the rifts in her parents' relationship.

While other plot elements surrounding the stakes of Malia's spiritual power are established in this first book—her lineage as a direct descendant of Māui the demigod, her status as the heir to her Māori grandmother's tribal knowledge, and a plot by her aunt (also a matakite) to destroy her spirit and inhabit her body in order to steal the inheritance—these elements are not resolved. However, Malia's initiation into the spirit realm provides her with a new perspective on her family that gives her purpose and identity as a daughter and an older sister. Malia's dream experiences underscore the spiritual importance of paying attention to dream warnings in order to cultivate family relationships and heal rifts.

As Indigenous Pacific Islanders, Kaopio, Parker, and Moleni provide positive representations of Pasifika youth that reflect their lived experiences. Kaopio, who was also an accomplished mouth painter, emphasized the importance of portraying Hawaiian culture in art forms like chanting, painting, and writing (Killeen 2004). His novellas are "based on his experiences while spending time in Ala Moana Park during his early days of rehabilitation" from a spinal injury that left him paralyzed (Kaopio 2005, back cover). The park is home to a large population of homeless individuals and families, including houseless Kānaka Maoli, and his work highlights the consequences of colonial land dispossession in Hawaiʻi while inspiring hope for change through a return to Hawaiian cultural and spiritual practices. Moleni, who is of Tongan and Māori ancestry, has extensive lived experience both within Oceania and in diaspora. She was born and raised in Aotearoa New Zealand, attended university in Hawaiʻi, raised her children in Tonga and Aotearoa New Zealand, and is currently living in the continental United States. Her inspiration for writing was borne of "an awakening . . . to find out who I was" (Moleni 2012, 2361), and she imbues Malia's character with cultural conflicts and diasporic experiences that resonate with Pasifika youth struggling to develop confidence in their identities. Like Moleni, Parker lives on the U.S. mainland in self-described "exile" as part of the Kānaka Maoli diaspora. As a writer, she is concerned with a lack of representation of Pasifika youth and stories in YA and middle-grade literature, arguing that "kids need access to stories that resonate with their experiences, that are full of people they know and love, that show themselves—their fully authentic selves—as powerful, valued, and real" (Parker 2018). She wrote the Niuhi Shark Saga as a way to fill that gap for Pasifika youth, particularly those living in diaspora and interested in learning more about their cultural values.

All three stories are particularly significant because they underscore the importance of spirituality in Pacific Islander cultures. Dreams in these novels provide avenues for acquiring knowledge that imbue their Pasifika youth protagonists with power and confidence in their identities. The stories emphasize the importance of family and healing severed relationships with both ancestors and living relatives. Recovering genealogical knowledge in particular is a critical source of power and potential for ʻIkau, Zader, and Malia; developing relationships with their ancestors through dreaming ultimately helps them to strengthen their families and create new relationships with friends and mentors. By normalizing Indigenous ways of knowing and being, and providing positive representations of Pasifika youth identity formation, these novels underscore YALO's decolonial power.

Works Cited

Amos, Kelsey. 2016. "Hawaiian Futurism: *Written in the Sky* and *Up among the Stars*." *Extrapolation* 57, no. 1:197–220. http://dx.doi.org/10.3828/extr.2016.11.

Battiste, Marie. 2016. "Research Ethics for Chapter Protecting Indigenous Knowledge and Heritage." In *Ethical Futures in Qualitative Research: Decolonizing the Politics of Knowledge*, edited by Michael Giardina and Norman Denzin, pp. 111–132. London: Routledge.

Efi, Tui Atua Tupua Tamasese Taʻisi. 2018. *Suʻesuʻe Manogi: In Search of Fragrance*. Wellington: Huia Press.

Freud, Sigmund. 1999. *The Interpretation of Dreams*. Translated by Joyce Crick. Oxford: Oxford University Press.

Handy, E. S. Craighill, and Mary Kawena Pukui. 1998. *The Polynesian Family System in Kaʻu, Hawaiʻi*. Honolulu: Mutual Publishing.

Ioane, Julia. 2017. "Talanoa with Pasifika Youth and Their Families." *New Zealand Journal of Psychology* 46, no. 3:38–45.

Jung, Carl. 1974. "General Aspects of Dream Psychology." In *Dreams (From Volumes 4, 8, 12, and 16 of the Collected Works of C. G. Jung)*, translated by R. F. C. Hull, pp. 23–66. Princeton, NJ: Princeton University Press.

Kaopio, Matthew. 2005. *Written in the Sky*. Honolulu: Mutual Publishing.

———. 2011. *Up Among the Stars*. Honolulu: Mutual Publishing.

Killeen, Susan. 2004. "Success Stories: Persons with Disabilities—Matthew Kaopio, 'Outsider' Artist Emerges as Native Hawaiian Arts and Business Leader." National Technical Assistance Center (NTAC AAPI), http://www.ntac.hawaii.edu/employ_success_stories/consumers/stories/story003.html.

Kneubuhl, Victoria Nalani. 2020. "Writing in the Vā." Talk given at the University of Hawaiʻi at Mānoa English Department, Honolulu, Hawaiʻi, June.

Kovach, Margaret. 2009. *Indigenous Methodologies: Characteristics, Conversations, and Contexts*. Toronto: University of Toronto Press.

Lesuma, Caryn. 2018. "Contemporary Young Adult Literature in Hawaiʻi and the Pacific: Genre, Diaspora, and Oceanic Futures." PhD diss., University of Hawaiʻi at Mānoa.

Lindsay, Nicole, Deanna Haami, Natasha Tassell-Matamua, Pikihuia Pomare, Hukarere Valentine, John Pahina, Felicity Ware, and Paris Pidduck. 2020. "The Spiritual Experiences of Contemporary Māori in Aotearoa New Zealand: A Qualitative Analysis." *Journal of Spirituality in Mental Health* (December): 1–21. 10.1080/19349637.2020.1825152.

McDougall, Brandy Nālani. 2016. *Finding Meaning: Kaona and Contemporary Hawaiian Literature*. Tucson: University of Arizona Press.

Mila, Karlo. 2010. "Polycultural Capital and the Pasifika Second Generation: Negotiating Identities in Diasporic Spaces." Master's thesis, Massey University.

Moʻa, Vitolia. 2014. "Le Aso ma le Taeao—The Day and the Hour: Life or Demise for 'Whispers and Vanities'?" In *Whispers and Vanities: Samoan Indigenous Knowledges and Religion*, edited by Tamasailau M. Suaalii-Sauni, Maualaivao Albert Wendt, Vitolia Moʻa, Naomi Fuamatu, Upolu Luma Vaʻai, Reina Whaitiri, and Stephen L. Filipo, pp. 93–108. Wellington: Huia Press.

Moleni, Rangi. 2015. *Terewai Island Dreamer (Children of Maui #1)*. Wetekia Publishing, Kindle.

Parker, Lehua. 2016a. *One Shark, No Swim*. 2nd ed. Makena Press.

———. 2016b. *One Truth, No Lie*. Makena Press.

———. 2018. "We Need Hawaiian Kine Voices." Lehua Parker: Talking Story, May 18. http://www.lehuaparker.com/2018/05/18/we-need-hawaiian-kine-voices/.

———. 2019. *One Boy, No Water*. 5th ed. Makena Press.

Pukui, Mary Kawena, E. W. Haertig, and Catherine A. Lee. 1972. "Moe ʻUhane, Hihiʻo, a me Hōʻailona: Dreams and Symbols." In *Nānā I Ke Kumu (Look to the Source)*, vol. 2, pp. 169–207. Honolulu: Hui Hānai.

Sage, John. 2017. "A Critical Literature Review of Dream Interpretation and Dream Work." PhD diss., William James College.

Suaalii-Sauni, Tamasailau M., Maualaivao Albert Wendt, Vitolia Moʻa, Naomi Fuamatu, Upolu Luma Vaʻai, Reina Whaitiri, and Stephen L. Filipo, eds. 2014. *Whispers and Vanities: Samoan Indigenous Knowledges and Religion*. Wellington: Huia Press, Kindle.

Suhr-Sytsma, Mandy. 2019. *Self-Determined Stories: The Indigenous Reinvention of Young Adult Literature*. East Lansing: University of Michigan Press.

Plate 9　John Pule, *Momoheaga,* 2021, photo credit Tobias Kraus, 2021. Enamel, pencil, and ink on canvas, 500 mm × 1500 mm.

Plate 10 John Pule, *Looking at Motu te fua from the Shores of Fonuagalo,* 2021, photo credit Tobias Kraus, 2021. Oil, enamel, and ink on canvas, 2000 mm × 2000 mm.

Plate 11 Sofia Kaleomālie Furtado, *Ma Waena,* 2021. Mixed digital medium, 2700 × 1800 pixels.

Plate 12 Kapiliʻula Naehu-Ramos, *Makalei*, 2018. Oil on canvas, 18" × 24".

Plate 13 Solomon Enos, *The Puhi Rider,* 2021. Acrylic and graphite on Bristol board, 9" × 12".

Plate 14 *When We Become Home Holobiont Ahi Mebachi,* art and photography by Lyz Soto, portrait photography by Jakob Soto Bauwens, 2021. Digital photograph collage with watercolor, 4240 × 2832 pixels.

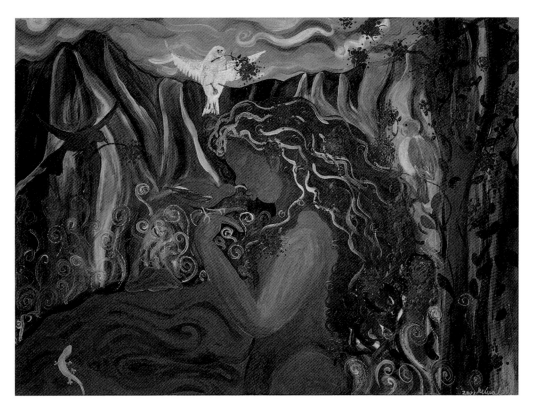

Plate 15 kuʻualoha hoʻomanawanui, *Ka Lei Hulu a Kahelekūlani i Hiʻilaniwai* (*The Feather Lei of Kahelekūlani at Hiʻilaniwai*), 2021. Acrylic on canvas, 36" × 48".

Plate 16 Tiare Ribeaux and Qianqian Ye, *Nakili,* 2021. Augmented reality sculpture, 3406 × 2206 pixels.

Artists' Statement for "Bowl of Stars"

Kristina R. Togafau, Alexander Casey, Aaron Kiʻilau,
Brittany Winland, and Briana Koani Uʻu

> It was a new discovery to find that these stories were, after all, about our own lives, were not distant, that there was no past or future, that all time is a now-time, centred in the being. It was a new realization that the centred being in this now-time simply reaches out in any direction towards outer circles, these outer circles being named "past" and "future" only for our convenience.
>
> —Patricia Grace, *Potiki*

The apocalyptic conclusion of humanity draws near as the Rot, an incurable congenital defect, steals the voices and lives of the young and expels humans into the vastness of space. From this dystopia emerge five narrative threads: a plant, a mother, a living archive, a boy, and a historian. Though seemingly isolated by their placement within the fabric of spacetime, these stories weave back together to convey the persistence of hope against increasingly bleak odds. Each reveals successive ecocritical layers that bind Indigenous and colonial systems through stories of birth, growth, loss, grief, scientific advancement, and cultural contemplation.

"Bowl of Stars" explores what Grace L. Dillon describes in the introduction to her anthology, *Walking the Clouds: An Anthology of Indigenous Science Fiction*, as "pasts, presents, and futures that flow together in a navigable stream" (2012, 3). We write from both Native and non-Native positions in time and history to construct what Dillon calls a "cultural experience of reality" where time travel allows us to build a better future together (4).

Time as a colonial tool comes in direct conflict with Indigenous timekeeping. For many Indigenous peoples, time is not linear but recursive. This is a recurrent motif in Pacific literature. Tongan scholar and creative writer Epeli Hauʻofa, in his essay "Pasts to Remember," understands this conception of time as a kind of reorientation "that helps us retain our memories and to be aware of its presence. . . . Since the past is alive in us, the dead are alive—we are our history" (2008, 67). This embodied temporality becomes a key element within "Bowl of Stars" as each character is reoriented by traumatic moments in their own timelines. While the Historian conveys the most recognizable form of time travel, history and memory keeping arise in each narrative as vital time travel methods. The Boy reunites with his mother through her journals, the Mother memorializes her child through the creation of the Loom, the M.A.L.Os. (Memory Archive and

Log Operation System) are living archives, the Historian keeps lost words and a collective memory, and all of this is encased by another form of timekeeping: the genealogy of an elusive plant.

This necessity of multiple viewpoints is owed to Mikhail Bakhtin's polyphony ("many voices"), which offers "a plurality of independent and unmerged voices and consciousnesses . . . with equal rights and each with its own world" (1984, 6). Polyphonic narratives resist a single authorial voice. Thus, the multiauthored "Bowl of Stars" embraces the promise of polyphony by representing multiple, diverse voices with each story, none of which are subsumed by one authorial perspective. Our shifting use of literary forms, languages, and diacritics likewise represents a polyphonic movement of time since language, like time, is a social construct of ideas evolving in tangent. This development is tracked by each character's historical relationship to language through their varied use of diacritics, both conventional ʻokina and kahakō as well as the Historian's backslash, to indicate the temporal and spatial distance from the audience's present.

The Rot kills more than bodies—it strips voice, hardens communication, and eliminates oral storytelling. But this is the future: stories need not only be written—now, tales and memories can be passed from mind to mind, memories and worlds shared directly into mass consciousness. Yet, even with this miraculous new form of sharing, the story—our telling, shaping, and recalling it—is lost. In considering our stories' functions and audiences, author David Mura asks us to "consider the original storytellers who sat around a fire after the day's activities and told their stories to their tribe. For such tellers and their audience, the answers . . . would be readily apparent" (2018, 135). "Bowl of Stars" attempts to reproduce and reflect on originary storytelling by dramatizing temporally disparate acts of orality. The Boy and the Mother both watch the Rot destroy their worlds from the inside out, and, having no solutions, their stories are stuck in the third person and seemingly written for them. The Boy retains his voice, but realizes that others around him have lost theirs for good, and he has no one left to speak with. Inversely, the Mother does not (and cannot) speak, and her life has been stripped away by the Rot. By the end of her story, the Mother takes some control in crafting the Loom, and the MALOs exist thereafter in the first-person plural: they are a unit, a living memory, and what they see, they communicate to themselves as a whole. But the Historian and the Plant's bookending stories are told in the first person, representing the two characters who share their story directly, who address the audience—the Earth and its former inhabitants—the two who watch the lives and stories of everyone, and the two who must, inevitably, give up some of their autonomy to join together for the sake of the Earth at large. The Plant's story is cosmogonic, similar to the Hawaiian Kumulipo, reminding us of a cosmos and history beyond oneself, inviting us to become "both moʻokūʻauhau (genealogy) and moʻolelo (history/legend)" (quoted in Warren 2015, 940).

While "Bowl of Stars" is a work of dystopian science fiction—death inhabits the lives of each protagonist—we do not see the ending as typically bleak. It does not signal postapocalyptic triumph, but, in keeping with our attention to Indigenous understandings of time as recursive, it focuses on the possibilities of more hopeful futures through a return to the land (home). This vision relies on the connections between all of our protagonists (human and nonhuman), for radical imaginings of the future must be collective ones. The answer to dystopia is not to thrive or to overcome, but rather to reconnect.

my new home's secrets,
in the bowl of my palms.

And from my roots,
I spoke of my father,
of my mother,
of my long voyage,
and they recognized me.
They embraced me
as a welcome foreigner.
Yet, I was allowed

to stand alone.

From sight alone, the boy never would have guessed that the farm was destitute. For that was the word his father used on the phone just the previous afternoon—destitute. The boy had watched the spit fly from his lips, watched him crumple the deed to the farm in one hand, and say all the words the boy was not allowed to think, let alone scream, into a screen-cracked phone. The boy had looked the word up in the dictionary later that night: "without the basic necessities of life."

As he walked through lines of wilting, leafless stems, the boy thought that perhaps the word was true. For it was true that the crops refused to grow taller than it took to tickle the boy's shins, and it was true that the well was caved in and that the cows wailed day and night because his father sold their calves and because they were locked within the farm's borders just as the boy too was landlocked, miles from the ocean, miles from home. It was true, also, that the life insurance had barely paid for fresh soil and that nothing new had grown in all that new dirt. And it was true that his father spent each night pacing the length of the living room, asking the boy's mother to guide them, and smashing his fist into the wall when he was met only with ghostly silence.

But still, that morning, like every other, the sun arrived without fail—not so bright as the island they'd left, not so warm as the ʻĀina of his ancestors, yet enough to warm the dew on every gently swaying stalk. He kēhau hoʻomaʻemaʻe ke aloha. The breeze's nimble fingers ruffled the boy's hair, and his stomach growled, and he thought the farm was very beautiful, despite its destitution.

And then his father screamed.

His father was a large man, built like a ship's mast with oar-worn arms, a scruffy black beard, and wind-flushed pink cheeks that turned scarlet and then deepwater-blue as he fell suddenly to his hands and knees, choking and pawing at the pale, sickly soil. The hose in his hand shot one last deadly gust of pesticides into the barren field, then sputtered out.

The boy stumbled, landing hard on his knees, and smashed a lone plant beneath the scratchy patches of his jeans. He struggled upward and grabbed hold of one small leaf for balance, so when he finally made his way back to his feet, the appendage ripped clean from its stem the way he'd watched the calves tugged from their mothers' udders. The boy's fingers were still green-stained

ocean floor. Their Historian guided them into an adjoining room, where they would shower, dress, and be assessed.

Their Historian had looked at me with a fear that made my throat tighten. As if sensing my discomfort, my face appeared in the window. I saw my smile on a body that was not mine. It was my Observer, a M.A.L.Os. of a companion line assigned to monitor my developing condition. Their grin widened, flashing small crooked teeth beneath large dark eyes.

The pod tipped back, locking in a horizontal position, and my Observer slipped out of view. The door latch released and the pod hatch pulled away, giving me my first taste of air: sterile and recycled through the aging vents of the va'a. It made me long for the high humidity of my first self's home.

Yet I remained still, remembering this procedure well. They placed the back of their hand on my forehead, checking for fever. We, M.A.L.Os., are born from the same Looms and DNA; all of our bodies are the same. We run cold from birth. But for my line, a slight rise in temperature signaled a defect, an illness that tangled the Long Memory into knots that caught and snagged on our present. We remembered too much, too intensely, too painfully. It made us mad; violent; we hurt.

The first of my line, born in the early distance of the Fleet's journey, was assimilated after such an incident. They spoke and touched another body. They succumbed to the weight of mātou leo.

This would be my twentieth cycle since that initial incident.

This would be my Observer's nineteenth turn as my companion.

M.A.L.Os. are genetically identical, but looking up at them, I know that they see me as different. We are woven from the same cloth and spun in the same Loom. We carry the Long Memory in our body. Our eyes are naturally sad, yet now I see that theirs are heavy with disappointment. I am a tangled thread; a cracked vessel leaking our collective self onto the va'a floor. Yet, they raised their hand again, pressing it against my jaw before smoothing down my sideburns.

I straightened myself, rolling my shoulders until they let their arms fall away. I loosened the muscles in my face. A M.A.L.Os. was meant to be solemn and steadfast in their oath, whether it be of office, allegiance, or silence. My former self had publicly broken one of our most sacred vows, and I was compelled to mend the fracture in our line. Unlike the others, we must perpetuate.

I carefully climbed out of my pod and stood before my Observer. They held out my robes for me to slip into. The bright gold of the fabric darkened with the birthing fluids, but that is the process. Our eldest will touch and test it for defects. This is the process. With as much care as possible, my Observer tied the opening closed high above my waist; the knot pressing snug against my diaphragm as a reminder of our vow of silence. It will bruise when the Rot finally claims me.

They gestured to the exit. I nodded and followed them across the Birthing Ward. A new Batch has already begun incubation in the vacated pods. There will always be more.

"Savali fa'atasi ma au." Our voice echoed sweetly within my mind.

The door slid open and we stepped through.

> Among the trees and brush,
> I caught their whispers,

And he grew. He grows. He smiles and he sits up, he crawls and then he walks. On brand-new shaking legs he walks toward her, grinning, chubby arms stretched to her, and he is perfect. Life with him is almost unbearably sweet, because all around them the world is not.

Joy: burying her face into his damp neck. Kissing his round, smooth cheeks. The weight of him lying on her chest. His first silent, shaking belly laugh, splitting her open.

Terror: the day his father returns from too many days at sea, arms empty of fish. Piglets that fail to grow, chicken eggs that crack open with nothing inside—just perfect, brittle shells holding emptiness.

She hopes this love will be enough.

<div align="right">

I honor both
with my feet planted
firmly in my mother's breast
and my hands
outstretched and reaching
for my father's face.
This is why
I was sent away:
a jealous wind
tore me from her chest,
casting me adrift on a raft
of storm-trodden rubble.

On unfamiliar sands,
I crawled deep
into a forest of mottled green.

</div>

I saw a darkening sky, and the smell of salt filled my lungs and stuck to my skin. I felt the timbre of his voice in his chest, where he held me close. From the bowl of her hands, she poured salt water over my head. Each drop glimmered like starlight against their black silhouettes. I felt their rough lips press against my temple and cheek. Even from the shore, her voice—the one that echoes loudest in pōuliuli—was heavy in my ears.

I smell blood.

The memory quickly receded like a wave back into the body of the ocean, folding into the collective. The wet of the Loom receded, too, uncovering my body and releasing me from the Long Memory of our first self, our first love, in the embers of a fallen sun.

I awoke in the Birthing Ward with my back pressed into the hard metal cage of my pod. Through the pod's observation window, I saw a newborn Batch, still wet with embryonic fluid, scuttling out of an adjacent Loom toward the Batch Receiving Bay. They moved around their Historian in muted excitement across the Birthing floor. Their uniformly lanky bodies moved as one eager accord, harmoniously slinking around one another like a bed of eels scavenging the

They've traveled on foot more than two miles to get here, just outside the new city limits where the State Commission has set up a checkpoint for mandatory well-child examinations. During the long walk, which the mother makes at every new moon, she tries to measure the weight of him in her arms, on her back—is it more than last month? Is he bigger, is he stronger?

Water has a give as well as a take. In the years since she moved to the island, she has watched the ocean ebb and swell, has learned its movements against the shore and farther out—while the water can push and smack, can pull you under and crush the breath from you, it also holds you up, caresses, enfolds. These state workers offer nothing but pinched mouths and hostile stares.

What are you feeding him? How much? Whom do you live with? Where does he sleep? Is your house clean? Are you sure you don't give him sugar water or soda? Their questions prick at her, scrawled in cold typeface on their sterile screens, and she hides the bleeding.

Today is hot. A damp orange haze hangs over the city skyline. In the distance, the sea has reclaimed parts of the high-rises, only the highest floors inhabited by people who still have money. The glass and metal tops stick up from the water like teeth, and ships slide around and between them. She waits in line to set her baby on the state's scales. There is dust on him, rust-red from the dirt path she walked to get here. Its ghost remains stubborn on his soft feet and legs no matter how she wipes at it with her shirt. Sweat makes slow tracks down her back; the baby's cheeks are flushed. And still, there is the long walk home and all her work in the settlement's greenhouses waiting.

When it's their turn, she watches, heart in her throat and palms itching to snatch him back, as the state auditor examines his arms and his legs, pulls up the little cotton T-shirt to check his torso for telltale spots of bruising. The auditor sets him wriggling on the scale and scribbles things down on a chart she is never allowed to read. His small body is clear of the dark spots—dime-sized and perfectly, eerily round—that appear on children suddenly and without warning. The spots are the first sign of the Rot.

At the moment of his birth, a small red cloud had bloomed in the tub and then dispersed, and the dark shape of jerky limbs and a full moon head unfolded underwater. "A boy," the midwife signed, and he glistened like a small fish caught in the light of the oil lamps. His first quiet gasp shook something loose inside her, like a stone fell from her chest and sank down endlessly through her body. It hasn't stopped falling since.

Fear has a smell. She recognizes it now—something sour and metallic. The crowd at the checkpoint stinks with it. They are all afraid. Of the Rot, of the white vans that pull up to settlements without warning. Of the child takers with their white coats and faces that reflect only disdain. The auditor gestures that she can take him back now, and she lunges forward too quickly, pulls him back against her where he belongs. His little shirt bunched up in her fist.

The night he was born, they walked from her house through the mangroves and toward the shore. Her body was quaking, but she felt strong, so strong. His father took him into the ocean, waded waist-deep and cradled his body while his other mother washed him in seawater pearled by moonlight. She felt then that their family was a constellation—each their own separate self, but connected—their shape a story, a talisman. She thought it was enough to keep them safe.

Bowl of Stars

Kristina R. Togafau, Alexander Casey, Aaron Ki'ilau,
Brittany Winland, and Briana Koani U'u

I was born
in the murky night,
when the heavens turned about
and called life forth
in a timeless, unspoken song.

My sky father and
my earth mother
tumbled in their throes,
and my father
pulled me out from my mother.
He set my sisters,
the fish and birds,
bursting into the seas and skies,
and my mother
sent forth my brothers
the rats, pigs, and dogs
upon the earth.

As the universe
swirled around us,
my siblings multiplied.
They chose sides
between mother and father:
the birds climbed
the vast arms of my father
and the pigs snuggled
close to my mother.

The baby was born in water.

Works Cited

Bakhtin, Mikhail. 1984. *Problems of Dostoevsky's Poetics*. Edited and translated by Carl Emerson. Vol. 8 of *Theory and History of Literature*. Minneapolis: University of Minnesota Press.

Dillon, Grace L. 2012. "Introduction: Imagining Indigenous Futurisms." *Walking the Clouds: An Anthology of Indigenous Science Fiction*, edited by Grace L. Dillon, pp. 1–12. Tucson: University of Arizona Press.

Grace, Patricia. 1995. *Potiki*. Honolulu: University of Hawai'i Press.

Hau'ofa, Epeli. 2008. "Pasts to Remember." In *We Are the Ocean: Selected Works*, pp. 60–79. Honolulu: University of Hawai'i Press.

Mura, David. 2018. "Four Questions Regarding the Narrator." In *A Stranger's Journey: Race, Identity, and Narrative Craft in Writing*, pp. 135–148. Athens: University of Georgia Press.

Warren, Joyce Pualani. 2015. "Embodied Cosmogony: Genealogy and the Racial Production of the State in Victoria Nalani Kneubuhl's 'Ho'oulu Lāhui.'" *American Quarterly* 67, no. 3:937–958.

and wet with morning dew when he placed them on his father's throat and begged him not to go where his mother had: coughing into the ground, silent long before her last breath.

The hours passed. The father drank water then whiskey, but nothing could mask the ache in his throat or in his bones or in his heart, an ache that had appeared the day they arrived on the continent and had deepened each day since he'd placed his wife six feet beneath unfamiliar soil. So he coughed only when he thought the boy was not listening. And he touched the spot on his neck where his boy had pressed a leaf like a bandage, and again, he called the lawyers, no longer hoping to get his money back on his destitute land, but to hear another human voice.

Beyond the window, a single spark of green glimmered amongst the rot of the land, a weed not very tall and not very pretty, a single, thin shadow that loomed over the pesticide's skull and bones.

<div align="right">

and the vines and ferns,
and the diggers and rooters
kept their distance.
Then the first fathers
and mothers of men
arrived and grew
close to us. They
honored us as family
in word and dance,
adorned us with names.
And we gave up our bodies
in love so they may live.

They called me—

</div>

transmission#incoming-hold for position . . . 36,347 km from terrain.
voyagerpod-23 online/begin order-code "final/crossing" in
0:30
0:29 . . .

If I tell you that the world is round, you would believe me, but you would not know what I mean. To you, ku\u kaikaina, the world is flat. Flat like the va\a decks. Flat like the comm screens that line our halls, our quarters, our minds. Your feet have forgotten what it is to stand on the curving belly of the world, but let me remind you.

The first time I saw the Planet's face was through the eyes of another. The va\a li\ili\i travels back and forth, from va\a to terrain and back across the final expanse, our last journey. It transmits to us its gift of sight. And time unfurls and contracts in the seconds, the minutes, the hours between each glimpse. I remember the image, flashed before us on the comm screen behind our assigned MALO, a glittering jewel, spinning in the vastness of space. We were still in

Conditioning, without purpose or station, my Long Memory had yet to reveal itself, just a seed waiting to burst forth. Mother-Loom planted the seed but it was the Planet that watered it. It was the Planet that fed me, pruned and cleaved from me that which I did not need. I thought then what I think now as I begin the last leg of our pilgrimage toward it,

I want to go.

even knowing that the atmosphere is too oxygen-rich for my failing lungs, so Rot-infested that they will be crushed as soon as I take my first breath,

I want to go. I want to go.

ku\u kaikaina, you can no longer recall, but we did not always live on the va\a, adrift in pōuliuli, the darkest and deepest sea, with our noses pointed toward the Far Blue Planet.

How many batches have been birthed at her mouth? All have gone to dust on her lips, fed to the Looms to become mulch, to become cuttings of batches that will go to dust, more fuel for the va\a.

You know me as the Criminal, the Terrorist, and it is true. It was I who took the knife to my mother's neck, I who destroyed my own Loom that had wombed and birthed me and my batchmates. I know to you mine is a story of horror, of unspeakable violence. To you, I may as well have carved out my own intestines. But I tell you, it was love that compelled me. It is love that propels me forward.

I was born like you were, as one and many. My batch was hewn from the cuttings of many who had come before. I was once the Hi-stor-r-riann I-I w-as -

error. Code . . . 009-@333. transmission disruption.

An entry from *Irving's Book of World Knowledge* (1905):

> *Paterastellarum Oceanesis;*
> *Hawaiian: Poho Hoku, pohohoku, or pohoku; or Ahu Hoku.*
>
> *"An obscure Polynesian chant lists among a collection of plants a 'Poho Hoku' ('star bowl' in Hawaiian), a rarely observed dandelion-like orchid called a Bowl of Stars. Its rarity in traditional chant is owed entirely to the fact that it grows alone and once every three human generations. How or why this is baffles western men of science as much as quaint island peoples who struggled to maintain its relevance in the latter's oral repositories."*

transmission#incoming-hold for position . . . 30,098 km from terrain. connection: fair. error.code:pilot/offline. begin revival. adjusting oxygen level. wake. wake.

T-h-here are t-two fish inside the bowl of my chest, gasping.

Above me, the voyager implores, *wake*. Ah, ku\u kaikaina, the twin fish in my chest are now sinking stones. Wake. The vessel shutters around me like the fluttering of my own two struggling lungs. Wake. Do you know that word? It means "to emerge." From a slumber. It suggests that those who hope to wake must first be asleep.

I was asleep. I dreamed. How about this word? Do you know this one? Forgive me, I always forget which words are ours and which are mine. There are so many words that I know that no one else does, except maybe for the MALO but I never dared to ask them what words they knew. And now, it is too late.

Dreaming is like a memory, ku\u kaikaina. I think that's where the dreaming must come from, my long, long memory. You have no capacity for memory. So I must remember for you.

Before the va\a, there was the great va\a of the world. If I reach back, back and back, so far that it feels as though I am reaching forward, I can feel the memory of the old world like a tooth falling out of my head, like the fleshy gap left behind. It was mostly water, this old world. It had things that you have never heard of. We left much of it behind, but took much more. Taking is what we do. It has sustained us thus far and so I reached the arm of my memory back and sought what more we could take, what we had left behind that we should not have, and I found it.

In Conditioning, we learned to mark the death of the old world at the launching of the va\a but it was dead long before that. Before the carbon storms and the acid sea. Before the calamitous earthquake that split continents in half like the cracking of a femur. It was the star bowl, *Sinumastris Oceanesis*. It died and we all died with it. It was the plant, the plant could save us, could cure our poisoned bodies. Even now, I can still see it. The memory of it. The dream of it.

Am I still dreaming?

error.code:pilot/offline. begin revival.

I am dreaming again. I dreamed of how I was once sleeping. I dreamed of my cells dividing and forming, an amalgamation of many molecular parts being compiled into one being. Think back, ku\u kaikaina, and I think you might be able to remember this much at least. We were all once sleeping and growing in our Mother-Loom, cartilage becoming bone, limbs elongating and unfurling. We slumbered and dreamt of each other. And when the Loom bid us, we wake.

I was the seventh of my batch to heed our mother's mandate. As I looked up through the oxygen-rich fluid of my pod, I was aware of the subtle curve of gravity as it bent our trajectory, circling us around the lodestone of the Planet's mass. My first look at the world was cast in pink as I came choking into consciousness. Of the six that woke before me, three died within their first few inhalations of open air. Their lungs collapsed as soon as their amniotic pods had been drained of our Mother-Loom's waters. At some point while they slept, the Rot in their bodies had managed to take root earlier than most, strangling their lungs and preventing their development. I have been permitted to read their cessation reports. Their outlying genetics are retired and labeled "DNP."

Do Not Perpetuate.

I am the only one of my batch that has been permitted the memory of C-4701, C-4704, and C-4706, but now I offer it to you. In my ears, I can still hear them beside me, gasping and choking on air. I remember the curves of their faces, the shapes of their ears. Can you hear them? Look amongst you now, can you not see their faces? I am reminded that "wake" also means "to hold vigil beside." I think I have been holding vigil all this time.

It was the MALO who gave me the idea that time can be defied. My long memory would not be enough. But it was possible. I knew that it must be. I thought I cou-l-ld

error.code:009-@333.transmission disruption.

> *"It has never been demonstrated that animals eat the Bowl of Stars, that birds or bees drink of its water or nectar, or that Oceanic peoples have ever used it for food, medicine, or any other purpose. Animal tracks are often found walking around its clearing, and hunters have been known to warn others away from what they describe as a heavy omen."*

The mother worked in the commune's nursery, where they carefully seeded the plants in nutrient-dense water and coddled the seedlings under giant grow lights. The young plants always grew quick and strong and beautifully, vitally green there, but after being transplanted outside in the fields, they fell to the black spots and a slow, sad withering.

She wasn't always a mother; when he was born, he remade her, and now, even separated, she is his mother at every point in time she remembers. Recollections of her own childhood, back on a distant continent, echo differently now. She was always his mother—she just hadn't known it yet.

The black spots first appeared on the crops. In the corn fields, on the papaya trees' long-fingered arms. Finally, even the taro's heart-shaped leaves succumbed to the creeping black fingerprints of the Rot. And then the bruises showed up on her neighbor's nine-year-old daughter.

Before she became his mother, she'd never remembered any of her dreams. Maybe it was the lack of a long, deep sleep while caring for an infant, or hormonal changes, or something stranger and wilder, but she recalled her dreaming now. And it was always the same.

She sleeps, and she goes to a place she's never been. There are four walls so close she can touch them all just by stretching out her arms. There is darkness until she pulls the end of a dangling string. A single electric bulb casts a puddle of gold around her, and she sees it—a strange, straggling plant in a chipped porcelain cup. When she kneels down, her knees find two dents in the plush carpet beneath her, as if another had also knelt there. She runs a finger gently up the fragile, patched-up stem of the plant, and as she watches, it bursts into life—growing, greening, turning its face up toward the light. Then she wakes.

Her walk is even longer now, and the heat so heavy. The world around her bleeds out from its edges—sun in her face, everything around her loses its color. In the corners of her vision, she imagines green and resurrects blue. She doesn't turn her head, though. Like everything else, the colors might fade away if she looks directly at them.

She is alone on this walk—same dirt road, but farther into the city. They won't let her through the checkpoint, so she skirts around it and enters through an old culvert that is only passable at low tide. Soon the culvert too will be continuously covered by sea water.

When she emerges, she's still on the outskirts. Only neighborhoods on the mauka side of the freeway remain, and she walks through them. He is missing from her. She doesn't know her body's weight without him perched on her hip or wrapped across her back; without the gravity of

his body to carry, she feels ungrounded. No longer pinned to earth, she might go spinning off the planet. When a constellation is broken, does it still have a name?

No one comes near her as she walks. Their faces shy away. Even the hungry dogs skirt around her movement. She is negative space now, she is a hole everyone is terrified of falling through. She is the specter in the corner of their eyes.

The place where the children are kept is a pale pink complex at the top of a hill. A long time ago it was a hospital, but she can't remember its old name. Now it is called the Children's Residential Home. When the white vans come, the state auditors claim that they're taking the children to be treated, to be cared for under *better conditions.* They say that when the Rot is stopped—when the marks like bruises that are not bruises fade, and the children start to grow again—they will bring them back. But she has never seen a child come back out of the Residential Home.

Nights without him cut her open. During the day, she has work to do—the settlement depends on the labor of every member, and she can keep her hands busy and her feet moving. At night, she collapses into the black hole of sleep, but his absence expands, roots taking over and strangling any hope of rest. It would be a relief if she could still scream, but even that was stolen from her long ago.

Her lovers don't stay at the house in the mangroves with her anymore. She has locked them out. She can't bear them. She can't bear any love that isn't his, can't give it to anyone but him. Her love fills her up, and with nowhere to go, it overflows and curdles. She is an empty tub, the taps left running. She is the flood. Bitter water, salted and brackish.

But she could bear it. If he got better, if he grew. If she could only have him back and could keep him close. She could bear almost anything.

As she climbs the hill toward the Children's Residential Home, she passes through a newly cut clearing, all roughly hewn stumps and disturbed dirt. The state views any encroaching wildness as undesirable, and any fauna that does not provide food or medicine to humans is nothing but a pest taking up valuable resources. They've missed something, though, or something has grown back in spite of them. In the middle of the clearing is a stubborn, insistent stem pushing up through the soil, two weak leaves on either side like a child's skinny arms. She has never seen a plant like it; unimpressive as it is, she carefully digs it out with her fingers and holds it cupped in her palm. Perhaps the kūpuna will know what it is.

There used to be sliding glass doors that opened up into the big pink building, back when it was a hospital, but they're boarded up now with big panels of thick wood. She knocks at one of them with her fist, and waits. Usually, one of the auditors will appear and give her a written report—just crumbs, really. *Yesterday he took nine ounces of enriched milk. He napped for three hours. He is still in the non-mobile toddler ward.* Today she waits longer than usual, and when the wooden panel cracks open, an auditor she has never seen before thrusts their hand toward her, offering up a white unmarked envelope.

She has seen these envelopes before. She has seen them arrive at the settlement, and she knows what they mean. The first sheet, an official announcement in cold, institutional English, stamped and signed; behind it, thin duplicates rendered into other languages, each one repeating the news again and again. Without thought, her arm rises and she stretches out her hand. They hand her a letter and break her world in two.

The thing about fear is there is always something worse.

". . . poorly documented human attempts to cultivate it have been catastrophic not only to the farms and research facilities that conducted each study, but also to the general health and—some say—luck of the people with whom it was associated."

"She does not belong to you," echoed in the metallic corridor of the vaʻa.

It was the first 156 kilometers of our journey and the crew—newborn and tireless cadets of the security sector—strode through the hallway of the awakening ship, practically running to the mess hall for their first meal. Their attention belonged to their stomachs, not our squabble. Even the forever watchful Batch Leaders and minor Historians now quickly shuffled past us to the lecture halls. Still, I saw a few of them throw us disapproving glances. Speech—sound itself—had folded itself into the layered sleeves of the M.A.L.Os.'s robes; we carried the memory of a thunderous chord that sank mountains in our throats and we were not to waste this gift on a newborn.

Yet my outrage remained unwavering. "She doesn't belong to *you,* Historian," I repeated, grinding the words with my teeth as I lunged for her, taking hold of her arm.

"She conceived of me and I am of her body," she argued, trying to tug her arm away.

"Your mother is the Loom: metal casing and copper wiring; a factory of orphan bodies!" The meat of her arm bruised in my grip. She grimaced but did not make a sound. I squeezed harder. I pulled her toward me, forcing our line of sight into alignment; forcing her to see me. Immediately I saw the meddling of the Loom in her dark eyes that were our own. I had not seen that before.

"We are the same," she said, our eyes staring up at me in defiance. "I am MALO, too."

I decided then I would break her arm.

"Uso." One of us stood behind me, waiting for me to return to our self, but I could not. This chimera, monstrous afakasi had severed me. *"And was trying to make a claim to my mother. Mine."*

My jaw clenched. I grounded my self in the feeling of softening skin against my fingertips and the shine in her eyes. They called again, this time applying the pressure of a small choir. I resisted, pushing my self further away from our self and into my body. I filled my lungs with air and exhaled against the building pressure in my brain. I felt the Historian's blood pool in the gap between my nails and fingertips. I held tight, willing her to scream, to use her voice again.

"Sōia," slapped against my shoulders like an unseen wave. I tightened the muscles in my legs and braced my self as I heard them inhale, swallowing the very breath from my lungs. And how quiet it was, my thoughts and theirs, before our voice crashed down upon my head like a tidal wave. I fell to my knees, trying to anchor my self to the Historian's body, but she pushed me away, leaving me to sink into the black depths of mātou leo.

The last thing I saw was her fleeing down the long corridor of the vaʻa, my vision already becoming a watery blur. Her robes fluttered like a red sail against a current of mottled brown and gold that dimmed as the echo and roar in my ears softened into a sleepy dirge that slipped its arms around my limbs and slid its fingers down my throat. Our voice replaced what little air I managed

to swallow with *"Ia e malosi, ia e malosi, ia e . . ."* I sank into the thick press and darkness of our groaning, a guttural chest-digging hum that made my skin tingle and flush.

It swallowed my self until we were one again; until I was swallowed whole by the whale of our being.

> *"As a sprout—according to a chanted legend of limited reliability—a Bowl of Stars looks no different or more impressive than a common weed: two puny and uneven leaves, and a little bulb atop a single thin stem. The sprout spends several weeks growing roughly to two or three feet in height. Then, always under the cloak of a new moon, the plant undergoes a rapid transformation."*

School didn't meet anymore. His friends could not attend classes after they lost their voices. His teacher never stopped crying. Her voice was too loud in all that silence, echoing through a classroom of ten students, of seven students, of three students, of one. The schools closed then, and the boy did not go back.

So he practiced his reading with every warning label left in the barn. Fire Will Cause Toxic Fumes. Proceed at Own Risk. Beneath the bottles and the hoses, the empty bags of fertilizer, and behind the carts of feed, a wrinkled, duct-taped box leftover from the move provided a new lesson in comprehension: his mother's name along the label. A date. The word Memories. This box did not have a warning sign, no skull or crossbones, no mark of D-A-N-G-E-R, but the wind howled as he ripped off the tape. The boy waited for a reprimand that never came. Silence.

The insides smelled of hibiscus and rot. He gutted the Memories to find journals with flowers pressed between the pages, a digital voice recorder, and endless diagrams, his mother's messy scrawl cramped well into the margins of every page. Late that night, after his father had fallen asleep, the boy smuggled the box into his room and, with the light of his phone, marked a new page and read, and read, and read.

In the morning, while the cows wailed outside, the boy watched his father pluck the garden weeds. They had no room, he said, for things that were not functional or practical—two more new words, which the boy wrote on the empty pages of his mother's journal. He watched his father tug, and tug, and tug, until the plant came loose. He watched him toss its body into the compost heap: a strange, ugly little thing with one tiny leaf left smashed amongst the rocky soil. There had once been dandelions in the heap too, chickweed and common mallow, but like the boy, this new, strange little plant was left alone.

He watched his father visit her grave without a single flower to place upon the headstone.

E hoʻopiha i ka mākālua i hakahaka.

The boy sketched the plant in the evening when the cows' crying became a terrible bass to the cricket's melody. With his mother's recorder, he let his own voice fill the air and recounted the little he knew: the plant's bulbous top, the way it had made his hands and his father's neck so sticky, and the fact that it had no mother he knew of, that like all weeds, it was born without a plan, another orphan finding life within a graveyard. His mother had said that every living thing had a tale to tell, but the plant was a stubborn one: for hours and hours, the boy stared, but not

once did it reveal the secret of how it had healed his father, or if it had at all. So when his father called him inside for dinner, the boy closed the notebook and stopped the recorder, but all through his supper of canned spam and baked beans, he stared out the window and watched that single leaf cling stubbornly to a broken stem.

At midnight, though the moon was still missing, the boy filled his father's coffee mug with soil and smuggled the plant back into his room. He repaired the stem with his old school tape and fed it the water from his bedside glass, and read to the plant the bedtime stories his mother had once read to him. When the books ran out, or when the boy did not know the words upon the page, he told his own, promising the little plant that it would be alright. He poʻo ulu kō nā mea kanu. And though he kept it hidden safely behind the doors of his closet, he returned at the hour, every hour, to give it light and to pray. He prayed for the plant to live, for the cows had not. He prayed for the plant to grow, for his friends could not. He prayed for the plant to speak because the people were all forgetting how.

Beyond the window, the howling did not sound like cows any longer. As the boy settled on the carpeted closet floor beside the plant and closed his heavy eyes, he swore he could hear a woman crying and something—the wind, perhaps, or the gentle brush of a very small leaf—wrap around his pinkie and carry him off to sleep.

> *"Its two leaves swell to form a tipped bowl: the lower catches rainwater beneath, and the higher forms a protective hood over a single flower: a dandelion-like clock whose blue, fluorescent seeds are held aloft by long, imperceptibly thin threads giving it all the appearance of a dancing sphere of stars orbiting a phantom center, all floating above a dark bowl of water."*

There is Before and there is After. Some days the mother quibbles with herself about the timeline; did her world split down its middle when he was born or when he died? How many fragments does her life now lie in? Does it matter?

The nursery is warm and humid, the big fans in the back churning the thick air. The white noise of their blades is her only comfort now—not silence, but noise killer. Static. She prefers to be alone with herself and the shape of what is missing.

The others have stopped working in this building. Like her grief might be catching. So she tends the doomed seedlings on her own. She has always worked in the greenhouses. At one point, they'd thought that maybe the soil was to blame for the Rot, and they'd built an entire system of hydroponic gardens. But although the plants appeared to thrive at first, they still succumbed to the Rot before they ever bloomed or fruited.

In a corner of the building used for storage—some old machinery from when it was used for making textiles, coconut fiber for starting seeds, jugs of nutrients, pH testing strips—she has set up the plant. Its single stem rises from a cracked porcelain bowl, the twin leaves reaching higher toward the ceiling every day. She still doesn't know what it is, only that, despite everything, it grows persistent. The kūpuna, when they saw the plant, shrank away. They told her, in emphatic signing, to return it. Although they had no name or details for it, they insisted it should be left alone.

She did not return the plant. *You don't understand,* they wrote on rare, precious paper. *You are not of this land, and you should not meddle with it.* But she knew the plant; she had seen it nearly every night for more than a year now, had knelt before it in a poorly lit closet during every nightly dream. So she didn't listen to the kūpuna. The worst had already happened, anyway.

Today when she goes to tend it, the plant's two leaves have thickened and curved toward each other. Swollen, they form a green, fibrous bowl. Inside: small pinpricks of light, delicate starry-white flowers suspended on thin, nearly invisible stamens. Her eyes burn as she looks at it, her throat closes as her eyes trace its constellation.

This plant grows alone. She has found no use for it, no symbiotic relations to other plants or animals. But by some secret, it survives. It is the only thing she has managed to keep alive to flowering.

There is a part of her, something that's been pushed down so deep she can almost pretend she's forgotten it, that knows what she's about to do is wrong. Where she knows this plant should be revered, not defiled. But the worst has already happened, and that part of her is quickly drowned as she reaches for the plant, pulls its leaves apart to get at the universe inside. The plant is strong; it grows while everything else declines. It visits her dreams. If only she hadn't found it too late, maybe he—

But she has spliced many seedlings. And she has pieces of him still: a lock of hair, clippings from his fingernails, a tiny tooth that fell out too soon. In the back of the warehouse are the hulking skeletons of the looms that birthed giant bolts of cotton, back when it was a factory. She could knit them together.

A thought winds its way into her mind like a tendril of sapling, a curl of root, and she meets it with something that, if she cared anymore, might be surprise:

She is the something worse.

> *"The Bowl of Stars' bizarre and outlandish appearance against the rest of the forest can be unsettling despite its striking beauty."*

By the time the farm caught fire, the plant was almost three feet tall and too big for the closet.

They called it an accident. Flames licked the barn doors, every panel of the house, and what was left of the empty feeding troughs. The boy screamed until he lost his voice, pressed his nose to the passenger seat window in his father's old pickup, banged his fists against the glass, and waited for the water to come, his mother's tears and the ocean tide. There had been no time to save their things: not his mother's poems or his grandfather's hat, or the poor, lone plant that just that morning had undergone the most beautiful of transformations. Its leaf, once shrunken and unruly, had doubled and now made a perfect bowl: one to catch the water that the boy provided each day, the other to shield a lone blue flower that had, when the sun overtook the new moon, become a fluorescent, glimmering star. The boy imagined the fire with fangs of orange and blue, devouring the cosmos in a single bite.

He was locked in the truck. Where it was safe. Where it was far. Where there was nothing left for him to hold. He watched his father drop two cans of gasoline into the truck bed and cover both with a woolen blanket that they had not used once under the dry desert heat. His father demanded silence. The boy obeyed, silent by choice, unlike the boy down the street or his friend

up at the mill or his mother beneath the earth. As they ambled down the road, his father already on the phone with the insurance company, the boy rolled down the window and watched the smoke spiral skyward. If he squinted, he could pretend it was the Milky Way and that the stars were safe, that the shadow he saw in the ashes, that of a long pole with a bowl balanced precariously on its head, was proof of life.

His mother's words drifted on the voice of the wind: Nānā no ka lāʻau kū hoʻokahi. *Look for the plant that stands alone.* The boy closed the window and turned away.

> *"Dead or withered Bowl of Stars have never been found as they seem to simply disappear during the eighth new moon after flowering, leaving no trace other than its clearing, which is filled within a matter of days by the surrounding vegetation. Where, when, or how its seeds are dispersed is unknown."*

The assembly hall was filled with us, clones of our first self, Malo. We sat in tight circles, huddled close as our hands whispered across each other; faikakala in our fingertips and mālō in the well of our palms.

The eldest among us stood together, their heads bent close and almost touching. Their spotted hands were busy weaving the thinly cut scraps of golden cloth collected from the MALOs that had recently receded into the body of the Long Memory. This ʻie tōga was our longest memory.

A hand came to rest on the back of my neck, and I knew these calloused fingers. They'd moved down my arms, following my veins to the inside of my wrist where they'd spidered across my palms. From an endless wave of darkness, they had gently pulled me from my Loom and swaddled me in their care. I turned and greeted my Observer.

Our sad smile tugged at their cracked lips as they pulled me close and whispered, "Are you scared?" Their usually strong voice now quivered. The Rot had too quickly settled in them, curling inside their body like an eel rocking itself to sleep.

I pulled away and I shook my head, not daring to use our voice or my hands. Their smile grew wider, reddening their lips where the space between the splits in their skin pulled apart.

"Lelei," they nodded, taking my hand and placing a crudely cut ribbon of gold cloth in my palm. *"Afai tatou te faʻatasi, e le mafai ona tatou fefefe,"* they said, turning me around and pushing me forward.

I stumbled toward our Eldests, presenting my self to them. A few others, my previous selves and a few newborns of my line, stepped forward with me. Our Observers stood just behind us, forever watchful. A younger self, born this morning by the look of their wet robes, offered their hand. I let them link their arm with mine and linked my other arm with the MALO beside me. We allowed ourselves to touch hips and succumb to the gravity of our collective body. We kneeled together like a mountain range sinking beneath the horizon.

Our Eldests unfurled the carefully woven tapestry, and with reverence grasped its edges between mottled fingers. With graceful steps, they ran the ʻie the length of the room, presenting it to our whole selves. *"Ua mātou potopoto mo le o mātou pele uso, Malo,"* they bellowed. The soft underbelly of our ʻie tōga divided the sea of MALOs who began to hum with approval.

As the 'ie returned to where my self and selves stood, we began to speak. Our ill-used voices cracked and squeaked, but as a single voice, we told of our first self, Malo, and the wound of the first of our line:

> My first self was the first of their mixed Batch. They were (we were) very happy. We lived terra-side on an island in the southern quadrant of the liquid space that was deeper than the one we drift in now. Their mother, our mother, was a woman tangled in dreams and memory, but we sat as a stone in the river of her thoughts. They lived in the remains of a city swallowed by the ocean. There were ships. When the Rot came, we were taken. Our mother cried because we were hers. Hers. HERS. There were ships. They died alone; we live as one. She is gone, her bones buried in the last plot of land. Yet now, we are all together: us, our first self, and her.
>
> We are fa'atasi.

I lifted the cloth, a strip of my Observer's robe, up above my head, presenting it to our Eldests to add to our memory.

> *". . . the same chant which mentions the Bowl of Stars makes a second reference to it as He Ahu Hoku, 'a star shrine,' probably owing to its auspiciously framed appearance—framed by its own leaves as well as by the surrounding forest."*

transmission#incoming-hold for position: 11,904 km from terrain. connection: poor.

O-n-ce ma-ny ba- tche—s ago, someone has said of the MALO that only they can resist the stream of time. If a body is a leaf on the surface of the moving river, then a MALO is a stone, is all the stones that line the river's bottom.

MALO. MALO. Every time I think of the MALO, of their sad, heavy eyes, my arms bend back and my skin hurts. They are at every point in time since they became MALO, a continuous strand unbroken by the sway of time. No. *No,* I'm sorry. Not a strand, nothing so simple. A web, a system of roots tunneling through the dirt of time, of space. If they could reach backward and forward, then so could I.

I am sorry, ku\u kaikaina. Too many words that have no meaning anymore. I will explain in easier terms. I went there. To the old world. I cut through the skin of time and space. I fashioned my Loom into a knife of fire and light. Do you understand now? I needed to tear a hole, enough power to rip the heavy curtain between us and that which would save us. So I burned my mother and all her children. Matricide. Infanticide. These words can be used to describe what I have done but it was enough. I went through-h-h-h . . . t-h- f-iirrrreeee . . .

> The sky and the earth
> tumble away from me
> in warring fire and water,

> and my father
> pulls me again
> up and away from the earth,
> leaving sisters, fish and birds,
> my mother, and brothers,
> the rats, the pigs, the dogs.

-i-rrre. Fire. You don't understand. How could you? You've never seen a fire. Never felt heat or known what it means to burn. These words are all useless to you, ku\u kaikaina. Fire is the rapid oxidation of a material in the exothermic chemical process of combustion, releasing heat, light, and various reaction products. I set my mother on fire. I set the batch in her womb on fire. And in the fire, I saw the star bowl.

What about beauty? Do you know this word? It was beautiful. Above me the sky! The sky, ku\u kaikaina!

How to tell you, how to explain? Through the thick ropes of ash and smoke, the smell of burning flesh filling my nose as I breathed in deeply, I could see our future. I could see the plant's little cup like a gentle green hand curving around its own tiny blue universe of stars. In the waters, I saw my mother. In the bowl amongst petals, I saw C-4701 and C-4704 and C-4706, I saw the MALO, their bodies snaking behind them, branching outward.

And I saw you, ku\u kaikaina. I saw you. I reached out to touch you and above my head I heard screaming.

And then I saw nothing.

> In the murky night,
> the heavens turn
> as I am cast forth
> again in the timeless
> sea of songs.
> I am recast.

When I returned, I was no longer a historian. I was a villain, a murderer. Mother killer. Batch burner. Failure.

> They died,
> my siblings,
> countless generations
> of gilts and eggs:
> hollowed out by rot.
> Without my mother's warmth,
> I drift on a dark sea.

I have returned with my palm full of ash. The plant lives only in my memory now and so, too, our future. But there is no time to waste. I have seen blue skies and tasted the tang of the salt sea. I have seen our Planet's face echoed in the face of another and it is a beauty beyond stars. So I will go to the Planet and let it crush my lungs, break my bones, cleave once again from me all that it does not require. Come with me, come with me. Do not delay. I will be waiting for you

<div align="right">

on another shore where
your body becomes mine,
my breath becomes yours,
and our eyes see the face
of our new mother.

</div>

I love you. Goodbye.

error.code:009-@333.transmission failure. connection: unreliable.

We are born
in fire and night.

Artist Statement: The Art of John Pule

Nicholas Thomas

For over thirty years, John Pule's art has returned, time and again, to Niue, and especially to Liku on the island's east coast, the place of his birth and his family's ancestral lands. His paintings have not offered literal depictions. In earlier works, localities were mapped through a visual idiom inspired by the grids, plant motifs, and written names of *hiapo*, the nineteenth-century Niuean painted barkcloths distinctive less for structured design than for quirky freehand illustration. Often, botanical designs were interrupted by some motif—such as a ship or compass—that represented maritime trade, and indeed globalization. In the same way, Pule's work has represented Niue, but never just Niue: migration, missionary colonization, global conflict, and violence ostensibly driven by faith are part of the story. That story has also, throughout Pule's career, been energized by a personal mythology. His spaces are neither simply natural environments nor theaters of purely human interaction. They are also populated by hybrid, voracious beings (somewhat like Maori *manaia*): his worlds are sensual but also scary, they incorporate scenes of sexual acts, but also of creatures poised to devour some indefinite prey.

From the outset, Pule has been preoccupied with conflict and migration. At the very heart of his work has been the issue of loss—the irretrievable personal loss of the death of a child, and also the loss of ancestral gods and sovereignty. These are constants in his art, as has been a commitment to making large paintings, which happen to be on the scale of many hiapo, and could be seen to have the dazzling impact on a community or public that, historically, the optically dynamic painted barkcloths once had in Niuean ceremonial settings.

Yet the artist has never stopped reinventing forms and styles that express those constant concerns. Through the early 1990s, he used acrylic paints to create mostly monochrome sienna, green, red, and black works on unstretched canvases, which often "looked like" hiapo, even though their constituent motifs were actually personal inventions, not even loose adaptations of the customary designs (as Pule's interest was always in something less predictable than art as revival of cultural identity).

Those canvases themselves were relentlessly shape-shifting, but in the early 2000s, Pule turned the very constitution of his paintings inside out. The maplike imaging of ancestral lands inhabited by scenes, symbolic motifs, and predatory creatures gave way to a profile view of the heavens, made up of extraordinary cloudscapes. Clouds like those seen from the side, out of the window of a plane, were scenes of cosmic interactions, conflicts, esoteric rites and edifices. Over the last few years, the painter has returned to earth, to islands specifically, and to islands bursting with

ebullient plant life. Along the way, he has turned to varnish and enamel paint, interspersed fine ink drawings among big painted motifs, and manipulated paint poured directly onto the surface of works that are now always stretched.

The paintings included here (**Plates 9 and 10**) are selected from Pule's most recent exhibit, which centers on a famous and extraordinary dimension of Polynesian history, though one Pule has never previously addressed, at least in this explicit and focused way. For 250 years, European travelers and scientists, and Islanders themselves, have been astonished by the voyages over millennia that led to the settlement of the sea of islands. Questions of exactly where Islanders came from, when and how they voyaged, and why they might have left former homelands to attempt passages across vast expanses of open ocean have long been vigorously debated. Over recent years, archaeological research has done much to refine understandings of Oceania's maritime past, essentially in support of the kinds of narratives of deliberate, exploratory voyaging expressed in traditional history and myth.

The first Niueans were said to be two young demigods, Huanakai and Fao, who were wearied by endless conflict, but sought support in each other and eventually decided that the best course of action was to leave their home island, Fonuagalo. They swam around the Pacific and at last discovered a reef, which they stomped on and thrust up and, after much shaping, created the island of Niue.

The paintings evoke an island environment that is lush and extraordinary. The plants are gigantic. Some erect, some pendulous, they are fleshy, overripe, on the point of exploding into a shower of seeds. It is arresting that the island that bears this vital, fecund flora is Fonuagalo, the land that the young demigods *must leave.* In one painting in the series, *Still Not Close Enough,* Huanakai and Fao are shown consoling each other, seemingly consumed by grief as they realize that their only escape from incessant struggle—which across Polynesia was always about land and other resources such as reefs, water, and trees, as well as chiefly titles and sanctity—is to enter the sea and depart. Whereas the literature about Islanders' voyages of settlement over the course of Pacific history emphasizes the heroism of ancestors and navigators, and the incredible achievement of sailing across, in some cases, thousands of kilometers of open ocean, for Pule the issue is the pain and loss of being forced to depart.

This vibrant evocation of the strife and the passage that led to Niue's formation is an allegory of more recent times, and the challenges that Pule himself has faced. All his work speaks from the predicament of those who left island homes and became immigrants. Such passages always involved loss, fear, and hope. Migrants have dreams that do not become real. Those who at some stage in their life return to their place of origin often suffer new challenges. What was given up, on departure, cannot be retrieved through return.

If these paintings, like so much of Pule's work, express the permanence of loss, they are also joyful. Strangely so, since they were created during the pandemic, when people everywhere underwent immense suffering. Even those fortunate enough to be essentially safe suffered separation, isolation, fear, frustration, and anxiety. Pule was affected by all that; yet these works are all the more urgent and optimistic. Their titles acknowledge impossible but inescapable choices: *Stay, or Go.* Yet they revel in beauty and look toward the future.

Artist Statement: Writing from the Vā

Victoria Nalani Kneubuhl

What may seem "fantastic" or "supernatural" in one world may not be so in another. Many of us of Pacific Island ancestry who were brought up in the islands or with families that maintained some semblance of their island roots have developed the sense of a reality that is different from that of contemporary western civilization. Although we may not have been formally or directly taught about this different reality, we have quietly absorbed an awareness of it from a myriad of sources. I would suggest that one of the most important ways this sensitivity develops is through observing the talk and behavior of our kūpuna and other elders with whom we have had shared moments. Other things that have been passed down to us such as our relationship to our ancestors and our genealogies, a knowledge of our ʻaumākua, our connections to ʻāina, our spiritual beliefs both practiced or latent, our communal stories, our particular family stories, our dreams, and, most powerfully, our personal experiences all form threads that weave a different experience of life, a different worldview than the one taught by our colonizers. We are continually aware of the people and events that have gone before us and the intermingling of past and present.

I was delighted and astounded when one day I found among some papers left to me by my uncle, John Kneubuhl, also a writer, an unpublished essay on Samoan identity that articulated these experiences in the context of Pacific Island thought. In the essay, he speaks about the vā as a space in-between. Vā, he says, refers to the space between people, which is not as in the papālagi world, an empty space but a space that defines relationship. He goes on to say:

> There is a Samoan social rule that says it all: Teu le vā. That injunction has two meanings. In times of trouble, it means that we put away the differences between us. However, at all times it means that we must tend (as one tends a garden) the space between us. . . . Your view of Reality shapes your view of yourself, or your identity. And if your view of Reality—the world as it is—is one in which the living and the dead intermingle, then they intermingle in you as you identify and describe yourself . . . Teu le vā. You tend to your ghosts not by exorcising them, but by distancing them, but by putting them in that proper balancing act . . . to live at the proper distance—the socially proper distance—with the dead. It is at once an act of respect and worship.

Writing is this space, this proper distance, where we can safely explore with love and respect the things from our collective and individual past, our present world and our future. This vā, this

in-between, safely grounds us in an open reality with infinite cultural dimensions as we move closer or back away to maintain equilibrium. The act of writing then becomes the act of balance itself. Teu le vā.

I am laughing now to see that in writing this I have been evoking and intermingling, on very safe ground, with one of my beloved and departed kūpuna. So in closing, I would like to give to all of my fellow Pacific Island writers the words that he gave to me when I first began this journey: "Remember we began as priests and oracles, as conjurers of our dead ancestors. Find your voice and honor it. The words that give it body are sacred."

Hoʻoulu Lāhui

Victoria Nalani Kneubuhl

At dawn, the chanting called Kahikina out of sleep. She sat up and parted the bedroom curtains from her upstairs window. No, she wasn't dreaming, he was still there. Only the wooden gate separated him from the stone path which led up to her door, but she knew he would never come across unless she chanted back to him with her own kāhea, welcoming him in the formal and polite way of their ancestors. Unless she did so, the flimsy wooden gate might just as well have been a forty-foot moat swimming with sharks and water snakes. She could see him clearly, his white hair, his tall figure against the morning, his vibrant breath rising in his chest and falling out through his voice in rich, dark tones.

Anger pricked at the back of her neck. What the hell does he expect? Three days and he's still out there thinking I might welcome him in. Why should I? I don't even know him. I don't even want to know him. Let him wait. Let him wait forever or go back to where he came from. It's all too ludicrous.

Kahikina sat at the edge of the bed and stared at the floor. She stood up, grabbed her robe from the chair, and walked downstairs to the kitchen. While she waited for the water to boil, she brushed out her long dark hair with its streaks of white. She could take the pill, the gene therapy pill that would keep her hair its natural color forever. She'd already surrendered to the same kind of treatment for aging skin, but Kahikina wanted the gray in her hair. She liked having a sign that announced the kind of maturity she felt she'd earned after sixty-seven years of living. She braided up her tresses, twirled them around, and secured them with a wooden hair pick, carved in the shape of a lizard, at the back of her neck.

The man at the gate began chanting about Papa and Wākea: Papa, the earth mother, and Wākea, the sky father, progenitors of the Hawaiian race. Kahikina listened and for a minute mused over his version. I guess he never heard the *old* story, the way it was told before the Ministry of Hawaiian Culture reshaped oral history. "Kanaka nouveau," Grandma used to call the proud new bureaucrats. But I remember hearing a different story, from Grandma's lips, alone, in secret.

That was Kahikina's first year in school, the year 2035, when Ke Aupuni Hawaiʻi Hou, the New Hawaiian Nation, was only ten years old. She used to think her grandmother made up that story. It was certainly different from the one she learned in school, but now it all made sense. Yes, there *was* a great darkness. And in that darkness there *were* great shadows, and in the shadows

Previously published: Kneubuhl, Victoria Nalani. 2020. "Hoʻoulu Lāhui." In *The Quietest Singing*, edited by Darrell H. Lum, Joseph Stanton, and Estelle Enoki, pp. 183–192. Honolulu: University of Hawaiʻi Press.

dirty hands sealed secret deals—without the knowledge or consent of those whose lives their plans would splinter.

His chant was closing, and Kahikina could almost feel the calling in of his life breath like the smoke of a genie spiraling back into a bottle. Yes, he has a voice. Kahikina knew she must have met him at some time in her life. He was about her age and looked full-blooded, kanaka maoli piha. All the families met every year at the counsel when she was growing up. They were only a handful by then. At the time the new nation was formed, pure Hawaiians had dwindled to 500 men, women, and children. The first sovereign parliament set aside the best land for them, subsidized their housing, provided educational benefits, job counseling, training, and complete medical care. The medical programs were the most intensive. On a compulsory basis, pure Hawaiian children received extensive biyearly physical examinations. In addition, every month their weight, diet, and exercise regime were monitored. At the age of eighteen, the program became voluntary, but almost all of the other benefits required "voluntary" participation in the medical programs, so the routine continued. The doctors must have watched her for a long time.

It didn't seem so strange then. She'd grown up being treated like one of an endangered species. All of them were subjected to the poking and prodding, but in return, they were always given the best, always an honored place at ceremonies, always invited to every national event and to an endless series of public occasions. Kahikina remembered how she hated going out in public when she was a child. Visitors to Hawai'i had somehow come to believe that it brought good luck to touch a pure Hawaiian. She hated strangers always grabbing at her, trying to touch her hair, her clothes, and even her feet. She hated it. She looked out at the man again through the kitchen curtains. He must remember those things. He must know how she valued privacy.

Maybe he was the Kapuahi boy, the one from Ni'ihau. The family was tall and slender that way. Why won't he just go home?

Alika arrived when Kahikina finished her first cup of tea. She heard his bicycle on the back gravel path. When Kahikina's husband died a few years ago, she closed off the driveways with pass gates, strung up laser fences around her thirty acres to prevent trespassing, and rarely left home. She couldn't figure out how the man got through without a passcard. Alika didn't have one. He was programmed on voice security. Kahikina thought about calling the police and having the man removed, but what if it really was him? How could she be sure? She couldn't bear more publicity, more exposure, more invasion. She asked Alika to speak to him again.

"He said he doesn't want to talk, Auntie. He said he's waiting for you to greet him."

"He trespasses on my property, uninvited, and expects me to welcome him?"

"It's not his fault, Auntie." Kahikina knew that Alika thought it *was* the man, the one she'd read about. And was it her imagination or did Alika say the word "Auntie" with a hint of mockery? Kahikina looked at him in confusion.

Alika walked out to survey the lo'i. Across the taro ponds, the heart-shaped leaves of the plants fluttered in waves. He stopped and examined the two new varieties, the 'Uahi-a-Pele and Pā'ū-o-Hi'iaka. They were named for the volcano goddesses Pele and Hi'iaka because of their smoky-colored foliage. He checked them carefully, and then he went into the house, taking the laser key card from its place in the kitchen drawer. At the water data board, he keyed in and ran a house

water treatment and recycling process. All wastewater would be converted for garden use. Water and land conservation had become the first priorities of the New Hawaiian Nation, and Hawai'i was now a model for other island communities. Alika walked back out to the lo'i and put his hand in the water near an inflow valve to check the temperature of the circulating water. A fish glided by. Alika had recently introduced them in the ponds, starting with the traditional awa, āholehole, and 'o'opu. The water felt cool and soothing on his hand.

A nitro-evulsion process extracted liquid nitrogen from the air, making an affordable cooling agent that kept the water below 25° centigrade, the perfect temperature for a thriving lo'i. Taro cultivation previously depended on naturally circulating water to maintain the low temperature. Now, despite a dramatic increase in production, streams and rivulets flowed freely, and ground water was necessary only to make up for evaporation. As in the ancient days, taro once more filled the valleys and terraced hillsides.

Kahikina sat in her rocker on the lanai and watched him tend the plants. Taro was said to be one of nature's most perfect foods. Hāloanaka, a taro, was the first born of the gods. Hāloa, a man, was born second. Born of the same parents, the taro is the elder brother, man being younger. Alika looked back toward the house.

The sun climbed through the sky, and at noontime, awakea, the world was bright. Kahikina made sandwiches and set them out on the lanai for Alika. The pitcher of water on the table dripped its transparent beads. From the kitchen, she could hear Alika come up the back stairs and leave again. Through the window, she saw as he went around to the old man sitting under the tree. The man rested peacefully, leaning on the tree, protected from the brilliant light. Alika offered him a sandwich wrapped in a napkin, and gave him water from a cup. The tree's umbrella shade shaped them into sculptures, a dark tableau of shadows against a world of light—the old man looking up at Alika, Alika's hand held out with the cup of water, his head tilted to one side the way it did when he was intensely interested.

Kahikina turned away from the window and sat at the small table in the kitchen. Hearing Alika come back, she rose, picked up her plate of salad, and moved out to the lanai. She always ate lunch with him. She listened to his reports about the plants and the grounds, and sometimes he told her things about his life outside her world, what he did, his friends, different things. He made beautiful bowls at home in the evenings, beautiful wooden bowls that he turned and polished. Kahikina imagined that the small house he lived in was illuminated by the warm colors of wood. She saw bowls like dark amber hanging from the ceilings, set up on shelves and window sills, filling up his world with the essence of trees, with the hearts of trees, making him strong. Alika has the heart of a tree, she thought, growing sturdy and full of life. On this day, they ate in silence until Kahikina finished. She looked at him and felt a pang of quick, sharp, hurt.

"Why did you feed him?" As soon as the words left her mouth, she knew they were wrong—wrong words gone out, not to be taken back.

Alika stopped. He put down the cool glass he was about to drink from. He took a second to look at her, making sure their eyes met. His head tilted slowly to the right and his voice was soft and silken.

"I'd do the same for you, Auntie," he said quietly.

Kahikina stood up, her face hot and flushed. She grabbed her plate and vanished into the house, slamming the screen door. She couldn't tell what he meant. Was he rubbing it in, she asked herself, or am I just oversensitive and vulnerable, seeing it everywhere? Why shouldn't I see it everywhere? God damn it, it *is* everywhere. At the sink, while rinsing out the bowl, she let the cold water run on her hands—water, running water to calm her down.

After a few minutes, she moved into the cavernous living room, where her quilt was stretched across the frame, strewn with its pattern of breadfruit leaves. She sat, breathed deeply, and took up the needle, moving it in and out, in and out, quilting a pattern of lines that emanated from the appliqué, "like waves around our islands," Grandma used to say. The rhythm of the stitches began to soothe her, like chanting, like the swaying ocean, like her breath coming in and going out.

She had just turned twenty-one, and Hoʻoulu Lāhui, Increase the Race, was the slogan of the project. It was an ancient slogan from another century, but the health clinic had revived it, and now it stood out, emblazoned on a holographic wall poster. In the image, the words "Hoʻoulu Lāhui" stretched out through a rainbow that arched over Waipiʻo Valley. Light rain fell in the valley over fields of fertile taro gently moving in a slight breeze. Under a black umbrella, two Hawaiian children meandered on the web of paths that separated the taro ponds. Raindrops swelled on the translucent leaves and rolled off. A dragonfly flew by. The sound of flowing water drifted from the poster image. It mesmerized Kahikina, making her feel peaceful and good about the project.

Dr. Haulani Haehae entered the room. She had been Kahikina's kahuola, her personal health caregiver, since Kahikina was about eight years old. Her dynamic and comforting presence gave Kahikina an immediate and almost childlike sense of security. Dr. Haehae had cared for Kahikina during all her childhood illnesses. She had seen her through a difficult adolescent depression when Kahikina's mother died, when anger and fear nearly swallowed her.

"Participating in this project would be a true act of aloha to those who can't have children." Dr. Haehae's voice began with sincere compassion.

"It's like the old idea of hānai, isn't it?" Kahikina mused. "Like giving your child to be lovingly raised by others."

"Exactly," smiled the doctor.

"But this project *is* confined to people of Hawaiian ancestry?"

"Of course, one of the partners has to be. I'm sure that's mentioned in the written information I gave you." The doctor's voice became subtly authoritarian.

"I guess I missed that point." Kahikina hated appearing less than smart with the doctor. "Well, most of it I've read before, about how stress, pollutants, and chemicals have affected infertility. But I didn't realize that 50 percent of our couples can't conceive."

"Sad, isn't it? Carrying a child is not the problem, it's conception. Low sperm counts and defective ova."

"I just didn't know it was that bad."

"It's a very serious problem," said Dr. Haehae with a hint of emotion, "especially when you think about the long-term survival of Hawaiians as a group." The doctor let a few moments of silence pass. "But the hopeful news is that in-vitro fertilization is now well advanced, and through this program we can offer Hawaiian couples the chance to raise a child of our own race."

"And you think this selective screening process that you're doing might improve fertility in the next generation?" Kahikina did remember reading that and hoped the smart question would please the doctor.

"I'm quite sure, Kahikina." The doctor smiled and watched her.

"It sounds like it would really make a difference."

"Absolutely. And I've asked you because I know your records, and I know you could make an excellent contribution. Most of the donors, as you can probably guess, are only part Hawaiian. Being a full-blooded Hawaiian, your participation would be a great gift to the future."

"How will you . . . ? I mean how does it . . . ?" Kahikina didn't quite know the exact words for her question.

"How will it work?" Again, Dr. Haehae smiled her reassuring smile. "The procedure takes about twenty minutes for women. We extract ova from you at the right time of the month, just before release from the ovary, which in your case will be in about four days. We take the specimen, make sure it is an absolutely healthy one, and then we begin the cloning and storage processes. We expect about 300 specimens from men and women. Specimens will be matched through a random selection process that assures usage of every healthy specimen on a rotation basis, so that they are all used equally."

"And you're only giving children to people who really, really want them?" Kahikina asked.

"Oh, of course, dear, a child is precious, especially one which carries our blood. Any couple requesting our help will be thoroughly evaluated."

"And no one will ever know who—"

"Absolutely not." The doctor was emphatic. "Nothing about this project will ever appear as part of public information. Our government has guaranteed the tightest security. We want to protect *everyone's* privacy."

Kahikina knew the New Hawaiian Nation carefully monitored the media, in order, as they always said, "to avoid the self-serving and divisive confusion perpetrated on our people by the irresponsibilities of mass communication in the late twentieth century." She felt confident that everything was simple and straightforward, and so she agreed to help. She was one of only fifty pure Hawaiian women of childbearing age left in the world. She had half the potential for precious human life, for full-blooded Hawaiian human life. At the time, she felt a kind of obligation to participate. Dr. Haehae knew everything about her and probably counted on her to have those feelings, but this woman she thought of as her guardian and friend had lied. Had all her nurturing kindness been just to take them both together to this one day? If so, it all worked very well, and Kahikina had certainly done her part to increase the race. Four days after her conversation with the doctor, she had submitted to the simple procedure that sealed her commitment.

She looked up from her quilting and out at the healthy taro leaves, sparkling and ripe in the sun. Rapid advances in genetic engineering had revitalized everything: beautiful crops, beautiful animals, and beautiful children too, beautiful healthy children.

How could she have ever noticed? Two years after she had participated, she married a man in her own professional field, agricultural economics. Modeling their work on old-fashioned home economics, they were trained to help people establish the maximum self-sufficiency in home

environments. Aquaculture, productive home gardens, and small-scale agriculture were all part of the home systems they designed and helped maintain. Almost too easily, she reflected, they were offered really good government jobs in this quiet rural setting. Because of her pure ethnicity, Kahikina's eligibility for a land grant became automatic upon request after age twenty-one. She and her husband were nevertheless astounded at the stroke of luck which awarded them, through commission lottery, the exquisite thirty-acre parcel complete with the restored historic plantation manager's house. In such an idyllic setting and with such an engaging daily routine, she never had an inkling of what was going on. Of course it must have been part of the plan, the jobs, the house, the raises, and the special new projects. They were far too clever for her. They were far too clever for everyone. Their dispersal had been so meticulously planned, everyone and everything so carefully monitored for all these years, that no one ever suspected a thing.

Two weeks ago, everything changed. Dr. Haehae had recently died at the ripe age of eighty-seven. Her last years were spent in her comfortable home, where she passed the days reading mystery stories and propagating orchids. She died without much fanfare or public notice, bequeathing all of her worldly goods to a niece who had also become a doctor. While sorting through her aunt's personal belongings, the young woman came upon a little leather-bound book with pages of handwritten text. On the first page were inscribed these words: Hoʻoulu Lāhui. Charmed at discovering her aunt kept a journal, she sat down and began to read. In one afternoon, she read the diary that documented the project and Dr. Haehae's passionate feelings about her work. This niece had always suspected her own mother and father were not her biological parents, and she pursued the clues in the book, wanting to discover her true genealogy. She was also determined that history would not forget her aunt's heroic work.

The minister of health had come himself to tell Kahikina before the story became public. "I've ordered national security to delete your name and address from any and all public files. I've changed your communication numbers and covered any other possible traces which could lead strangers to you. The government is willing to provide permanent security for you for the rest of your life, but now, after what's happened, we can't guarantee complete anonymity."

"Can't or won't? You don't seem to have any trouble controlling other information." Kahikina wouldn't look at him.

"It just happened too fast. She gave out the information as if it had been approved. It's just too late." The minister paused and cleared his throat. "At any rate, the Sovereign Parliament, in a special session, asked me to tell you that Ke Aupuni Hawaiʻi Hou would like to honor you. We would, if you agree, in a religious ceremony of the most elaborate and ancient formality, invest in you all the power of the highest, I mean the highest, aliʻi. We could even establish certain kapu for you to make your life more private. We would create a special name for you, and the nation would hold you always in the greatest esteem."

Kahikina continued to stare out the window.

"You see"—the minister was doing his best to sound concerned and sincere—"the nation needs figures of substantial proportion, figures which in some way echo the grandeur of a great past."

"Like a queen bee."

He ignored her remark. "I know you need some time to think this all over. It must be quite a shock to find that your family is so, so big. I think I understand how you might feel."

Kahikina turned to him with a stare so cold he couldn't disengage from it. "Oh, I don't think so." Her voice was steel. "I don't think you will ever know how I feel."

The minister left hurriedly, saying he would contact her soon.

And then two days later, this man, she shook her head at the thought, this man at the gate. Kahikina stopped to rethread her needle.

Instead of selections on a rotation basis, they had simply chosen two donations of the very best, one male and one female, both of them from pure Hawaiians. First they were cloned for grooming purposes, and then altered to withstand inbreeding. Lab technicians combed through the strands of DNA, searching for and removing all defects. They engineered, strengthened, and activated enough genetic traits from each ancestral pool to produce an infinite variety of looks. Next, they cloned these perfect specimens again. Not once, but hundreds, maybe thousands of times. In hundreds of sterile dishes, they were joined. She, Kahikina, had been joined to a man that she did not even know, a man made as perfect as herself, and thousands of pure Hawaiian children came into the world. They didn't come all at once, but were properly spaced and placed to avoid arousing suspicion. The race didn't die. It began to flourish—Hoʻoulu Lāhui.

How ironic, thought Kahikina, that my husband could not have children and didn't want to use the available alternatives. How ironic that my one disappointment in life was that I never had any of my own. She sighed and lost herself in a sea of stitches. Kahikina didn't know if minutes or hours had passed before she saw Alika standing in the door, with the afternoon sun behind him. In a touching gesture, he removed his hat and nervously fingered it.

"Don't stand there looking at me like that. Come inside and sit." She said it kindly.

Alika sat in his favorite chair, right next to the one her husband always used to sit in.

"Well?" Kahikina kept her eyes on her quilting. "You want me to welcome him, don't you?"

"It's not like *he* did anything to you."

"I never said he did." She paused. "But do the words 'violated,' 'deceived,' 'used'—do those words mean anything to you, Alika?" She hadn't intended to be close to tears.

"I'm sorry, Auntie. It's none of my business. I didn't mean to intrude on your privacy." He rose to leave, but turned at the doorway. "He's just a simple man, Auntie, mahiʻai, dirt farmer, just like me. He says he doesn't know what to do, where to go. I'm sorry. I just feel—I'm sorry." Alika left the house quietly.

"This is our secret," whispered Grandma. "Now don't tell Mommy. Wākea was the sky father and his wife Papa was the earth. They were man and wife and together they had a beautiful daughter, Hoʻohōkūlani. In time, Wākea developed a great desire for his daughter, but he was afraid of Papa's anger. Wākea went to his kahuna and asked him for help. The kahuna created the kapu, all the laws which include nights, nights when it was forbidden for man and wife to sleep together. He told Wākea to go and tell Papa about these laws and to say they were declared by the gods. So on the forbidden nights, Wākea crept away to sleep with Hoʻohōkūlani. She had children with her father. First she bore Hāloanaka, who became a taro. Next she bore a man, who was named Hāloa, and from this man came the Hawaiian race. Papa found out about the deception and spat in

Wākea's face. People today don't like this story. They don't like that it tells of how our people came from a lie, a lie to use and deceive women, but this is the story our ancestors told, my pua."

Kahikina continued quilting until the old clock chimed four. She started out through the screen door, and saw Alika in the loʻi cleaning something out of the water. He looked far away and golden in the sunshine. As a boy, he was shy and eager to please. Now, he was old enough to have a family of his own. The thought that he might have been one of them was too painful to be anything but a brief stab in her consciousness. Suddenly the big house seemed very quiet and empty, just a big wooden frame yawning and creaking and growing old. Would it have been different if children had run through it? She thought of a house full of children laughing and playing and leaving trails of crumbs and toys and clothes, filling up the big emptiness of the house.

Alika examined the leaves of different stalks in the loʻi. When he moved the larger leaves at certain angles, glistening water droplets sparkled and flashed in the sunlight like a signaling mirror. He saw her on the porch and began to come toward her.

He has a nice way of moving, she told herself, quiet, sure, and strong, but he doesn't really understand. He'll never understand what it's like to be forced, to have it all forced on you, forced to spawn a race against your will, without your knowledge—to be like a hole, a big gaping hole in the heavens through which thousands of offspring pour, not one or two, not five or six, but thousands. Elements are missing here, vital, aching human elements: motherhood, pleasure, the feel of tiny feet and the closeness of small clinging limbs, the intoxicating smell of your flesh made flesh.

Alika reached the porch and sat. Kahikina poured his tea into the glass. Yes, she saw, genetic manipulation had made everything strong and beautiful, including the children, but Alika, in all his beauty, could not touch this dark and wide emptiness, no one could. She sank into the white rattan chair, watching the luminous sun in its declination.

Far away, she heard birds singing. Their songs were faint but present, somewhere on the periphery of her thoughts. Then, another sound began to rise quietly, slowly and gradually like water, like punawai, spring water, seeping up from the voice of the man waiting under the tree. It ascended through the lines of space, washed over her, crumbling gently in waves, crisp waves, his kāhea, calling out to be answered, calling out for recognition, flooding in the empty space and vibrating the darkness.

Kahikina rose to her feet. She moved slowly, straight through the house, the fire sky behind her and fixed in her mind, warming every visible thing. Throwing open the front doors, she faced the east, and her voice returned to the tall figure at the gate, making for him a deep and resonant chant of welcome.

Auntie

Victoria Nalani Kneubuhl

I want to drift away so badly, to find some solace, to escape into sleep, but I think I hear someone crying. It's not me, but it's in me—like someone else is in me. I know this sounds confusing, so I'll say it another way. This is what it's like: I start to drift off, and I'm in that half-dream state, hearing, feeling, and knowing that someone is crying. I can hear her sobs moving through my body in tremors. With my eyes closed, I see a place with a tunnel. On one end of the tunnel, she is sitting and weeping her heart out, and on the other end of the tunnel, someone, I don't know who, is listening—kind of like in that fairytale about the goose girl. You know, when she sits down and tells her troubles to the old iron stove, and the king is hiding on the other side listening, and he discovers the truth. The goose girl in that story didn't have a father, at least one she remembered. Later on, the king becomes her father on account of her destiny, which in this case turns out to be marriage, so far as the story goes.

So far as my story goes, I did have a father and a mother and two sisters and a brother. And like a lot of the girls in those fairy stories, I turned out to be the youngest. Being the youngest usually means that your mother doesn't pay much attention to what you're up to because by this time she's had it with being a mother. Your father, however, may enjoy you more since by now age has mellowed him out a little, and he likes kids more than he used to. That is, of course, unless your father has a hobby. My father was into pig hunting. He retired when he was fifty-five years old, quite an achievement, everyone said, for a local boy with only a high school education. Like his father, he had been a sea captain on a freighter. When he was young, someone left him a little piece of property in town, where he built a couple of houses, almost by himself, and rented them out. I guess he used some of that money to buy and build a few more houses, and eventually he got to quit his job ten years before all his friends could quit theirs. Other people said he and his father made a bundle of money during Prohibition running illegal booze from Canada to San Francisco via Mexico. I was born right when he retired, in 1949, just after the war. I don't remember him working very much. I just remember him going hunting all the time in the back of the valley where we lived.

We lived on the windward side of the island, about six miles down the coast from the nearest town. You'd drive along the road, past the rock formation that was supposed to resemble a pouncing cat, past that pool that was supposed to have no bottom, and past that beach park with the statue of the Virgin Mary, and pretty soon you'd see a red mailbox on the left. If you turned onto the dirt road there and went another three miles toward the mountains, you'd come to a bridge that crossed a stream. The bridge had a gate on it with a lock, and if we knew you were coming,

we'd unlock the gate and you could come in. If not, there was no other way to get into the valley and over the stream to our house. You could have gotten in by hiking down into the stream bed, crossing the stream, and climbing up on the opposite bank, but my father kept a pack of hunting dogs, and they didn't really like strangers wandering around uninvited. Don't ask me how they knew, but they always did know who was welcome and who wasn't supposed to be there. It may sound unfriendly to you, but it wasn't like that at all. We had lots of visitors and parties and relatives, and we also had wide expanses of lawn and garden and forest and a valley that went back a really long way to where the mountain trails began—the trails where my father spent days and sometimes nights with his gun and his dogs.

Once, my father had been away for an unusually long time. I think my mother had begun to worry about him. I remember that on the day he came back I had gotten up early. It was a soft, gray day. The clouds veiled the mountains, and an unusual damp mist hung in the air. I went out to the wide wooden porch that encircled the house. I saw my father walking toward me. He didn't look the way he usually did when he came back from hunting. He usually had dirt and animal blood smeared on his clothing. He usually came right back and got in his jeep to go back up and pick up the game he'd left at the trailhead. This time, he came home clean, unsullied, and in the company of a tall woman with long hair that was mostly brown but had all these very light streaks. She was wearing old dirt-stained clothes, men's clothes that were torn in more than one place. I wanted to run out and meet my father, but all I could do was stand at the top of the porch stairs and stare at the woman who walked behind him. Even from a distance I could tell that she had unusual eyes, and she turned her head slowly from side to side as she walked along, as if she were searching for something she'd lost. Her hair reached down to the middle of her back. It was thick and looked like a veil.

"Is someone out there?" My mother's voice drifted through the screen door.

"Daddy's come home now," I answered in a whisper. "And somebody else."

"Luna," my father called out to me. "Come take Auntie and go sit down in the back while I talk to your mother."

I first took her hand when they reached the top of the stairs. It felt warm and cozy. I led her around to the back porch to sit on the big swing that looked out toward the valley.

She turned her eyes to me and repeated my name. "Luna."

I had expected her face to look old, but it didn't. In fact, she didn't look much older than my mother, who at that time was in her early forties. Her skin was smooth and brown, with a spray of freckles across her cheekbones. I could hear my parents arguing and so could she, but she ignored them and just looked at me.

"That's just my nickname," I told her. "My real name is Keʻaoilunaokekai, but everyone calls me Luna. Sometimes the kids at school call me Looney, but I just ignore them."

"Looney," she repeated.

I don't know why, but the way she said it made me laugh, and then she started laughing too, and right there, I knew I was going to really like her. My parents stopped arguing, because my father had gotten whatever it was he wanted. My mother never won an argument. Her efforts at disagreeing were feeble and passive attempts at assertion, nothing more. The next thing I knew, my mother was out on the porch asking me to fill up the tub for my new auntie.

It turned out she was going to live with us, and she was given the attic room on the third floor that used to be a playroom. I was nine years old then, with two older sisters who went to boarding school and a brother in college in California. My parents had a big bedroom on the first floor. All us kids had our rooms on the second floor, and the attic was above. I hardly ever used it for a playroom anymore.

Looking back, I now realize that everything about Auntie was strange in the extreme, and I can only excuse myself from not recognizing it at the time on account of my youth, and because I was so fond of her. After my mother cleaned her up, washed and braided her hair, and dressed her in some clean clothes, she looked elegant. When she smiled, it was like the sun shining. She had long legs and arms, and when she moved, it looked like she was dancing.

She pretty much didn't talk for the first couple of weeks she was with us. She only repeated words and watched and listened. We had a television set, and at first, she used to spend hours watching, and sometimes I could see her repeating in whispers the things the characters were saying. She especially liked *Father Knows Best* and *The Adventures of Ozzie and Harriet*, I think because they spoke slowly and simply on those shows. Then one day, she just started talking like a normal person, only better. I found out later that when I was away at school during the day, my father had a tutor come and teach her how to read and do math and stuff, and she learned so fast that he hardly had time to collect his first paycheck. This tutor, or whoever he was, had explained to her how money worked, and after he left, she started asking my father about it, and he explained to her about banks and checking accounts and interest. Then one day, she asked him what the thing in the newspaper called the stock market was all about. He gave her a book to read and then took her into town one day to one of his advisors, who explained things to her. Then she and my father used to have these meetings about money and stocks, and the next thing I knew, Auntie bought an MG, learned to drive, and my parents were taking expensive cruises and long trips to foreign places.

Auntie loved to make clothes. She saw my mother at the sewing machine one day and asked her what she was doing. My mother explained about the machine, the patterns, and the fabrics, and before we knew it, all we had to do was show Auntie a picture, and she could make us anything. Auntie developed her own style. She liked slim, expensive-looking clothes—the kind she saw in *Vogue* magazine. And she loved sunglasses. She had a whole drawer full of them, and she used to let me wear any ones I liked, anytime I liked.

One of the first things she did after she got her car was to cut off her long hair (of course, she did it herself) into a short sleek hairstyle like the one she saw on Shirley MacLaine in that movie, *The Trouble with Harry.* That was one of her favorite movies. Sometimes she would take me to school in her MG. We would drive with the top down, wearing our sunglasses. She would pull up to the drop-off place at the elementary school where I was in the fourth grade, and I would get out of the car, take off the glasses, put them in my school bag, and run my hand through my hair like I'd seen women do in the movies. Then I would give Auntie a perfect Queen Elizabeth wave good-bye with my chin stuck up in the air. And she would always throw her head back in a laugh as she pulled away from the curb.

Auntie also learned to cook, and, much to my mother's delight, helped her out a lot in the kitchen. But there were certain things she wouldn't touch, like eggs or chicken or any other kind of poultry. She said it made her sick.

You would think that having such a beautiful and remarkable woman in our house would have caused trouble between my mother and father, but it didn't. Lots of people speculated and gossiped, but I know, because I was there, that my father was not remotely interested in her that way, and treated her like a younger sister. My mother may have been uneasy at first, but she quickly saw there was no attraction between them. In fact, Auntie did not seem interested in men at all, although lots of men were interested in her. Once, when a very handsome man was calling her up all the time and asking her to go out, I asked her if she liked him even a little bit.

"Well, Luna," she replied, looking thoughtful and tapping her lips with her forefinger. "No, I think I just don't give a hoot." And she burst out laughing.

Auntie's presence in our lives allowed my mother and father to have more freedom. They could go off anywhere, at any time, and Auntie would always be there to take care of me and my sisters if they happened to come home for the weekend. She would make us special dinners, take us to the beach, the movies, and hiking to special places. She loved to play card games. She had long clever fingers and could shuffle cards in extraordinary ways. Because I was the youngest and lived at home, I spent most of my time with her. The truth is, I liked her better than anyone else.

Sometime after she arrived, she helped my father on a new project. He decided he wanted to protect the bird life in the valley, and he particularly wanted to see that the pueo, the Hawaiian owl, population in the back of the valley had a chance to recover. I didn't even know there were any owls back there, but apparently there were a few. My father hired some workers. They did lots of fencing. They put out traps for feral cats and for mongoose, and we were not allowed to use any poison on mice or rats. He even fenced off a big area and then wiped out all the pigs inside the fence because he said it was a nesting area. We were all surprised that he wanted to do this with Auntie, because he never cared about anything like this before, and when we asked him about it, he said it was about time we started to take care of our land.

Of course I asked Auntie about it, and one day, when my parents were on a trip, she called my school, told them I was sick, and took me for a hike into the back of the valley. We walked for a long way until we came to where the mountains dropped down in steep, sometimes really sheer cliffs. The fenced area came up against the rocks and stretched way down into a grassy area, with ohiʻa trees. It was protected on the other side by a long rocky outcropping. It was pretty big, and the fence went into the forest, so I couldn't even see all of it.

"The pueo nests on the ground," Auntie said. "So the eggs and the babies are vulnerable. Look up there."

She pointed up in the sky. An owl was circling overhead and slowly descending. It landed on a tree stump inside the fence, and I swear to you it just sat there and stared at us. Auntie looked at it, and I think there were a few tears in her eyes. "So beautiful," she whispered. Then she wrapped her arms around me, and we both looked back at the owl. "Isn't he?" she said softly.

"Yes." I thought I could feel the owl's eyes looking into mine.

"I think he likes you, Luna."

I turned to look at her. "Why did you come to live with us?"

She smiled at me. "Finally, you ask."

"I'm not supposed to talk about it."

I went back to looking at the owl. He was shifting his weight on the tree stump. He was still watching us.

"Your father and our side of the family agreed to exchange favors. We decided to work together, so they sent me here."

"You're not going back, are you?"

"Not just yet," she said as she held me close. "But one day, I will have to go."

I don't know if the owl had puffed up his feathers or something, but he looked bigger. He spread his wings, took to the air, and circled the stump a few times before he flew straight at us—right over our heads—and disappeared into the mountains. We were both quiet. We walked. She held my hand, and everything was peaceful. The forest trees looked so green and alive, and the wind moved in soft waves through the leaves. Everything seemed to be slowing down, as if I was experiencing every moment on its own. The grasses swayed, and the clouds drifted, and soon we were sitting by a pool of water. The stream bubbled into a perfect circle and spread out silently into a transparent blue-green membrane. I remember thinking that it looked like a watery blanket covering something up. I took off my clothes and waded in, and then dove under, letting the icy coolness of the water swallow me under.

The next thing I remember was waking up, at home on the pūneʻe on our back porch. Auntie was sitting next to me, propped up by some pillows. She was crocheting.

"That was a long nap," she said, without lifting her eyes from her work.

"How did we get here?" I asked, trying to rub the sleepiness out of my eyes.

"We walked."

"I don't remember walking home." For some reason I felt unsettled.

She sighed and smiled. "How else do you think we got home? Maybe we flew."

"I just don't remember."

"We went a long way." She had the kindest way of talking. "Go back to sleep, and when you wake up, I'll make you something nice to eat."

It was during the summer, after I completed the eighth grade, that my father died. Auntie had been with us for about five years, and a few months after his death, she disappeared. My mother insisted that she never knew where Auntie really came from, and she didn't know where she had gone. Auntie left a letter with my mother saying goodbye, and she left me a card and a little locket with her picture in it. The card said she loved me very much and would always be with me. It felt like night had fallen and there would never be another morning.

The next years are a blur in my memory, so unlike the vivid days of childhood. I was sent to a girls' boarding school, like my sisters. By then, they were grown up. My brother and my oldest sister were married, and my other sister was in medical school. My mother hired caretakers for our valley home and moved into town. My school years flew by. I developed a taste for art, and spent most of my time drawing and learning to paint. I especially loved painting plants and flowers, and when I was ready to graduate, my high school art teacher encouraged my mother to send me to an art school. One of the art museums in town had a studio program, and I decided I wanted to start there because I didn't really want to go away just yet. I was happy living at home with my mother, and going to the studio classes, when my life suddenly changed. A week before my eighteenth

birthday, I received a letter from a lawyer. The letter was followed by a call for an appointment, and I found myself sitting across a desk from a man telling me I was about to be extremely rich and that some unnamed person had created an obscenely large trust fund just for me. My mother, who had come with me, turned to me with a wide-eyed look and whispered, "It must have been Auntie."

I have come to the conclusion that a clueless mother can be just as dangerous as a mean one. My mother definitely fell into the former category. I want to say she was naïve, but it was more like she just couldn't see what was going on around her. After my father died, and she moved into town, she started frequenting the Kamaʻāina Club—this snooty club my father had joined just because he could. They hardly ever went there when my father was alive, but now my mother was there three or four times a week. She ate lunch there, played bridge there, went to flower-arranging classes, and a book club. Besides being clueless, she used to talk a lot too, about everything under the sun. Most of her chatter was shallow and frivolous, but sometimes she was careless. I'm sure that's how I came to be on Evan's radar, because of my mother's idle chatter about the money. And I'm sure when she cajoled and begged me to eat lunch with her on that certain Thursday, it was by his design.

Evan Winters was not without charm or good looks. He had already beguiled my mother, and when we first met, he behaved in a very polite and circumspect way. I realize now he was extremely adept at sniffing out women who were vulnerable, and good at figuring out ways to use their weaknesses in his favor. Of course, he already knew certain things about me because of my mother's big mouth, but he was careful and methodical about moving in on me. He started that day by casually mentioning an art exhibit he had seen in San Francisco. Two months later, we were in San Francisco together going to the Legion of Honor to see the Pre-Raphaelite exhibit just before it closed. Then, a few days later, I found myself in Las Vegas getting married.

It is so easy to blame our mothers, isn't it? To call them clueless and to say it's their fault because they didn't prepare us for the nasty world. The truth is, I was clueless too, not about everything, but I was clueless about men. I had never opened the door to a man. Oh, I had been on dates and stuff, participated in make-out sessions, even had furtive sex once, but it was a brief encounter. It was more like an experiment, and I made sure it was over, with no lingering effects, the very next day. I knew nothing about real relationships with the opposite sex. Evan was the first man I had allowed into my life, the first man I had ever wanted to see again and again, the first man whose attention, flattery, and romantic overtures I had eagerly accepted. I admired his looks, his confidence, his articulate evaluations of people, things, and situations. I thought him so much more worldly and sophisticated than I was, and I couldn't believe he had chosen me out of all the women around him to be his. Yes, I was more than willing to accept the veil of illusion.

The first wake-up call came on the night we were married in that cheesy little wedding chapel on the Vegas Strip. I thought we were being so passionate and rebellious. After the whirlwind ceremony, we went back to our fancy hotel suite, drank champagne, and made love, but after the first time, Evan wanted to do it again. Then he wanted to do it again. Then he wanted to do it again, and again, and when I was sore, frightened, and even bleeding a little, I asked him to stop. He just laughed at me and said, "You didn't know it was going to be like this, did you?" The next

day, he half-heartedly apologized with a chuckle and mumbled something about having too much to drink.

We went back to the islands and set up house. I'm sure you've already guessed that my money would be supporting us, that Evan did not really want to work very hard (he had a part-time job selling very expensive foreign cars), and that he expected to have full access to my trust fund. The fortunate thing was that he could not get his hands on all of my money at once. The terms of the trust were that the money was to be doled out in certain amounts, year after year. It was more than enough for us to qualify for a fat mortgage and to live the lavish kind of lifestyle he craved. We bought a beautiful house in Pacific Heights overlooking the city. I had my own studio, and Evan had a three-car garage for his flashy cars. He always wanted to have parties. He had lots of friends, good-looking people I found loud, egotistical, and insincere. The first time I expressed an opinion at one of these soirees, Evan laughed and said in front of everyone that I didn't know what I was talking about. He did this frequently, and after a while, I just decided to shut up. I spent a lot of time alone in my studio.

I can remember the first time he hit me. We had a minor argument, and I was refusing to go to some dinner party he had been invited to. His hand came down hard on the right side of my face. I have to say, my first reaction was disbelief. I couldn't believe he had hit me. Yes, I had seen my father bully and belittle my mother, but he had never, ever hit her, and so the idea that this could be happening to me came as a shock. From that point, things got worse and worse. I will not trouble you with, pardon the pun, a blow-by-blow account, but now, something very different has happened.

Above this house, at the end of the road, there is a trail. It wanders along the side of Nu'uanu Valley and then up to the top of Konahuanui, the highest point in the Ko'olau Mountains. Evan had arranged an outing with some of his friends that included a little hiking and a glamorous sort of picnic at a spot he had picked out, a place with a fabulous view that overlooked the valley. I was a reluctant participant, in particular because Kitty McAndrews was going to be there, someone whom Evan flirted with shamelessly and whom I was pretty sure he was screwing.

The afternoon was exceptionally beautiful. It was bright with a breeze, and the air felt comfortable but not cold. There had been just enough rain to make everything green and just enough sun to keep the ground from being muddy. Birds wheeled and turned on the air currents along the valley walls, and the clouds flew by like beautiful big white notes on a blue song sheet. It was so lovely to be away from the city, from the urban neighborhood as nice as it was, and I had an overwhelming longing to move back to the valley, to the place of my childhood, to the place that had filled me with joy and wonder. We got to a stunning overlook, the chosen spot for the picnic, and immediately the alcohol and the ice cubes appeared, along with boxes of catered food, chopsticks, and pretty paper plates. Everything was nicely arranged on several large blankets.

As usual, I was pretty sure my trust fund had paid for everything, and as usual, after his first drink, Evan started flirting with Kitty. I was sitting on the edge of the blanket, watching them. They stood, two beautiful people on the edge of the cliff, with a backdrop of green and the mountains across the valley rising like ancient sentinels. The wind was blowing through her hair. She smiled up at Evan. Then, she turned ever so purposefully and smiled at me, just before she walked

away from him to go and sit with another couple, who were pitching pebbles over the cliff and singing some popular song. Eric, one of Evan's friends, was on the other edge of the blanket, eating grapes and drinking some horridly sweet-smelling wine. We were both focused on Kitty, and I hadn't noticed where Evan had gone. After a few minutes, Eric shifted his gaze to me.

"That Kitty is certainly a beauty," he said, hoping to get a reaction from me.

"I suppose she is," I answered. I tried to sound uninterested.

"I'm surprised someone hasn't snatched her up and married her," he continued.

"Poor Kitty," I replied slowly, "I guess it's too bad she didn't have a fat trust fund."

As soon as the words left my mouth, a hand came down hard on my head, grabbed my hair, dragged me to my feet. I screamed as Evan pulled me up the trail and slapped me across the face.

"What the hell do you think you're doing, talking to my friends like that?" he growled and slapped me again.

I could see the others frozen and staring at us. There were red drops of blood on my white shirt, and as I looked at them, the words came out of my mouth by themselves. "Everybody here knows if she had my money you would never have thought twice about me."

He hit me again and said, "Shut up, bitch. You just better shut up. Things could happen, you know, and all that money could be mine."

He was twisting my arm and pushing me down when Eric came over and said, "Evan, don't do that here, you're upsetting the others."

Evan smiled at him and let go of me. "Just a minor disagreement," he chuckled.

As soon as he let go of me, I got up and ran. I flew down the trail, and then down the street back to the house, sick to my stomach. The words echoed in my mind over and over again: *Things could happen and all that money could me mine. Evan, don't do that, you're upsetting the others.*

So here I am, hours later locked in my bedroom, locked up in fear with no one to help me. Here I am, looking down at the drops of blood from my lip, now on the white pillowcase. Here I am, thinking that I am not the one who is crying, but in reality, it is me. In reality, I'm praying that at the other end of the tunnel someone is listening. I do not know how many hours or minutes I have passed in this place that is neither here nor there, but now I feel a darkness moving over me, the way clouds or mist move slowly and gently over a landscape, and I am more than willing to be covered in this dark oblivion.

* * *

It is now two years since I have come back to the valley, back to my first home. When I told my mother I wanted to move back here, to my surprise, she said she was sick of the city and wanted to come with me. We still have our caretakers. They live in a comfortable cottage close by and help keep the grounds and the house in neat order. They are honest and kind—traits that I have learned, the hard way, to value above all others.

There is a dog, Raven, my black lab and constant companion. There are a couple of cats that wander around, one is orange and the other is a calico. I have turned the old attic room into a studio where I draw and paint and daydream. Sometimes, I think I hear Auntie laughing, and

sometimes I am sure she is close by. I wear her locket and never take it off. My mother decided to become a quilter. She quilts at home and goes to a group on Tuesdays. On Thursday afternoons, she plays mah-jong at her friend's house. I think they play for money, but not much money. My sister and my brother visit sometimes with their children, and we hike and play games and eat very well. My other sister, who is almost a doctor, visits during her vacation, and tells us all what we should and shouldn't be doing to stay healthy.

And there is Keanu. He is a graduate student who is getting his doctorate in zoology. He is an ornithologist, to be more specific, and he is writing his dissertation on the Hawaiian owl, the pueo, *Asio flammeus sandwichensis.* Another thing Auntie did, unbeknownst to any of us until Keanu appeared about a year ago, was to set up a generously funded foundation that included scholarship money for the study and preservation of the pueo and their habitats. Keanu is the first person to qualify for the scholarship, and the first ornithologist to ever pick the pueo as his focus of study. The area that my father and Auntie fenced off so long ago is one of the main habitats that he uses for his study. Sometimes he goes to the Big Island, where there are still prime habitats for these special beings. Keanu is considerate and easygoing. He is dedicated to his work. Beyond living in a reasonably comfortable way, he doesn't care that much about money. His favorite meal is barbequed chicken. He has a quirky sense of humor, and my mother finds him very funny. I am helping him by making drawings for his dissertation. I think he is in love with me, and while I am happy so far to spend my days with him, I find it hard to see any advantage for myself in being married.

But now you are wondering what happened to Evan. After two years, I am finally able to think about it and feel distanced and safe. Time may not heal all wounds, but it can give meaning to them.

That night, after the "incident" on the trail, Evan did not return home. I had run home in the late afternoon and fallen asleep at dusk, only to be awakened by the phone ringing some hours later. It was Eric. He sounded completely hammered, and he mumbled something about Evan and an accident, and the hospital. A few minutes later, the police came knocking on the door to inform me that there really had been a serious accident. There was a rush to clean myself up and hide my bruised face. There was a fast ride to the hospital. When I arrived there, I met with the doctor, who informed me that Evan had been pronounced dead. It had barely been an hour since Eric's drunken phone call. I think there may have been some of the others from the picnic at the hospital, but I left right away. I told the doctor I did not want to see the body and would make the necessary arrangements.

After listening to everyone's story—with the exception of Kitty, they all had to call me before the funeral and tell me what they saw—I have pieced together a picture of what happened. It seems it took barely five minutes after I left before the party resumed. They went on a little hike farther up the trail. They got back in time to watch the sunset. Apparently it was a particularly spectacular event, with vivid changing colors in the sky. Evan and Kitty were off by themselves, standing on a flat rock overlooking the valley, where they had an exceptional view. No one wanted to disturb them. Kitty had turned away to refill their cups of champagne (yes, of course they had champagne) when a large bird appeared in the sky, flying from the direction of Konahuanui. The

bird gave several piercing cries and dove straight for Evan's neck, knocking him off balance. It retreated and attacked him again. The third time, the bird succeeded in causing him to trip over his own feet and to fall over the cliff to his death. None of Evan's friends knew anything credible about the natural world. They could hardly tell a mynah bird from a ring-necked dove, but I didn't need any of them to identify the winged spirit who delivered me from evil, the one who listened at the other end of the tunnel.

There are some people, many people in this world, whose deaths I will mourn, whose presence I will genuinely miss. I want to say that I sincerely wish them all a natural, painless, and easy passing from this life. But, there are others whom I would just as soon see die from being rolled in a nail-spiked barrel, their bodies thrown over a cliff and forgotten. And if you think this is callous or spiritually immoral of me, I would reply as my favorite auntie once did: *I just don't give a hoot.*

Artist Statement for " 'Āina Hānau"

Brandy Nālani McDougall

I am a Kanaka 'Ōiwi poet, and my work is rooted in the rich literary genealogies of mo'olelo, mo'okū'auhau, and mele, and honors Hawaiian 'āina, culture, histories, aesthetics, and futurisms while also aiming to expose and fight against American imperialism, militarism, and social and environmental injustice. As a makuahine, I can't help but write with a sense of urgency.

'Āina hānau refers to the land of one's birth. The poem " 'Āina Hānau" was written for my daughters and reflects on what it means to have an 'āina hānau, to be from and belong to a place, as well as what it means to *be* an 'āina hānau, as all mothers serve as the first birthland for their children. To ho'omakuahine, to act as or to be treated as a mother, is a tremendous honor and kuleana. I wrote this poem as part of my own continuing journey as a makuahine living in this time when much of our culture, history, and knowledge, including our birth practices and approaches to caring for and raising children, continue to be repressed or dismissed. Part of the kuleana of having keiki has meant that I need to do whatever I can to reconnect with 'ike kupuna (ancestral knowledge) and, in turn, teach my keiki.

This poem is inspired by the Kumulipo, a 2,102-line mele ko'ihonua (genealogical chant) that traces all life born from Pō—the creative darkness, who herself spontaneously emerged from the "walewale ho'okumu honua," the fertile slime that creates the earth. From its very beginning, the Kumulipo gives us a record of life and life-giving creation, emphasizing interconnection and interdependence. Pualani Kanahele notes in the "Foreward" (using the title to indicate both its place as a foreword, but also to imply "forward" momentum) to Queen Lili'uokalani's translation, published by Pueo Press, that the Kumulipo "recognized that the interrelationship of all things is an everlasting continuum" (1978). Among the many important lessons of the Kumulipo is that 1) we, as 'Ōiwi, are genealogically related to all other lifeforms in our lands and waters; 2) in the order of creation, we humans are the youngest lifeforms since we emerge after all plants and other animals; and 3) like all other lifeforms, we come into the world through hānau. The Kumulipo is endlessly regenerative—a mother giving birth—in countless ways for our people.

In his 1865 Hawaiian-English dictionary, Lorrin Andrews translates hānau as a verb that means "to come from or be separated, as a young animal from its mother; to be born." Separation in this case infers the movement from being in or part of a mother to being in one's own body out in the world. Despite Andrews's example applying to animals, the Kumulipo describes stars and constellations, as well as ocean and land plants, as being born in this way, too. To be born, then,

is to be separate, yet always *from*—ʻāina, ocean, genealogies, ʻohana. Our *from-ness* is a way for us to know we are always connected; however, our separateness requires us to learn how we are part of the creative continuum of connection for all other beings.

This includes understanding our place in the birth order as the last to be born. From an ʻŌiwi perspective, being the pōkiʻi, or the youngest, in an ʻohana means that you are cared for and often doted on or indulged; however, pōkiʻi are also vulnerable and dependent on the ʻohana and must understand their place as needing to learn from, listen to, and be guided by their wiser, more experienced older family members. This manaʻo is at the heart of core concepts of our culture such as aloha ʻāina, which emphasizes that we should learn from, care for, and protect ʻāina because we are dependent on all that the ʻāina provides for us.

"ʻĀina hānau" is a poem comprised of stories of creation, renewal, and birth that I hope will teach my children about their deep familial connections to our ʻāina and every other being, seen and unseen, upon it. Some of these stories are broad in their scope, reflecting on ʻŌiwi creation stories, on space, time, moʻolelo, water, and the qualities of personhood. Other stories are personal, sharing my own experiences of being hāpai and giving birth, of learning and sharing ʻike kupuna, as well as my hopes for my daughters. The selections included here are *fantastic* in all the ways that I understand our ancestral stories to be, and by that I mean *truthful*.

The fantastic urges us to suspend our beliefs and fully open ourselves to a creative experience—as if we have just been born, as if we are mothers giving birth to children, to poetry, to music, to movements. The fantastic transports us to new or ancestral worlds, opening our imaginations so we can remain ever hopeful as we actively create new realities and contribute to cultural and political resurgence in the present. The fantastic gifts us with what has been and what can be, if only we let go of the constructed *now* even for a moment.

The decolonial implications of the fantastic, especially when born in our own communities, are nothing short of revolutionary. Colonial systems (and those who wield or are otherwise aligned with them) are maintained and reinforced with lies, with stories of scarcity, chaos, and devastation should the ongoing oppression of our peoples and abuse of our lands and waters end. Or we may hear lies about how colonialism is good for us—a savior, or a place of refuge, safety, and abundance. Or we may hear lies about how we are deficient, unworthy, somehow deserving of violence. Some of these lies are laughable and easy to dispel, but others can be internalized within our communities, where they can generate fear, complacency, and hopelessness.

Central to decolonial fantasy is the truth and the journey toward truth—taking a hard, unflinching look at colonial systems and projects and resisting and overturning the colonially imposed limits on our capabilities and ongoing connections with our kūpuna and ʻāina. In turn, the fantastic has the potential to strengthen and continue our ancestral knowledge and intellectual practices, including learning, sharing, and interpreting moʻolelo, and to show us how our ʻāina and our bodies and spirits can be liberated, healthy, and able to reach our greatest potential. But beyond all that, the fantastic also reveals the truth that all of this, all that we can dream and envision, is always achievable and just a breath (and birth) away.

I hope my daughters always know they can birth generations of good, green dreams and breathe them into being.

Works Cited

Andrews, Lorrin. (1865) 2003. "Hanau." *A Dictionary of the Hawaiian Language*. Originally printed by Henry M. Whitney. Waipahu: Island Heritage Publishing.

Kanahele, Pualani Kanakaʻole. 1978. "Foreward." In *An Account of the Creation of the World according to Hawaiian Tradition*. Translated by Liliʻuokalani. Kentfield, CA: Pueo Press.

Recommended Reading

An Account of the Creation of the World according to Hawaiian Tradition. 1978. Translated by Liliʻuokalani. Kentfield, CA: Pueo Press.

Beckwith, Martha, trans. and ed. 1951. *The Kumulipo: A Hawaiian Creation Chant*. Chicago: University of Chicago Press. Available at: Internet Sacred Text Archive, https://www.sacred-texts.com/pac/ku/ku31.htm. Accessed July 28, 2021.

"The Kalakaua Text, Pule Hoʻolaʻa Aliʻi, He Kumulipo no Kaʻiʻimamao a ia Alapai Wahine." Kalakaua, 1889.

McDougall, Brandy Nālani. 2019. "Genealogizing Colonial and Indigenous Translations and Publications of the Kumulipo." In *Oceanic Archives, Indigenous Epistemologies, and Transpacific American Studies*, edited by Kendall Johnson, Otto Heim, and Yuan Shu, pp. 129–146. Hong Kong: Hong Kong University Press.

Selections from "ʻĀina Hānau"

Brandy Nālani McDougall

for Kaikainaliʻi and Kuʻuleihiwahiwa

1.
As it is told
there was darkness,
the deepest blackest
darkness called Pō
turning in her sleep,
knowing what it is
not to breathe,
to verge between
need and climb.
He pō wale kēlā,
He pō wale kēia.

Her sleep was motherly—
thin and uneasy. She
dreamt of flying and falling.
Her turning churned
the dark to heat to light
then to fire. She awoke
and gave birth first
to herself.
He pō wale kēlā,
he pō wale kēia.

The earth and heavens
turned hot and darkened.
Stars erupted on her

Previously published: McDougall, Brandy Nālani. 2023. "ʻĀina Hānau." In *ʻĀina Hānau / Birth Land,* pp. 101–138. Tucson: University of Arizona Press.

skin. Makaliʻi watched
as the walewale flowed
from her and welled
over it all and every
where and when
was breath.
He pō wale kēlā,
he pō wale kēia.

2.
Eia Hawaiʻi, he pae ʻāina, he mau
moku, he mau kānaka, he mau
kānaka nui Hawaiʻi ē. He mau
Hawaiʻi kākou mau a mau.

Like you, these islands were born.
They came from Kāne, from Kū,
from Hina, from Lono, from Kanaloa,
from Haumea, from Papa, from Wākea,
from Hoʻohōkūkalani, from Kaula,
from Lua, from Māui, from Pele,
from the deep darkness of Pō: Hawaiʻi,
Maui, Molokaʻi, Lānaʻi, Oʻahu,
Kauaʻi, Niʻihau, Kahoʻolawe.
They fed on water, salt, and heat,
crawled and then stood up in the light.
They grew tall and wide and turned
and slept and laughed and ate and
fought and shared in black and brown
and green and red. They inhaled earth
and exhaled mountains, beaches, pali
and pōhaku. They inhaled sky, exhaled
the rains, winds, clouds and stars.

Like you, these islands were born,
and every part of them born. Coral
children, worm children, shell, fish,
limu, grass, gourd, ocean and forest
children. Children of rock and vine
and shrub and tree, fruit and fur.
Water children of salt and spring.

Insect children. Seeded, propagated,
corm children. Children who slither,
crawl, cling, and creep, who curl and unfurl,
who hatch, peck, bite, glide, and fly.
Rooting, digging, hill-building
children. Hiding, peeping, nesting
children. Brindled, speckled, tentacled,
shape-shifters. Those with eight legs,
with eight eyes, those with four
and two. Those with fins, with iwi
and without. Tasters who sing
their names, and hearers who
answer or retreat. Children of howl
and screech, of paw and claw,
blind and sighted, tail and tendril,
skin and scale, web and wing,
stemmed, veined, and rooted.
Children o ke au iki a ke au nui.
'O nā mea 'ike maka 'ia,
'o nā mea 'ike maka 'ole.

Older, wiser children born
breathing long before us. Born
like you. Like these islands.

<p style="text-align:center">*　　*　　*</p>

6.
High in the mountains
in the piko of each
of these islands,
where earth sieves
the sky in the kua hiwi,
the kua mauna, the kua
lono, the kua hea,
the wao kele, the wao
akua, the wao lani,
where the air is
a thick howl and
the gods are seeds
of cold cloud mist

billowing between
short, bent trees

na wai ka moʻolelo hānau?

Descending to
the wao ʻeiwa,
the wao lipo, the
wao nahele,
the wao lāʻau,
where ʻōhiʻa, koa,
kukui, and aʻaliʻi,
where māmane,
lauaʻe, wiliwili,
and ʻōhelo, where
alaheʻe, ʻūlei,
kauila, and maile,
where the uhiuhi,
kōkiʻo, ʻaiea, and
halapepe arouse
fat clouds with
sweetened wafts,
where the fog lingers
and drips and birds slurp,
their songs seeding
the understory

na wai ka moʻolelo hānau?

Flowing down
the ridges, over beds
of lipo, mossed
pōhaku, ʻiliʻili,
upwelling cool,
the gushing puna
of underground
arteries, from the
darkened blur of
cloud shadow
to the wao kanaka,
the wao ʻilima, the

wao ʻamaʻu, the kula,
where kalo, ʻuala,
ʻawa, wauke,
ʻulu, and maiʻa
flick and clatter
their leaves, and
tufts of tangled
pili ribs bow to
bury their seeds

na wai ka moʻolelo hānau?

Flowing still
to the muliwai,
where stream
and tide stir,
swirl, the murky
mouth, soil, salt,
and green gurgle
eddying brown,
mottled where
the seeds of moi,
āholehole and
ʻamaʻama feed,
their dark spines
concealing as
they dive together,
channeling
current

na wai ka moʻolelo hānau?

* * *

9.
With you
my body was Pō,
some unknowable
dark dwelling full
and slow. The world
was water to you.

I hope it was heart-
beat and song, too.

When you were
wing flutter I slept
long and had dreams
of flying and falling
from where toward
where I don't know.

When you were
heleuma turning
and sinking, my body
swelled and flooded.
Sleep was in waves.
I dreamed of my
father, who loved
the ocean, and woke
in sweat. On my skin,
silver rivulets zigzagged
like lightning from
my piko. A dark line
trickled down from
my heart and up from
beneath my belly, over
the whole of you,
the whole of me.

The world was water.
And heartbeat and
song. I was an opening
nuku, almost high
tide, a heavy heap
of cloud, full and still
somehow floating.

* * *

12.

I'm not sure where I first heard that ʻŌiwi women
do not scream when they hānau, that doing so would
be considered embarrassing or attention seeking.

I've never seen another ʻŌiwi woman hānau, not
even your aunties, and it never seemed appropriate
to ask. I can tell you, though, that when the time came
I didn't scream—not because I was worried I wouldn't
be ʻŌiwi enough if I did, or that somehow I'd bring
shame to my ʻohana (those kinds of self-conscious
thoughts don't really happen since your focus isn't
on what others might think of you)—but because
screaming seemed so loud and outward, when all I
wanted was to go inward. When you hānau, you stay
with your body, pulsing through every contraction, but
in the soft lull between the rise and fall of waves you find
hānau makes time stretch slippery tentacles to hold you
as you slide between pō and ao, not quite dreaming.

* * *

16.
E kuʻu mau ʻōmaka i ke kīhāpai:
may you always know these islands,
like you, daughters, are more
than enough, know that like you,
they are everything beautiful,
everything buoyant. Their winds
and rains and mountains, ravines
and valleys love without question.
Like our islands, may you give birth
first to yourselves then love always
with green tenderness, thrusting
your hands into mud, opening
your body into ocean, knowing
these islands are here for you,
for your children and their children,
knowing we *are* these islands.

For you, may there always be refuge,
safety within the walls you reach,
behind borders, under flags, and in
your own bodies. May you always
be grateful for peace, for open harbors
not freely entered, for treaties honored,
for nothing taken that was not first

given, for iwi still earthed, for new
coral growth unbleached, for black
cloud cover and trees, breathable air,
a beach, stream, or ocean without
plastic tangle or sewage or toxic seep.

I wish you words and medicines
that lift and heal, vegetables and fruit
from organic earth, free-flowing waters
from mountain to ocean, daughters, cool
and clean, unowned, shared. I wish you
ocean-salted rocks and shells you can taste
and hold in your mouth, blades of grass
and ridged bark—all coolness and warmth
to press to your cheek, to your lips. May you
know love in every form, but always
in the food you eat, that you love the crust
dried poi makes on the skin around your lips,
the dark green of lūʻau, soft steam of ʻulu,
of ʻuala, the way you must slurp the red wild
of ʻōhiʻa ʻai—all from ʻāina you've curled
your toes into—may you always be full.

May there be hiding places to keep you
as hidden as you want, climbing places
to keep you above, flying places, resting
places, low-lying and high cliff caves,
more places carved by winds and rains,
salt and waves, fragrant jungles, terraced
gardens, islands old and still being born,
places where you wait for welcome,
places that you know are not for you
or anyone to enter—may you protect all
of those places and may they protect you.

May the wind and waves lift you up
and may you let yourself fly, wonder,
from a pali overlook as ʻiwa or pūʻeo
circle above, or as koholā or naiʻa
breach through ocean in the distance,
about lightness and sky—that you

remember you can rise high above
whatever may hold you down.

May you hear these islands breathe
with you, let them be big enough
to carry you, small enough to carry
with you. May you know these islands
depend on your breath, that the ocean,
rains, and winds need your voice.
That every green growing thing lives
and births more green growing.
That there is safety and warmth
enough, shade enough when you
need it—water, food, shelter, love.
That you sleep deeply and
let yourself hear our kūpuna.

May you know smallness—know
to be careful and think of unseen
workings, to remember the smallest
can be the strongest, to feel you are
islands like ours, not separated
by ocean—but threaded—your roots
woven and fed by the same fire
and water and salt and darkness.

May you know immensity, too—
that even when you think you are
alone, that you feel the ocean
in your sweat and tears, that you
watch rain wash the hillsides
into a dark stream and see your skin,
that the sun, moon and stars, dark
underwater caverns, underground rivers,
all you see and don't see of ʻāina,
are your kūpuna, your ʻohana in
your every breath, that something
of you, something of all of us before,
and something of all of us to come
are these islands. May this always
be with you: E ola mau, e ola nō.

Artist Statement for *Līlīnoe*

Joy Lehuanani Enomoto

This work is one of twelve digitally enhanced drawings of the akua and flora of Mauna Kea I made for the Mauna Kea Syllabus Project in 2020. This image is a rendering of the akua Līlīnoe, who is the fine rain or mist that prepares the hair of her sister, Poliʻahu. She is also the akua of Haleakalā, dead fires and desolation. While her mist can be beautifully delicate, it can also be unpredictable, threatening and powerful enough to blanket the slopes of the Mauna rapidly and thick enough to remove all visiblity. I experienced the power of Līlīnoe during the 2019 standoff against the Thirty Meter Telescope as a presence that was all-encompassing, unbound and undefined by clear edges. This is why I chose to draw her as part being that is atmospheric, in constant motion and made from mist. She is a reminder of the realm of the wao akua.

Joy Lehuanani Enomoto, *Lilinoe,* 2020.

Previously published: Mauna Kea Syllabus Project. https://www.maunakeasyllabus.com/.

Artists' Statement for "Across Lewa and Kikilo" and *Ma Waena*

Nicole Ku'uleinapuananioliko'awapuhimelemeleolani Furtado and Sofia Kaleomālie Furtado

Nicole: "Across Lewa and Kikilo" was created during a graduate-level seminar with Dr. Nalo Hopkinson. After I visited Maunakea in June 2019, I was inspired by the ongoing struggles and land protests happening and tried to connect my own observations and conversations of the events unfolding. The story pulls from my own embodied experiences, but the majority of it is written from an amalgamation of people, places, and events I've come across. My own love of science fiction is influenced by the storytellers Solomon Enos, Nalo Hopkinson, Phillip K. Dick, and Octavia Butler. While I aspire to create more creative writing works, I am grounded in critical writing. However, I seek to combat the misconception that there is a vast difference between the two. I want my critical writing to embody creativity and believe that creative writing is also critical and incredibly theoretical.

I approached this story with the specific question of "What would happen in the next 241 years of colonialism in Hawai'i?" The year the story takes place in is significant. When I wrote it in 2019, I calculated how many years it had been since Captain Cook's arrival in Hawai'i. Therefore, I added 241 years to create the story in AD 2260. While much has changed over time in the story, I wanted to convey that resilience is key for persevering and thriving within Kanaka Maoli culture. The protests that happened at Maunakea inspired me to ask, "How far will people go? To desecrate Maunakea? Until there is nothing left but forgotten memories, sadness, and performative cultural actions like Waikīkī?" While climate change issues are also at the heart of the story, I want to convey a sense of hope for the future, in which the main character, Leilani, remembers something critically important after an urgent reconnection or pilina to the past occurs.

Sofia: As Nicole's younger sister, I was fortunate to witness her writing process. Her speculative world of Nouveau Waikīkī incited my deep concern for the future of Hawai'i and its dwindling resources from our 'āina. *Ma Waena,* or *In Between* (**Plate 11**), depicts several key elements such as the Hyper-Rail, submerged islands, climate-impacted environment, code-activated visions, and Leilani herself. *Ma Waena* offers a visual insight into the world of Nouveau Waikīkī and reveals a glimpse of Hawai'i's past. Exposure to a once-vibrant beach framed by Native Hawaiian-inspired motivic code is featured. Leilani's metaphysical sensations after using Keanu's code heavily

influences *Ma Waena*'s uneasy, glitchy, reality-breaking color palettes. The striking diagonal blue streak of motivic code "peels" back a corner of the Nouveau reality and disrupts the standard binary code framing the right side of the piece. Not only can you see the Nouveau code being interrupted by the past motivic code, but viewers can bear witness to past and future realities being caught in transition to one another. Time and space merge into a central point where the Nouveau reality is interrupted by "old Hawai'i." In this piece, viewers are in-between the convergence of Hawai'i's time and space.

Across Lewa and Kikilo

Nicole Ku'uleinapuananioliko'awapuhimelemeleolani Furtado

Inside us the dead,
like sweet-honeyed tamarind pods
That will burst in tomorrow's sun,
or plankton fossils in coral
alive at full moon dragging virile tides over coy reefs
into yesterday's lagoons.

—Albert Wendt, "Inside Us the Dead" (2000)

Prologue

Are you listening? Good, you're going to have to follow along closely on this journey. The story I'm about to tell you requires you to see an ocean oasis swallowing up lush, green islands sunken in. Drowned continents everywhere, the sea levels continue to rise, and those from these islands must either leave or wait to one day be consumed. The rich and powerful in this world huddle together in their luxe, clutching the last of their earthly materials in a marriage of tech and tourism atop the highest point on Earth—Maunakea.

YEAR: 2260

The Hyper-Rail glided quietly just above the deep ultramarine colors of the ocean below. It moved through with such light-speed efficiency that none of the cool water was disturbed, as a clear image of the deteriorating architecture underneath reflected deep into the depths of the Pacific like submerged galaxies. Schools of fish, other ocean animals, and algae swam and moved through the budding coral reefs of buildings from the centuries prior. Crushed asphalt and crumbling concrete where sidewalks and roads used to be, apartment complexes, skyscrapers, cars—all the collateral from the Earth's infuriated climate catastrophes that continued to drown the world.

Leilani arrived at the platform right before the sundown simulation. As the doors warped open, an artificial voice enunciated through the train's intercom, "Aloha, final stop in Nouveau Waikīkī."

She hurried through the exit, wanting to beat the crowd of mostly tourists and haole foreigners wearing plastic leis and flowers topped off with kitschy aloha wear. The tourists had all most likely finished island hopping, or at least what remained of the four Hawaiian Islands that weren't completely covered by ocean water. 'Ukulele music played softly as the geodesic dome screen of

Nouveau Waikīkī projected a sunset of bright pinks and oranges. This image was coupled with a synthetic feeling of a warm breeze of exactly seventy-three degrees. Nouveau Waikīkī attempted to replicate accurate humidity levels using algorithmic data fostered from the Americana imaginary and memory of what Hawai'i had once been, before all the environmental destruction. However, getting the weather *just right* was the only thing proving hard to mimic.

The Acclimation Centre in the middle of Maunakea was necessary to continue to the uber-glitz, ultra-riche, super resorts that were built at the top of the mountain. Leilani waited for her oxygen mask to adjust to the atmospheric change and not cause her lungs to burst when she reached Maunakea's International Shopping District. Leilani always felt unnerved here, like the place stood for something long forgotten. She could never sort out the feeling.

Warning signs in the Centre told tourists that the oxygen acclimation masks were necessary, otherwise their tech-cation would be ruined due to either not being able to breathe properly or the shutdown of their bodily functions because of the high altitudes. It only took three minutes for Leilani's mask to ensure her body was ready.

Nouveau Waikīkī was a tech-cation outpost for the elite in the tragedy of the world's changing climate and a monument to humanity's last-ditch effort to remain above water. The rich were shopping on borrowed time, but from inside the luxury boutiques and supertech hotels, you'd never see them worry about it. Nouveau Waikīkī was also the only place that threw the best parties on Earth in an effort to forget the dire circumstances of the fate of the world.

A message glitched inside of Leilani's iris, and a small screen displayed the data of the message into her consciousness visually. She touched the button of the thin communication device placed in her ear.

"Hurry up!" Keanu's voice echoed with a pressing playfulness in its hurried exasperation. "I just got to WaveHaus. I have a Mod-Tab waiting for you."

Leilani laughed and materialized a message back with her communication device. "Be there soon, don't take the Mod-Tab without me."

She entered confidently onto a moving walkway toward the nightlife district of Maunakea. As Leilani adjusted her communication device in her iris to navigate to WaveHaus, a holographic ad burst in front of her. The ad interrupted Leilani's movements and caused her to input the incorrect route. The hologram's hips swayed in languid gestures of hula movements. Leilani stared at the ad with annoyance. It was a digital rendering of a hula girl: wavy brown hair dipped into the waist of her grass-lined skirt, plastic lei obscured everything but the outline of her breasts.

"Aloha. Mahalo," the ad said and smiled. It never broke eye contact and moved its hand up Leilani's shoulder.

Leilani took a step back, as an 'ukulele appeared in the hula girl's hands. A dancing pineapple and talking tiki statue also popped up to accompany the hula hologram. Together, all the holograms began to sing a new ad for an augmented-reality swim and surf lesson on a virtual beach with dolphins. Leilani stared long and hard at the holographic hula girl image and hopped onto another moving walkway, this time in the right direction. She lamented the constant American Neo-Democracy mandated updates on the tech in the islands. Those updates always created more and more aggressive encounters with the tourism advertisements everywhere in Hawai'i.

She hated coming into Nouveau Waikīkī with its endless crowds of people visiting, but it provided a temporary reprieve from the constant threat of flooding on her home island. Leilani never told anyone because she didn't think anyone would believe her, but every time she visited Maunakea, mysterious words, like a song, would float to her. The first time she came to Nouveau Waikīkī to visit the artificial beaches as a little girl, the unfinished and curious words had sung in her head. She didn't know what the words meant, but each time Leilani came to this place, they would get clearer and clearer. Like a forgotten song stuck in her head that she only knew the rhythm and beat to, she had been here enough times that she could make out the peculiar words "he aha ka puana o ka moe?" Hell if she knew what they meant or why they always rang in her mind when she was exploring the city, but Leilani knew that even if she told someone the words, no one would be able to tell her what they meant.

Leilani arrived at WaveHaus and sent a message to Keanu through touching her earpiece and visualizing the message in her iris. "I'm outside."

She looked for him among a crowd of young tourists. Their alabaster skin tanned to a crisp color from the simulated sun and from having frolicked on man-made replications of beaches. The group laughed, loud and obnoxious on too many Blue Hawaii cocktails, as she moved past them.

Keanu's tall form walked quickly out of the WaveHaus club. She could tell it was him because of the mishmash of blond and black hair and his new iridescent jacket they bought together shining in the night. Their eyes met. Leilani saw by the way the glitter on his face crinkled that he was irritated with her.

"Why are you so late? The Hyper-Rail is never even a millisecond late. We still have to drop our Mod-Tabs and P0pKilleR is about to perform!"

"Yes, yes—I'm sorry. It was a long day hustling the island-hopper tourists and my car got flooded after work."

"How do I look?" Keanu asked.

"Amazing. How do I look?" Leilani straightened the pearlescent dress she had thrown on before she left home. "What if Mason is here tonight, too? The military has some sort of banquet for them in Nouveau Waikīkī."

Keanu rolled his eyes at the thought of Leilani's ex-fling Mason. He took a dramatic and flagrant bow, then grasped Leilani's hand to place a small kiss on it. He finished the gesture by outstretching his arm for Leilani to take hold of.

Leilani giggled. "What are you doing?"

Keanu laughed. "I don't know. I saw it in an old movie called *Titanic*. Seemed cool cuz it was a movie about everything sinking. It was so old, I had to backward-stream it to play on my video scanner. Point is, who cares if we run into Mason? We're *the* dynamic duo. We got this."

Leilani snorted, but felt grateful Keanu was trying to cheer her up. Keanu paused and took a long look at her outfit.

"I do think you need more glitter though."

He pulled out a glitter outfit modification that shimmered in the night and blew it gently onto Leilani's face and body. Leilani spun around to make sure it covered her evenly.

They continued their conversation on which audio render they thought P0pKilleR was going to stream as they moved through the illuminated bright lights of the moving walkway of Wave-Haus. The floor and walls danced to the fast beats, and a symphony of music and lightshows leaked from the inside of the club toward them, indicating it was going to be crowded. Leilani felt optimistic that it was going to be a good night.

"Did you streamline your clubbing mod? You need the latest update to even party here," Keanu said.

They scanned through the heavy security and flashed their identification. Leilani was a bit nervous to sneak in their Mod-Tabs. Drugs, even artificialized digital ones, were still technically illegal on most of the islands. There were six heavyset security guards searching bags and making sure people brought the proper clubbing mods to plug into the nightclub's extra features. As they passed through security, a scantily clad woman with bright blue hair and silver pasties waited to take their cover charge.

"Keanu! Leilani! What are you two doing here all the way from Oʻahu?" The woman looked up from her desk to greet them.

"Kaycee, I didn't know you got this new gig over here!" Leilani smiled at seeing their friend. Kaycee was witness to Keanu and Leilani's adventures whenever they came to Nouveau Waikīkī. Whether she was working as a cashier, hostess, or in the different bars, Kaycee hustled different jobs in the leviathan of the techno-tourism industry on Maunakea and they always bumped into her everywhere.

"Yeah, you know how it is. They got me plugged into all the different tourist-trap jobs out here. My teleport clock-in at the next joint starts in . . ." She pressed the communication device in her ear and her iris flashed with code. "Four hours. I'm honestly just happy to see some familiar faces. Go on in, no need to worry about paying cover." She waved them in.

"You're the best!" Keanu bolted in—excited to start the night.

"Yeah, yeah. See you two again next weekend, yeah?" Kaycee laughed as the strands of her blue wig reflected the light emanating from her silver outfit.

Leilani waved her goodbye before stepping into the bright lights and fast-paced music of the club. Her anxiety about taking the Mod-Tab kicked in again.

"You picked up the Mod-Tab from Vinny, right?" Leilani whispered as she used the latest immersive clubbing tech to plug into her surroundings.

"Ugh, don't worry! It's high-quality shit!" Keanu said while doing little dance moves with his hands.

She pressed the communication device in her ear and her senses immediately flipped. Prismatic colors erupted behind her eyes as she was anchored into the party. The light shows and bodies inside the club pulsated and moved in time to P0pKilleR's beats—a shining array of luminescent gleams. To an outside observer, it looked like a low-key gathering of people, but the clubbing mods allowed the party to come alive in the lowlights of the club. Leilani's senses were manipulated with digitally transmitted visions that interconnected with the other patrons. The illegal Mod-Tabs Keanu brought were supposed to enhance her ability to interplay with the high-tech of the club. Keanu's body glitter danced in time to the beats as he handed her the Mod-Tab and effervescent light streams waded around their bodies.

Leilani smiled big at Keanu as she moved her fingers around the tangibly warm and delicate light waves emanating from the DJ booth toward them. "Technology is kind of magical, yeah?"

"This Mod-Tab is called Vapor Wave. Make sure security doesn't see you taking it. I heard this one really responds to stimuli."

She always got a little nervous with Mod-Tabs. However, she deserved this, right? Everything was sinking and one day she'd have to leave the islands. Was there even going to be a next place left on Earth to go? The Mod-Tab was going to provide her and Keanu a fun getaway in the getaway capital of the world.

Keanu had already eagerly dosed his Mod-Tab before handing Leilani her own. She could tell by the dreamy look he had on that it was already amplifying his surroundings by the little fireworks of code exploding in his eyes. Leilani took the thin, vaporous Mod-Tab of code and made a peace sign with her two fingers as she inhaled it deep into her lungs. It released quickly, like the spark of a flame to light a cigarette.

She smiled again at Keanu—waiting for the Mod-Tab to give her more access to code. However, Keanu's face rapidly began to spin. Leilani stopped smiling and shook her head. She looked at him again, but everything felt swift and slow in her body at the same time. Leilani couldn't recognize him.

"That's Keanu. I'm at WaveHaus."

That was the last thought Leilani had before the entire club started to melt in a swirl of colors and dying radiances. Her body oscillated between feeling heavy and light. Leilani knew she was screwed when what felt like her soul poured out of her body. She tried to make sense of it all, but nothing made sense. Leilani dropped to her knees as the atmosphere felt curved in a tunnel that moved backward past her in a detonation of stars, effusions of water, and a feeling of the cosmos falling away. A swell in her mind and a ripple that felt like it was ripping apart dimensions of existence made Leilani shut her eyes.

Leilani's hands dug into her skin, her body tense. She was too scared to open her eyes and she wasn't even sure they would open if she tried. Her entire being felt oblique, but the soft, fine texture poking gently on her legs made her curious.

Leilani fluttered her eyes open, blinking a few times to catch up to what she was seeing. She was sitting on a beach. Leilani grasped at her neck, ears, and everywhere else a mod was placed. She couldn't find any. Was this a *real* beach? She had never actually been to one as beautiful as this—most were all augmented reality. Leilani stared transfixed at the powerful ebbs and flows of the crystalline ocean water as it pounded against the almost-white sand. It was tantalizing, yet scary to watch.

She looked around. It was difficult to grasp what she was looking at, but she was surrounded by simple buildings. A bright pink one caught her attention. There were coconut trees around her, green mountains, and not much else. Leilani couldn't believe there was all this beauty without the tech that went into sustaining the beaches she was used to. She also noticed she was sweating. The sun beat down on her skin, and the air felt too hot around her.

"You look like you rolled around in some stars."

Leilani whipped her head to the side. A woman with vivid, brown hair and red lipstick peered at her over curved sunglasses. She wore a white-and-red polka-dot ensemble that barely covered her body, while she lounged on a chair.

"It's called a bikini—since you're staring at it." The woman gestured to her outfit.

Leilani looked at her own skin and noticed she was shimmering brightly from all the glitter. She also noticed that there were people passing by staring at the woman with confused looks.

"Why?" Her voice cracked. "Why are they looking at you like that?" Leilani asked.

"I don't know, I think they're shocked or something. They've never seen a bikini before, but I don't care if people look. They're probably put off because they're living in the past and think women have to be covered up at the beach or something." The woman reclined further back on the chair.

Leilani gazed around steadily. "Where are we right now?"

The woman didn't move as she replied, "This beach is called Waikīkī. It means spouting water. It used to be a beautiful place filled with springs, streams, and other resources from the land, a very long time ago."

"Living in the past?" Leilani felt sick, like rocks were resting in her stomach.

"You alright?" The woman sat up. "Where you from, anyway? I'm Noelani Madeira."

Leilani perked up. The sickness dissipated and was replaced by a strong notion of familiarity, but a confluence of emotions made her feel incapable to recall the sudden intimacy she felt as Noelani finished speaking.

"I'm Leilani."

Noelani's face brightened, like she had an ancient secret that she could barely keep to herself. Looking directly at Leilani, she smiled ardently, took off her sunglasses, and gestured for Leilani to follow her into the ocean's waters with an outreached hand.

Leilani hesitated; she didn't know if she could actually swim. She remembered the dangerous ocean water where she was from . . . came from . . . is from? Was this all in her imagination? What was imagination other than just another plane of existence? Leilani couldn't stop the cataclysmic pull she felt toward the ocean and followed Noelani. The emotions of familiarity sprouted from the bottom of her abdomen.

The tangy salt water of the ocean was cold, but felt mellow, contrasted with the warm sun enveloping everything around them. Leilani felt centered, but could feel a calm mix of force, velocity, and ocean currents swaying her back and forth. Seeing her hand refracted through the clear aquamarine of the real ocean's brilliant blue, Leilani could see tiny schools of fish circle around her.

Leilani wasn't sure how much time had passed or if it even mattered. They had swum in the warm water and they spoke of the past/present/future together. Leilani's mind opened and saw knowledge she had never known existed.

"I don't have all the answers. I can only tell you what I know."

"Everything used to be so different. How did this all get forgotten? Why does it feel so familiar?"

"I never knew the elders were so resourceful! I only heard threads from Great-Grandma, picking up pieces of the story here and there."

"You have to remember. You have to carry it with you back."

They cried together; they laughed together. A homecoming parlay of history, ancestry, and a filling in of the missing pieces Leilani didn't know she didn't have.

They talked story with each other like this for some time and now they watched the sunset together from the shoreline. A real sunset. As she sat next to Noelani, Leilani squished the wet sand between her fingers. The setting sun cast an opalescent glow around them.

"You have to go back," Noelani said while she tucked her hair into a bun, as the breeze whipped around them.

Leilani said nothing. She continued to squish the sand. She felt heavy from everything.

"I'll be with you. We'll always be with you."

Noelani suddenly grabbed Leilani by the back of her neck and brought her close. Noses touching, they exchanged breath deeply. The heavy feeling left Leilani as the sunset fell into night.

Instantaneously, Leilani was back. Still breathing deeply, Leilani opened her eyes to the polychromatic lights dancing to the fluttering basslines of the WaveHaus club.

Keanu touched her face with a concerned look of wonder.

"What the actual fuck? Are you good?"

Leilani laughed because he looked so frazzled, but as the glitter and code danced around him, she couldn't take him seriously. Leilani stared up at him, as a deep feeling shrouded in unknown comfort played within her, and the words just spilled out.

"I have something to tell you. I have something to tell you about this place . . . paʻa pāhemohemo." Leilani laughed. "I remember imperfectly, but I remember . . ."

> Oceania is humanity rising from the depths of brine and regions of fire deeper still, Oceania is us. We are the sea, we are the ocean, we must wake up to this ancient truth and together use it to overturn all hegemonic views that aim ultimately to confine us again.
>
> —Epeli Hauʻofa, *We Are the Ocean: Selected Works* (2008)

An Aloha ʻĀina Imaginary

Kahikina Kelekona and the Fantastic

Bryan Kamaoli Kuwada

In 1895, in an attempt to restore the monarchy that had been overthrown with the assistance of the U.S. military, a force of over 300 aloha ʻāina took up arms to retake control of the Kingdom of Hawaiʻi. Word of the uprising leaked too early, and the koa aloha ʻāina were, by and large, arrested after several armed battles. Kahikina Kelekona was arrested alongside these armed revolutionaries, though he himself had not come near a rifle. His crime? He was a writer.

The Hawaiian-language newspapers and their multilingual, multigenre writers/editors had long been a powerful foe for the white elites[1] trying to wrest control of Hawaiʻi from Kānaka Maoli. The Republic of Hawaiʻi, the faux government established after the overthrow, was so afraid of the written Hawaiian word that when it drew up its constitution, its proposed language for the provision of freedom of speech said that everyone had a right to free speech *unless they were calling for the restoration of the monarchy* ("New Constitution" 1894, 7). The white elites even drew up libel laws that they used to jail Hawaiian writers in a vain attempt to curb their power. Thus, after days of gun battles, the republic also arrested newspaper editors and printers, and clapped them in irons right next to the armed revolutionaries, Hawaiian writing as dangerous as bullets and artillery.

The Hawaiian kingdom had one of the highest rates of literacy in the world at the time, and Hawaiians raised writing, which was introduced as a missionary tool for proselytizing, into a beautiful, powerful, evocative, innovative, and very Hawaiian art form. Yet there is no place in a colonizer's worldview for highly literary Indigenous societies, so in the intervening century, through problematic translations and a field of academic study that relied on the antiquity of its subject matter for relevance and prestige, Hawaiians were portrayed in history and popular culture as unlettered ooga-booga witch doctors.[2] Parts of this understanding have even affected our

1. It is important to point out the class aspect of this struggle, as many haole who were not in this class actually supported the kingdom.

2. Though these representations were widespread across various media, visual, and often visceral, representations of these racist caricatures can readily be found in newspaper political cartoons about Hawaiʻi. Images ranged from Queen Liliʻuokalani as a half-dressed "savage" wearing feathers, Hawaiian legislators depicted as monkeys, or Hawaiians in general represented as brute savages lurking in the bushes waiting to assault white women. A curated collection of some of these images can be found on the Hawaiʻi Digital Newspaper Project's website: https://sites.google.com/a/hawaii.edu/ndnp-hawaii/Home/historical-feature-articles/political-cartoons.

cultural and linguistic revitalization efforts. We have spent decades recovering our practices of kalo farming and of different types of fishing and aquaculture. We have undergone an inspiring recovery of our long-distance ocean navigation techniques. Hula and traditional medicinal practices are thriving. But we have been practicing writing for almost 200 years, and our kūpuna raised it to a high art, yet rather than understanding it as a traditional practice we often characterize writing as a western imposition or describe ourselves as mainly an oral culture. We have been alienated from one of the most powerful venues of aloha ʻāina we had ever seen, one that had the oligarchical republic government quaking in its boots.

Aloha ʻāina is often spoken of as our love for the ʻāina, the land. The land is our family member, and our understanding of the kanaka, the person, as always being in service to the ʻāina orients much of our culture. This love is what has always moved us to care for and nurture our ʻāina. But the aloha ʻāina that motivates us to fight to protect our ʻāina is not just about love, it is about imagination. Kānaka Maoli, like the koa aloha ʻāina, fight because we can imagine another world, where all of our possibilities exist, where we are the ones in control of our futures, not subject to capitalist and colonialist depredations. This world is so far beyond the ken of the occupier's imaginary that it seems like fantasy. Yet it is these very things, the fantastic and the imagination that leads to it, that are such an overlooked and underutilized part of our aloha ʻāina. Too often we make the mistake of seeing our Kanaka Maoli literary ancestors writing in ʻōlelo Hawaiʻi, our mother tongue, as mere vessels of the oral tradition or thinking they only wrote about our cultural practices and traditional stories. We forget that their love of language and wordplay led them to experimental literary expression that expanded the generic and stylistic bounds of our moʻolelo. Aloha ʻāina writers like Kahikina Kelekona deployed these literary experiments—their fierce imaginations and their fantastical dreams for our world—in service of restoring and maintaining our ea (life/breath/sovereignty/rising).

The Hawaiian Fantastic

From a multigenerational newspaper family, Kahikina Kelekona was "kekahi o na kanaka kaulana loa i ke kakau moolelo" (one of our most famous writers of moʻolelo) ("John Kahikina Kelekona Ua Hala" 1914, 4).[3] In 1875, Kelekona wrote an exhortation in the newspapers that characterizes his approach to writing: "e ao aku, e hoike aku aole i pau loa na iwi kuamoo, aka, ua puipui loa" (teach them, show them, that our spines, our iwikuamoʻo, are not broken, that they are stronger than ever!) (Kelekona 1875, 1). Iwikuamoʻo is the word for spine or backbone, but it also implies a continuity, often genealogical, that stretches back into the past and continues on into the present and future. So while he is saying that we should show our enemies that we have strong backs for the work ahead, he is also saying that we have strong connections to our culture and history that will carry us forward.

The best examples of Kelekona's usage of the fantastic in service of aloha ʻāina appear in his 1906 book, *Kaluaikoolau, Alo Ehu Poka* (Kaluaikoolau, enduring the mist of bullets). Kaluaikoʻolau, his wife Piʻilani, and their son Kaleimanu were a family whose iconic story came to represent

3. All translations into English are mine unless otherwise specified.

Kānaka Maoli standing up against the forces of colonialism. Kelekona's complex and distinctive writing style really comes to the fore in this book, and there is a consensus among many Hawaiian scholars that Kelekona's high level of language was not just to show the beauty that ʻōlelo Hawaiʻi was capable of displaying but also to be a reminder to the haole usurpers and foreign scholars, for most of whom his writing would be out of reach, that they might think that they know everything about our people and language, but there is still much more for them to learn. Another stylistic innovation unseen in our traditional moʻolelo was that Kelekona wrote in the voice of Piʻilani in order to tell the titular story.[4]

The story of Piʻilani, Koʻolau, and Kaleimanu deserves much more attention than is possible here,[5] but we will be focusing on two "odd" little ghost stories that Kelekona included in the book with their story. The reason I use the word "odd" is that when I describe these stories to other people who are familiar with Hawaiian literature, they chuckle. These stories are rather different from the moʻolelo that we are familiar with, and what makes them different is Kelekona's use of the fantastic. Now, our moʻolelo include stories of a blind warrior who uses ducks to tell him where to throw his spears, someone who was born from a blood clot floating on the ocean, giant reptiles who try to trick you into using their tongues as surfboards, people that have shark jaws between their shoulder blades who warn you to watch out for sharks and then turn into sharks to try to eat you if you don't listen, and a woman who can remove her vagina and send it flying across the islands,[6] so how do Kelekona's stories stand out as fantastic among all of that?

The answer is that all of those things in the examples above are just a part of our natural world. They are neither supernatural (outside of nature) nor impossible—two ways the fantastic gets described. When we see that the hau flowers are yellow or that the tī leaf we have tossed in the water has gotten sucked down, we know that there is a moʻo around. We recognize the feeling in our gut, our naʻau, when our ancestors are trying to tell us something. Our stories really do populate the land and seascape. But what Kelekona does in his odd little stories is use fantastical elements that are outside of our understanding. Those of us who know Hawaiian literature will not bat an eyelid at a giant who uses a koa tree as a club, but when I mention that Kelekona's stories

4. It was such an innovation that the contemporary translator who translated this text did not understand that it was Kelekona writing in Piʻilani's voice rather than Piʻilani herself speaking, and thus the translation lists Piʻilani as the author of the book, though there are notarized affidavits in the books attesting to what each person's role in the book was.

5. See kuʻualoha hoʻomanawanui (2000) and Kuwada (2016) for more about Kelekona and Kaluaikoʻolau.

6. Just as with other cultures, the breadth and depth of Hawaiian moʻolelo is stunning. For those interested in learning more about these moʻolelo, there are printed sources in English for some of them—for example, one version of someone being born from a blood clot in the sea can be found in the story of *The Legend of Keaomelemele*—but to truly begin to responsibly approach learning moʻolelo, you have to build a connection with the ʻāina, the land. That connection starts by being on the ʻāina out of which these moʻolelo grew, but also learning the language of that ʻāina.

Some of the stories mentioned above are relatively easily found in print, but to approach them without the humility of having those connections to land and language often leads to shallow interpretations or damaging misunderstandings. As an illustration of this point, when I was one of the translators working on *Ka Moʻolelo o Hiʻiakaikapoliopele*, I had the necessary linguistic skills to translate much of what I read, but it wasn't until I went to the island of Kauaʻi (my family is from Hawaiʻi Island), to the very places where some of the important events of the story took place, that the translation even began to approach the basic level of insight necessary for connecting with that part of the story. And still, I bet that people from those parts of Kauaʻi would know that someone not from their ʻāina had translated those parts of the story.

have talking skeletons in them, everyone shakes their heads incredulously because that is outside our experience and very weird in a Hawaiian story.

What we want to try to get at here is a response to Brian Attebery saying that "the interesting question about any given story is not whether or not it is fantasy or science fiction or realistic novel, but rather what happens when we read it as one of those things" (2014, 38). Kelekona would not likely have called his stories fantastic, but as Attebery points out, that is beside the point because what happens when we read Kelekona's work as making use of the fantastic is that we get to see how our ancestors were trying to use literature/moʻolelo to imagine and enact the kinds of futures that they wanted for us. Throughout the end of the tumultuous nineteenth century and into the twentieth, other Hawaiian authors were rewriting and representing our traditional stories, which were full of what people from other cultures would see as fantastic, but those stories were providing us with the roots, the foundations, of our culture. These stories by Kelekona, filled with things that Hawaiians find fantastical, are the branches, showing us the way forward, the way to new growth. And this is a property of the fantastic. As Daniel Heath Justice explains, "the fantastic is an extension of the possible, not the impossible; it opens up and expands the range of options for Indigenous characters (and readers); it challenges our assumptions and expectations of 'the real'" (2017). Kelekona seems to be cognizant of this power, as his stories are mostly about the possibilities offered by believing that the world could be different.

By using the fantastic as a new branch of Hawaiian literature and moʻolelo, Kelekona is trying to live what he said in his 1875 editorial: "e ao aku, e hoike aku aole i pau loa na iwi kuamoo, aka, ua puipui loa" (1). Another aloha ʻāina writer, Joseph Poepoe, who wrote around the time that Kelekona did, said that "O ka makaukau ma na Moolelo o kou Aina Makuahine ke keehina ike mua ma ke Kalaiaina e hiki ai ke paio no ka pono o ka Nohoʻna Aupuni ana"—that a ready knowledge of the moʻolelo of our mother ʻāina is the first knowledgeable step or standing place in the political action that will enable us to fight for the pono, the righteousness/balance, of our governance (1906, 2). Poepoe is pushing for the idea that we have to know our traditional moʻolelo first, and then we will be able to move forward toward more justice for our people, but read in another way, Poepoe is also saying that our traditions and traditional moʻolelo are the foundation from which we can go in new directions toward justice. It is thus this strength and foundation that Kelekona is building upon with his use of the fantastic to allow us, his readers and his lāhui, to imagine more just futures.[7]

The first of Kelekona's two fantastical stories that we are going to analyze more in depth is "Kuu Nalohia Ana a Hoea Hou" (My disappearance and subsequent return), in which Kelekona gives a fictional account of what happened when he had been reported missing for a few days a couple of years prior.[8] He has gone camping with his family out in Nānākuli, when one night he

7. For more on how some of these nineteenth- and early twentieth-century moʻolelo and values were employed for Hawaiian political and literary purposes, see Dudoit (1999), hoʻomanawanui (2014a), McDougall (2014), and Warren (2019).

8. The narrator of the story, the fictional Kelekona, mentions that his disappearance was in the newspapers, which I assume to be part of the conceit of the story, not an actual disappearance, as I haven't been able to find mention in the newspapers of the actual Kelekona disappearing or if/when/how his son died, though not all the newspapers are easily accessible or searchable.

sees the spirit of his deceased son beckoning to him. He follows the apparition of his son, who takes him along a railroad track. Kelekona sees two glowing canals running alongside the tracks and is even more surprised when it becomes clear to him that there are throngs of spirits on both sides of the tracks as well. He recognizes some as his ancestors or members of his extended family and has a conversation with them about what the afterlife is like. He then begins to look for his immediate family, such as his parents, but cannot find them before his son disappears. Then Kelekona essentially goes mad and wanders the hot and desolate plains of Nānākuli for days, until he finally comes back to himself, dressed in only his undergarments and cut up from the rough vegetation, and is able to make it back to civilization.

The other story we are going to focus on is "He Haawina Pahaohao" (A strange lesson/occurrence). The narrator climbs to the top of Pūowaina, or Punchbowl, a peak in the middle of Honolulu, and there two elders, a kāne and a wahine, from a past time appear to him. They look out at the expansive view of the city and talk about what they see from their time period, and then they disappear and reappear in a much disheveled state, this time speaking about what they see now in the present time. The story ends when the narrator looks toward the town and hears the thunderous voice of the Kamehameha statue making his thoughts known about the present day.

Interestingly, Kelekona's use of the fantastic seems to invert some of the critical frameworks that scholars who have theorized the fantastic have created. Both "Kuu Nalohia Ana a Hoea Hou" and "He Haawina Pahaohao" fit into what science fiction and fantasy scholar Farah Mendlesohn has characterized as an "intrusion fantasy" (2008, xiv), in which "the fantastic is the bringer of chaos. . . . It takes us out of safety without taking us from our place" (xxi–xxii). This is what happens in "Kuu Nalohia Ana," where the intrusion comes in the form of the akakū, or apparition, of his dead son, who literally takes him from safety into a liminal space that turns into a mad chaos when the narrator has to transition back to the aokanaka, or realm of people. But this intrusion is even more evident in "He Haawina Pahaohao" and inverted, or at least multiplied. The two spirits who appear to the narrator are elderly, but not decrepit. The wahine, for example, is described thusly: "e luhe kawelu ana na oho lauoho hina keokeo maluna iho o na kipoohiwi o ka hapauea wahine a kamoe malie aku la mahope o kona kua, a e paani malie ana ke ahekehau me kona mau mole aweawe, a he leihulu mamo ke poaipuni ana i kona a-i" (her growth of grayish-white hair hung loosely down to the shoulders of the elder woman and gently flowed down her back, the tips gently playing in the light breeze, and she had a lei of mamo feathers encircling her neck) (Kelekona 1906a, 116). It is hard to tell from the translation, but the words used in ʻōlelo Hawaiʻi also tie the woman to the health and abundance of the natural world around her, and the lei ties her to earlier times, both as a chiefly symbol, but also because the mamo bird was extinct at that point, the last sighting being recorded only a handful of years before Kelekona published the story.

The hapauea, the elderly man and woman, describe the world around them, and it is the world of their time, a time when "ka lawa pono i na mea a pau e palekana ai ka noho'na" (everything that we need to live in safety and abundance is well-supplied) (117). But then the hapauea appear to him again later, and their appearance is different. They are almost naked, wearing only tatters, and the man's lei of ʻilima flowers has wilted and the woman's mamo lei has lost most of its feathers. The man describes what is wrong:

Ua nalohia loa aku la na wahi pupupu kauhale o kakou a ua nalo pu aku la me na wahi kaupapaloi, a o na kini lehulehu o na ewe a kaua i ike mua aku nei, aole lakou . . . O ke kahua ihikapu o na ʻLii ua pau ka hie a me ke kapu, a o ka hae kalauna aole ia, he hae kahakahana okoa loa ia aʻu e ike aku nei. . . . ua hele a pihakuineki i kanaka ilikea namu palale. . . . Ke kamaaina nei ka malihini a malihini hoi kaua na kamaaina.

(All of our clusters of kauhale [family living compounds] have been disappeared, and all of the loʻi [taro patches] are gone too, as are all of the throngs of our people that we had seen before, they are no more . . . And the revered grounds of our aliʻi, the dignity and sacredness has all been stripped from it. The flag of the crown no longer flies above it, all I see is a strange striped flag. . . . Our lands are filled with white-skinned people who speak gibberish. . . . The malihini [the stranger or visitor] have become kamaʻāina [familiar with or child of the land], while we the kamaʻāina have become strange). (119)

Though we see that the fantastic, in the form of these ghostly elders, has indeed intruded into the normal world of the narrator, we see that the true intrusion has come from colonialism and the occupation of Hawaiian lands by the United States. Daniel Heath Justice warns against a realism that is "framed by social presumptions that naturalize colonialism and its effects" (2017), and in "He Haawina Pahaohao," rather than being an intrusion of the "real" into the fantastic, colonialism's inverted intrusion upon the fantastic serves to show just how unreal and unnatural the colonial intrusion is.

Mendlesohn continues on to describe intrusion fantasy as being full of description in order to investigate and make transparent the intruding fantastic, of which the point-of-view character is often ignorant and must learn (2008, xxii). But because of this ignorance, the language used in the story reflects constant amazement, which too is true of "He Haawina Pahaohao" (and the other stories). Words like the pāhaʻohaʻo in its title, which means to be puzzled or to try to guess at things; ʻeʻehia, which is a state of awe and being stunned in the presence of something greater than you; kamahaʻo, which is when something is almost incomprehensible to you because it is so out of your experience of reality; and others appear throughout the story. Mendlesohn continues on to say that "the protagonists and the reader [of intrusion fantasy] are never expected to become accustomed to the fantastic" (xxii), but in "He Haawina Pahaohao," the fantastic is what we had been accustomed to, that is to say, our traditional culture and the way that we lived before the hae kahakahana, the striped flag, waved over our nation. It is the intrusion of colonialism and occupation that Kelekona's protagonists and readers are never expected to be accustomed to.

Another way that I think Kelekona's work inverts certain understandings of the fantastic can be seen in reference to how Brian Attebery describes fantasy, as a literary form, as "a way of reconnecting to traditional myths and the worlds they generate" (2014, 9). Kelekona's use of the fantastic is actually a step away from traditional moʻolelo. I really appreciate Attebery's framing of myth in his book *Stories about Stories: Fantasy and the Remaking of Myth,* and think that he makes a very

convincing argument using the texts that he covers, but I also think that it is a different situation when fantasists are trying to connect with myth (which I am reading to be akin to moʻolelo and worldview here, even though that might be a bit different than how Attebery was using it) rather than when the fantasist is coming from that tradition and placing the fantastic on top of their lived understanding of "myth." The "normal world" of Kelekona is the one in which we are actual siblings to the ʻāina, with all of the responsibilities between the younger (us) and the older (the land). It is the world where lovers become hills standing next to each other for an eternity or where you can call forth the wind from a gourd if you know its name and the correct chant. Daniel Heath Justice is again useful here when he argues that "*relationship* is the driving impetus behind the vast majority of texts by Indigenous writers—relationship to the land, to human community, to self, to the other-than-human world, to the ancestors and our descendants, to our histories and our futures, as well as to colonizers and their literal and ideological heirs—and that these literary works offer us insight and sometimes helpful pathways for maintaining, rebuilding, or even simply establishing these meaningful connections" (2018, xix, emphasis in the original). Kelekona's "normal world" is filled with all of these connections, these relationships, what we would call pilina,[9] and they would very much be considered fantasy or fantastic to those who do not respect our pilina or the pilina of other Indigenous peoples.

Kelekona frames "He Haawina Pahaohao" with traditional Hawaiian understandings, like when he writes that the early morning mist had covered "maluna o na hiohiona o ko kakou kapitala o ka Ua Kukalahale, a me he ʻla, o ka hapanui o na kini, aia no iloko o ka poli hoonanea kulipolipo o ke kamaeu Niolopua" (the features of our capital belonging to the Kūkalahale rain, and it seemed as if the majority of the population remained nestled in the depths of the relaxing bosom of the trickster Niolopua) (1906a, 115). Kelekona mentions the Kūkalahale, which is one of hundreds of place-specific rain names so appreciated by Hawaiians, and then mentions Niolopua, who is an akua related to sleep. He then goes on to give a panoramic description of the lands that he can see from the top of Pūowaina, such as "ke opu kukilakila mai no a Konahuanui, me he la e kaena mai ana no i ka ui o kana punua i ka nuku lihipali o Nuuanu" (the majestic rising of Kōnāhuanui, as if it were bragging about the beauty of its fledgling perched on the cliff-edged pass of Nuʻuanu) (1906a, 115). What would be called personification in western contexts is just the way that Hawaiians speak about the land, not as a person, but definitely as a living relative, and so these are the pilina, the relationships, that appear throughout the "normal world" of Kelekona's stories.

In order for something to be fantastic in Kelekona's stories, we have to step away from all of the possibilities available in the Hawaiian world and move toward something that is impossible in a Hawaiian understanding. And that is, in this case, ghosts. It's not that Hawaiians do not believe in ghosts or spirits of the dead who linger on, only that we do not believe in them in the way that Kelekona portrays them in his stories. As a brief example of how haunted our stories can be, in

9. Pilina means to be in connection with some place or some thing or someone, or to be close in a proximity sense, but also in a relational sense. It is a powerful emotional and spiritual bond that often reflects a sense of shared responsibility toward whatever you are in pilina with. It is frequently used to describe connections to cherished ones or to land.

Hiʻiakaikapoliopele,[10] one of our longer published traditional moʻolelo, there are flying ghosts that bleed (Hoʻoulumāhiehie 2007, 53), disembodied specters in a forest (71), the essence of a girl turned to stone (73), flying ghosts who look like people surfing (101), ghosts without bones (106), and a whirlwind made up of hundreds of ghosts (234). While an overview of Hawaiian understandings of death and the afterlife is beyond the scope of this paper, and I am admittedly not an expert in that area of our culture, I can say that Kelekona's descriptions of the ghosts in his story do not seem to align with any traditional understandings that I am familiar with:

> Ua paa no me na aahu, he papale no ko kekahi poe, aka, ma kahi o na helehelena, he iwi wale no, a mawaho ae, e ike ia aku ana he aka meheu o na hiohiona o ka mea nona ia kino, a me ka nana pono loa e hoomaopopo ia aku ai na hiohiona o na helehelena. O na manamana lima he iwi wale no, a pela me na wawae, a o ka nui kino ua paa no i ka uhi ia e na aahu.

> (They were clothed, some even wore hats, but instead of faces, there was only bone, and just above the bone could be seen the faint traces of what the person to whom the body belonged looked like, and if you looked closely, you could make out the features of their face). (Kelekona 1906b, 101–102)

For all of the spirits who were described in Hiʻiakaikapoliopele and the other moʻolelo I am familiar with, none of them have their iwi, or bones, visible. We have a saying, "mai kaulaʻi i ka iwi i ka lā" (do not dry out the bones in the sun), which is a metaphorical way of talking about exposing secrets, but also a literal admonition not to allow the bones of our ancestors to be visible and exposed to the sun. Mana, the spiritual power imbued in all things, resides in the bones, not the defiling and temporary flesh. The way Hawaiians treat iwi for death and burial includes stripping the flesh and then hiding or protecting the bones, so descriptions of spirits in Hawaiian stories did not include visible iwi the way that Kelekona's descriptions do.

Also, spirits often just looked like regular people, and humans like Wahineʻōmaʻo in the Hiʻiakaikapoliopele moʻolelo had to be given special sight to tell the difference. People would also check if people were spirits by looking at their feet. Ghosts had no feet or would not make imprints on the ground when they walked. One way to "test" for a spirit was to put leaves of the ʻape plant down, as a normal person would crush the leaves under their feet while a spirit would not. Thus, the phantasmically fleshed ghosts of Kelekona's storyworld would stand out to the Hawaiian reader as fantastic.

These ghosts are truly where the transformative power of Kelekona's stories are centered. Fairy-tale scholar Jack Zipes talks about how "more than titillation, we need the fantastic for resistance" (2008, 2), and that is what these ghosts bring to Kelekona's story. Zipes locates the power of the fantastic in the idea that "it is through difference that the fantastic provides resistance and illuminates a way forward. . . . The fantastic offers glimpses and markers that recall the original meaning

10. For a much more in-depth treatment of Hiʻiakaikapoliopele, see hoʻomanawanui (2014b).

of fantasy, the capacity of the brain to show and make anything visible, for without penetrating the spectacle that blinds us, we are lost and lose the power to create our own social relations" (5). I would argue here that the spectacle that Kelekona is trying to pierce or penetrate is that brought by the hae kahakahana, the striped flag, which has turned all of the kamaʻaina into malihini, and he is using these ghosts to do it.

These specters of resistance uncover the emptiness behind the striped flag's spectacle, its grand narrative of progress and benevolence. Kānaka were told that literacy was the key that would unlock the riches of the world's knowledge for them, but when they took control of the press and used literacy to unlock the riches of their own moʻolelo, they were excommunicated from their churches and denounced. Kānaka were taught that democracy and a constitution were the ways to secure rights and protections for themselves, but when Kānaka implemented these things and refused to use them as directed, changes to their constitution were forced upon them at gunpoint. Each time Hawaiians achieved the goals the haole laid out for them and bought into the hae kahakahana's spectacle, they would find that the haole had moved the goalpost farther downfield. But these ghosts give us the special sight to see past the spectacle, for, as novelist, playwright, and scholar Andrea Hairston points out, "ghosts are an embodiment of the invisible forces of a past that hasn't gone anywhere. Revealing what is normally concealed, ghosts are sacred/demonic tricksters who provide alternate perspectives on the here and now and on the future" (2016, 7). The ghosts in Kelekona's stories make manifest the failures of the colonial intrusion's grand promises. They remind us how our ʻaina was laupaʻi, full of people and abundance, yet is now neoneo, ravaged and desolate (1906a, 151).

The ghost of Kamehameha I, who unified the islands and founded the Kingdom of Hawaiʻi, thunders forth from his statue, saying,

> e oʻu io, e oʻu koko a e oʻu iwi mai ka po mai, ke nana aku nei au aole oukou; o kuu lei aʻu i kui ai, i hilo ai, i milo ai a i naʻi ai i wehi kuleana paa no oukou e aʻu mau mamo ua eheu a na ka malihini e lei haaheo nei, a ke hooho mai nei ka leo o ka hanehane kupinai e kalahea ana—"Ua lilo ke ea o ka aina i ka hewa!"

> (O beloved ones of my flesh, my blood, and my bones who originated in the generative dark Pō, this lei that I have strung, braided, twisted, and striven for as a beautiful reminder of our firm kuleana [right/responsibility/burden/opportunity], my beloved descendants, it has flown, and now the malihini is proudly adorned with it, and a resounding ghostly voice is proclaiming—"The ea [life/breath/rising/sovereignty] of our ʻaina has been lost to the ones who have wronged us!"). (1906a, 120)

The ghost of Kamehameha is, as Hairston says above, "provid[ing] alternate perspectives on the here and now." When Kelekona published this story, it had been over a decade since the overthrow. The here and now looked like this: heavy Americanization efforts had become institutionalized. Hawaiians were still a strong presence in the Territorial Legislature, but all their legislation was easily defeated by gubernatorial veto. And people like the Reverend Sereno Bishop were

blaming the "dying out" of Hawaiians (our population dropped from estimates of several hundred thousand or even a million to 40,000 by the turn of the twentieth century) on unchastity, drunkenness, oppression by our own aliʻi, kahunas, and sorcery, and even wifeless Chinese (Bishop 1888, 3–15). And this is the spectacle that Kelekona's ghosts try to penetrate. That we are disappearing. That there is no place for our laupaʻi, our abundance in land and people. That we are just inherently weaker than the people who have made us malihini in our own land. That our stories are all in past tense. That all that will be left of us is ghosts.

But Kelekona does not leave us there, with the ones who have wronged us. After the thunderous denunciation by Kamehameha, the final line of "He Haawina Pahaohao" is, "Kuailo ia mai?" (Do you give up?) (1906a, 120). Kuailo is the traditional answer in riddling games if you do not know the answer. Riddling was done as a fun diversion in person or in the newspapers, but it was also done in traditional times for high stakes. In the moʻolelo of Kalapana, losers at riddling would have their bones made into a fence. So Kelekona's invocation of kuailo is done knowing what is at stake if we give up trying to solve the riddle of colonialism and occupation, and that is why Kelekona's use of the fantastic is so important in these stories. They lead us to wonder. These types of moʻolelo haunted by ghosts "remind us that other worlds exist; other realities abide alongside and within our own" (Justice 2017), and they furthermore remind us that we can create new worlds. As Scott Richard Lyons (Ojibwe/Dakota) says, "the pursuit of sovereignty is an attempt to revive not our past but our possibilities" (2000, 449), and the refusal to kuailo is an assertion that we as a people will continue to seek out new possibilities, to be filled with wonder about what we can do next.

Kelekona's stories fit in with what educator, writer, and scholar Walidah Imarisha terms visionary fiction, "fantastical writing that helps us imagine new just worlds. . . . that helps us to understand existing power dynamics, and helps us imagine paths to creating more just futures" ("What Is 'Visionary Fiction'" 2016). Where much of the ʻōlelo Hawaiʻi literature created at the turn of the century was to root Hawaiians in our traditions, Kelekona's stories branch out onto these paths toward creating more just futures. The refusal to kuailo makes these stories visionary, futurist, and connected to wonder. As Indigenous futurist progenitor Grace Dillon (Anishinaabe) points out about Indigenous futurism, "it might go without saying that all forms of Indigenous futurisms are narratives of *biskaabiiyang,* an Anishinaabemowin word connoting the process of 'returning to ourselves,' which involves discovering how personally one is affected by colonization, discarding the emotional and psychological baggage carried from its impact, and recovering ancestral traditions in order to adapt in our post-Native Apocalypse world" (2012, 10). Indigenous futurism has as its ancestor Afrofuturism, and speculative fiction author and scholar Troy Wiggins points out one of the powerful aspects of Afrofuturism that Indigenous futurists have learned from it: "one of the central tenets of Afrofuturism is that Black creators take lessons and spiritual resolve from their past to reckon with/navigate their present and create better futures" (2019).

All the wonder engendered by the question of kuailo, the disappearance of Kelekona, the reminder that our ancestors (talking skeletons and all) are always with us, the statue-borne

critiques gesture, as Daniel Heath Justice says, "to other ways of being in the world, and it reminds us that the way things are is not how they have always been, nor is it how they must be" (2017). Wonder is about possibilities, which makes it about sovereignty, and to quote what humanities scholar Aiko Yamashiro (CHamoru/Japanese/Okinawan) and I wrote about wonder in regards to Indigenous activism,

> wonder changes us and changes our world. When we stop marveling at ourselves—ourselves in the most connected and expansive sense, that is, we as individuals, as activists, as communities, as past and future ancestors, as gods, as mountains and rivers and ocean—we lose belief in our ability to heal and transform even the deepest wounds. The act of bringing new life to our Indigenous stories reawakens our lands and peoples to remember the power we have always had, to feed our families and strangers, to care for the past and future. Hope is fed by our ability to apprehend and trust our storied connections, by the rush of unexplainable movement, by the unruly growing of our love and gratitude for the strange and marvelous ways we live on. (2016, 19–20)

It is through the fantastic and wonder that we "return to ourselves," as Grace Dillon says. And this is the point of all of Kelekona's insistence that our iwikuamoʻo are stronger than ever, the point of all of the fantastic in his stories, the point of all of his writing, the point of all the wonder in his readers, the point of all of his possibilities, the point of all of his ghosts: that we live on.

Works Cited

Attebery, Brian. 2014. *Stories about Stories: Fantasy and the Remaking of Myth*. New York: Oxford University Press.

Bishop, Sereno E. 1888. *Why Are the Hawaiian Dying Out? Or, Elements of Disability for Survival among the Hawaiian People*. Honolulu: Honolulu Social Science Association.

Dillon, Grace L. 2012. "Imagining Indigenous Futurisms." In *Walking the Clouds: An Anthology of Indigenous Science Fiction*, edited by Grace L. Dillon, pp. 1–12. Tucson: University of Arizona Press.

Dudoit, Mahealani. 1999. "Against Extinction: A Legacy of Native Hawaiian Resistance Literature." *Social Process in Hawaiʻi* 39:226–248.

Hairston, Andrea. 2016. "Ghost Dances on Silver Screens: *Pumzi* and *Older than America*." *Extrapolation* 57, no. 1–2:7–20.

hoʻomanawanui, kuʻualoha. 2000. "Hero or Outlaw? Two Views of Kaluaikoʻolau." In *Navigating Islands and Continents: Conversations and Contestations in and around the Pacific*, edited by Cynthia Franklin, Ruth Hsu, and Suzanne Kosanke, pp. 232–263. Honolulu: University of Hawaiʻi Press.

———. 2014a. "I ka ʻŌlelo ke Ola, in Words Is Life: Imagining the Future of Indigenous Literatures." In *The Oxford Handbook of Indigenous American Literature*, edited by James H. Cox and Daniel Heath Justice, pp. 675–682. New York: Oxford University Press.

———. 2014b. *Voices of Fire Reweaving the Literary Lei of Pele and Hiʻiaka*. Minneapolis: University of Minnesota Press.

Hoʻoulumāhiehie. 2007. *The Epic Tale of Hiʻiakaikapoliopele*. Translated by Puakea Nogelmeier, Sahoa Fukushima, and Bryan Kamaoli Kuwada. Honolulu: Awaiāulu Press.

"John Kahikina Kelekona Ua Hala." 1914. *Ka Nupepa Kuokoa*, April 3.

Justice, Daniel Heath. 2017. "Indigenous Wonderworks and the Settler-Colonial Imaginary." *Apex Magazine*, August 10. https://apex-magazine.com/indigenous-wonderworks-and-the-settler-colonial-imaginary/.

———. 2018. *Why Indigenous Literatures Matter*. Ontario: Wilfred Laurier University Press.

Kelekona, Kahikina. 1875. "E Pau! I Pono Ai!!" *Ka Lahui Hawaii*, March 25.

———. 1906a. "He Haawina Pahaohao." In *Kaluaikoolau, Alo Ehu Poka*, pp. 115–120. Honolulu: Office of the Treasurer.

———. 1906b. "Kuu Nalohia Ana a Hoea Hou." In *Kaluaikoolau, Alo Ehu Poka*, pp. 98–110. Honolulu: Office of the Treasurer.

Kuwada, Bryan Kamaoli. 2016. "A Legendary Story of Koʻolau, as Serialized in the Newspaper *Ka Leo o ka Lahui,* July 11–20, 1893." *Marvels & Tales* 30, no. 1:93–110.

Lyons, Scott Richard. 2000. "Rhetorical Sovereignty: What Do American Indians Want from Writing?" *College Composition and Communication* 51, no. 3:447–468.

McDougall, Brandy Nālani. 2014. "Putting Feathers on Our Words: Kaona as a Decolonial Aesthetic Practice in Hawaiian Literature." *Decolonization: Indigeneity, Education & Society* 3, no. 1:1–22.

Mendlesohn, Farah. 2008. *Rhetorics of Fantasy.* Middletown, CT: Wesleyan University Press.

"The New Constitution." 1894. *Hawaiian Gazette*, June 5.

Poepoe, Joseph. 1906. "Ka Moolelo o Kou Aina Oiwi." *Ka Naʻi Aupuni*, January 17.

Warren, Joyce Pualani. 2019. "Reading Bodies, Writing Blackness: Anti-/Blackness and Nineteenth-Century Kanaka Maoli Literary Nationalism." *American Indian Culture and Research Journal* 43, no. 2:49–72.

"What Is 'Visionary Fiction'?: An Interview with Walidah Imarisha." 2016. *EAP: The Magazine*, March 31. https://exterminatingangel.com/what-is-visionary-fiction-an-interview-with-walidah-imarisha/.

Wiggins, Troy L. 2019. "Let's Talk about Afrofuturism." *Apex Magazine*, May 9. https://apex-magazine.com/lets-talk-about-afrofuturism/.

Yamashiro, Aiko, and Bryan Kamaoli Kuwada. 2016. "Rooted in Wonder: Tales of Indigenous Activism and Community Organizing." In "Rooted in Wonder," special issue, *Marvels & Tales* 30, no. 1:17–21.

Zipes, Jack. 2008. "Why Fantasy Matters Too Much." *CLCWeb: Comparative Literature and Culture* 10, no. 4:1–12.

Artist Statement for
Hānau Pōʻele and *Makalei*

Kapiliʻula Naehu-Ramos

Hānau Pōʻele, 2017

The first moonlight
Dawn rises from the sea
Heʻe, to melt, flow
as the earth warms and forms
Heʻe, whose skins turn like the sky
That splits and heaves, changing
An open mouth
A slumbering eye awakened
In the making of worlds
Hānau Pōʻele
The darkness is born
—Hānau Pōʻele i ka pō he wahine

Hānau Pōʻele (**cover art**) is inspired by the Kumulipo, our creation chant. I made Pōʻele in the colors of the night and gave her heʻe hair because I thought that the qualities of heʻe reminded me of Pōʻele. Heʻe have ink so they are able to create darkness. They also have the ability to change the color of their body, which felt like a good connection to the changing of the sky as Pōʻele is born in the Kumulipo.

Makalei, 2018

I was inspired by a moʻolelo from Molokaʻi ʻĀina Momona for the painting titled *Makalei* (**Plate 12**). Makalei is a magical tree whose branches can attract fish. On Molokaʻi, parts of Makalei were used in the makahā of lokoiʻa, ensuring a reliable food supply.

Artist Statement: Once upon One Time

Lehua Parker

Once upon one time, in a land far, far away (1971, Kīhei Elementary, Maui), Keoni and I were assigned to the listening center. Back then, a lot of early elementary classrooms in Hawaiʻi had centers that encouraged kids to learn through discovery. There was an arts and crafts center where you could string oddly shaped beads onto old shoelaces, a math center filled with Lincoln Logs and Tinkertoys, a handwriting center with laminated charts and tracing paper, and a language arts center filled with stacks—single words on three-by-five cards, double-punched and bound in tall flip charts.

The listening center was a corner of the classroom with a record player that had a place to plug in two sets of headphones, the kind with big puffy earpieces. As I sat on the floor next to the record player, Keoni slid open the cabinet containing our class's record collection. I can still smell that distinct mix of dank wood, lacquer, paste pots, and library dust that permeated the cabinets and cubbies of a 1970s Maui classroom.

"So what you like hear?" Keoni asked.

I shrugged. There were only two records in the cabinet, a 45 of "Paint It Black" by the Rolling Stones and an LP of *Pidgin English Children's Stories* narrated by Kent Bowman.

Sometimes truth is stranger than fiction. I think the *how, why,* and *intention* of those two choices in a kindergarten and first-grade listening center—and *only* those choices—could make an interesting story. But back then these kinds of things were often about availability of resources and nothing more.

Keoni slapped on "Paint It Black," commandeered the listening center's lone fake ʻukulele, a thin plywood cutout with painted-on strings, and pretended to strum along. When the song ended, we looked to one of our teachers. She waved at us to stay in the listening center.

So we listened to "Paint It Black" again. And again. And again.

Eventually, even Keoni got tired of fake strumming and removed the 45 adapter, changed the speed to 33, and put the big album on the turntable. The record spun up, the needle dropped, and my mind was forever blown. After a musical flourish, Kent Bowman's voice boomed, "Aloha! Dis is da story of Goldie, da blonde malihini, and da t'ree wild puaʻas. Once upon one time . . . "

As the story unspooled, I heard words and rhythms that sounded like stories I'd heard in Uncle Tiko and Auntie Millie's backyard, stories marinated in Primo beer and punctuated by ʻopihi slurped from the shell. The story followed the pattern of *Goldilocks and the Three Bears,* but

was unmistakably told in Pidgin. Not someone reading English with a Pidgin intonation or accent, but told straight up in local-style, talk-story *Hawaiian Pidgin*.

I wanted to hear the whole album, right then, right there.

This was my first introduction to western fairy tales told through an island lens, and it left a tattoo on my bones that resonates today. A week ago, I found Braddah Bowman's *Pidgin English Children's Stories* on YouTube. They were as hilarious as I remembered—and not so much for keiki! Ho! The kūpuna were right. The ability to recognize kaona—the veiled meaning within a story—*is* a matter of age and perspective.

Through the decades, I came across many western fairy tales retold through a humorous Pidgin lens. In island-style plays, narrative mash-ups, and comedy routines, bears were swapped out for pigs, porridge for chicken lū'au, Cinderella's kitchen ashes for Lani's lei sweatshop, wicked stepsisters for māhū stereotypes, and ball gowns for Filipina frilled dresses. All bus' laugh hilarious and entertaining to the max—and, like all modern fairy tales, a bit subversive. I loved them.

But once upon a time, before the Disneyfication of fairy tales, these cautionary stories had teeth. I wondered what modern fairy tales would look like if freed from gentrification. I looked for stories that kept the modern equivalent of wolf's claws and huntsmen's axes intact and found them in young adult sci-fi, fantasy, and dystopian stories. Like fairy tales, they were serious and cautionary tales, but still told through a western lens. I dug a little deeper, searching for published folktales of the Pacific in contemporary American literature for children. While there were picture books about Maui and geckos in the night, I couldn't find any contemporary titles for middle grade and young adult readers.

Auē, I thought. *What magic spell allows Hans Christian Andersen and the Brothers Grimm to maintain a stranglehold on the literary golden goose?*

About ten years ago, a story started taking shape in the back of my mind, a story about a boy who was allergic to water and sharks that could pass as human—just like the wolf in *Little Red Riding Hood*. In the Niuhi Shark Saga trilogy, I created a world where all the beings in folk stories, myths, and legends were real, but under the radar of most humans. I set the story in an authentically islander/Kānaka Maoli place that was entirely imaginary and called it Lauele, O'ahu. Like Jack's magic bean, the idea grew into the Niuhi Shark Saga trilogy.

Told through a multicultural islander lens, the Niuhi Shark Saga trilogy is unapologetically sprinkled with Pidgin and Hawaiian. When islanders speak from the heart, it's often in the backyard kanikapila rhythms and patterns that pulse through our veins. *One Boy, No Water; One Shark, No Swim;* and *One Truth, No Lie* explore traditional Hawaiian beliefs in a modern setting in ways that hadn't been done before.

Like I said, truth is always stranger than fiction. Once I'd published the Niuhi Shark Saga trilogy, another publisher reached out and asked me to contribute to a series of novellas written by various authors, each taking a different spin on the same traditional western fairy tale. Wanting to continue writing island-style stories, I expanded my imaginary Lauele, O'ahu, giving it an ancient history and bright future. From this place, I write stories steeped in themes both culturally ancient and critically vital today.

The first fairy-tale novella was *Nani's Kiss,* a bonkers sci-fi riff on *Beauty and the Beast* and *Sleeping Beauty* that explored what space expansion might look like if it stemmed from Lauele's Polynesian seafaring roots. I think of it as my "Hawaiians in Space" story. Despite being mired in arranged marriages, intergalactic alliances, alien lifeforms, and space battles, the characters in *Nani's Kiss* plant taro and breadfruit to feed starving fringe worlds. They gift these modified crops not because it's good trade, but because it's their kuleana. It makes sense to me that canoe plants are space plants, too, and the idea of food being something shared with those in need instead of hoarded fits my narrative of Polynesian values. With the publishing rights recently returned to me, *Nani's Kiss* is undergoing a massive rewrite as it expands into a full novel and perhaps even a series. Hawaiian Futurism Fiction. It's going to be a thing.

The next fairy-tale novella was *Rell Goes Hawaiian* (now available as *Rell's Kiss*), a contemporary urban romance inspired by *Cinderella*. It takes place after the events of *One Truth, No Lie.* Rather than wave a wand and shout bibbity-bobbity-boo, Rell's scary badass faux fairy godmother uses Gecko car service and delicate slippahs to get her to the charity lū'au. Rell's there just in time to uncover her stepmother's land development scheme that has the potential to change Lauele forever. It's not a prince Rell desires, but freedom from her stepmother and a connection to her past. Jerry, the handsome car rental jockey, is just a nice bonus.

Most recent was *Pua's Kiss,* a speculative fiction romance based on the *Little Mermaid.* It's the backstory of how Zader's parents met and set off the events in *One Boy, No Water.* Pua is Niuhi, a shark that can appear as a woman. Unlike Ariel, she has no interest in being human, but does have an itch only a human male can scratch. As Pua knows, the consequences of breaking the great ocean god Kanaloa's kapu are dire, but some things are worth the risk. However, Justin, jilted at the altar and flying solo on his romantic Hawaiian honeymoon, has no idea of the risks he's taking while enamored with the beautiful woman he found sleeping on the beach.

These stories and others centered in Lauele have taken on a life beyond what I imagined when I was sitting alone in my office, living in my head, and writing down conversations with imaginary people. The fact that these stories exist in print at all—regardless of their literary merit—is a victory. To Pacific literature readers and writers, these stories are wayfinding beacons lighting the way for bolder trailblazers to go much further. New writers tell me they persist because they now know publishing islander-centered stories with Pidgin and Hawaiian is *possible.*

Seeds planted today feed future generations. Hard to get more Hawaiian than that.

"Tourists" is a short story set in imaginary Lauele, O'ahu. It's a modern fairy tale, a cautionary tale, one with teeth. But no worry! E komo mai! Come on in. The water's fine.

Once upon one time . . .

Works Cited

Bowman, Kent. (1961) 2002. "Goldie the Blonde Malihini and the Three Wild Pua'as." Hula Records. https://www
.youtube.com/watch?v=qgPFinqer0o.
The Rolling Stones. 1966. "Paint It Black." By Mick Jagger and Keith Richards. London Records.

Tourists

Lehua Parker

In the calm waters off Keikikai Beach, a thin crescent moon bleeds silver into the ocean as it cruises along the horizon like a shark's fin. Drifting beyond the reach of lights on shore, Kalei and a woman he met in the bar across the street skinny-dip in dark anonymity. The woman flicks her wrist, delighting in the little blue sparks that fly from her fingertips.

"Magic," she whispers.

Kalei's chuckle bubbles to the surface as he circles, gliding through the water as effortlessly as a seal. Splashing, he sends ripples of electric blue in every direction.

"Not magic," he says. "Bioluminescence."

"What?"

"It's plankton. Bioluminescence. You don't believe in magic."

"No. But out here in the ocean with you, I might change my mind."

He grins, his teeth gleaming like stars.

Kah-lay, she thinks, *remember his name is Kah-lay. Like the strings of flowers at the airport.*

"Cold?" Kalei asks.

"No, the water's wonderful. It's like silk."

"Good."

"I've never seen the ocean glow like this," she says. "It's spectacular."

"It doesn't happen very often."

"You were right. I wouldn't want to miss this. I don't know what that guy's problem was."

"Don't think about him," Kalei says. "We left him back at the bar. He's long gone."

"I can't believe he grabbed my arm." She rubs the spot.

"What did he say?"

"You didn't hear?"

"No. He pulled you away, remember?"

"I could barely understand him," she says. "He slurred something like, 'No go in da wah-dah.' I think he knew we were headed across the road to the beach."

Kalei nods, bobbing in the current. "That makes sense. I've seen him around. He's a part-time lifeguard. Probably wants to enjoy the evening without his pager going off."

Previously published: Parker, Lehua. 2013. "Tourists." In *Mystery in Paradise: 13 Tales of Suspense,* edited by Lourdes Venard, pp. 141–153. CreateSpace Independent Publishing Platform.

"Funny," she says. "I can swim and so can you."

"He's just trying to keep you safe. The ocean's tricky at night."

"You mean he wants to keep this place to himself." She shakes her head. "Locals. Never want to share. Think everything belongs to them."

"Sometimes," he says, rounding to her side.

"Without tourists this island would fall apart in a week."

"Hmmmmm," he says, trailing a lazy fingertip from the point of her shoulder down to the delicate spot on her wrist. Her pulse quickens; blood leaps to the surface. *Beautiful,* he thinks. *I can trace the veins by her heartbeat.*

Like wax on a surfboard, he eases his body behind her and rests his fingers lightly on her shoulders. Despite her words, she doesn't swim well, and he wants her relaxed, not struggling to stay at the surface.

"First time?" Kalei asks.

She flinches. "What?"

"In the islands."

"Oh. Yeah," she says, turning and pulling away. "First, but not last. I'll be back next month."

"Another Hawaiian vacation? Lucky." He cocks his head. "Or spoiled. Trust fund baby?"

She laughs. "I wish. I'm a senior location scout for Miramax. We're in preproduction." She lifts her chin and looks down her nose, waiting for the obligatory starstruck moment.

Kalei says nothing.

A little miffed, she fills in the blanks herself. "I can't tell you the title or the director, so don't even ask. It's all hush-hush. I've been here a week, hiking from one mosquito hell to another."

"Hiking? Whatever for?"

She splashes a perfect arc of blue stars. "Like you don't know what a location scout does!" When he doesn't laugh, she hesitates. "Wait. You really don't?"

Kalei shrugs.

"Miramax? The movie company?" she says. *"Working Girls; Kill Bill; Don't Be Afraid of the Dark; Sex, Lies, and Videotape?"*

He tilts his head to the side. *She really is lovely.*

She narrows her eyes at him. "You've seen those movies, right?"

"I've heard of them. I don't get out to theaters much," he says.

"Unbelievable. I keep forgetting this isn't L.A. You Hawaiians spend all of your time at the beach."

"Only when the urge strikes. You Angelinos have beaches, too. But as you said, you prefer movies. Easier to control the story."

She bites her lip. "I'm not a writer or director," she says. "It's my job to find the right place for the story to happen. It's not up to me to tell it." Tossing her head, she turns and regards the moon.

Jerk, she fumes. *"Come swim with me in the moonlight, and I'll show you real Hawaiian magic." How did I fall for a line like that? It's straight out of one of Trudy's beach movie marathons. We're in a scene from* Gidget Goes Hawaiian *or* Blue Hawaii. *Next he's going to say he's a real* Soul Surfer!

Leaning forward, her bangs drip ocean into her eyes, but she remembers in time to flutter her lashes like Esther Williams until the salt washes away. No rubbing—no matter what.

He's got to be messing with me. Who doesn't watch movies? She catches his eye and tries not to frown. *He was better-looking at the bar,* she realizes. *Out here in the water, his smile's too wide; his teeth are too big.*

Who cares if I have raccoon eyes? This saltwater sucks. She gives in and rubs her eyes, kicking harder to stay afloat.

She's off the hook, Kalei thinks. *Time for a new approach.* He circles, considering. "I hate hiking," he says.

She shrugs.

"Hiking through the rainforest is hard work even if you know what you're looking for."

She purses her lips.

"I bet you found it, though," he says, capturing her hand with his. He lays her palm flat against his bare chest. "To be a senior location scout so young, you'd have to be really good at it."

"I'm not that young," she snaps.

"What? Twenty-five? Twenty-six?"

She softens. "You think I'm twenty-five?"

"Only because you have to be at least twenty-five to rent a car here. And you have all that Miramax responsibility. But you look much younger."

"Now you're flattering me."

"Truth," he says, raising a hand to the sky. "You said you've been hiking. Tell me what you found."

"It wasn't easy."

"Of course not. Anybody can do easy," he says, squeezing her fingers and stroking her wrist.

"It took me a week and a hundred-dollar tip to the guy at the hotel desk, but I found it—it's perfect. There's no hint of civilization in sight—no telephone poles or paved roads—and the tree canopy is straight out of the Amazon."

"Amazon? You were looking for Brazil on Oʻahu?"

"Of course! Hawaii's great. All the modern conveniences with a third-world vibe. Exotic without the hassle of diseases and currency exchange. Hawaii can be anywhere in the world. Production crews love it."

"Hmmmm," he says, releasing her hand.

As she drones, Kalei's attention wanders. *There's nothing better than being in the ocean as the moon slips into the sea and the lights on shore wink out,* he thinks. *When the sky and water are the same inky black, impossible is effortless.*

"It's all good," she says, laboring a little in the water. "I've got three of my four locations under contract," she says. "All but the murder scene."

His attention snaps. "Murder scene?"

"Don't worry," she says. "It's a revenge story with a twist, not a boring whodunit or a slasher flick. We'll shoot most of it on sound stages in L.A."

"But you don't have the murder location. Maybe I can help."

She brushes his cheek. "You're sweet, but this afternoon I found what I was looking for. The only problem is getting the permit."

"Pink malasada boxes," he says.

"What?" She laughs. "Mala—what?"

He shakes his head. "Nothing. Just a saying: if you want something done, bring a box of malasadas—they're like doughnuts, but better—to the secretary or clerk of the guy who signs the permits. Any permit."

"Business 101," she says. "I thought I'd greased the local wheels, but when I called to register my murder scene's location, Marie—that's my contact at the Honolulu film commission—Marie Wong? Wang? Something like that—Marie Whatevers, my new best happy-hour friend all last week—she stiffed me over the final location permit because of a pile of rocks."

She kicks harder, rising a little in the sea.

"That doesn't make sense," Kalei says. "Films bring a lot of money and tourists here."

"I know, right? Who holds up a multimillion-dollar film over a heap of moldy lava that some old guy claims is sacred?"

"Sacred?"

She feels him twitch; his movement sends a signal through the water to her brain. Something niggles for her attention, tugging at her subconscious. *Catholic school guilt,* she thinks. *Like Trudy says, I have to let go. But don't think about Trudy now.* She waves her hand, banishing that train of thought.

"Who said sacred?" he repeats.

"Some cultural advisor claimed the area was an ancient Hawaiian hey-ow temple." She rolls her eyes. "But it's only a pile of loose rocks. It's not like it's Chichén Itzá or the Great Wall of China." She kneads the water faster.

She swims like she's churning butter, he thinks, drifting away to give himself room to breathe. No matter how tantalizingly she splashes, the confession must come first. "A heiau temple? Around here?"

"Next valley over. Maybe two. I dunno; I can't keep anything straight. Not even the locals know which direction is north."

"Mauka and makai are easier," he says.

"That doesn't even make sense. Nothing islanders say about the land makes sense. That's why I rely on GPS and survey maps."

Kalei blinks. "What are you talking about?"

She bristles. "Get this: after Marie Whatevers tells me no, I try to explain that I've been all over the island. There's no place else like this perfect spot—it's crucial to the film. Right in the middle of my explanation, she hands the phone to the cultural advisor, who just cuts me off. He demands to know where I am. I read him the GPS coordinates, and he announces that I'm trespassing."

"Trespassing?" Kalei asks. "He used that word?"

"Yes! I say the GPS and survey maps say it's public land. Fair game. He says it's not, and I have to leave. Now. Like I'm some child he can boss."

"But he can't," Kalei says.

"Hell, no. I tell him it's not posted no trespassing, and he says to look for a sign saying kah-pooh, k-a-p-u. I'm standing under it. Kah-pooh means no trespassing. Why don't these people just say what they mean instead of being all wink-wink with the Hawaiian? It's still America, damn it."

"That's rough." He cups a hand and strokes, pulling his body through the water to circle behind her.

This time she doesn't turn with him and keeps her eyes on the last sliver of moonlight. She leans back in the water, shaking her hands and sending blue plankton twinkling from her finger-tips like the Fourth of July. "Superstitions." She slaps at the water. "It's all a game. When enough green shows up, the spirits change their minds. I've seen it a million times."

"Green?"

"C'mon, this ain't my first rodeo."

"Senior location scout," he says.

"I'll get the permits. We'll shoot there. I just need to figure out which native support group gets the generous donation."

"That's frustrating."

"Don't worry; it's built into the budget. It's not like it's coming out of my pocket."

Time to calm, he thinks. *All this agitation leaves nothing to savor.*

With one finger he lightly brushes her shoulder. When she doesn't move away, he rests his palms; when she sighs, he begins massaging, rolling her muscles in slow circles under his thumbs.

She closes her eyes, thinking back. *At the bar in his ratty aloha shirt and swim trunks, he probably couldn't afford to buy me a drink. That's why he wanted to go to the beach. He wanted the fun without buying the rum.* She lifts a shoulder, and he obliges by digging deeper. *He's got blue-collar hands. Rough. They're better than loofah at scratching an itch.*

Trudy won't understand. She'll be jealous if she finds out. Meal ticket, she'll say; he's hoping you'll be his sugar mama. But the joke's on him if he thinks I'm good for more than breakfast in the morning.

As her breathing slows, he gentles the massage. His hands rasp lightly, just enough to warm and pink her tender skin. "Securing the perfect spot for your murder scene shouldn't be this hard," he says. "You're too tense."

She shrugs. "Par for the course. It's all about money and control." Stretching her neck, she swivels her head like a hula dancer's hips. "Ummm," she says. "Feels good."

"It's supposed to."

"I'm glad I let you talk me into going for a midnight swim. So much better than that sorry excuse for a bar. I feel like I can be myself out here," she said.

"Me, too."

"That bar! What's it called?"

"Hari's."

"That's it. Hari's, with an i. Can't believe I even walked into that place, let alone used the restroom."

"The TV's nice."

"The bar is missing an entire wall! It's open to rain, rats, roaches; I don't even want to think about what crawls over the tables. Who eats in a place like that?"

"Locals," he says. "Who else?"

Oh-oh, she thinks. *I've offended him. Time to play nice.* She reaches back to touch him, but he slides away again, curving to her side. Fighting the undertow, her hands flutter in the water like a bird with a broken wing.

For a beat he watches her struggle, amused.

Water is so foreign to her, he thinks. *She needs to just let go. You can't make a wave change its course.* He reaches out and steadies her.

"Thanks," she says, clinging to his arm.

"No problem."

She clears her throat. "I can see why some people like the open wall. It's breezy, quaint. Definitely gives the bar an authentic *Gilligan's Island* feel. Do you go to Hari's often?"

"Not really. I don't have many friends there."

"You don't?"

He smiles.

Braces, she thinks. *He could really use some. Why didn't I notice his snaggleteeth before?*

"I don't have a lot in common with the people who live in Lauele now. I'm more of an old-fashioned guy."

"I knew it!" She beams. "You have that real, what's it called—oh! It's on the hotel brochure—"

"Brochure?"

"Don't tell me; it's on the tip of my tongue! Aloha—"

"Aloha? Are you going somewhere?" he teases.

"Ah, spirit! Aloha spirit."

"I have a real aloha spirit? You can sense that?"

"Yeah. It shines in your eyes." *Better,* she thinks, but she knows she's fooling no one, not even herself; they've both read this script long ago. She cuddles closer, her body warming the ocean between them.

"My aloha spirit," Kalei says. "No one's noticed before."

"How could they if you're always lurking in the shadows? You were sitting at a table practically hidden in the jungle. The light from the bar didn't even touch it. If I hadn't been coming from that horror of a restroom, I would have missed it completely."

"It's my usual table," he says, a little off-script. "When I'm in town, I sit there."

"Whatever for?"

"Out there people leave me alone. And it has a great view of the TV."

"But when I saw you, you weren't watching the TV." She tilts her head, coy in the water, determined to get them back on track.

"No," he says.

"You were watching me."

"Yes."

"It's my long, red hair, right?" She touches it. "All the island boys love it. So different from what they're used to."

He arches an eyebrow. "There is something special about you, something that attracted me to you, but it's not your hair."

"Oh?" she wavers. He's off-script again. She has no idea where this ship is sailing.

"That specialness is the reason I asked if you'd join me in a swim. It calls to me."

Reassured, she smiles. "Now you're feeding me a line. I won't take the bait."

Kalei shakes his head. "No line. It's true. Tonight I only have eyes for you."

"That's so romantic." She unspools the love scene in her mind. *Will it be* From Here to Eternity *or* Blue Lagoon? she wonders. *Damn. We don't have a beach mat. Sand could be a problem.*

"I really am here just for you," he insists.

"I can tell."

In the water? I've never done that, she thinks. She splashes him, sending more blue embers into the night. He doesn't duck away, but lets them rain down on his head. Touching her cheek, he brings her eyes to his, the perfect Tom Cruise moment.

"Good," he says. "I want you to remember, to believe, that tonight I'm here for you. Only you."

She swallows. "You said that before."

"I mean it." He squeezes her hand as the last lights on shore blink out. The darkness gathers and nestles close, the stars blazing like diamonds against black velvet.

"Mean what?" she whispers.

"Let me show you."

Ocean slick, Kalei eases around her body, coming to rest behind her. As she bobs in the current, he gently rolls his thumbs in the tight spot where her neck joins her shoulders, easing away the tension.

"I'm sorry for your troubles," Kalei murmurs.

She barks, her laughter shattering the moment.

"Don't be. Back in L.A., I'll dine out for a month on this story. I even picked up a small souvenir from that heap of stones to use for show and tell."

"A rock? You took a rock from the heiau?"

"Just a little one from the top of a pile. No one's gonna miss it," she says.

"The rock," he persists. "Where is it?"

"Relax. It's in my pocket on the beach. I'll show you; you'll love it; it's covered in moss like some ancient relic from a movie set. So *Indiana Jones.*"

"I feel like I know it already," he says. "It's small and round like a perfect lichen-covered golf ball."

"Exactly!"

"It fit into your pocket. That's why you took it. Simple to show off."

"See, you get it."

"I do," Kalei says. "Completely."

"The islands need more people like you. If you were in charge, I'd have my film permit!"

"I'm not a cultural advisor. Those things aren't up to me." He pinches harder, grinding her skin against her bones.

She exhales, releasing stress in one long breath.

That's more like it, he thinks. *Just relax. It will all be over soon.*

"There's some good in all this," she says. "If the cultural advisor hadn't threatened to call the cops and report me for trespassing, and if I hadn't been desperate for a restroom, I never would have stopped at that bar. I'd be back in my hotel room in Waikīkī. I wouldn't have met you, and we wouldn't be here now."

"You're right. I don't get to Waikīkī often. Too many tourists."

He presses his palms down into the meat of her shoulders and uses his fingers to tap a rhythm along the ridge, calling the blood to the surface and sending tingles down her spine. Her breath swells in her chest as she melts into his touch, the last of her anxiety slipping away.

I deserve this, she thinks. *I will not allow myself to feel guilty.*

"Let go," he says. "Let me do all the work." He cradles her head, rocking it from side to side, loosening the joints and sinews. The water laps over her collarbones, brushing her chin.

"You know what this is?" she asks.

He leans close, his breath tickling her ear. "I know exactly what this is," he whispers. Moving deftly, his hands work their magic deep into tissue and fiber along her spine, soothing away her concerns.

"You should know I can't promise you a part in the film. A little Hawaiian holiday, that's all this is. I'm headed back to L.A. and my girlfriend in the morning."

"Lie back," he says, placing one hand on the small of her back, the other supporting the nape of her neck. "I want to see all of you."

She sighs and brings her toes to the surface, floating. Baring her face to the sky, her breasts and hips are islands in the sea, her hair a coral fan of red and gold in the starlight.

"You are truly lovely," he says.

"You're not so bad yourself."

"Look at you. So luscious in the water, full and ripe and sweet." He smiles without showing his teeth.

"Flattery will get you everywhere," she giggles. "Want a bite?"

"I thought you'd never ask."

She senses him slip under the water, gently sliding his hands away as her toes dip below the surface, her body settling upright. His tug on her ankle is first, just a little lover's nip sparking a shiver of anticipation.

In the water, then, she thinks. *It's the perfect location for our happy ending.* Lolling her head back, she floats, closing her eyes, holding her breath for his next caress.

His skin, rough and cold, his beard perhaps, she isn't sure, chafes along her thigh. A nuzzle, a nibble, then sudden warmth floods, sending dark red blossoms rising around her in the sea.

Confused and off-balance when she tries to kick, she opens her eyes and throws her arms wide, blue sparks shedding from her fingertips, the only sound the blood pounding in her ears when she recognizes the impossible: a dorsal fin behind the lei of shark teeth lovingly embracing her neck.

* * *

"It's got to be over here, 'Ilima. Poor thing's been calling all night."

Old man Kahana and 'Ilima, his four-legged companion, pick their way down through the bushes to the beach. In the predawn light, Kahana pauses to survey the scene: women's clothes piled above the tide line, no beach mat, and two sets of prints disappearing into the water, one dainty, the other larger and missing part of a toe. Farther down the beach, the larger prints return, heading toward Piko Point.

Kahana shakes his head and rubs his whiskery chin.

Auwē, he thinks. *Last night Kalei came to Hari's, but not to watch TV. He was hunting. All 'Ilima and I can do now is try to make things as* pono *as possible. How, I don't know. Making this right is not going to be easy.*

He eyes the lump in the pocket of the shorts and grimaces. *It's in there,* he thinks. *I need to get it out, but I'm not doing this alone.*

Raising his arms above his head and facing the sea, he chants a short prayer asking the gods and ancestors for their forgiveness and protection.

Satisfied he has their attention and approval, he wiggles his fingers into the pocket and pulls out the small lava rock whose terrified calls kept him awake all night. Turning it in his fingers, he notes which sides are mossy and which are plain, so he'll know exactly how to replace it later on the heiau's altar. In safe hands, the rock promptly goes to sleep. It's been a long night.

From the beach, Kahana glances back across the street toward Hari's, scanning the parking lot. He easily spots the new white Avis rental next to Mrs. Espinoza's orange pinto.

Bingo.

'Ilima whines as she paces, looking out to sea.

"It's okay, 'Ilima. Kalei's gone. We'll take proper care of the stone. Kalei won't have a reason to come back," Kahana says.

'Ilima turns and noses through the woman's clothes, uncovering a leather purse.

"Good thinking. We're going to need to take care of that." Kahana opens the purse and takes out the wallet. He flips through the credit cards and stops at the driver's license. "From California. Pretty. Whatchu think?" Kahana holds out the card.

'Ilima chuffs.

"Nah, she's not sick. All the L.A. girls want to be that thin."

'Ilima lifts a brow and tilts an ear.

"Old? No, thirty-six is not too old for tank tops!"

'Ilima snorts.

"You're just jealous." Kahana thinks for a moment. "We better take the credit cards and shred them. I don't want somebody finding them and running up a big bill. We'll leave the ID for the cops to find, though. Wow, there's a lot of cash."

'Ilima yips.

"You're right, waste not, want not," Kahana says, pocketing the bills. He scrambles through the crumpled tissues, hair ties, and lipstick, digging through the purse for the rental car's keys. "We'll leave the rest in the car in Waikīkī. Won't take long for somebody to find it, especially if we

park it in a handicap spot. It's an easy bus ride back to Lauele, but that means you gotta fake service dog again."

'Ilima licks her nose and pouts.

"Only on the bus, I promise. You can wear your pretty pink leash and collar with the bling. Sharp, that. I'll wear the extra-dark glasses and stumble a little. It'll be fun. We'll make a day of it. Heiau first, drop the car in Waikīkī, bus, home." He pats his pocket. "We even have lunch money."

'Ilima perks her ears and wags her tail.

Stooping, Kahana rolls everything into a bundle, then plows his feet through the sand, erasing all traces. As the sun rises over the mountains, 'Ilima prances along the shore break, dodging waves and smudging the last of Kalei's footprints.

Kahana stands for a moment at the water's edge, looking out to sea.

"Tourists," he sighs.

THE END

Artist Statement for *Kanaloa, Nanaue, The Puhi Rider*

Solomon Enos

Having grown up immersed in Hawaiian culture, with my lessons coming directly from the land through gardens, farms, and watersheds, I sought to share these experiences through my art. Having also spent many hours as a youth in the sci-fi section of our public library in Waiʻanae, I began to see fantasy and science fiction as a perfect medium to translate the Indigenous wisdom of my ancestors into a form that was contained, therefore I could experiment with my culture and share it in new ways while protecting the traditional narratives. Kind of like a cultural sandbox, this allowed me to project radical narratives that were based on the traditional stories, with one example being, What would happen if Hawaiʻi was left alone to develop into its own sovereign nation? Just from that idea, many threads and stories and drawings have sprung. And this narrative has also come back to me in the form of another question: What were we doing before we were interrupted, and how can we get back to that way of life in one form or another? And this narrative has universal application. This narrative continues on into space, but this is not a story about escaping a dying planet to colonize other worlds with our bad ideas. Instead, it is a story about a species who know how to take care of planets, like the islands in space that they are. And this species, in concert with all of life on Earth, Honua, expands its consciousness, and later, its physicality, out into the cosmos. And we learn how to ask the cosmos permission before we enter, bringing our ecological and societal best practices with us.

Kanaloa, the god of the great ocean and ocean voyaging, as he emerges from the depths studded in barnacles and embraced by an octopus— this is one of his many body forms (**Plate 2**). Kanaloa is well-known across the Pacific, more so than other akua in the Hawaiian pantheon, for he fills the space between and unites all of Oceania.

The story of Nanaue (**Plate 3**) is a cautionary tale about not breaking kapu (laws based on enviro-ancestral wisdom). Nanaue was born with a shark's mouth on his back, and so that he would not be further afflicted, it was paramount that he never ate meat. And when that kapu was broken, his hunger for human flesh gave him the ability to turn into a shark and a threat to every community he escaped to, until caught and killed by forewarned villagers in Molokaʻi. This is a cautionary tale about maintaining kapu, and, in a modern sense, understanding addiction. I have a hunch that he actually would have tried to persuade folks away from going to the beach, and only when they ignored him did he give in to his appetite.

The Puhi Rider (**Plate 13**) is a dive into our ka'ao tradition of fanciful storytelling. Here I am creating a narrative based on the mo'olelo (stories and legends) shared with me, of whole societies thriving within the realms of Milu, in the depths of the ocean. She is breathing through an oxygenated symbiotic jellyfish, and upon the back of a giant puhi, eel, our rider travels across the vast plains below.

Artist Statement for "Ka Hoaka"

Marie Alohalani Brown

Although "Ka Hoaka" is a creative work, it is based on traditional Hawaiian knowledge, understandings, and practices, and incorporates my personal experiences as a Hawaiian child growing up in Mākaha on Oʻahu. Thus, this story could be described as a kaʻao, a traditional genre that includes creative takes on traditional topics.

Moʻo are Hawaiian reptilian deities associated with wai (fresh water), although some moʻo may frequent or live near the shoreline, such as the moʻo in this story, which is based on a moʻo wahine (female moʻo) associated with the coral outcrop known as Kūlaʻilaʻi. I took liberties with the cave's description, which is actually a small hole, to make it big enough for a large moʻo wahine to crawl in and out of. Furthermore, some families, such as mine, count a moʻo among their ʻaumākua. The camping scene at Kūlaʻilaʻi is inspired by my own childhood experiences as my family would camp at this same beach and we children greatly enjoyed chasing and catching sand crabs at night. At any family gathering, we children loved telling and scaring each other with ghost stories. Akua lele (flying deities), known elsewhere as fireballs, were a topic I remember hearing about as a child. The siblings Kaulana and Koa are inspired by actual siblings—myself and my younger brother, but also my daughter Lehua and her younger brother Cristoforo. Koa's thumb-sucking is based on my son's own habit as a child. My son also greatly enjoyed licking my face to hear my laughing exclamations of pretend disgust. In turn, I would lick him back. Leilani is inspired by my own Hawaiian cousins who would visit in the summers from Goshen, New York. Kaulana's story about the moʻo in the cave was inspired by a friend, David Wallace, who grew up on Molokai and who told me a story about a certain beach where a number of children had drowned over the years. As I remember the story, these drowned children would call out to living children to come and play with them in the ocean, and then these living children would drown in turn. Kaulana's kupuna's description of the drowned children is based on research about deaths by drowning and my familiarity as a child with the occasional dead fish on the reef upon which crabs had feasted. The children eating s'mores is an invention for present-day readers. In my family, we'd be more apt to drink hot tea or chocolate into which we'd dip or crumble buttered pilot crackers.

I have written many short stories about moʻo such as this one, which are always based on traditional knowledge and practices but place moʻo in present-day settings. These kaʻao are inspired by either my imagination wondering "what if" or random conversations with other Hawaiians.

Ka Hoaka

Marie Alohalani Brown

The cave drew in the ocean swell through one of its many lava tubes and spat it out in an explosive spray of seafoam. As the tide ebbed, the water in the cave calmed. Soon, large black ʻaʻama crabs appeared from fissures and scuttled along limu- and ʻopihi-encrusted walls in search of prey. From the watery depths, something rose and slowly made its way to the surface. Eyes stared up, unblinking, through the water at the crescent moon perched in the cloudless sky. Hawaiians called this night in the lunar calendar "Hoaka," or the night when lapu (ghosts) cast long shadows that frightened the fish away. It would be low tide until morning.

In the distance, several campfires flickered in the still summer night.

"An' when da fireball wen' chase the small kid all da way from out da graveyard, he wen' go shishi in his pants," said Freddy Boy. He licked the chocolate from his s'more off his fingers.

"Ho, junk your story. Not even scary!" said Malia, Freddy Boy's little sister.

"I thoht ith wath schary," said Koa, as he sucked his thumb and stared defiantly at Malia.

"Mom said you goin' get funny-kine teeth lidat. Stop already. You six years old." Kaulana gently pulled her little brother's hand away from his mouth.

"When we pau tell ghost stories, I promise I stop, 'K? Besides, I no moa teef." Koa smiled at his sister, showing the gap where his two front teeth were missing, and put his thumb back in his mouth.

Kaulana and Koa's cousin Leilani, who was visiting from New York, concentrated on prying a sticky burnt marshmallow from her fingers to put it on her graham cracker. "Fireballs are nothing but an accumulation of decaying organic matter; for example, cadavers. The decaying matter transforms into gases. These gaseous vapors exit from the gravesite, creating those green fireballs that superstitious people think are spirits. It is nothing more than gravesites farting up gas."

When all of her cousins and the other children burst into laughter, she looked up. "What?"

"Gravesites futtin' up gas?" asked Kaulana. The children burst into another round of laughter.

"Eh, I got one good ghost story," said Kaulana. "It's about some kids that drowned when dey wen' campin' with family."

From around the campfire, a collective sigh of appreciation rose into the night.

"I wen' hea my parents talkin' about it a few weeks ago when dey thought us kids was sleeping. My mom was whisperin' dat she nevah like come hea 'cos she said get ghosts, but my faddah wen' whispah back dat it wen' happen when his kupuna was one small kid. Da next day I wen' ask

Puna what wen' happen. She wen' tell me dat she was twelve years ole, just like me, and was campin' wit' her 'ohana on dis same beach, and dat one night, one of da families no could find dere two kids, one sistah and her little braddah. Dey wen' go check all da oddah families foa see if dere kids was dea, but nobody wen' see dem. All da families wen' try fo' help dem find da keiki, but nobody wen' find nottin'. Den my kupuna wen' tell me sometin' dat wen' give me chicken skin. She said dat she and her braddah wen' remembah playing wit' dose kids the day befoah dey wen' drown, and dat it was her and her braddah dat wen' find da bodies covered wit' black crabs and floatin' face down trapped in one cave. Da same cave das way ovah dere." Kaulana pointed toward the end of the beach, where the distant cave was too far to be seen, and all eyes followed her finger—every child had been lectured by their parents about not going near the cave.

"My kupuna and her braddah wen' run tell dere parents, who wen' call all da oddah parents, and she had to show all of dem whea da bodies wen' stay. Puna tole me dat when da men wen' fish da bodies out from da cave and turn dem ovah, dat da girl and boy had white foam comin' outta dere nose and mout', and dat da bodies had chicken skin. But da worse ting was, both bodies had wit' deep scratches and whea da eyeballs had been, was empty holes wit' baby 'a'ama crabs nestin' inside."

"I no like dis story," said a little boy, who started crying. Kaulana and the other children watched in silence as he left with his older sister.

Kaulana looked at Koa, who slept in her arms. "I bettah stop, I no like get in trouble for scaring anyone, bumbye I get scoldin's."

"No! Tell us da res' of da story," chorused the remaining children. There was a scramble as the children drew closer together.

"OK den. So anyway, she tole me dat she and her braddah wen' wake up latah dat night 'cos they both heard kids callin' dem foa come outside and play. Dey even heard scratching sounds, but dere parents still nevah wake up. The next day had one big stink cos one maddah was screamin' dat she wen' lose her four-year-ole boy. Den someone wen' find his body, poor ting; all squish up in one crack on da reef. And wen' look jus' like da oddah keiki bodies. Aftah dat, all da families' wen' wala'au, and das wen' my Puna, her braddah, and all da oddah kids wen' get all nerjus'. Seem like all da kids wen' hea' da voices callin' dem in da night. But, only da kids wen' hear 'em, not da adults."

"Eh, Kaulana, Koa, time for go sleep already, it's late," said Kaulana's father.

The children screamed, then giggled nervously, each child embarrassed to be caught off guard. They all exchanged sheepish looks. Koa woke up with the commotion and rubbed his eyes and yawned.

"What? You guys telling ghost stories?" Kaulana and Koa's father grinned at the circle of children. "Must've been one good one!"

Kaulana and Koa waved goodnight to everyone and followed their father back to the tent.

The campers drifted into sleep. The silence was occasionally broken by the sound of dying campfires as burning wood snapped, or by the occasional snore. There were other noises, but these were audible only to a select few. Voices began to whisper in the night.

"Kaulana . . . Kaulana, wake up. Come play with us." From deep in her sleep, Kaulana stirred, reacting to the voices that called her name. Next to her, Koa whimpered in his sleep. Kaulana woke up with a start. She wasn't dreaming the voices.

"Kaulana, come swim with us," called a singsong voice. Kaulana heard the sound of fingernails dragging on the tent. Her throat was suddenly dry when she swallowed, and she looked over at her sleeping parents.

"Go away," she whispered angrily. "Dis not funny. If my parents wake up, you guys gonna get it!" Kaulana waited. When she thought the pranksters had gone away, she went back to sleep.

When Kaulana woke up the next day, a boy mentioned that he had heard voices in the night calling him to come and swim in the ocean. Soon all the other kids told their versions of scary voices calling their names in the night and the sound of fingernails scratching tent walls. Everyone laughed nervously, but no one admitted to being the prankster. When Koa told the other children that he dreamt of a little boy calling his name, Kaulana felt her skin prickle, and she shivered.

Night fell, and the parents organized a crab hunt. A prize was offered for whoever caught the most sand crabs.

"Kaulana, Koa wants to stay with you. Make sure you take care of him, 'kay?"

"OK, Dad, no worries." Kaulana took her brother from her father's arms, and nearly fell over as Koa wrapped his arms and legs around her.

"Ho, Koa, you gettin' too big to be carried." Kaulana was tall for her age, but so was her little brother. He giggled and tried to lick her cheek.

"Eww, Koa, stop it!" Kaulana laughed, and then licked him back.

Armed with buckets and flashlights, the children's enthusiastic cries rang up and down the beach as they chased crabs. Both exclamations of disgust and hysterical laughter punctuated the hunt as crabs scuttled over little feet in their attempts to avoid capture. Occasionally, in a tussle over a crab that sought refuge in the ocean, children tripped over each other and fell into the water.

Kaulana caught five crabs before she remembered that she was supposed to keep an eye on Koa. She looked around, but couldn't see him. Nearby was her cousin Malia.

"Malia, you wen' see my little braddah?"

"Yeah, he wen' go dat way wit' one girl and boy." Malia pointed her finger in the general direction of the distant cave. Kaulana thanked her, and set off in that direction. At first, she jogged, but then the fear of being scolded by her parents for not watching Koa fueled her pace.

It was a long way to run, and she was breathing heavily by the time she was close enough to see a girl and a boy dragging her brother into the ocean next to the cave.

"I no like go swim at night. I scared." When a wave hit Koa in the face, his complaints turned to screams for help.

Thoughts raced through Kaulana's mind—ghost stories of drowning children, children hearing voices inaudible to adults calling in the night for them to come and play, the off-limit cave, and her brother screaming in fright. Kaulana's knees buckled beneath her as the realization hit her.

"Let go of my braddah, you frickin' ghosts," screamed Kaulana, throwing herself at the female apparition. The girl ghost gripped Kaulana by the arm, gouging deep holes in it with her nails. With her other hand, the ghost tried to claw out Kaulana's eyes. Kaulana flipped her face to the side to avoid the blows. The fingers missed her eyes, but left long claw marks down Kaulana's cheek. Blood started to drip into the water. As Kaulana desperately wrestled against the inhuman

strength of the girl ghost, the boy ghost dragged Koa into water over his head. Beneath the water, the boy ghost had wrapped himself around Koa in a deadly embrace and was squeezing his last breath out of him.

In the cave, ʻaʻama crabs felt the reverberations of a heavy mass that moved through the lava tubes, and scurried into crevices to hide. There seemed to be no end to the thing that crawled out of the cave.

"Uoki!" commanded the creature, ordering the ghosts to stop. It was a moʻo deity. From a long black and powerfully built reptilian body rose the torso of a woman, whose beautiful face was devoid of expression. In one quick movement, the moʻo goddess separated the boy ghost and Koa. Grasping Koa close to her body with one arm, she seized the boy ghost with the other and used the long claws of her front legs to savagely tear him into pieces. Still holding Koa, she reached out to grab the girl ghost by the hair, and ripped off the ghost's head. The ghostly remains faded before the children's eyes.

The moʻo turned her attention to the two siblings. Time seemed to stop for the children as unblinking eyes stared at them in appraisal. "E hele aku ʻolua i ko ʻolua mau mākua," ordered the moʻo before she turned and crawled on four legs back into her cave.

Kaulana and Koa obeyed the moʻo's command to return to their parents, running the entire way without stopping. In tears, and incoherent from shock, they tried to explain what had befallen them.

"The moʻo of that cave is our ʻaumakua," said Kaulana's mother with a shaky voice. "But I wasn't sure if she really existed." She tended to the deep scratches on her children's bodies, while her husband and all the other families began packing up camp. By the next morning, the entire town knew what had happened, but nothing ever appeared in the newspapers. Neither did anyone go looking for the moʻo. They all knew better.

Artist Statement for "When We Become Home"

Lyz Soto

"When We Become Home" began with "When We Become Butterflies,"[1] a multimedia experimental poem based on Donna Haraway's *Staying with the Trouble,* which, set in multiple future times, suggests, in the final chapter, a way our contemporary society dominated by earth phobia could become more responsive and more symbiotic with our planet. "When We Become Home" is set in this world and continues the story in a future Pacific. This world does not try to slough off the troubles of our history—colonialism, imperialism, slavery, genocide, pleonexia[2] (thank you, Zadie Smith)—and our present—neoliberalism, neocolonialism, imperialism, institutionalized racism, genocide, pleonexia, mass extinctions, climate change—yet it manages to imagine a future where we are still present in positive, hopeful ways. Indigenous strategies built through relationships with land, water, and sky going back thousands of years are placed at the forefront of believing that it is possible we might be a thriving species 400 years from now. It also recognizes that the problems of yesterday and today will not disappear through magic and wishful thinking. Foundational to this future is the faith that we can make generous choices engineered for tomorrow, today.

Haraway's universe imagines some groups of humans genetically tying themselves to animals we have historically harmed, and in many cases annihilated, to become chimeric beings, who are molecularly tied to the lands of their birth. They commit to being in spaces we have damaged and they work to rebuild functional healthy ecosystems. There are no capital gains here. Avarice is not rewarded. Some of us might recognize this epistemological approach and take note that it is not new. "When We Become Butterflies" tried to create a conversation, which began with Haraway's genetic so(u)rcery weaving humans with butterflies. Necessarily, that was a continental story. "When We Become Home" ties humans to ahi/bigeye tuna—a beautiful carnivorous

1. In Honolulu, Hawaiʻi, "When We Become Butterflies" was performed by David Kealiʻi MacKenzie and me at the Science Fiction Research Association Conference in June of 2019.

2. Smith writes, "An ancient word for a contemporary condition. Where *pleonexia* does the linguistic work that simple greed or avarice does not, is in its diagnosis of a covetousness that is not healthy, that is abnormal. It is a word that needs to be added to the more harmless terms with which we describe the modern consumer. *Pleonexia* is a heightened and unhealthy condition, as *anorexia* is the pathological extremity of a brand of asceticism. There is need, then there is desire, then there is greed, and then there is *pleonexia*" (Smith 2012, 392). *The Oxford English Dictionary* (2nd ed.) records that in 1858 "pleonexia" was used as a term for greediness regarded as a mental illness.

warm-blooded fish native to the Pacific—a Pacific recognized as an ocean with a rich complex symbiotic history physically and spiritually connecting islands and island people together (Hauʻofa 2008), rather than an empty space or a bridge between continents. Equally intrinsic to this world-building is the notion (borrowed from N. K. Jemison, Nalo Hopkinson, and other speculative writers of color) that brownness and blackness are the character norm, rather than the exception, so we are an intrinsic, necessary part of this future.

I imagine this world as multilayered, multitextual, polytemporal, and polyphonic. In this way, tomorrow's ancestors, like Albert Wendt, Epeli Hauʻofa, Teresia Teaiwa, Hinemoana Baker, Karlo Mila, and Kumalau Tawali are interlaced into this text as a poetic forecast—a divination that our past will be alive in our future. We will be alive in our future, because in something closer to today we will work toward that tomorrow. In "When We Become Home," I try to embrace Haraway's universe, because experiments could be the practice that keeps us breathing, and I believe this is work worth doing.

Works Cited

Hauʻofa, Epeli. 2008. "Our Sea of Islands." In *We Are the Ocean: Selected Works,* pp. 27–40. Honolulu: University of Hawaiʻi Press.
Smith, Zadie. 2012. *Oxford American Writer's Thesaurus.* 3rd ed. Oxford: Oxford University Press.

When We Become Home

Lyz Soto

I. Math for a Sky

They read to us once about a blue sky.
Sister pointed to an old cloth—once called a tapestry.
She said
 This is blue.

Why would they tell us about that sky?
Sister says
 It's for hope.
She says
 this is why you get stuck

with all those numbers in your head.
She says = is the most important. My math
might make the sky blue

someday. I need to hope for a blue sky
first, she says = then I must
make it happen.

II. Tomorrow a Star

I know from the pages there is a star above us.
I know it's like a long song of lightning. We:
the flash in its wake.

Aunty told me about a mother
three hundred times past—she wrote about a day
she walked outside and an itching burn
blanched across her skin.

The sun all over her flesh—I thought
it would burn me to nothing—she said.
She said—in all that followed, there were days
I wished it had. We stopped counting
time. The stars were there, or they were not.

She wrote a lot about those stars talking
so long ago, so long dead. Tomorrow a star,
I cannot see, will hear her, my mother thirty-ten-years past, lament.
The sun all over her flesh—
Today is all I know. And all I know today
is a thousand forms for grief.

III. Mothers Thirty-Ten-Years Past

We die with our star.
In three billion years, but today it kills us.
Blistered and peeled this skin molts—a stretch
of unwound body. They say delight

in the sun while it's still here. They say tomorrow
it will be an unseen thing, but tomorrow
is a vague unknown thing, and today
it unwinds us. Our frame forgets itself.

IV. A Thousand Forms for Grief

Grief might be untamable. But we tried to truss its limbs. Keep them from twisting
into every hollow. And grief becomes the hollows—tangible unfilled
 theatres. Dilated threads we tried to knot. Then forget. Try forgotten.
Sleeping remembers its filaments. Unmoored. Duplicitous release. We dream
until we wake and we cry.

V. For a Blue Sky

After one hundred years of mass extinctions, some humans decided to link the lives of their children with vulnerable species. They were interlinked genetically before birth and spent their lives listening to the stories of their ancient newfound kin—holobionts. Some call these Speakers of the Dead.

In 2455, there might be three and a half billion humans on Earth. We once were nine billion. Some said the world became too tired to hold us.

Twenty mothers before me have been Speakers of the Dead. When we became Holobiont Ahi Mebachi, they knew we were dying. In 2455, we are still remembering our stories.

> Sym-poiesis is a simple word; it means "making-with." Nothing makes itself; nothing is really auto-poietic or self-organizing . . . That is the radical implication of sympoiesis. Sympoiesis is a word proper to complex, dynamic, responsive, situated, historical systems. It is a word for worlding. . .
>
> Another word for these sympoietic entites is holobionts or, etymologically, "entire-beings" or "safe and sound beings." That is decidedly not the same thing as One and Individual. Rather, in polytemporal, polyspatial knottings, holobionts hold together contingently and dynamically, engaging other holobionts in complex patternings.[1]

VI. Storms in My Skin

I'm waiting for my scales.
Aunty tells me they'll come in soon.
Look around your sides. Under
your arms—she says—you know

where you never look—so I look
all the time now, 'cause what color
will I be and what kind of light
will I carry in the water?

I want to be like the blue sky
we read about. I want to be
able to have storms in my skin
like thunder in a frame.

I ask Aunty—Hey Aunty, what
will water feel like with scales?
She says—it will feel like every part of you
has come home.

1. Haraway (2017, 25, 26).

VII. My Body for a Thousand Fruits

Twenty mothers before me she said we could know the future if
we say tomorrow is loved. She said my mother imagined
they could do better than they had done. She said when I die
give my body for a thousand fruits for tomorrow. She said the world
is a beautiful frightened monster.[2] She said we
are interwoven with the world. She said we
are a monstrous desire for more. Insatiable mouths. She said we
are so hungry.

> She said
>
> I am a needle of bone
>
> on my aunty's knee
>
> She said
>
> I am a thatched weapon
>
> a flake of obsidian[3]

Twenty mothers before me said here is my body for a thousand fruit trees
 my body fossil
 my body chimera
 my body sand as a Sphinx[4]
 my body
so my daughters might never go hungry
 again.

VIII. Safe and Sound Beings

There were two brothers, sons of Lumawig . . . the older brother turned to the other and said, Let us flood the world so the mountains may arise . . . [5]

Some said we were the lucky ones. Isolated. But
for more than a hundred years the waters came for us, like we could quench
 that rage. Or we could dilute
their acrid swallow. Some talked about the wounded ocean the bitter ocean

2. Sagan (2017, 169).
3. Baker (2004, 11).
4. Sagan (2017, 173).
5. Wilcken (2013, 31).

the ocean that would have seen us disappear. And we were lucky
as we drowned. But we stayed.

We stayed. We are still here. Became making-with—since we could not make ourselves. Remembering the world. Remembering inside us lamented. Remembering how to breathe
underwater.

> Albert said,
> inside us the dead.
> Maybe I wouldn't feel so lonely/if my body could recall those connections/there are only silences.[6]

Fear deafens—such a loud tempest/small kin to wrath. Not silent. Quiet.
Stop our noise to hear.
They were in waiting. Here. Waiting for us to listen. Waiting for us to come back to our bones.

> I am not capable of thinking/this blood is a ripple/in an ocean/of our blood/I am/the next wave
> of tide that has been coming/for a long time/this vein/leads back to my bones.[7]

When we remembered the ocean in us . . . the sea of islands.[8] When the Sympoieses came to us.
We were waiting. Inside us the dead waking/waiting for more worlding to begin.

> A memory/of all the bodies that have been/the making of me.
> Inside us the dead.[9]

IX. *This Is Blue*

Aunty said color is a piece of sacred.
So I think the ocean must be full of sacred.
Only in the water am I seen complete. Scales—prisms filled with angles, full of change.
Aunty said color was everywhere, like blue, but this is a hundred mothers past.
I am my own color now. I point to my scales and say, this is blue
refraction in my body. I am blue and I know the numbers of the sky.

6. Mila (2008, 10). "Albert" refers to Sāmoan author and anthologist Albert Wendt, and "inside us the dead" refers to his seminal poem "Inside Us the Dead."

7. Mila (2008, 10).

8. Hauʻofa (2008, 27–40).

9. Mila (2008, 10).

Sister said, Make maths for a blue sky. Build a new language.
When I swim I see the numbers in the water. Light in water
wants a new alphabet. We should have asked the water
fifty mothers dead, but Sister told me they stopped listening to water
a thousand mothers dead. After time, I think the water stopped trying to speak.

But water is another word for world.[10] Inside us—an ocean waiting to go home.
In all our forgetting, still—inside us: a source for a river. Inside us: another word for world.

X. Speakers of the Dead: Ahi Mebachi

When you know you are dying you may ask even your enemy for reprieve.
 Chew the flesh of our young
and swallow cousin. We come from the same mud. Remember. Find our bodies as yours.

Someday you will know the scales covering our face. On those days
you will know we are the color of smolder and kith.
On those days we will know nothing will be enough to pay back this debt.

First mother became Holobiont Ahi Mebachi when the lands were on fire. She knew
we were dying. Her mother twenty-mothers past remembered
the sea still full of life the sea that was dying.
The sea that almost died. The first time first mother went home to that sea—the sun
all over her flesh. Burning. Blurred. When rain became another word for fire.

First mother wrote about her scales as a bubbled mess scrape her skin to the bone
 when home was another word for grief.
First mother wrote about water too sour to drink—too sharp to breathe.
First mother wrote of swimming down with all our sorries. In the deep
where the sun has no reach her big eye bright the water cried
 nothing you do will pay back this debt.
And she answered But we will try.

XI. Mirror of the Blue[11]

Sister gave us the maths for a blue sky.
She was so underwater = a big eye in the deep

10. See Le Guin (1976).
11. Tawali (1970, 13).

remembered the moon = the tide as a heartbeating
<div style="text-align:center">oxygen slight as thread</div>
maths for blue = numbers for gardens—for forests.

Sister was a mirror of blue—a memory of feasts
when we almost ate our bodies to extinction. So underwater
Sister remembered and gave us a blue sky filled with the moon
<div style="text-align:right">numbers filled with breathing.</div>

XII. Water Is Another Word for World

Our mothers—a thousand mothers past—had water as another word for wealth.[12] Some days
I am a lament for the generations who did not listen. Atonement:
 woven strands of chromosome = a coded apology
 A thousand mothers past my mothers
knew rotting as a gift. Give to earth and you are given a garden. My body
for a tree. A tree with fruit for a thousand. My body for a thousand fruits. This gift
for a thousand daughters tomorrow. My daughters without grief.

Aunty told me about our mother—one mother, who saw the blue sky. She wrote
about the color of her skin, like a tear. She wrote about her traditions, like a tear
in the wind—a threatening rend.
 They call us dusty.
 They call us lesser than.
 They call us resources.
 They call us uninhabited.
 They call us dead.[13]
This mother saw the blue sky. She wrote about her people shadows of the sun. I wish
 we could send her a prophecy. Mother
 They tried to change you.
 They tried to disappear you.
 They tried to conquer you.
 They tried to make you dead.
Mother, who saw the blue sky, we are still here.

Works Cited

Baker, Hinemoana. 2004. *mātuhi needle*. Wellington: Victoria University Press.

Haraway, Donna. 2017. "Symbiogenesis, Sympoieses, and Art Science Activisms for Staying with the Trouble." In *Arts of Living on a Damaged Planet*, edited by Anna Lowenhaupt Tsing, Heather Anne Swanson, Elaine Gan, and Nils Bubandt, pp. 25–50. Minneapolis: University of Minnesota Press.

12. Teaiwa (1995, 16–18).
13. Smith (2017).

Hauʻofa, Epeli. 2008. "Our Sea of Islands." In *We Are the Ocean: Selected Works*, pp. 27–40. Honolulu: University of Hawaiʻi Press.

Le Guin, Ursula. 1976. *The Word for World Is Forest*. New York: Berkeley Books.

Mila, Karlo. 2008. "Inside us the dead (the New Zealand-born version)." In *A Well Written Body*, pp. 10–11. Wellington: Huia Publishers.

Sagan, Dorion. 2017. "Beautiful Monsters: Terra in the Cyanocene." In *Arts of Living on a Damaged Planet*, edited by Anna Lowenhaupt Tsing, Heather Anne Swanson, Elaine Gan, and Nils Bubandt, pp. 169–174. Minneapolis: University of Minnesota Press.

Smith, Danez. 2017. *Don't Call Us Dead*. Minneapolis: Graywolf Press.

Tawali, Kumalau. 1970. "Tuna." In *Signs in the Sky*, p. 13. Port Moresby: Papua Pocket Poets.

Teaiwa, Teresia Kieuea. 1995. "No One Is an Island—for Georgie." In *Searching for Nei Nimʻanoa*, pp. 16–18. Suva: Mana Publications.

Wilcken, Lane. 2013. *The Forgotten Children of Maui: Filipino Myths, Tattoos, and Rituals of a Demigod*. Scotts Valley, CA: CreateSpace Independent Publishing Platform.

Nā Mana Moʻolelo, Nā Moʻolelo Mana

Adaptations of Moʻolelo Hawaiʻi to Empower Moʻolelo through the Generations

Pono Fernandez

No ke Kūkulu Kahua

The stories told to me as a child remain a part of me; they are the pōhaku upon which my life has been built. I do not remember ever hearing any of these stories told to me in the ancestral language of this land. But I discovered that, in the three years we had together, my great-grandfather, the last ʻōlelo Hawaiʻi native speaker of our ʻohana, fed me his knowledge in his mother tongue when I was born. Some of the stones that make up my foundation are foreign, nestled amongst those of my ʻāina and whispered through the lips of the colonizer. Others of those pōhaku are well-worn, hidden and out of reach, so much so that I may have never seen them. They reside in the ancestral memory I have yet to access. Today, I stand upon all these stones, thinking of those I will place for the generations to come.

For Kanaka Maoli, moʻolelo have been the channel through which knowledge flows from generation to generation. Cosmogonic genealogies, inoa ʻāina, and cultural values and practices were preserved through the adventures of aliʻi, akua, kupua, and kānaka. With colonial overwriting and erasure, however, ancestral ʻike has either disappeared with its original orators or been buried beneath layers of cynical translation or ignorant judgment.[1] The practice of storytelling, as Cherokee author and scholar Daniel Heath Justice says in his book *Why Indigenous Literatures Matter,* "makes meaning of the relationships that define who we are and what our place is in the world" (2018, 75). Therefore, when our stories are told through colonial filters, Kanaka Maoli relationships outlined in moʻolelo become distorted, and life becomes disenfranchised. The losses

1. Many contemporary authors speak to this point. M. Puakea Nogelmeier in *Mai Paʻa i ka Leo: Historical Voice in Hawaiian Primary Materials, Looking Forward and Listening Back* discusses the problematic "canon" that is often referred to as the foundation of Hawaiian knowledge but relies heavily on flawed or biased translations and does not cite the Native knowledge keepers through whom the information was gathered (2010, xiii). Brandy Nālani McDougall also writes that, despite work done on the Kumulipo by King Kalākaua and Queen Liliʻuokalani, independently, Martha Beckwith's translation is by far the most widely distributed and studied. Beckwith's representation of the Kumulipo, McDougall argues, is "primarily commentary" influenced by Beckwith's colonial perspective and also seeks to reconcile Hawaiian cosmogonic genealogy with "Western standards of ʻhistorical accuracyʻ" (2016, 59).

are heavy, and Kanaka Maoli of this hybrid world experience what might be described as an identity crisis. To this point, though, Justice argues the following:

> If we focus entirely on the losses, we lose sight of what our families and our communities [. . .] have managed to maintain. It presumes that we're only in a position of trying to hold on to a finite set of resources, and doesn't take into account our capacity to grow anew and to create new practices, relationships, and cultural forms. Like all humans, Indigenous peoples are creative and visionary. The losses of the past don't inevitably determine the possibilities of the present and future. Given how the dominant deficiency narratives about Indigenous peoples are firmly rooted in the idea of absence, it's not too far a leap from acknowledging our losses to figuring our humanity *only* in terms of loss. We're more than absence. (55)

It would be easy to view my childhood years bereft of moʻolelo kūpuna, or ancestral stories, from a place of loss. However, a more recent journey toward bridging the gaps in my intellectual genealogy has led me to understand that even those moments of my life's path make up the ʻiliʻili, or the smaller stones that bolster the foundation beneath my feet.

My mother raised me to have a fascination for any kind of tale, reading aloud books like *The Mists of Avalon* or the *Narnia* series when I was still in her womb. My passion for dance comes from my grandmother, who taught me my first hula in the days when I could barely walk. Her love for music and hula was ingrained in my spirit and continues to live on in the movements of my hands and feet. Growing up as a girl who could be found only in the dance studio or with her nose in a book, I longed for the fantastic realms I read about to leap from the pages and land in my human world. Who lived in the thick forest lining the Likelike Highway on the drive home from school? What might I find on an adventure to the pools at the foot of those majestic waterfalls cascading down the Koʻolau mountains near our family home? Gods and goddesses perhaps, or a plethora of supernatural beings all certainly with a story to tell—a story that I could feel in my bones but never found in the pages of my books.

Now, as both a hula practitioner and scholar, I find that my youthful yearning for moʻolelo has become a kuleana and a gift—a responsibility to embody the stories of my ancestors and remind the world that those stories continue to live and breathe today. Goddesses like Laka are only a chant away, and she reveals herself in the scent of the mailelauliʻi vine winding through Koʻiahi. Kānehekili makes his voice heard as he rumbles through the mountains in the midst of a thunderstorm. The elements that tie us to this ʻāina are the manifestations of all those moʻolelo our ancestors experienced and they continue to tell moʻolelo to this day, proof that the fantastic is not bound to ink on a page. It is our kuleana to learn how to recognize them, embrace them, and honor them. For these reasons, I posit that the creation of new performance narratives as adaptations of traditional Kanaka Maoli moʻolelo engage generations and promote ancestral knowledge as a part of the continuum of both storytelling practices and of traditional moʻolelo.

In the introduction of *Ka Honua Ola,* Taupōuri Tangarō writes about the impact of practicing "culture absent of meaning" (Kanahele 2011, x), stating that "no matter how concentrated and

attached the mana is to an ancestral name, children will eventually walk away from their most sacred inheritance if meaning is not established in the terms they can relate to and sustain" (x). In other words, establishing meaning in Hawaiian practice, in this case moʻolelo and storytelling, is an essential part of ensuring its relevance to future generations. By telling these stories through contemporary perspectives and continuing those narratives into present time and space, new breath fills the lungs of ancestral knowledge and lives on the lips of a persevering people.

Storytelling in performance has been part of Kanaka Maoli culture for a long time. Kapāʻanaokalāokeola Nākoa Oliveira describes "Kanaka performance cartographies" (2014, 65) as a Kanaka Maoli method of mapping ʻāina and knowledge. She writes, "through eloquent mele, gracious hula, and captivating moʻolelo, talented Kanaka artisans kept people and places alive via their compositions by commemorating the histories and natural features of their ancestral places and by acknowledging the accomplishments and stellar characteristics of their ancestors" (93). New performance narratives add to the life of moʻolelo Hawaiʻi, remapping and reestablishing ancestral knowledge for contemporary Kanaka Maoli.

The moʻolelo that will be the kahua, or foundation, for this essay is that of *Hiʻiakaikapoliopele.* In encouraging my readers to expand our understanding of Hawaiian literature, I will lift up two mele written in the twentieth century that speak to events from this moʻolelo as contemporary versions, or mana, of the foundational moʻolelo. The first, "Hālauaola," was written by composer, musician, and kumu hula Manu Boyd in 2011 and performed in the Merrie Monarch Hula Festival that year by his hālau hula, Hālau o ke ʻAaliʻi Kū Makani. The second, "Haʻihaʻi Pua Lehua," was written by another kumu hula and famed composer, Frank Kawaikapuokalani Hewitt. I will provide a brief synopsis and analysis of these mele, as well as their relationship to the moʻolelo of Hiʻiakaikapoliopele, and demonstrate the impact of their adaptations in the medium of performance art. I will close this essay with considerations for my readers, invoking Kanaka Maoli kuleana to the moʻolelo of our ancestors.

ʻO Ka Moʻolelo Mana, He Leo Kupuna

Where have the stories of our kūpuna gone? Perhaps they ride on the wind, rustling through the trees on the highest peaks. Perhaps they sound in the crashing of the ocean as the waves meet the sand, or the echoing swish of the water caressing ʻiliʻili. Perhaps we no longer know how to hear the stories of our ancestors. But they remain nevertheless, waiting for each of us to learn again how to receive the gift of their song. The time will come, if we are patient, if we are open, and if we are ready. Our kūpuna will find us once again.

As part of readying ourselves, we should recognize that moʻolelo Hawaiʻi may not necessarily fit a traditional western definition of narrative, as Kanaka Maoli engagement with moʻolelo has historically blurred the lines of means and mode. Mieke Bal, in the introduction to her book *Narratology: Introduction to the Theory of Narrative,* defines a "narrative text" as "a text in which an agent or subject conveys to an addressee ('tells' the reader, viewer, or listener) a story in a medium, such as language, imagery, sound, buildings, or a combination thereof" ([1985] 2017, 5). It is within the "combination thereof" that moʻolelo Hawaiʻi reside. Moʻolelo like *Hiʻiakaikapoliopele*

are historically oral traditions, a combination of prose and mele, chants that make up a significant portion of the moʻolelo itself. For these reasons, I choose to use the ʻōlelo Hawaiʻi vocabulary where at all possible.

kuʻualoha hoʻomanawanui writes in *Voices of Fire: Reweaving the Literary Lei of Pele and Hiʻiaka* that "*moʻolelo kuʻuna have genealogy*" (2014, 52, emphasis in original). She establishes that genealogy by tracing the moʻolelo of Hiʻiaka and Pele from oral traditions to its appearance in print, and how these media of the moʻolelo have been woven together over the ages. She asserts that "rather than *replace* oral tradition (as a 'progressive' Western timeline would suggest), writing is an *addition* to Kanaka Maoli cultural expression, [. . .] the two strands comfortably coexisting and complementing each other" (54). In this way, so too have the oral and the performative aspects of moʻolelo Hawaiʻi always coexisted and complemented one another, as both mele and moʻolelo retain and transmit the knowledge Kanaka Maoli prized through the generations.

Awaiāulu Press's more recent publication of *Ka Moʻolelo o Hiʻiakaikapoliopele* is a reproduction of the moʻolelo as adapted by author Hoʻoulumāhiehie as it was printed in *Ka Naʻi Aupuni*[2] from 1905 to 1906. On the topic of Hawaiian-language newspapers, in his book *Mai Paʻa i ka Leo: Historical Voice in Hawaiian Primary Materials, Looking Forward and Listening Back,* scholar Puakea Nogelmeier, who also drove Awaiāulu's contemporary publication of *Hiʻiakaikapoliopele,* notes: "In just over a century, from 1834 to 1948, Hawaiian writers filled 125,000 pages in nearly 100 different newspapers with their writings. While literacy was at its highest, Hawaiians embraced the Hawaiian-language newspapers as the main venue for news, opinion, and national dialogue, but also as an acknowledged public repository for history, cultural description, literature, and lore" (2010, xii). He continues to explain that writers, including already "skilled storytellers" (xii), chose to publish their moʻolelo as a means of preserving the knowledge of their time and the time of their ancestors, in response to a quickly changing social and political climate in Hawaiʻi. For scholars of ʻike Hawaiʻi today, these newspapers are among the closest of our direct sources of cultural knowledge and history in the words of our kūpuna. Thus, the Pele and Hiʻiaka story, like all moʻolelo Hawaiʻi, is a carrier of the culture, voice, and perspectives of the generations who told it.

In this epic tale, Hiʻiakaikapoliopele—the youngest sister of the legendary Pele, goddess of the volcano—is sent on an arduous journey to Kauaʻi, during which she faces harrowing challenge after challenge, all to fetch Pele's lover Lohiʻau. Hiʻiaka takes on each dangerous task with the supernatural mana she is gifted, and blossoms on her journey until she finally fulfills the goddess potential she held all along, as the life-giving source of ʻāina in the wake of her destructive sister of the lava. While Hiʻiaka makes her way across the islands, her moʻolelo is steeped in ancestral place names, practices, and community values, instilling within the reader the perspective with which Kanaka Maoli engage their universe. The moʻolelo itself is a map of ʻike kūpuna that has endured across the ages.

2. *Ka Naʻi Aupuni* was one of the many nūpepa Hawaiʻi—Hawaiian-language newspapers—that sprung up in Hawaiʻi after the arrival of the printing press. Joseph Mokuʻōhai Poepoe was the editor of this particular newspaper, established in 1905, which "promoted the perpetuation of the native language and published works of historical and cultural importance in Hawaiian" (Silva 2017, 138). It is also purported that the name Hoʻoulumāhiehie could be a pseudonym for Poepoe himself, a well-known scholar, author, and editor who began publishing in the late 1870s.

'O Ka Mana Moʻolelo, He Mele Aloha

The stories we inherit speak through our hands and feet as we move to the beats of the drum, as our hearts pulse in time and call out to the hearts of those who have lived these dances before. Our voices in chant mingle with the notes of our kūpuna and reverberate with the ʻāina as it responds. Our stories are their stories. Their stories are our stories, brought to life as we breathe as one, revitalizing the ʻāina within and without.

Moʻolelo Hawaiʻi, true to the nature of oral tradition, are known to have many versions. Those versions will differ from island to island, capturing the perspective of those kūpuna who lived on the ʻāina upon which the story takes place. Kauaʻi's people will speak differently about Lohiʻau, and moʻo descendants might paint an alternative picture of the volcano clan. To this end, hoʻomanawanui writes, "the more mana (versions) a moʻolelo has, the more mana (power) it has as well—living, surviving, adapting, and thriving with the Lāhui" (2014, 50). It stands to reason, then, that as moʻolelo kūpuna take on new forms in new times, not only do our ancestral ways of knowing continue on, they are viable means of seeing and understanding the world for today's and tomorrow's generations. With this in mind, I now turn to contemporary interpretations of ʻike kūpuna through two mele to demonstrate how these moʻolelo continue to live, breathe, and inform.

Famed kumu hula and scholar—and descendant of Pele herself—Pualani Kanakaʻole Kanahele compiled twenty-five mele from the Hiʻiaka and Pele moʻolelo in her book *Ka Honua Ola*. She says that "the mele of *Ka Honua Ola* reveal that word and sound have substance; the reverberation of traditional mele in today's settings creates a venue for activation" (2011, xiv). Kanaka Maoli are thus reminded of how traditional ways of knowing can live and thrive in a contemporary context as we continue to practice those traditions. Hula, what Amy Stillman calls "a site of cultural memory" (2001, 188), plays an integral role in the continued presence of mele in Kanaka Maoli consciousness. Stillman, a professor of musicology whose renowned body of work focuses on Indigenous performance in Oceania, goes on to argue that "through hula dances and songs, memories of people and events endure long after they have passed. Performances are moments in which remembrances are sounded and gestured" (188), and "hula masters, then, were performers who had mastered an understanding of hula as a cultural system as well as a means of entertainment" (192). Mele found in moʻolelo such as *Hiʻiakaikapoliopele* project an ancestral understanding of Hawaiʻi for a contemporary reader. The particular imagery kūpuna used to call upon akua or ʻāina give Kanaka Maoli today a glimpse into that ancestor's perception of the world. And when hula is paired with those texts, that world is experienced in multiple dimensions.

To that end, the first of the new mele to be discussed is accompanied by hula. I have been fortunate to dance for a hālau that is founded in the traditions of hula and whose kumu is grounded in ʻōlelo Hawaiʻi and the cultural genealogy of hula. Kumu Hula Manu Boyd often reminds us of the common misunderstanding regarding hula—some say that the hula tells a story. But in actuality, it is the story that tells the story. As the ʻōlelo noʻeau or Hawaiian proverb goes, "I leʻa ka hula i ka hoʻopaʻa. The hula is pleasing because of the drummer" (Pukui 1983, 133). While the hula is often the focus, both the drummer and the chanter are pivotal for the delivery

and experience of the performance. The hula complements the moʻolelo, portraying the story in a different medium.

In other words, the language of mele and hula communicate moʻolelo in ways that ʻōlelo wale nō, language only, might not. Authors Linda Hutcheon and Siobhan O'Flynn recognize this point more generally in their discussion of adaptation of print to performative narrative when they write, "The performance mode teaches us that language is not the only way to express meaning or to relate stories. Visual and gestural representations are rich in complex associations; music offers aural 'equivalents' for characters' emotions and, in turn, provokes affective responses in the audience; sound, in general, can enhance, reinforce, or even contradict the visual and verbal aspects" ([2006] 2013, 22). I would argue here in accordance with my earlier assertions that the ancestral intention of moʻolelo was for all media—moʻolelo, hula, and mele—to interact with one another as a holistic and multisensory way of knowing. However, in a contemporary setting, moʻolelo are often considered separately from the mele held within them. More often than not, a reader is engaging with the text of mele rather than the auditory or visual performance of it. The two mele to follow demonstrate how their performative elements carry the essence of the moʻolelo.

Pualani Kanakaʻole Kanahele, whose family is viewed as a premier source of knowledge for hula and hula study, writes: "Hōpoe is the physical essence of [Pele and Hiʻiaka]. She is the kiʻi, or recipient of the natural movements inspired by the gods, which developed into the haʻa, or the dance. The imitation of these movements is an act of recognizing, praising, and honoring these sources which are Pele and Hiʻiaka. The haʻa[3] is a ritual to maintain the saga of Pele and Hiʻiaka in dance form" (Kanahele 2011, 115). As mentioned earlier, the Hiʻiaka and Pele story is a source of ancestral knowledge through which contemporary Kanaka Maoli navigate the worldview of our kūpuna. The celebration and practice of traditional mele like those in *Ka Honua Ola* lend mana and energy to those mele, allowing them continued breath, while new mele and hula allow Kanaka Maoli to revisit that moʻolelo and continue to participate in decoding meaning, for both the generations before us and the generations of today.

An example of one such new mele is "Hālauaola," written in 2010 by Manu Boyd and performed by our hālau, Hālau o ke ʻAaliʻi Kū Makani, at the Merrie Monarch Hula Festival in 2011. This mele focuses on a significant portion of the moʻolelo of Hiʻiaka and Pele—the time that Pele spends with Lohiʻau in his home at Hāʻena on the island of Kauaʻi.

Boyd's interpretation of this event brings to life the perspectives of both Pele and Lohiʻau as they see one another for the first time. The first verse is written for Pele, bedecked in splendor and describing her fiery beauty as she carries with her the natural elements associated with her home at the lua pele. The second verse is reserved for Lohiʻau, "Waiho i ka puʻe one o Maniniholo," reclined on the sand dunes of Maniniholo. In his composition, Boyd uses place names and epithets for Pele and Lohiʻau, never actually uttering their names. He calls upon Kīlauea and Puna of Hawaiʻi

3. As I am not a formal hula student of Hālau o Kekuhi of the Kanakaʻole lineage, I cannot speak to the difference between hula and haʻa, which may have been studied by other scholars and/or practitioners, and I am not making any claims to doing so by using this quotation. The reference here is simply to ground the following analysis of the mele "Hālauaola" in the study of hula in general, as a performative interpretation of moʻolelo and its purpose in connecting the practice of creating new mele and hula as part of a continuum of Kanaka Maoli engagement with culture.

island and Waiʻaleʻale of Kauaʻi. He describes Pele as the "wahine puni kui ʻōhelo/Mānai mikiʻoi a ka Puʻulena," the woman who enjoys stringing ʻōhelo berries with the deft needle of the Puʻulena wind. In reference to Lohiʻau, Boyd mentions wai Kūʻauhoe, the famous water associated with the Nā Pali coast on Kauaʻi. Here, he uses kaona, which is often simplified as "hidden meaning," but, as Brandy Nālani McDougall (2016) shows, works as a means of connectivity in Hawaiian traditional and contemporary poetics.[4] To McDougall's point, Boyd demonstrates that "kaona in contemporary Hawaiian literature informs and emphasizes ancestral reconnections" (McDougall 2016, x), insinuating in his poetry and animating via storied performance the inherent connection between akua, kanaka, and ʻāina. The motion of the Puʻulena wind and its name associated with Puna is meant to take the audience to that place, suddenly noticing the scent of hala in the air and feeling the energy of that makani on their skin, recalling Pele's home on the island of Hawaiʻi. The wai Kūʻauhoe and Maniniholo references will make a Kauaʻi audience swell with pride for their beloved chief. McDougall argues that through the use of kaona, moʻolelo, or mele in this case, "might continue to compel us, a contemporary Kānaka, to see through the eyes of our kūpuna" (McDougall 2016, 5). In his mele, Boyd skillfully summons ancestral memory by reviving the invisible genealogy between these renowned heroes of moʻolelo, their ʻāina, and the audience.

The "Hālauaola" hula is a hula pahu, utilizing the shark-skin drum as the instrument of the hoʻopaʻa. The resounding, steady beat of the pahu simulates the rhythm of the heart and the breath of kanaka. Kumu Manu Boyd modulates his oli between the first and second verses, chanting in a deeper voice as he moves from the description of Pele to the story of Lohiʻau. In the third verse, the drumming speeds up, alluding to the action taking place in the moʻolelo as Lohiʻau and Pele are swept away in their lovemaking. The lyrics make reference to natural phenomena like the rolling, clapping thunder as the dancers stamp their feet, clap their hands, and kāhea or call out to replicate the sound.

Perspectives vary from hālau to hālau regarding the embodiment of the mele and those for whom the mele is written. And yet, the performative aspect of a mele for both dancer and audience adds another layer of life to the moʻolelo. In preparation for Merrie Monarch that year, our hālau spent time studying the lyrics in relation to the story of Pele and Lohiʻau. What must it have felt like for the residents of Kauaʻi to witness the arrival of a mysterious, alluring, and unparalleled beauty? How did Lohiʻau feel, beholding her visage for the first time? We as a hālau, as an audience, as readers of moʻolelo can only imagine what those moments were like. But on stage, it is our responsibility to transport the audience in space and time, to put them in a place where they themselves can see Pele, smell the fragrant hala that Puna is known for, and make their breath catch in their throat in the same the way it did for Lohiʻau when Pele appeared before him.

Kekuhi Kealiʻikanakaʻole, daughter of Pua Kanakaʻole Kanahele, teaches that all of our elemental relations—the plants, the ocean creatures, the rain, the land itself—vibrate at particular frequencies. Oli and hula with the right intentions allow kanaka to vibrate in harmony with ʻāina, communing with the elements. It's no coincidence that the sun will peek through the clouds when

4. The study of kaona is a much deeper practice than can be elucidated in this essay. McDougall's text referenced here demonstrates the depth and weight that kaona carry as they are utilized in ʻōlelo Hawaiʻi.

certain oli are voiced. So when I recall this time in preparation for the Merrie Monarch competition, we were training not just to dance in sync with one another and the beat of the pahu, but with the vibrations of Pele, Lohiʻau, their ʻāina, and their attraction to one another. The mele itself tells of the rolling thunder and the ʻenaʻena, or the heat of the volcanic goddess, but it is our bodies that experience the heat, and it is our feet that create the thunder to be heard by all. With every breath taken during the performance of this mele, Pele and Lohiʻauʻs story breathes again. And in all these ways, the voice of the chanter, the movement of the dancers, and the rhythm of the drum intermingle to tell the story in a way that resonates with the audience, that hopefully entices them to feel and see the energy of the attraction between Pele and Lohiʻau. After all, theirs is the love that incited one of the most epic and widely known moʻolelo in Hawaiʻi.

Another mele that brings the fire of Pele to life is Frank Kawaikapuokalani Hewittʻs mele "Haʻihaʻi Pua Lehua." In the story of Hiʻiakaikapoliopele, she is the only Hiʻiaka sister to agree to Peleʻs request to bring back her lover from Kauaʻi. Hiʻiaka made two pleas to Pele before she departed—that Pele look after her aikāne[5] Hōpoe and her beloved lehua grove, both of which Pele agreed to. Hiʻiaka made promises of her own, including that she leave Lohiʻauʻs body for her elder sister. Even though Hiʻiakaʻs journey was long and fraught with many obstacles, including supernatural storms, violent battles with moʻo, and the arduous task of bringing Lohiʻau back to life, she remains committed to the promises she made to her elder sister. However, in a fit of rage, Pele destroys both Hōpoe and the lehua grove, covering them over with her flaming lava.

In "Haʻihaʻi Pua Lehua," the composer imagines the grief felt by Hiʻiaka as she sees her aikāne and their sacred lehua grove destroyed by the fires of Pele. I do not have the musical language to discuss the musicality of this song as arranged and performed by Shawn Pimental and Lehua Kalima. However, as a dancer, I am able to feel the music and comment on what the melody and the lyrics evoke within me. The arrangement of the mele is reminiscent of a loving tribute, but in the ʻea or melody of a kanikau, a beautifully haunting lament to a loved one. In this case, the expression of grief is written for the splendid lehua blossoms, which have been left in ruin. Those lehua blossoms also are symbolic of kanaka connectivity to ʻāina; as the arranger Pimental says, he "hopes to evoke in music that we, Kanaka Maoli, lament ʻāina in the same way we lament people" (personal communication with the author, October 14, 2022), here with the death of Hōpoe and perhaps the potential destruction of Hiʻiakaʻs relationship with Pele. The soft, tender nature of the music tugs at my heartstrings and begs me to ask how Pele could hurt Hiʻiaka so deeply, after all the trials and tribulations she had endured for her older sister.

Hewitt writes, "Haʻihaʻi pua lehua i ka manawa ē," as Hiʻiaka cries that all that remains of her love is broken fragments of lehua blossoms. The ʻokina and duplication of the word "haʻihaʻi"

5. An aikāne is generally defined as an intimate friend of the same sex. A study of the definitions found in the dictionaries over the years will demonstrate the implication of a sexual relationship that may not have been thoroughly understood by those working on dictionary projects and who might have functioned in western-perspective contexts. A close read of the relationship between Hiʻiaka and Wahineʻōmaʻo, another pair of aikāne in the moʻolelo, can help the reader understand Hiʻiakaʻs dedication to Hōpoe and thus the despair Hiʻiaka felt when Pele broke her promise to her sister and killed Hōpoe. This event is a catalyst for the events in the moʻolelo that follow, those events that catapult Hiʻiaka into a new level of her goddess power.

convey the shattered nature of the lehua, and exemplify the 'eha as experienced by Hi'iaka. The first verse, however, speaks of love: "He aloha 'oe e ku'u ipo ē/Ku'u lei lehua lā pili poli ē," or "Aloha to you, the one I love/My beloved garland of lehua that clings close to my chest." While the composer later uses the imagery of lehua in the chorus as a figurative reference to the destruction wrought by Pele, he uses the same symbol to suggest both Hi'iaka's love for Hōpoe and her respect and responsibility toward her sister. Despite her love for Pele, and the way in which she fulfilled her kuleana to her elder sister, the broken blossoms are all that lingers of their promises to each other.

A shift takes place, however, and as the mo'olelo as a whole demonstrates, balance is restored. In the final verse of the mele, Hi'iaka tells her sister, "Pau ka'u hana lā i ka pono ē/Ua pono ho'i au i ka ha'ina ē," reminding Pele of her fulfilled duties and promises. Throughout the mele, despite Hi'iaka's expression of grief, the chords are gentle, not a statement of admonition but perhaps implying the restoration of the love between the sisters and the acknowledgment of their kuleana toward one another. The arrangement of this musical interpretation of the story invokes the sisters' intertwined relationship and reminds the listener of the balance that Pele and Hi'iaka provide for the 'āina. Says Pimental, "For me, the major 7th chords evoke love, warmth and emotion in the music, which is what gives the song hope. The melody rises with each line, like light shining through Hi'iaka's grief. These are the musical cues hinting to the listener that the sisters can reconcile" (personal communication with the author, October 14, 2022). The mele ends this way, calling again to the broken bits of lehua blossoms, but with the hope of pono being reestablished between the sisters and thus upon the 'āina.

Both segments of the Hi'iaka story referred to in these mele are accompanied by oli in their printed representations. I'm sure that the 'ea (both the melody and the life) of those oli live on in the practice of many hālau. But for my hālau that performed "Hālauaola," and for the audience who witnessed that performance, we have collectively experienced a variation of the famed love affair between Pele and Lohi'au. "Ha'iha'i Pua Lehua" gives the listener, the dancer, and the audience the opportunity to wonder how Hi'iaka must have felt when she saw the smoke rising above Puna, signifying the death of her aikāne. The soft breeze created by the motion of an arm or a longing glance toward the broken fragments of a lehua blossom are physical extensions of imagery I once read and can now feel through music that is a manifestation of mo'olelo. Both the words on the page and the words in vocal performance invoke imagery and emotion, lighting a fire that revitalizes the cultural connection in our mo'okū'auhau of knowing and allowing our ancestors to speak again.

These two mele written in contemporary times focus on pivotal parts of the Hi'iaka and Pele saga, reimagining the turbulent emotions and the unparalleled ecstasy described by ancestors hundreds of years ago. These particular episodes of the Hi'iaka mo'olelo are revived for new participants and create new wonder that a generation might feel through the sounds of the pahu or the strum of a guitar. Hula dancers, as they work to embody the mo'olelo through their gestures and expressions, internalize the story and bring it to life for the captivated audience, for those about whom the story is told, and for the 'āina itself, which is always listening. Through these new performance narratives, stories continue to breathe, and ancestral knowledge perseveres through the present to live on for more generations to come.

I Mana Mau Ai Nā Moʻolelo, I Ola Mau Ai Ko Hawaiʻi

Sometimes it hurts to wonder. Why do our grandparents' stories tell of suffering, rent violently from a language meant to be fed from the mouths of their parents? Why do our stories tell of desperation, clawing for the remnants that will tie us back to the pōhaku kihi of our foundation? How are we supposed to stand in the wind when our roots are shallow, searching frantically in the ground for the strength to hold on? And then the ʻāina answers. It's been there all along. ʻĀina answers through the soles of our shoes and the pavement that attempts to separate us from the earth of our ancestors. Pele and Poliʻahu respond, sending rivers of lava and blankets of snow upon an ʻāina, making themselves known to a people who are begging for some reminder that the mana of Hawaiʻi has not gone with the ancestors who have left this realm. They remain. We remain. And once we remember how to hear, how to see, how to remember, the stories we tell are those of healing.

For the generations of Kanaka Maoli who have grown up in the gap left by colonial erasure and trauma, the artifacts of our culture are held to be as precious as a lei hulu—much of our admiration for such a delicate and intricately woven treasure is spent protecting it from harm. Any drop of rain or gust of wind threatens the impeccable beauty of the lei, and often the reimagination of that cultural practice may garner criticism in the fear that any movement away from tradition might render unrecognizable such a cultural artifact our people worked so hard to protect. The same can be said for hula, mele, and moʻolelo. Misappropriation is an imminent threat, as continental American corporations attempt to trademark Hawaiian words in an attempt to protect the name of their poke shop,[6] and Kanaka Maoli of the twenty-first century experience déjà vu being reminded of the theft of land, language, and identity experienced by our ancestors.

And yet, as Justice tells us, we must remember that we are to become ancestors for a generation of Kanaka Maoli that will depend on our ʻike in our context to be grounded in who they are. To do that, we must add to the canon of knowledge that our ancestors laid out for us. As he considers the creation of new stories, which he calls "Indigenous wonderworks," Justice writes, "they're rooted in the specificity of peoples to their histories and embodied experiences. They make space for meaningful engagements and encounters that are dismissed by colonial authorities but are central to cultural resurgence and the recovery of other ways of knowing, being, and abiding" (2018, 154). What then, does it mean for new wonderworks to be created, performed, and experienced? Imagining that Pele and Hiʻiaka exist enough to sing and dance for them gives them life in new minds, new generations of knowing. The moʻolelo of the past are alive not only in the ever-present elements, but in the breath of a new song and the gestures of a new hula.

6. In April of 2019, a Chicago-based poke shop sent cease-and-desist letters to other companies to stop using Hawaiian language in the names of their poke businesses, including Kanaka Maoli–owned and Hawaiʻi-based companies. An article in the *Chicago Tribune* (McAvoy 2019) outlines the cultural implications of this move. Not mentioned in this piece is the issue around a stolen language. The 1896 English-only law enacted a mere three years after the illegal overthrow of the Hawaiian monarchy forced students to speak English instead of ʻōlelo Hawaiʻi in classrooms, essentially cutting off Kanaka Maoli youth from their mother tongue and creating a rift in generational acquisition of a family's mother tongue. English quickly became the native language of Kanaka Maoli, disassociating kanaka and culture. An act like the one of the Chicago poke company is a contemporary instance of a colonially influenced body attempting to separate Kanaka Maoli from the language that is their birthright.

When considering the trend of contemporary Indigenous authors to use the present tense in their composition, Thomas King writes:

> What Native writers discovered [. . .] was that the North American past [. . .] insisted that our past was all we had.
>
> No present.
>
> No future.
>
> And to believe in such a past is to be dead.
>
> Faced with such a proposition and knowing from empirical evidence that we were very much alive, physically and culturally, Native writers began to use the Native present as a way to resurrect a Native past and to imagine a Native future. To create, in words, as it were, a Native universe. (2003, 106)

How are our children to know that the floods on Kaua'i and the lava flows on Hawai'i island are the actions of our 'āina reestablishing its mana in our own space and time if we don't write about those events? The culture of this 'āina and Kanaka Maoli ancestors is a present-tense culture. So we must tell more stories, new stories, all of our stories, for the generations who will call this generation kūpuna. Reimagining is necessary for our future generations to understand that despite the Land Commission Act, despite private property laws, despite the Supreme Court's decision to allow the building of the Thirty Meter Telescope on Mauna Kea, our 'āina continues to resist colonial impact. And we as Kanaka Maoli honor that resistance, taking up arms in our own ways. There is often an issue of kuleana at hand—who has the right to tell which stories? I can only imagine that scholars like Samuel Kamakau and Mary Kawena Pukui struggled with the same questions. And yet, they seemed to know that for the greater good, they needed to contribute to the intellectual genealogy of the generations to come. There will always be stories that are kapu and stories that are noa. I will always wonder how many stories were meant to be told but have nonetheless passed into pō.

For those reasons, though, reimagining empowers our generations and future generations to continue to honor the land and the voices of our own ancestors, so that we may continue to produce material in the genealogical mo'olelo of Hi'iaka and Pele and lend to the mana of those stories. This is the reality of our mo'olelo—recognizing that with those mo'olelo so rooted in 'āina, our knowledge and our ancestors' worldview have survived. And through us here and now, they will thrive. If we continue to see 'āina as ali'i and akua as forms of 'āina, and if we continue to explain them in that way, vibrating with them in the style of our kūpuna, then aloha 'āina lives on through the generations. We defy the advancement of colonial power and refuse to participate in the widening of the gap forced upon our grandparents. In the creation of work that will add to the canon for Kanaka Maoli, it is important to ask: Will the past and future generations recognize our work as part of their mo'okū'auhau? Because as we build upward and outward, our foundational stones will always be the kūpuna and the mo'opuna, an everlasting continuum of the source, empowered by the mana of mo'olelo.

Works Cited

Bal, Mieke. (1985) 2017. *Narratology: Introduction to the Theory of Narrative*. Toronto: University of Toronto Press.

Boyd, Manuʻaikohana. 2011. "Hālauaola." Performed by Hālau o ke ʻAʻaliʻi Kū Makani, April 29. Recorded by the Merrie Monarch Hula Festival.

hoʻomanawanui, kuʻualoha. 2014. *Voices of Fire: Reweaving the Literary Lei of Pele and Hiʻiaka*. Minneapolis: University of Minnesota Press.

Hutcheon, Linda, and Siobhan O'Flynn. (2006) 2013. *A Theory of Adaptation*. London: Routledge.

Justice, Daniel Heath. 2018. *Why Indigenous Literatures Matter*. Ontario: Wilfrid Laurier University Press.

Kanahele, Pualani Kanakaʻole. 2011. *Ka Honua Ola, ʻEliʻeli Kau Mai: The Living Earth; Descend, Deepen the Revelation*. Honolulu: Kamehameha Publishing.

King, Thomas. 2003. *The Truth about Stories*. Minneapolis: University of Minnesota Press.

Kulāiwi (Shawn Pimental, Lehua Kalima, Kawika Kahiapo). 2021. "Haʻihaʻi Pua Lehua." Written by Frank Kawaikapuokalani Hewitt. *Kulāiwi-Native Lands*.

McAvoy, Audrey. 2019. "Hawaii Pushes Back after Chicago Restaurant's 'Aloha Poke' Trademark: 'They Need to Have Some Cultural Sensitivity.'" *Chicago Tribune*, April 19. https://www.chicagotribune.com/business/ct-biz-hawaii-aloha-poke-trademark-20190419-story.html.

McDougall, Brandy Nālani. 2016. *Finding Meaning: Kaona and Contemporary Hawaiian Literature*. Tucson: University of Arizona Press.

Nogelmeier, M. Puakea. 2010. *Mai Paʻa i ka Leo: Historical Voice in Hawaiian Primary Materials, Looking Forward and Listening Back*. Honolulu: Bishop Museum Press.

Oliveira, Katrina-Ann R. Kapāʻanaokalāokeola Nākoa. 2014. *Ancestral Places: Understanding Kanaka Geographies*. Corvallis: Oregon State University Press.

Pukui, Mary Kawena. 1983. *ʻŌlelo Noʻeau: Hawaiian Proverbs and Poetical Sayings*. Honolulu: Bishop Museum Press.

Silva, Noenoe K. 2017. *The Power of the Steel-Tipped Pen: Reconstructing Native Hawaiian Intellectual History*. Durham, NC: Duke University Press.

Stillman, Amy Kuʻuleialoha. 2001. "Re-Membering the History of Hawaiian Hula." In *Cultural Memory: Reconfiguring Identity in the Postcolonial Pacific*, edited by Jeannette Marie Mageo, pp. 187–204. Honolulu: University of Hawaiʻi Press. https://www.academia.edu/1337374/Re-membering_the_History_of_the_Hawaiian_Hula.

Artist Statement for *Ka Lei Hulu a Kahelekūlani i Hiʻilaniwai (The Feather Lei of Kahelekūlani at Hiʻilaniwai)*

kuʻualoha hoʻomanawanui

In the 1870 version of the moʻolelo of "Kamaakamahiʻai," the hero's daughter Kahelekūlani is hānai and raised on the cliffs of Hiʻilaniwai, along the Koʻolau mountains of Kāneʻohe, on the island of Oʻahu by the moʻo (reptilian water deity) Kamehaʻikana. When her dream lover Hānailani arrives from the summit of Waiʻaleʻale on the island of Kauaʻi, he sees her being bathed by the native forest birds: "Hānailani saw Kahelekūlani, the beauty of Koʻolau mountains, being swayed back and forth by a multitude of small forest birds, while several other little birds were shaking the drops of water from the blossoms onto the body of the beautiful young woman." The painting (**Plate 15**) depicts this scene; the native birds include the ʻiʻiwi, apapane, amakihi, and akepa. The endemic honeycreepers are endangered because of introduced foreign diseases, such as avian malaria and avian pox, human encroachment on and destruction of their native habitat, and now climate change, the warming environment allowing disease-carrying mosquitoes into higher and higher elevations, where the birds live. In September 2021, the U.S. government declared eight more species of native Hawaiian forest birds extinct. The painting represents an ʻŌiwi understanding of spiraling time, where ka wā ma mua, the time before (the "past") inspires ka wā ma hope, the time that comes after (the "future"). The spiraling of time intentionally contradicts linear time and fatalistic western views of vanishing natives, and instead offers a hopeful vision proposed through Indigenous futurisms, as our ʻāina and moʻolelo are regenerative on myriad levels.

Artists' Statement for "Hāloaʻaikanaka: An Origin Story of the Rise of the Third-Born Hāloa"

Māhealani Ahia and Kahala Johnson

The short story "Hāloaʻaikanaka: An Origin Story of the Rise of the Third-Born Hāloa" is a satiric sci-fi horror creation story. An ʻohā to feed readers now, and a huli to be replanted, this corm grows out of our most-treasured ancestral stories of the elder kalo Hāloanakalaukapalili and its sibling, the first Kanaka Maoli named Hāloa, and extends that genealogy into speculative futures. To puka, or burst forth from rich soil, "Hāloaʻaikanaka" begins a new kalo story cycle. It is the first in a series of interconnected moʻolelo that feature these characters throughout shifting time-space wā of the *Kumulipo*, our most famous genealogical koʻihonua.

Our writing is rooted in Hawaiian cosmogonic moʻolelo like *Kumulipo*, alluding to ancestors such as Hāloa, Papahānaumoku, Hoʻohōkūkalani, Wākea, Haumea, Hina, Maui, as well as the Lāhui Moʻo and Lāhui Pele. Hāloa is a beloved ancestor and therefore often deemed untouchable. However, we queer our reading of Hāloanakalaukapalili as our māhū plantcestor and the younger sibling Hāloa as born within a context of lack of consent and native patriarchy. When we elevate our stories beyond reproach and cling to particular versions, we run the risk of missing subtle and insidious ideological repercussions. Therefore, we offer this transgressive variation to show how, when taken to extreme consequences, we may recognize robotic hypermasculinity, an essentialization of women where they are literally the ground from which life springs, and an uprising of māhū leadership whose historical oppression results in the unbounded flowering of suppressed welo talents to seductively heal and harm. By extending the story into a future *Kumulipo* wā 17, we may enter a new era where "He aliʻi ka ʻāina (the land is chief)" reigns supreme as the plant itself becomes the apex ruler. As Kanaka Maoli evolve into a new species called ʻAikanaka Maoli, this human-devouring reciprocity exceeds its sustainable limits.

This story serves as a warning against patterns of Hawaiian statism and fascism arising today within movements to restore Hawaiian Kingdom sovereignty. A common belief that everything will work itself out *after we restore the kingdom* allows a noncritical erasure of pertinent issues like internalized white supremacy, heteropatriarchy, anti-blackness, and homophobia. A dangerous Hawaiian exceptionalism has risen in the soil of de-occupation discourses that elevate faith in the law and the state. Rather than imagine alternatives to these troubling patterns in our nation and

movements for sovereignty, we instead push them to their limits to expose these terrible trends as sites for the emergence of an indigenized fascist state. Simply indigenizing colonial practices, re/turning to a romanticized past, or hybridizing these models does not do enough to transform our current predicament. To critique these problems, we twist and invert the principles of Hawaiian anarcha-Indigenous feminism to envision fantastically terrifying futures where Kanaka Maoli extend an indigenized colonialism and imperialism to the stars and across time.

Hāloaʻaikanaka: An Origin Story of the Rise of the Third-Born Hāloa

Māhealani Ahia and Kahala Johnson

Keola hustled into the overcrowded conference room, his bulky emergency pack hanging off one shoulder and an overstuffed backpack clumsily on the other. He hated getting called in to work on his rare day off. *Their lack of planning is not my emergency. The climate crisis is hardly news; what band-aid solution could possibly be worth waking me and my crew at the crack of dawn?* His disaster response team was used to dealing with chaos, trauma, fear; but something about this call was different. *Why me? Where's the actual disaster? Hanu mai, hanu aku. Breathe in, breathe out. Just breathe through it. Heeuuuummn. You'll know specifics soon enough.* His capacity to calm a room was legendary. Some say it was his humming under his breath that soothed those around him, like a lullaby. Keola was definitely the grounded type, but his contemplative style did sometimes get misread as woo-woo. Still, he was more like his twin sister Kaʻimi, the scientific brains of the operation, than his boyfriend Nalu, the cautious artistic soul, or their girlfriend Makaloa, with her suspicious glare and political acumen. Keola took the long and patient view of things, insightfully noting the patterns and incremental transformations of environments and societies. Even so, he had learned to trust Makaloa's lightning-speed intuition; so when her insistent glance did not falter that morning, he did not hesitate.

Keola searched for some open seats and marked out four chairs with his bags and hoodie; as he slumped in, the rest of the crew made the rounds. Makaloa hunted for coffee and Nalu for pastries. Kaʻimi joined the other environmentalists being introduced to the two exceptionally tall guests. With an imposing seven-foot stature, the elder Māhū 8889 sized her up but did not speak; she sensed disapproval. When the sweat dropped from the māhū's forehead, a strand of maile winding itself intimately around their neck perked up, and one of the leaves caught the beadlet and appeared to drink it in. The other varying colors of leaves perked up and each individually searched for more nourishing perspiring rain as they stretched the vine longer and wiggled up the nape of their neck. The aroma induced a somewhat intoxicating delirium in those close by.

The younger and slightly shorter Māhū 6969 was fixated on Dr. Liner's very bright aloha shirt with its hideous yellow hibiscus on a wrinkled pink background, an obscene color combination in any palette. *Why did haole scientists insist on wearing nostalgic colonial clothing?* It was certainly perky next to the visitors' perfectly pleated regimental dark green fatigues, polished steel-pointed boots, laces evenly threaded, stances firmly rooted. Gesturing to the assortment of rubber slippers,

Kaʻimi overheard them ask, "How does one hunt in such footwear?" Dr. Liner chuckled as he led the two across the room.

Kaʻimi slid into the folding chair to Keola's right and pulled out a spiral notebook and erasable pen and started scribbling notes and sketching a strand of maile. The Hawaiian endemic *Alyxia oliviformis* lacked the spectrum of greens she noted in this foreign strand: from moss to metallic, lime to seafoam, deep shoots near black and leaves vibrant and fragrantly unfurling. "Well, I'd like to think I've gone beyond the historical atrocities of my profession, but we all know the perils of believing we can leave our biases at the door. Objectivity and all that. Fictions." She leaned in closer to whisper, "You wouldn't believe what comments the good doctor just made about their—"

Dr. Liner shuffled over to the map on the wall and cleared his throat rather loudly. "Thank you all for coming in. We have some, um, visitors who have traveled great distances and, um, time, to share some colorful, um, visions of what they see coming in the next weeks. After tracking some troubling weather trends and predicting their shifting patterns, they're offering assistance in developing, um, sustainable food sources resistant to cataclysmic conditions."

Keola strained to listen to his boss with his good left ear, while half-hearing his sister mumbling something about an unusual maile plant on his right. And while scanning the room, he noticed Makaloa still standing grumpily near the coffee station; she was clearly mouthing something to him that he could not decipher. Her eyes kept gesturing to the two tall visitors, who, under the outdated fluorescent lighting, were looking a bit pale and green.

The two māhū nodded their heads respectfully to Dr. Liner as they marched synchronized to the center of the room and saluted. The taller Māhū 8889 adjusted a small green metallic device that was wrapped carefully around their ear. It projected their voice like a microphone as they spoke. "Aloha mai kākou e nā Kānaka Maoli me nā hoa aloha ʻāina. Hello, I am Special Ambassador Māhū 8889. I trace my genealogy to Hāloaʻaikanaka and Loʻihine 8000. And this is my companion, Intertemporal Envoy Māhū 6969 from Loʻihine 8531. We are ʻAikanaka Maoli and we come to visit you from the year of Hāloa 2420. We have reviewed the timeline of our collective development and recognize this coming anahulu for you will be a critical hulihia, a turning point in the history of all our species." As Māhū 8889 stood with unflinching confidence in their pronouncements, Māhū 6969 crossed their arms behind their back, hiding their fidgeting wrists. "We are here to urge you to adopt our plans and accelerate the necessary changes that will lead to the establishment of our empire. If you could see what we have, you would not delay. You have exactly ten days to adopt our measures to transition quickly and avoid wasting human life."

The room murmured in confusion, as workers turned to each other skeptically. Keola caught Makaloa's raised eyebrows and her "See, I told you something's up. What are we gonna do about it?" look. He instinctively took a deep breath and exhaled a long rumbled hum. As the room quieted, the speech continued.

"We are also here to locate several agitators who we believe may be leading a dangerous rebellion." The room again erupted in surprise. "There are some women among you that may not even realize you are aiding your own demise. We will be reaching out to these individuals we've identified to help us protect the operations."

When hands anxiously sprung up with questions, Dr. Liner interceded, "Let's hold all questions until the presentation is finished, please." As assistants began handing out information packets, Dr. Liner tapped Ka'imi's shoulder and signaled Makaloa to join the female scientists exiting the room. As Nalu tried to follow, he and another very handsome man were intercepted at the door by Māhū 6969, who was holding a copper tray of food.

"Our beloved kalo is the savior. Please partake in the body of Hāloa, in everlasting life." They glanced at each other, and, not wanting to appear rude, picked a chunked slice. It tasted seductively smooth and slightly sweet, despite it not being mashed into pa'i 'ai or sweetened with coconut into kūlolo. Immediately after the sample, a deep craving arose from the pit of Nalu's stomach, and his tongue roamed his mouth searching behind his teeth for more.

The lights dimmed slightly as Nalu sat back down next to Keola. Māhū 6969 passed by the row and offered his tray of kalo. When Nalu's eyes lit up like a child reaching for a second piece of candy, Keola sampled as well. The bite was substantial yet caused an insatiable longing for more; the sweet and salty tang lingered on his tongue long after he swallowed. Curious. This food from the future. He yawned as lights faded to night.

"Let us begin with a short documentary that we show all recruits in our year of Hāloa 2420, and then we will lay out our particular practices and invite you to join us in the future. You will marvel at the majestic progress of our 'āina returning to its prominence. He ali'i ka 'āina, he kanaka ke kauwa. As our ancestors remind us, the land is our chief and we are its servants. It is through returning to our beloved Hāloa that we have endured your immanent cataclysms."

Māhū 8889 rotated their ear device, and suddenly a projection appeared like a movie screen on the far blank wall. By twisting the device, the picture came clear and an overhead voice filled the room. A slick neon title flashed on screen: "Welina Mai! Welcome to Lo'ikanaka. The Year of Hāloa 2420." A disembodied voice over in a hyperfemme-pitched register began speaking over photos of lush forests and fields, which strangely resembled their home valley.

> *Welcome to Lo'ikanaka 61186, the true birthing plantation of our future generations. You are about to enter the sacred grounds where life begins and ends. A place where ancestral stories like Hāloa come to life.*

The voice reminded Keola of the kind of seductive and sugary-sweet invitations to adopt a pet you can't afford to care for, or give away your worldly possessions for the cause, or even nobly sacrifice your life. *Cult propaganda;* that's what Makaloa would call these images of an Edenic garden filling the screen.

> *For the privilege of entering Lo'ikanaka, you will be called upon to make the ultimate sacrifice for our lāhui. And in return, you will reach 'aumakua status, a deified reverence that our beloved ancestors like Hāloa still evoke.*

Wait, what? Oh, come on, divine status, really? He shifted his weight uncomfortably as his body heated slightly; Nalu shadowed his posture changes, his own back so warm it was sweating

through his bright pink T-shirt. The sounds of the waterfall and flowing banks of the river hypnotized his concentration so much he hardly noticed Nalu staring unblinking. Their eyes traced the water cycle from the top of the mountain forests down through the loʻi, and out to the ocean. Their salivation and swallowing rhythm mimicked the tides. Keola unconsciously began to softly hum under his slowing breaths. The rise and fall of Nalu's chest kept intimate pace.

The film's 3D effects transported Keola's singular consciousness so that he felt himself walking through the plantation. He could feel his muddy feet. *Why wasn't he wearing boots like the other soldiers? Was he a farmer?* Nalu's fluorescent-pink T-shirt glowed with a ridiculous technicolor dream quality and somehow snapped him out of his daze to pay closer attention.

Our ancestral story of Hāloa guides life here at Loʻikanaka. When Wākea Father Sky mated with his daughter Hoʻohōkūkalani of the stars, their first child was stillborn, and after being planted by the east side of the house, it miraculously grew to be the first kalo or taro plant, which they named Hāloanakalaukapalili, the long stalk that flutters in the wind. When Wākea and Hoʻohōkūkalani mated again, they named their second child Hāloa as well. Hāloa, the long breath, is considered the first kanaka, or human. As the elder kalo plant grew, it nourished and fed its younger sibling; the younger tended to and cared for the older. For hundreds of generations, we considered this story the quintessential reciprocal and symbiotic relationship.

Over time, dozens of varieties of kalo were cultivated, each with their own nutritional and tasty genetic makeup, which fed the diverse populations of these islands for thousands of years.

Now in this our year of Hāloa 2420, we tell an even greater, more efficient story! That of the third-born Hāloa ancestor: Hāloaʻaikanaka, Hāloa who eats kānaka, where kānaka are not only nourished by the plant, but Hāloa, too, can now feed upon kānaka, in a mutually parasitic reciprocity. Hāloaʻaikanaka is a carnivorous variety of kalo that grows by consuming the mana, wailua, ea, and ola of humans.

You see, 400 years ago, during the climate megacrisis and great Euro-American collapse, Hawaiʻi was finally able to regain its Ea and Ola as a sovereign nation-state once more.

And instead of the previous American oligarchy, which had seized these islands and infected them with white supremacist and neoliberal Asian-settler policies, we have since developed one of the most sophisticated Indigenous states yet. This glorious rise of Indigenous fascism has brought much progress.

We've witnessed the radical transformation of the Hawaiian islands and their peoples, who are now officially designated the ʻAikanaka Maoli.

Our greatest scientific minds that survived the global cataclysm became very resourceful in their food-finding missions and experimented with our sacred Hāloa plant through genetic tribridization.

This trifecta combined kānaka, kalo, and Kalaipāhoa—the legendary poison tree—and ultimately produced the single greatest plant food source ever. Ever. With mana and power so great, it literally changed kānaka at the cellular level.

The first Hawaiians to eat Hāloaʻaikanaka experienced several rapid changes. Wāhine, or women, transformed into living wombs. Kāne, the men, died, and from their corpses were bred the second generation of Hāloaʻaikanaka.

As all other food sources were inevitably destroyed by this superkalo, eating became restricted to Hāloaʻaikanaka, and in order to ensure its growth and reproduction, human sacrifices were fed to Hāloaʻaikanaka, which resulted in a sharp human population decrease. Unexpectedly, all Hawaiians lost the ability to reproduce sexually as a result of eating Hāloaʻaikanaka, but our scientists have mitigated that problem with a specialized breeding program.

Here at Loʻikanaka, we devote significant resources to Loʻihine, our women's breeding program. The wāhine who consumed Hāloaʻaikanaka mutated slowly into loʻihine, essentially flesh wombs for the cloning of kānaka. We are honored to ensure the sacred calling of the elevated female essence. For years we have acknowledged the quality of the earth as divinely female and, in this way, we celebrate the full return of the feminine. Our moʻolelo even name her Papahānaumoku, our Earth Mother who births islands. And now all wāhine are literally the fertile ground upon which Hāloaʻaikanaka is implanted. In our sacred rituals, at the correct mahina moon, the loʻihine will produce māhoe, a beloved set of twins, one kāne and the other māhū. However, no wāhine have ever been produced; hence the need for ambassadors to track remaining rebel wāhine and call them home to their true regenerative purpose.

Whatever moons and planets the wāhine have fled to in the style of their beloved ancestor Hina, we have pursued them into the farthest reaches of Hoʻohōkūkalani, in the domain of Wākea. We are determined to reproduce our loʻikanaka wherever wāhine can be secured. Perhaps you come from one of these rare spaces or times where wāhine still exist in their ancestral human bodies.

Keola suddenly realized the absence of Kaʻimi and Makaloa. He looked around the darkened room to confirm a visible gender separation. He hadn't thought much of it before, that the women were led outside during the break. Where had they taken them? As he looked down at his fidgeting hands, wrists wringing, he wiped a bead of sweat on his temple with his sleeve. Aware his breathing was shallow, he tried to slow it. *Hanu mai, hanu aku. Stay alert, Keola. Who are these people? They seem to have extrasensory capabilities. Perhaps they might sense an elevated heart rate.* He couldn't believe his eyes: they didn't look quite human. That green tinge of their skin wasn't bad lighting reflecting their clothing. *You are what you eat.* His eyes flew open with horror. Why weren't any of his colleagues alarmed as he was? Were they listening to the same presentation? They're talking about eating a plant that eats them. The men in this future hell are obviously workers and soldiers, with māhū running the plantation, and there are no more women. Wāhine are the very earth, like some sort of feminist nightmare. *Where are you, Makaloa? Kaʻimi, please check in with me.* Essentializing the women until they literally become the earth. Their fertility embodied and in service to a plant. A god. A new god. The third-born Hāloa. Like the fucking Third Reich, you mean! Could this really be the future they were all fighting so hard for? Keola struggled to focus and track this horrific origin story.

Following the ancestral traditions of planting the piko umbilical cord, in all Loʻikanaka the piko from this cultivation process are then fed to Hāloaʻaikanaka to maintain the singular norm. In a modern twist of niʻau piʻo relations—that sacred bond between siblings whose stalks bend back upon themselves—all status has fallen away. With the same parentage and a single piko to tie all members of the nation together genealogically, we are all Hāloaʻaikanaka. All other piko, including those of the body, have been ideologically cut in order to emphasize the ultimate unity. One kalo, one world.

Keola looked for the nearest exit, but the way was closed. Too many folding chairs squeezed in. How could he sit and listen anymore? He nudged Nalu, who was in a visible trance, hypnotized by their voices.

The need for language has even subsided as all kānaka gained the ability to use hālelo as a pheromone language. Of course, as the descendants of our twentieth and twenty-first-century ancestors, who struggled so fervently to recover the ancient Hawaiian language, many of us still enjoy speaking for nostalgia's sake. Our mother tongue is our treasure.

Yet our superior nonverbal communication techniques are best exemplified by the māhū, our nonbinary and intersex kānaka, who were granted special abilities to use pualelo to enforce balance. This pualelo language of kaona, hidden meanings and allusions, has been enacted upon those ʻaiku rebels who refuse to partake of Hāloaʻaikanaka, and who still hide in the uplands and pillage for their food. Pualelo has the wondrous ability to subtly persuade others to one's particular agenda and will. The powers of persuasion granted māhū have proven most successful in luring the ʻaiku to sacrifice themselves to the most noble of causes, nourishing the next generation.

We are so fortunate in this year of Hāloa 2420 to witness Hāloa's descendant, Hāloaʻaikanaka, that superkalo plant powerful enough to feed us, to give us life, for generations into the future. And what a wonderful offering you make to ensure our insatiable ancestor has the required nutrients to sustain us all, in that reciprocal ancestral bond of life and death.

We have reached that proverbial moment when all must lay down their lives for the greater good, into the Loʻikanaka. So are you ready to fulfill your destiny? Hele mai. Come, and take the eternal walk through the ala Loʻikanaka and join the third-born, Hāloaʻaikanaka. E ola Hāloaʻaikanaka! Eō! Eā! E ola loa ē!

ʻAʻole i pau.

The room erupted in applause. "Eō!" As the lights returned to normal, Keola noticed an intimidating squad of Māhū soldiers lining the entrance. Keola started to panic but hesitated to draw too much attention. Dr. Liner was present, check. Still none of the women, no check. *Come on, Kaʻimi, sense me. Are you okay? Where should I find you?* As Māhū 6969 carried his copper tray of kalo around for another pass, Māhū 8889 took center stage. As Nalu eagerly grabbed another for each of them, Keola caught his arm before he ate it. "Don't want to spoil our lunch date, eh?" Nalu pulled out a recycled baggie from Keola's backpack to store them for later.

Without food in his mouth, Nalu raised his hand but didn't wait to be called upon. "You're time travelers? What kind of technology are we talking? And what of those ear devices?"

"We travel backward. We occupy the same space as you, yet the resounding wāwā allows us access to return from our Wā 17 to previous times. Your hulihia is also our future."

"I ka wā ma mua, i ka wā ma hope." Nalu seemed enraptured and intent on connecting with these visiting malihini.

"Hmm, something like that." Their eyes offered sly affirmation with a kolohe glint.

As Māhū 8889 answered, Keola couldn't even hear; his anger simmered like the volcanic descendant he was. Keola blurted out, "You spoke earlier of resistance? What sort of resistance and what level of danger?" *Watch your words, Keola; don't give anything away. Perhaps someone else will enquire about the status of our female counterparts.* Keola began gently gathering all his belongings at his feet for an imminent exit.

With a measured gate, Māhū 6969 walked to the center, then pivoted swiftly so that their hair fluttered like the quivering kalo stalk over their eyes, clicking their boot heels at attention. After twisting their ear device, they spoke with an arrogant drone. "I thank Special Ambassador Māhū 8889 for providing you, oh ancestors, a glimpse into our glorious future, the one you are now dreaming into being. I am Intertemporal Envoy Māhū 6969 of Loʻihine 8531 tasked this day with presenting to you, dear kūpuna, our plans for building the ʻAikanaka Empire."

"As my counterpart described, we are seeking to detain a contingency of highly dangerous criminals of the most profane character. These individuals proudly refer to themselves as Indigenous anarcha-feminists, and they threaten the stability of our timeline with their perverse discourses, naively attempting to envision futures beyond the nation-state. Hah! We therefore warn and advise you, oh ancestors, of these recalcitrant women and their degenerate writings so that you may surrender them into our custody."

He scrolled through a series of mugshots of those they considered the resistance, mostly women. Keola recognized most of them and knew many personally. These were colleagues, even mentors; the best minds of their respective generations. He held his breath, waiting to see if his girlfriend had made their top ten. *Thank goodness Makaloa isn't there.*

Māhū 6969 spoke with such disdain that they seemed to confirm their own bias in convincing themselves they were doing the honorable thing by hunting them down. "In absolute and total opposition to the evils of anarcha-Indigenism and queer anti-state heterodoxy, we fully encourage and promote the state-centered nationalisms of this age, as well as rebellion against all Hawaiian feminists in particular. Nevertheless, we also note a limitation to your political aims. Just think, if you will. Why should you, our glorious ancestors, be satisfied only with restoring the sovereignty of your nation-state? While we can sympathize with your desire to make the kingdom great again, why stop there?"

"Aloha ʻĀina!" Shouts of patriotism erupted in the room from those of every political persuasion. Opportunely building upon the crowd's enthusiasm, the line of Māhū soldiers added their own frenzied cheers and began waving various Hawaiian flags. Māhū 6969 then approvingly stepped forward dramatically. "We therefore suggest, dear kūpuna, that your efforts to embrace statism could be far more rigorous, your relationship to the state deepened. We exhort you to go

further, to not simply adopt the state form or a weak half-bred version of it. Instead, we urge you to use your agency, your sovereignty, to indigenize the state in full."

"How, you might ask?" They twisted their earpiece and the wall was again full of projected images and a slide that read: "1. Hāloaʻaikanaka: The Third-Born." Speaking forcefully, they continued: "You have heard our origin story, now understand how such a triumph could be produced in our eight-point plan."

"The Third-Born, or Hāloaʻaikanaka, serves as the dictatorial nonhuman leader of the ʻAikanaka Empire. Engineered in the post-occupied Hawaiian Kingdom 2040 by eight māhū scientists using kānaka, kalo, and kālaipāhoa genomes, Hāloaʻaikanaka was created as a solution to food shortages in an age of rapid climate change. Upon consuming the genetic tribrid, we experienced mutations that would affect our political and cultural trajectory for the next 400 years."

They gestured to Māhū 8889 to join them. "I sense, 8889, that you have a comment?"

"Indeed. Unlike your weak and vacillating human politicians, Hāloaʻaikanaka is superior to all past and current leadership, recombining the original lineages of Hāloa I and Hāloa II to become the perfect and ideal god-emperor. As Hāloaʻaikanaka provided nourishment to our nation and exceptional abilities to us, the ʻAikanaka Maoli, we have all become united under the reign of the Third-Born. We admonish you, oh ancestors, to think of the possibilities unlocked under a more-than-human leader."

Māhū 6969 tapped their earpiece for the next slide: "2. ʻAikanaka Maoli: Para-Hawaiians."

They continued in their explication of their progress. "The first ʻAikanaka Maoli were the eight māhū genetic scientists and their test subjects: four wāhine, four kāne. The women transformed into the first loʻihine, flesh vats or womb vessels; the four kāne who ate Hāloaʻaikanaka died soon after, their flesh offered to the new kalo plant to become the genetic material to produce human clones. The eight māhū scientists who engineered Hāloaʻaikanaka also consumed their experiment. All sixteen test subjects immediately lost their reproductive capabilities but gained enhanced strength, speed, endurance, reflex, sensation, regeneration, and biological immortality. Our species is also capable of speaking Hālelo and Puaʻōlelo, pheromone languages that use chemicals to control the behavior of other species."

Keola steadied his rage by humming under his breath, while the rest of the room listened enraptured by this future history. *Is this subtle silent language why no one is concerned that we're watching a sophisticated PowerPoint about our own demise? Why am I not as affected?*

Māhū 8889 added matter-of-factly, "By selectively appropriating settler science, you can use biocolonial knowledge to enhance your individual anatomies and the population at large. We successfully indigenized genetic modification, taking the technology out of the hands of the occupier to improve our wāhine, kāne, and māhū beyond their current limitations."

The next slide read: "3. ʻAihāloa: Parasitic Law."

"The Third-Born maintains totalitarian jurisdiction over the government through a parasitic relationship with ʻAikanaka Maoli. Unlike our ancestors' original kinship to kalo, which was based on mutual symbiosis, Hāloaʻaikanaka requires us to provide endless sacrifice as part of its cultivation. Failure to do so means death as the kalo parasite will consume its host."

Māhū 8889 added, "'Aihāloa reduces the complex relational politics of current ages to the simple practice of human sacrifice in order to unite all Kanaka Maoli under one rule. The parasitic law of 'Aihāloa punishes with death those who refuse to obey Hāloa'aikanaka. The jurisdiction of 'Aihāloa extends across our entire empire, beyond this planet to the stars, requiring each 'Aikanaka Maoli in the universe to submit to the cycle of sacrifice. We encourage you, oh ancestors, to continue to reduce your relational identities to strict legal definitions for we, your descendants, have finally realized the dream of creating a lawfully ordered universe."

"Order is essential within families." They forwarded to a slide: "4. 'Oha'akolo: Clone Kinship." They smiled sinisterly. "In our indigefascist future, family structure is based on fratriarchal clustering between kāne, māhū, māhoe, kaikua'ana, kaikaina, aikāne, and punakāne who trace to a common lo'ihine and from there to a Hāloa'aikanaka ancestor."

"There are many roles for all these family members to fulfill." The logo appeared: "5. Lo'ikanaka: Plantation." They continued droning on: "In order to feed the Third-Born, we have created a plantation system called Lo'ikanaka to raise human stock. Flesh farmers tend to the sacrificial rites that ensure a good harvest; Breeders."

The photos and signs of "6. Lo'ihine: Motherlands" blinked. "In addition, Hāloa'aikanaka has evolved to survive in environments where carbon dioxide is abundant. In fact, it has exhibited the climate-changing ability to assimilate oxygen from the atmosphere, releasing carbon dioxide as a byproduct. Expansive cultivation of Hāloa'aikanaka has accelerated atmospheric carbon dioxide, essentially terraforming the planet into an uninhabitable, toxic space for all other species except 'Aikanaka Maoli."

"A most precious bond is created." An image flashed with the title "7. Pikoku'ikahi: Paradependence." They spoke, "In our indigefascist future, a single piko exists tying all members of the nation together to Hāloa'aikanaka. All other piko, including those of the body, have been ideologically cut in order to emphasize unity to this kalo variety."

"Lanakila! Our final triumph in our eight-point plan." The final slide appeared—"8. 'Āinapāku'i: Parastate"—to a round of applause.

Keola just didn't get it. The māhū voices and mannerisms were quite commanding, but nothing like others he'd seen who could suddenly whip crowds into a frenzy. Perhaps they were engaging in their secret language?

Amid the clamor, several hands were raised eagerly.

"What exactly is coming?" One of the scientists stood up near the map on the wall and pointed to our region. "Are we talking sea-level rise? Tsunami height? What kind of hulihia?"

As Keola placed the kalo into the side pocket of his bag, he began to doubt himself. How was everyone so calm? Did they not see the same film he did? Had all his colleagues eaten too much kalo? Was there some sort of narcotic inducing hallucinations? Maybe they really didn't see the same film. Maybe he fell asleep. He wasn't sure if it was the vocal cadence of the film's narrator, or that crazy Hālelo they mentioned, but some sort of sonic hangover was affecting his equilibrium as he stood shakily and stumbled toward the restrooms with his bags. Nalu followed faithfully, while others rotely cued up to eat more kalo and to ask more questions. Both Keola and Nalu wrestled their bodies' magnetic pull toward the trays. Keola's bags were heavy and he pressed on,

without seeing Nalu hesitate then grab one last piece. As Nalu was leaving, one of the soldiers with a badge that read Māhū 9999 took off his maile lei and put it around Nalu's neck.

Nalu followed Keola into the restroom with his new maile lei. After splashing water on his face, Keola noticed the smell first, then the bearer. He inquired as emotionless as he could, "Where did that come from?" *Now don't be jealous, Keola, it's just a lei.* Nalu immediately took it off himself and put it around Keola. With his face still dripping, the maile recoiled and shriveled up as if the water were toxic. They both looked at it astonished.

"We need Ka'imi to see this," Nalu insisted. At that moment, Māhū 9999 entered and noticed the lei change. Nalu looked down apologetically.

"We only have a moment. Your friends are in great danger. They are both on the list. Your sister can be coaxed to work for us, then she will be safe. But the other wāhine, she is considered dangerous and is on our restricted want list. You saw the film; you can anticipate the conclusion. Understood?"

"Yes, but what do we do? Where are they?"

"All of the women are safe right now. They were gathered and shown maps of the area and told of the impending doom, in hopes they will choose to use their intelligence to problem solve in our directed efforts. But those who already showed disdain have been marked."

As the bathroom door swung wide open, Māhū 9999 leaned over and whispered to Keola. "I have seen the ones who will rise. I have heard the songs that heal. That lei and the kalo you pocketed will reveal their secrets, in time. You must protect your crew at all cost, so your descendants can do what our generation must to bring back balance." As Keola's coworker entered, Māhū 9999 exited, swift as an apparition. Keola and Nalu tried to follow, but there was no trace except a lingering fragrance of maile. Keola wondered. *Double agent? Shape-shifter? Whose side was this māhū on, really? Can they be trusted?* He had no choice. He had to warn the wāhine.

At the end of the hallway, he spotted Ka'imi with her clipboard and a stack of documents.

"Sorry to interrupt, sister, but Nalu isn't feeling too well and we need to get him home."

"Dr. Souza here was just sharing some of the unusual properties of the maile they wear and the symbiotic relationship of—"

"Sister, Nalu's kua wela is acting up again. Why don't you grab Makaloa and we regroup at the house in half an hour?" His insistent coded tone cued Ka'imi and she jumped into gear.

"Right. Thank you for your time, Dr. Souza. I'm sure we'll talk again soon. Aloha." She turned and left him wondering as the others sprinted toward the parking lot.

* * *

Keola, Nalu, Makaloa, and Ka'imi collapsed bewildered on the wraparound porch of their refurbished plantation house. This do-it-yourself fixer-upper money pit, as Ka'imi referred to it, was the eternal artistic work in progress by Nalu. He adored that old house, despite Makaloa's critiques of its colonial legacy. Nalu loved to make things, to take them apart, to put them back together better, more aesthetic. No one could deny its charm and beauty, and it held their chosen family of four's collective mana. An unlikely revolutionary headquarters nestled among the trees, nourished

by the river, protected by their fierce moʻo water guardians. Keola had a feeling that old house was about to be a central character in a dramatic new story. If the visitors were correct, they had an anahulu, only days before the great hulihia, a change that radically destroys life. He looked out into the valley, then up to the kuahiwi. How long could they survive up mauka if they have to run and hide? For all their training in emergency preparedness, they were the rescuers, not the hunted. Would they really pursue and capture Makaloa? When Keola hung the maile lei on the railing, it climbed and wound itself tightly up the ridge pole. As if straining to catch the setting sun, maile leaves shivered in the gusty winds, reaching toward the orange horizon.

ʻAʻole i pau.

Artists' Statement for *Nakili*

Tiare Ribeaux and Qianqian Ye

Nakili (**Plate 16**) is a collaborative augmented reality (AR) sculpture cocreated by Tiare Ribeaux and Qianqian Ye. As an AR transpacific portal, *Nakili* draws inspiration from the living Hawaiian deity Hinaʻōpūhalakoʻa (*lit.* Hina of the coral stomach), goddess of corals and spiny creatures in the ocean. She is one of the many forms of the goddess Hina. A shell from her reef was given to and fashioned by Maui, which he used to pull together the Hawaiian Islands. On Nakili's body are visualized many coral forms and creatures found near the shores of the Hawaiian islands, which support vast amounts of marine life, but are at risk and facing bleaching due to ocean-temperature rise, global warming, and the chemicals found in many sunscreens worn by visitors to the islands. *Nakili* positions the coral forms above water, merging them with a humanlike figure, to remind us of our interconnection to it and to all living creatures in the ocean. According to the first wā (verse, epoch of time) of the Kumulipo, a Hawaiian cosmogonic genealogy or creation chant, "Hānau ka ʻUkukoʻakoʻa, hānau kāna, he ʻAkoʻakoʻa, puka" (the coral polyp is born, it gives birth, the coral head appears); coral is the first living organism born from Kumulipo and Pōʻele, the male and female elements of night, a lineage from which all Kānaka Maoli descend.

Nakili is part of a larger series of augmented reality installations called *Kai-Hai*, which utilize transpacific stories, oral histories, and folklore from Hawaiʻi throughout Polynesia to East Asia to explore environmental issues, Kānaka Maoli and other Indigenous narratives, migratory paths, immigrant narratives, and diaspora across the ocean.

"Nakili" means to glimmer through, as light through a small opening; to begin to open, as eyes of a young animal; to twinkle (wehewehe.org).

Kai-Hai, a hybrid of ʻōlelo Hawaiʻi and Chinese, is a collaboration between Kanaka Maoli artist Tiare Ribeaux (Bay Area and Honolulu based) and Chinese artist and technologist Qianqian Ye (from Wenzhou, based in LA).

Try *Nakili* on Instagram (tinyurl.com/nakiliAR).

The Fag End of Fāgogo

Dan Taulapapa McMullin

No.

Nothing.

Nothing on a really tall chair; a chair with very long legs; up to the sky, which was empty.

And down fell fragrance; fragrance of flowers, although there were no flowers; before there were flowers there was just this fragrance, which fell, falling.

Into dust; like dusty books; but there were no books, not even the sound or whisper of words; just a fine grit on which fell this fragrance of future flowers.

And dimly, in the foreground, far from Papatea in the distance, in the nearness, out of focus, coming into focus, something, not quite someone.

Something one could almost grasp, hold in one's arms, share warmth with, almost.

Standing on the earth, not the white earth of Papatea in the distance, but here in the center of things, as it were, in the center of the blue-black sea, on this black sandy place, standing suddenly, like standing rocks, a red jet of fire standing.

And falling into small stones like the coral of my great-grandmother's floor, like river stones arranged around her feet by a child, like scattered black boulders along the strand waiting, waiting always.

Then the mountains, long-lived family of islands. Older than us, older than our lines, of which we are a part, those mountains on which we wash, and are washed away from, clinging. We open our eyes to, and close our eyes on.

As we, or they, those two, I mean, those two ones met in a green field, a clearing in the forest, a clearing that moves from place to place. A girl walks from the trees into the field and picks up some dust.

And through the sugarcane a boy comes to her with a sugarcane flower on his ear. (McMullin 2017, 44)

Previously published: Taulapapa McMullin, Dan. 2019. "The Fag End of Fāgogo." *Narrative Culture* 6, no. 2:216–228. Reprinted with the permission of Wayne State University Press.

So begins my story "Papatea,"[1] which was published in *World Literature Today*'s Indigenous issue of May 2017. I took the beginning of a cosmology, a genealogy of Malietoa Talavou, from the mid 1800s, as remembered by the Reverend George Turner in his book *Samoa, A Hundred Years Ago and Long Before* (1884).[2] I made a fāgono of it, although it was originally a *tala* or a *solo*.

Pratt's Samoan English Dictionary of 1862 defines *fāgogo* as the plural of the singular *fāgono*: a fairy tale.[3] Fāgono, a fairy tale, has a homonym *fāgono*, or boasting, a boasting person, different from *mitamita* or prideful boasting; fāgono as a form of boasting suggests telling a tall tale, fictionalizing, making fabulous. *Tala* is a historical tale, told by chiefs who sit at the *tala* post of the meeting house; *solo* is sacred poetry, also an elite communication, although these distinctions are perhaps less distinct today as their social basis changes. *Talanoa* is informal conversation, a kind of enlightened conversation, eliciting *mālie*, calm goodness, as fāgogo is informal storytelling, a kind of enlightened storytelling, mālie (Pratt 1862).

As a queer fa'afafine Samoan diaspora writer from American Samoa living in the original Mahican homelands of upstate New York, my work is in various media, from poetry to video to conceptual art to painting. Throughout my work, I queer the heteropatriarchy of white settler culture, not by choice but by being.

Amy Tielu, in her *Searching for a Digital Fāgogo*, gives a succinct abstract of the best most recent Samoan study of fāgogo practice by Su'eala Kolone Collins, *Fāgogo: "Ua Molimea Manusina"* (What the seabird brings; 2010): "In her study of fāgogo as a pedagogy for the education of Samoan children, Kolone-Collins identified that, with the numerous sources fāgogo draws from, it is a holistic foundation for *'gagana* (language), *tu ma aga* (behaviour), and *metotia* (skills) for the *fa'afailelega* (nourishment) and 'grounding' of Samoan character. Fāgogo is a conversant mode of moral instruction imparting history, beliefs, values and principles. Chief among these values is the understanding and practice of *alofa fetufaa'i* (reciprocity), based on the *vā fealoa'i* (mutual respect) and *vā tapuia* (sacred space between people and their environment)" (Tielu 2016, 37). This definition of fāgogo is post-Christian and post-monotheism, its basis in the great conversion of the 1830s and 1840s, which no doubt changed the fāgogo. The fāgogo we know are post-monotheism (or post-western, if you will) not just because of the occasional western object in the stories, but

1. Papatea, meaning white earth or bright cliff; I thought at the time that I published the story that Papatea references in various fāgogo referred to a distant place, but I've come to realize it's an old name for Manu'a, my ancestral place in Samoa.

2. One of the first missionaries to Samoa, George Turner arrived in 1840 as a representative of the London Missionary Society. He spent the next forty years in Samoa, where he established a mission seminary and published two books on Samoan history and culture: *Nineteen Years in Polynesia: Missionary Life, Travels, and Researches in the Islands of the Pacific* in 1861 and *Samoa: A Hundred Years Ago and Long Before: Together with Notes on the Cults and Customs of Twenty-Three Other Islands in the Pacific* in 1884.

3. Pratt defined fāgono as "a tale intermingled with song; boasting" (1862, 116) in the Samoan and English part of the dictionary. The grammar part of his book includes "Samoan Poetry," and in it the story of Sina and her brothers is presented as an example of fāgono (1862, 21–23). The tale is interspersed with the "Soufuna Sina" song and emphasizes the importance of the brother-sister relationship in Samoan culture through Sina's love for gogo sina bird and her capture by a large *sauali'i* (ghost, spirit, or god), from whom she is later saved by her brothers. The fairy-tale connection of this Indigenous Samoan genre of storytelling is there. As Amy Tielu remarks, fāgogo is a capacious genre that can mix together oral history and biblical material, "import folktales, render contemporary events, or be works of pure fiction" (2016, 49).

because of the stories themselves. Their hybridity cannot be unwoven, they connect our post-monotheistic present to our polytheistic past.

Richard Moyle, the major New Zealand ethnomusicologist of the Southwestern Pacific, recorded about 200 fāgogo collected in independent Samoa and American Samoa in the 1960s, some of which are online with their original recordings, as part of the University of Auckland's Archive of Māori and Pacific Music. The first of these, "'O Sina ma le 'Ulafala," from Seiuli of Falelima, Savai'i,[4] like many fāgogo, influenced me greatly in my painting and writing practice. Fāgogo have likewise influenced many other diasporic Samoan artists and writers, especially since they became available in Moyle's 1981 book *Fāgogo, Fables from Samoa in Samoan and English.* Seiuli of Falelima in the story "'O Sina ma le 'Ulafala" utilizes spells in the form of *tagi* or songs that are familiar to Samoan listeners in various forms, from various fāgogo, and tala, and solo.

The social systems of our past are present in the life of Tigilau and his wives, Sina and the *sau'ai* or ogresses. When the sau'ai, out of jealousy, kill Tigilau, Sina goes in search of her lost lover, singing to a wood pigeon who offers her no sympathy and to a *sega* or red parrot who sends her to her *ilamutu* or sacred sisters of her father or family line. The ilamutu take her to the sea doors of the afterlife, a maelstrom where streams of people are passing to the lands of the dead beneath the sea. Through a final spell, one used in many transcriptions of Samoan stories, not just in Moyle's recordings, the ilamutu calls up the four directions that the spirits of the dead wander on in search of their afterlife:

Where do they go?

Eastward . . .

West . . .

Inland . . .

Seaward . . .

Then, the ilamutu grasp Tigilau's 'ulafala, the garland around his neck, and with this spell, they bring him home to Sina. The uniqueness of this fāgono, and of all fāgogo, is in the qualities of language, of culture, of polytheism, of animism, of transformation, in ways that are distinctly Samoan, Polynesian, Pacific Islander.

Because fāgogo or fairy tales are magical or fictional or impossible, they are always outside time, in an Indigenous futurism, which can be the same as an Indigenous past, a sutured cleft, an eternal return. Animism is a western definition of transformation, fa'amanu, the way of the wild. One might see animism as a way of understanding animal beings and other nonhuman beings, as well as understanding other human beings, living and dead, or how we feel about the physical being and nonbeing. How a fairy tale can make a fairy real, because nothing else can. How a fāgono can make a ball of earth into a bird again, a seabird, a gogo.

4. Audio, transcription, and English translation for "'O Sina ma le 'Ulafala" are available through the University of Auckland's Archive of Māori and Pacific Music at http://www.fagogo.auckland.ac.nz/content.html?id=1.

And why the fag end of fāgogo? A fag end is a cigarette butt, an inferior and useless remnant of something. Like the fag end of the day, an abject ending, the fictional last of the Mohicans. In my work, I'm looking at fictions of disappearance, Indigenous disappearance, the disappearance of fāgogo, and the appearance of fāgogo, Indigenous futurism, an end that—like coral—is always renewing. As a fa'afafine,[5] our traditional Samoan nonbinary, or trans-binary being, neither male or female, both male and female, just fa'afafine the way of women of nonmen, just fa'amanu the way of the wild, just fa'amea something, being and nonbeing. An understanding of the liminality of all things.

Fāgogo are communal. They are told at night when we gather to sleep. The night is *pō,* the darkness is *pogisā,* sacred, to be pō is to be blind, to dream is *fa'alepō,* our pre-Christian bacchanalias were *pōula* and *pōsiva,* the darkness of our paganism was the time of our *pōuliuli,*[6] to be in an unsanctified relationship is *fa'apōuliuli,* an illegitimate child is a *tama o le pō,* a *pō* is a slap, as when we were young, we were told not to linger in the rainforest at night because we would be slapped, pō, by the *aitu,* a demon, who would leave a red handprint on our faces.

Fāgogo influenced the way Samoan contemporary writing developed. Poetry began as storytelling, as with Ruperake Petaia in his 1974 poem "Kidnapped," where at school "a band / of Western philosophers" in books kidnap the young Petaia as he "grew whiter and / Whiter," until his graduation or "release" (Petaia 1980). The title of Petaia's poem is the title of a story by Robert Louis Stevenson, although Stevenson, who died in Samoa, interestingly (but not surprisingly) doesn't seem to mention fāgogo in any of his writing; like the missionaries, he was monotheistic. His Samoan name was Tusitala,[7] painter of histories, a kind of silence.

Fāgono is a fictional tale, told in a domestic setting, told by storytellers in the evening, at bedtime. I grew up in the 1960s in American Samoa households where there was a great room, our sleeping room, each one or two on separate sleeping mats with embroidered pillows, and white diaphanous mosquito nets over each mat, each net lit from within by kerosene lamps, against the pō, the pōgisa, of the rainforest around us. Everywhere about were children, mothers, fathers, grandparents. The stories of fāgogo were tales for everyone; children were not in the nineteenth- or twentieth-century category of the western child, nor the parents in the western definition of parents. We were all the children of all the adults and elders, and everyone had a first name only, although that was changing, had changed, but not quite. The fāgogo were domestic, spoken in the home, with songs, often by women, but also by men. I remember as a small child walking on my great-grandmother Fa'asapa's thin, hard-as-wood legs, balancing myself as she murmured and told me this and that story, none of which I can remember exactly, but I do remember the smell of coconut oil on her skin. It may be the strongest memory I have.

5. Literal translation: "in the way of a woman or wife."

6. "Elements of these ancestral Samoan ways of being, were (as we know) in Christian eyes, heathen, pagan, sinful or evil: Pouliuli. The enduring Samoan and Christian rhetorical opposition, crafted jointly by foreign, Polynesian and Samoan missionaries, cast Malamalama (Christian Enlightenment and Knowledge) in opposition to the Pouliuli of ancestral Samoa" (Salesa 2014, 145).

7. For additional reading on Stevenson in Samoa, see Colley (2017).

Albert Wendt, the first contemporary Samoan novelist, wrote of the hybrid nature of fāgogo:

> Like most children I was fascinated by oral literature—stories, poems, chants, legends and myths of our own people. Samoa was and still is rich in its oral traditions, and I was lucky to have the grandmother I had. I attribute my continuing interest in listening to good yarns (and to writing my own yarns and fables) to her. She was steeped in Samoan culture and the Bible, and she spoke fairly fluent English. Every night she would reward us with fāgogo. I didn't realise until I read Aesop's fables and Grimm's fairy tales in English years later that some of grandmother's stories were from these collections, but she was telling them the fāgogo way in Samoa. (quoted in Crocombe 1973, 46)

Tui Atua Tamasese, Samoa's philosopher, describes fāgogo in terms of language: "both mama and fāgogo bespeak the passing on of physical and cultural life from generation to generation in closeness and alofa. It is an image of intimacy, of sharing, of love, of connection and communication. It imparts mana and shares the feau (i.e., a message) between generations" (Efi 2003, 59). Elsewhere Tui Atua writes, "The powerful influence of my childhood minders on me can be heard today in my Asau dialect. My minders were ladies of my family from Asau. They told me fāgogo in the Asau dialect. Thus, the fāgogo and the Asau dialect have special meaning for me" (60).

In my work—living as I have most of my life in the United States, with years at a time in American Samoa, and in independent Samoa, and elsewhere in the South Pacific, and being now a better reader of Samoan than I am a speaker—I look at fāgogo as a foundation for my practice as an artist and writer. Within the English language, I practice fāgogo because it was and is a way of queering monotheism. My first widely published poem, "The Bat," from the 1990s, looked at queer identity as cultural flowering and deflowering:

<div align="center">

The Bat

Once upon a time in old Pulotu there were two fa'afafine named Muli and Lolo.
Lolo was pretty but Muli knew how to talk.
Every night they walked the beaches looking for sailors.
In those days everyone in Pulotu was a sailor. When they found one they had their
way with him because they never did each other:
one of those things.
Afterwards,
because the islands used to be dens of cannibalism, one of them hit the nodding
sailor with a rock,
and they devoured him.
They did this until there were no more young men left on their particular island.
In fact around this time Lolo had really learned everything she would from Muli,
and Muli was starting to desire Lolo,
so they did each other; but afterwards Lolo killed Muli and devoured her

</div>

as people who come to one for advice will. This act made the gods very angry at
Lolo, so for punishment they turned her into a bat.

For years Lolo flew up and down the beach at night on little leather wings.
And there were no young men until finally the Americans landed.
Lolo's first white man, still she knew a sailor when she saw one. Lolo sank her
teeth into the sailor's fat neck and the sailor fainted.
Then Lolo drank until she got plump and passed out.
When she woke up she was in a basket aboard ship and ended up at the
University of Minnesota Medical School
where she was given a nice warm cage by a local foundation.

One day
I'm not sure how but I'll let you know, she escaped.
It was the especially cold winter of '94; eighteen-ninety-four.
Lolo flew above the buildings
and south over the pale Mississippi landscape.
It was snowing
and everything was white.
Suddenly far below she saw something in black leather.
Flying down she discovered a boot
that some young man had left there the previous summer
along with his glasses and a pair of shorts he had lost along the river bank while
walking to the corner store late one night to fetch a bottle of milk
for the wife and five kids.

By now Lolo's wings had frozen and she was stuck.
She was in love with the black leather boot although it didn't speak
and she couldn't eat it.
She didn't think she could eat it and love it.
The snow kept falling
until it covered them both like a blanket.
The end
(McMullin 2013, 68)

The contemporary fāgono is conceptual, and it is often visual, taking the form of photographs, as in the work of faʻafafine artist Yuki Kihara.[8] And younger faʻafafine like Tanu Gago and his partner

8. Images from Kihara's exhibition entitled "Velvet Dreams" (Milford Galleries Dunedin, September 27–October 22, 2014) are a good example of how contemporary fāgogo are being told visually: https://www.milfordgalleries.co.nz /dunedin/exhibitions/375-Yuki-Kihara-Velvet-Dreams.

Pati Solomona Tyrell, with their collective FAFSWAG,[9] make reference to my early works, my video *Sinalela* (McMullin 2001), and my poem "Jerry and the Eel" (McMullin 2013, 3). Gago made a series of drawings and photographic works *Jerry the Fa'afafine,*[10] in reference to my poem. The fāgogo have become a contemporary art conversation. They have also become a part of cultural appropriation.

A few years ago, a Samoan film producer friend called me, said, I'm coming to L.A., I said, Okay, see you at the airport; the next day she said, Drive me to Disney, I said, Okay, I'll drop you off and go get a coffee, call me when you're done. Afterward, we went to Venice, had a drink, she said, They're making a movie, I'm heading a Pacific Story Trust of cultural advisors, for an animated film called *Moana,* I said, Wow.[11] The Disney film *Moana* is about a Polynesian girl who has magical adventures with the demigod Maui, a sort of big-brother figure. Disney registered a trademark for the ancient Polynesian word for our sea, Moana, except in Europe, where the word Moana was already a registered trademark held by another company; so in Europe, Disney called their film *Vaiana,* and when I went to French Polynesia earlier this year to show my art video *100 Tikis,* about cultural appropriation, everyone was talking about *Vaiana,* because French Polynesia is under French law and trademarks. The Disneyfication of Polynesian storytelling is part of the privatization or corporatization of communal Indigenous intellectual property.

The Disney or Hollywood version attempts to westernize our Moana, to make it their Pacific, the South Pacific of Hollywood. Hollywood is the adult or human storyteller who somehow makes sense of the senselessness, makes rational the irrationality or even arationality of the child or nonhuman, the animal, the irrational pet, whose waking hours are a kind of dream, a dream we might experience, but from whose magic we must be cleansed. Over time, I moved away from the fairy-tale poetry of my earlier writing for a time.

<p style="text-align:center">Tiki Manifesto</p>

<p style="text-align:center">Tiki mug, tiki mug

My face, my mother's face, my father's face, my sister's face Tiki mug, tiki mug</p>

<p style="text-align:center">White beachcombers in tiki bars drinking zombie cocktails from tiki mugs The

undead, the Tiki people, my mother's face, my father's face

The black brown and ugly that make customers feel white and beautiful</p>

<p style="text-align:center">Tiki mugs, tiki ashtrays, tiki trash cans, tiki kitsch cultures Tiki bars in Los

Angeles, a tiki porn theatre, tiki stores

Tiki conventions, a white guy named Kukulelei singing in ooga booga fake

Hawaiian makes me yearn to hear a true Kanaka Maoli like Kaumakaiwa

Kanaka'ole</p>

9. FAFSWAG is a collective of transgender and queer Polynesian artists and performers based in Auckland, Aotearoa New Zealand. Many of the collective's recent projects can be accessed at https://fafswag.com.

10. Personal communication, 2010.

11. Dione Fonoti, personal communication, 2013.

sing chant move his hands the antidote to tiki bar people
who don't listen because tiki don't speak any language
do they

Tiki bars in L.A., in Tokyo, in the lands of Tiki, Honolulu, Pape'ete Wherever
tourists need a background of black skin brown skin ugly faces
to feel land of the free expensive rich on vacation hard working
with a background of wallpaper tiki lazy people wallpaper
made from our skins our faces our ancestors our blood

. . . And I'm here in Los Angeles or anywhere here in the so-called West which is
everywhere
and here, we are tiki mug people, my mother's face, my father's face
my face, my sister's face

. . . Can I remind us that Tiki Whom we call Ti'eti'e and Ti'iti'i Some call Ki'i,
some call Ti'i

That Tiki was beautiful, jutting eyebrow, thick lips, wide nose brown skin in some
islands
black skin in some islands brown black deep, thick thighs
jutting eyebrow, thick lips, wide nostrils, breathing

Lifting the sky over Samoa, lifting the sky over Tonga lifting the sky over Viti,
lifting the sky over Rapanui lifting the sky over Tahiti, lifting the sky over
Hawai'i
lifting the sky over Aotearoa, and looking to, paying respects to Papua, to the
Chamorro, to Vanuatu, to Kiribati
lifting the ten heavens above Moana, not your Pacific, not your Disney, but our
Moana

And now in tiki bars Chilean soldiers have drinks from tiki mugs after shooting
down Rapanui protesters in Rapanui, not Easter Island, not Isla de Pascua but
Rapanui, whose entire population was kidnapped and sold in slavery
to Chilean mines in the 19th century, and whose survivors are shot on the streets
of their lands in Rapanui today

And American police drink maitais in Honolulu bars from tiki mugs while native
Hawaiian people live homeless on the beaches

And Indonesian settlers drink from tiki mugs in West Papua where half a million
Papuans have been killed seeking freedom after being sold down the river by

President Kennedy so he could build some mines for his rich cultivated
humanitarian friends

And French tourists drink from tiki mugs in Nouvelle Calédonie and Polynesie
Française while native people are . . .

Where? Where are we?
In the wallpaper, on the mugs?
(McMullin 2013, 11–12)

"Tiki Manifesto" was the first poem I wrote that sometimes made Pacific people cry and nod, whereas my fairy-tale poems made them laugh or smile. I don't know which is better. Now I'm working on an appropriation novel and installations. Like my art video *100 Tikis,* it is based on cultural appropriation, where I appropriate western images and words for my own use, without permission, without trademark.

Fāgogo are our door to our pagan past, to how we at one time related to our animal others, our animal deities, how we were to ourselves and to each other through the forest and the sea, how polytheism suffused our lives, how we at one time believed. In that sense it tells us much about ourselves as we are now, how our monotheism, atheism, agnosticism, or polytheism is informed by a kind of magical communication with the physical world, through our bodies, through our ghosts, and through our stories.

Works Cited

Colley, Ann C. 2017. *Robert Louis Stevenson and the Colonial Imagination.* New York: Routledge.
Crocombe, Marjorie Tuainekore. 1973. "Pacific Personality: Samoa's Albert Wendt, Poet and Author." *Mana Annual* 1:45–47.
Efi, Tui Atua Tupua Tamasese Taisi. 2003. "In Search of Meaning, Nuance and Metaphor in Social Policy." *Social Policy Journal of New Zealand* 20:49–63.
FAFSWAG. 2017. "FAFSWAG: Pacific, Artistic, Queer, South Auckland." Last modified November 10. https://fafswag.com.
Kolone-Collins, Su'eala. 2010. "Fāgogo: 'Ua Molimea Manusina': A Qualitative Study of the Pedagogical Significance of Fāgogo—Samoan Stories at Night—for the Education of Samoan Children." Master's thesis, Auckland University of Technology.
McMullin, Dan Taulapapa, dir. 2001. *Sinalela.* Privately published. https://vimeo.com/130124443.
———. 2013. *Coconut Milk.* Tucson: University of Arizona Press.
———. 2017. "Papatea." *World Literature Today* 91, no. 3/4:44–47.
Moyle, Richard R. 1981. *Fāgogo, Fables from Samoa in Samoan and English.* Auckland: Auckland University Press.
Petaia, Ruperake. 1980. "Kidnapped." In *Blue Rain,* pp. 10–12. Suva: University of the South Pacific Centre.
Pratt, George. 1862. *A Samoan Dictionary: English and Samoan, and Samoan and English; with a Short Grammar of the Samoan Dialect.* London: London Missionary Society Press.
Salesa, Damon. 2014. "When the Waters Meet." In *Whispers and Vanities: Samoan Indigenous Knowledge and Religion,* pp. 158–172. Wellington: Huia Press.
Seiuli. n.d. "'O Sina ma Le 'Ulafala." Archive of Māori and Pacific Music, University of Auckland. Accessed June 2, 2023. http://www.fagogo.auckland.ac.nz/content.html?id=1.
Tielu, Amy. 2016. "Searching for the Digital Fāgogo: A Study of Indigenous Samoan Storytelling in Contemporary Aotearoa." Master's thesis, Auckland University of Technology.
Turner, George. 1884. *Samoa, a Hundred Years Ago and Long Before: Together with Notes on the Cults and Customs of Twenty-Three Other Islands in the Pacific.* New York: Macmillan.

Artist Statement for "The Forever Spam, 2055"

Craig Santos Perez

Spam is the most fantastic food in the Pacific. In one sense, Spam is fantastic because it tastes delicious and is universally loved. In another, Spam is fantastic because when it was first introduced to the region after World War II, it embodied modern technologies of food preservation as well as a vision and promise of an American futurity. Spam also embodied a "wonder tale" in many islander imaginations; for example, my grandmother once described the arrival of Spam on Guam after the devastation of the war like "manna from heaven." Spam was a magical and surreal meat.

Today, islands like Guam and Hawai'i have the highest rates of Spam consumption per capita in the world. Spam is ubiquitous in every grocery store, kitchen, and pantry. There are even Spam festivals, cook-offs, and competitions. Spam has become a staple of the Pacific Islander diet. As a result, many islanders suffer from high rates of diseases related to the overconsumption of this salty, fatty, and greasy protein. Thus, Spam also embodies a colonial monster in a horror story.

In my short story "The Forever Spam, 2055," I wanted to explore Spam through a fantasy and science fiction lens. I created a future in which Hormel takes over the U.S. government and instigates a war with China that utterly destroys the food system. Their goal: to establish Spam as the only food left in the world, allowing Hormel to achieve global hegemony over our stomachs and accrue unprecedented profits.

The main character is a Chamoru born and raised on Guam during the war. His generation is the first to live in this postapocalyptic future and to eat only Spam for every meal. When he is eighteen years old, he receives a scholarship to attend the Spam Research and Development Center at the University of Hawai'i, where he studies with a renowned Spam expert who is trying to develop a sustainable, Indigenous version of Spam. He begins to question the world's dependence on Spam when he discovers an underground group of Hawaiians who are trying to maintain their traditional food customs. Ultimately, he must make a choice between continuing his Spam education or joining the Spam resistance.

I hope this story contributes to the growing body of "fantastic" literature from Oceania. I hope that my focus on food colonialism and Indigenous food traditions will add to the important conversation about the future of food in Oceania.

The Forever Spam, 2055

Craig Santos Perez

When Anthony Ñålang was born at Guam Memorial Hospital on July 5, 2037, he was fed what all newborns of his generation were fed: Spam Milk. True to his surname, he was a *hungry* baby, devouring bottle after bottle of the nutritious pink formula made from powdered, vitamin-enriched Spam and desalinated water. After just two months, his mother, Maria, tried to satiate his seemingly unending appetite with jars of Spam purée. During teething, she soothed his sore gums with Spam popsicles. His first hot food: pan-fried Spam. By his first birthday, he had grown into a chubby infant with månnge' cheeks and thighs.

Anthony was fed *only* Spam because Spam was literally the *only* food left on the planet. In 2030, territorial disputes over the South China Sea turned violent. To support its allies in Asia, the United States declared war and detonated several Chinese warships. In retaliation, China unleashed its store of lab-grown viruses and biochemical weapons, triggering the American military to launch its arsenal of nuclear warheads. Millions died in the aftermath of explosions, radiation, toxic exposure, and pandemics. Soil and water were contaminated. Crops failed. Fish and animal stocks collapsed. Global starvation ensued.

All agriculture and food corporations went bankrupt. *Except Hormel.* A few years before the war, Hormel began building factories and slaughterhouses in massive underground bunkers. Their food scientists even developed hundreds of Spam-derived products "enriched" with vitamins and nutrients. They created a massive supply of Spam poised to feed the entire nation. At the time, no one understood why.

But after the war, Hormel received multitrillion-dollar contracts from Congress to become the sole supplier of food to the military, hospitals, and schools, as well as to the National Food Ration Program, which delivered cases of Spam to every household in all states and territories. By the time Anthony was born, Hormel was the largest, wealthiest, and most powerful corporation in the world. Its annual profits were more than the GDP of many nations. A majority of senators were former Hormel executives, and the president himself was a former Hormel CEO. Some pundits referred to the country as the "United States of Spamerica."

While it has never been proven, several respected investigative journalists (who were invalidated in the corporate media as conspiracy theorists) claimed a shadow cabinet within the Hormel Corporation had orchestrated the government takeover and the war because China was developing its own state-sponsored, cheaper version of Spam, which would threaten Hormel's canned-meat hegemony. Was it really a coincidence that Hormel moved their operations underground at the

perfect moment? Was it really a coincidence that Chinese pork-processing plants were targeted during the first bombing raid? We may never know the truth because these journalists have since mysteriously disappeared.

* * *

Guam was tragically impacted by the war. Anderson Air Force Base in northern Guam was the launching pad for nuclear missiles; as a result, it became the first site China targeted. Anthony's father, Michael, a pilot in the air force, was killed in action in 2038. His mother died from the third wave of the pandemic a year later. Ninety percent of the population: gone. Anthony was one of the few survivors on the island. From the age of two, he would spend the rest of his childhood at the Father Duenas Memorial Orphanage and School for Chamoru Boys, located in the village of Chalan Pago.

The Jesuit priests who managed the orphanage tried their best to creatively prepare the Spam rations. For breakfast: scrambled Spam. Lunch: Spam meatballs. Dinner: Spam shish kabobs. Snacks: Spam jerky. Dessert: Spam jelly. Every week, month, and year: Spam, Spam, Spam. For daily mass, Spam communion wafers and fermented Spam wine (Jesuits can transform anything into wine). Despite its ubiquity, Anthony still loved the salty, fatty, savory, and sweet flavor of Spam in all its delicious transubstantiations. Body and blood of Spam, Amen.

As a teenager, Anthony was studious. He enjoyed reading, completed his homework on time, and always asked questions in class. He excelled in all his courses, but his favorite subject was, by far, Spam studies, a new course created by the Department of Education and mandated by Congress to be taught at every grade level across the nation, with all the textbooks written and funded by the Hormel corporation. He received an "A+" on his final senior paper about the origins of Spam on Guam, entitled "'Like Manna from Heaven': How Spam Saved the Chamoru People after World War II." He even scored a perfect 1600 on the SAT, the Hormel-sponsored Spam Aptitude Test, and was named valedictorian of the Class of 2055.

* * *

On the last day of school before graduation, the principal, Påle' Christopher, called Anthony into his office.

"Håfa adai, Anthony. Have you made your decision?"

"Yes, Påle'. I plan to enlist in the military tomorrow. Air force, like my dad."

"All your classmates are enlisting too, Anthony. But you should read this first." Påle' handed him a letter. "I received it yesterday from the Hormel Corporation. They were very impressed with your perfect SAT score. You are the first student from Guam to achieve this rare feat."

Anthony read aloud: "We are pleased to offer you a four-year full scholarship to the Spam Research and Development Center at the University of Hawai'i at Mānoa, under the mentorship of the renowned Spam scholar Dr. Ho'opilimea'ai."

Anthony opened his mouth in shock. He had never imagined any future for himself outside of the military. He thought he was destined to defend the nation with Uncle Sam, not feed the nation with Uncle Spam.

"I know you think your dad expected you to join the military," Påle' Christopher said, breaking the silence. "He was a brave soldier, but he was also a devout Catholic. He would be proud of you serving the country by serving Spam. More importantly, he would be proud that you are serving God by serving Spam."

Anthony touched the gold cross on his necklace. A family heirloom.

"The Gospel of Matthew, chapter 14, verses 13–21," Påle' Christopher stated. "Do you remember it?"

"The feeding of the multitudes," Anthony recited. "The miracle of the seven loaves and fishes."

"Very good, son. But today, Spam is the miracle meat, and you . . . you can be Spam's apostle. It is your namesake *and* your birthright."

"What do you mean, Påle'?" Anthony inquired.

"You were born on July 5, 2037. The centennial of Spam's birth. *Plus,* you are named after St. Anthony, patron saint of swineherds. Look at his picture."

Anthony stood up, approached the dusty picture of the bearded and robed saint on the wall. As soon as he saw the pig at the saint's feet, he knew he must walk in the path of Spam.

"Amen," Påle' Christopher said, making the sign of the cross in the air with his hand. "I have faith in you, my son."

* * *

A few weeks later, a blue limousine with "Spam" in yellow letters emblazoned across the door arrived at the orphanage. The driver, wearing a black suit, yellow tie, and blue mask with "Spam" written across its mouth, opened the door for Anthony.

"Here's your Spam mask, sir. To protect you from the viruses."

Anthony put on the mask, then turned and waved goodbye to the priests and younger boys. The other graduating seniors were picked up by the military buses days earlier. *Would he ever see them again?*

The driver took Route 10 to Route 4, north to Hagåtña, the capital of Guam, then a right on Marine Corps Drive, the island's main artery, to the Antonio B. Won Pat International Airport. The only other vehicles they encountered were military Humvees since civilian cars were no longer allowed on the roads. Most of the buildings on the island were destroyed during the bombing. The only businesses that survived were the McDonald's and the massage parlors, but only soldiers were allowed to enter them. Along every street: barbed wire fences. The airport was now controlled by the military, tourists no longer allowed to visit. The limousine turned into Terminal "H," a private runway for the Hormel Corporation. Anthony boarded the private plane, painted blue with "Spam" printed across the tail.

"Hååååå-faaaaaaa daaaaaay! Welcome to Spam Airlines," the stewardess said through her Spam mask. "You are the only passenger today, so please sit anywhere you like. Would you like a glass of Spam juice before takeoff?"

"No, thank you," Anthony responded, too nervous to drink. He had never flown before, so he decided to sit in the last row just in case the plane nosedived. He strapped on his seatbelt.

As the plane took off, Anthony looked out the window. Rows and rows of fighter jets lined the airstrip. The hotels in Tumon were turned into military barracks. Thousands of soldiers marched below. Nearly every village was claimed by eminent domain during the war, transformed into military bases, radar stations, missile defense systems, munitions storage units, live firing ranges. Eighty percent of the land now controlled by the Department of Defense. In Apra Harbor, countless warships and nuclear aircraft carriers. Then the bleached coral reef. Then, the depths of the misnamed Pacific Ocean. Behind him, the accurately dubbed USS Guam.

Anthony felt nauseous. He pressed the button for the stewardess.

"How can I help you?"

"I think I'm going to throw up," Anthony admitted.

"Here, take this." The stewardess gave him a bottle of Spam-infused vitamin water and a pink pill. "It's Spam-flavored Dramamine. It helps with motion sickness."

He swallowed the pill, closed his eyes, and fell asleep for the remainder of the seven-hour flight from Guam to Honolulu.

* * *

"Aaaa-loooo-haaa," the stewardess loudly uttered over the intercom to wake up Anthony. "Welcome to the beautiful island of Oʻahu. The Spam gathering place of the Pacific! It's a beautiful, new normal day. A hundred and ten degrees Fahrenheit. Cloudless."

Anthony exited the flight and entered the air-conditioned terminal, where he was greeted by a masked customs officer.

"Stand on the 'X' for the bio-scan," he said in a serious tone. After the scan, an automated voice from the machine confirmed: "Anthony Ñålang. Guam. Temperature: Normal."

"Here is your Hormel ID card," the customs officer said. "Take the escalator to the underground rail station. Board the 'Waikīkī' train. Exit at 'Hormel Hotels.'"

In the station, the florescent lights brightened the white tiles. Other people, wearing Spam masks and blue jumpsuits, were waiting for the train. A few minutes later, a blue train with "Spam" written across its flank arrived. The train was full, so Anthony stood, holding on to a handrail. They rumbled through the dark tunnel. No one spoke through the Spam masks covering their mouths.

Thirty minutes later, Anthony followed the crowd off the train and to the escalator of the Waikīkī station. On the slow ascent, his stomach turned. *Was he excited for this new adventure, or was he just hungry?*

The lobby of the main Hormel Hotel bustled with employees wearing Spam masks and blue jumpsuits. A forty-foot-high and ten-foot-wide cubist-inspired sculpture of the iconic Spam can

was placed in the middle of the high, glass-ceiling lobby, with the late afternoon sun giving the artwork an entrancing, angelic glow. For a moment, Anthony almost knelt before what could have been mistaken for a pilgrim's holy shrine.

"Aaaa-loooo-haaaaa! Welcome to the Hormel Hotel! Are you checking in?" the desk clerk called out to Anthony through her Spam mask, breaking his spell.

"Yes, my name is Anthony Ñålang. I'm a new student at the Spam Research and Development Center. I'm from Guam. Here's my ID card."

"Welcome to Hawai'i! The Spam Center of the Pacific! You'll be staying on the eighteenth floor. Room 1898. Ocean view. Here's your key card. No unauthorized visitors. No travel outside the hotel unless you have a permit from the military. Any questions?"

"Um, how do I get to the university?"

"In the morning, go back down to the rail station and take the 'Mauka' train, exit at 'University.' Bring your ID card. Enjoy your stay."

The blue carpet and wallpaper in Room 1898 featured a repeating pattern of Spam cans. The single mattress was wrapped taut with Spam-brand linens. A chair and wooden desk were situated in the corner of the room. Atop the desk: *The Book of Spam.* On the wall, a framed picture of Jay Hormel, the creator of Spam, posed next to his father, George Hormel, the founder. Next to the desk, a mini-fridge packed with Spam-infused vitamin water. In the closet: five Spam laboratory coats, five pairs of yellow Spam socks, five yellow pairs of Spam underwear, and five Spam masks. On the floor of the closet, a pair of boots, a case of Spam, and a package of plastic spoons. In the bathroom, a blue toothbrush, Spam toothpaste, Spam mouthwash, Spam shampoo, and Spam oil soap. Central air conditioning.

Anthony undressed and took a long, hot shower, washing away the germs and sweat of transpacific travel. After, he put on a pair of Spam underwear, opened a can of Spam, and sat up in bed to watch the sun set. The famed Waikīkī beach. Diamond Head in the distance. The sparkling, oceanic horizon. Even though he was so far from the orphanage, so far from the memory of his parents, so far from Guam, and so mahålang, he thought, *maybe, someday, this could be home. Guma' Spam.*

His stomach filled with the familiar and comforting texture of Spam, causing his body to sink into the bed. He lay down and surrendered to exhaustion and jet lag as the sky turned a glorious, gelatinous pink.

* * *

Anthony woke up refreshed and immediately rushed to the bathroom to empty his bowels (the fiber-enriched Spam regulated the population). He showered again, brushed his teeth, and dressed in his Spam uniform. He thought about his father as he stared at himself in front of the mirror. *Do I look like him when he was my age?* Stout 5'7" frame, light brown skin, crew-cut black hair, goatee stubble, chubby cheeks, dimples. *Was he scared the first time he put on his air force uniform?*

He finished eating the can of Spam he'd started for dinner, laced his boots, fastened his Spam mask, and headed to the elevator. In the lobby, he joined the drove of Spam employees making their way down the escalator. He caught the seven a.m. Mauka train. Exited at University station.

Followed the sign "Spam Research and Development Center" down a hallway to an "X" on the floor in front of a locked, steel door. An infrared beam scanned his body. An automated voice stated: "Anthony Ñålang. Normal temperature." The door opened.

"Aaaa-loooo-haaa, Anthony," bellowed a deep voice that seemed to emanate from a prophetic Polynesian orator. "My name is Dr. Hoʻopilimeaʻai. I am the chief researcher and dean at the Spam Research and Development Center. Welcome to the future of meat."

Anthony, awestruck, struggled to speak. Dr. Hoʻopilimeaʻai loomed mythically in his imagination. *The* foremost Spam expert in the Pacific. *The* international pioneer in cutting-edge Spam innovation. *The* first and only Pacific Islander Spam scientist. Yet here he was, *real and in the flesh.* Six-foot-two, potbellied, wrinkled brown skin, gray ponytail, faded arm tattoos, black-rimmed glasses, Spam-musubi themed Aloha shirt, Spam mask.

"It's . . . it's an honor to meet you, sir."

Dr. Hoʻopilimeaʻai was born in Kailua, graduated from Punahou, received a BA and an MA in Hawaiian studies from the University of Hawaiʻi at Mānoa (UHM), and a PhD in food science from Stanford. His highly cited dissertation focused on the intersections of genetically modified organisms and Indigenous culture. Right after graduate school, he returned to Hawaiʻi and accepted an assistant professorship with UHM's College of Tropical Agriculture and Human Resources (CTAHR). Tenured after just a year. Full professor after three. An academic star.

But when the war broke out, the president reinstated the draft through executive order, so there were fewer and fewer high school graduates enrolling in college. As the economy collapsed, public universities were defunded. At first, only departments related to the arts, humanities, and social sciences were dissolved. But soon, even the sciences were axed. Dr. Hoʻopilimeaʻai, however, survived like a true rainbow warrior. He applied for and received a multimillion-dollar grant from the Hormel Corporation to establish the Spam Research and Development Center, located far below the surface of the otherwise abandoned university in Mānoa Valley.

Dr. Hoʻopilimeaʻai leaned forward and pressed his forehead against Anthony's forehead. Deep breath. Honi, a traditional Hawaiian greeting.

"Anthony, you are the first student from Guam to achieve a perfect score on the SAT, which I myself designed. I'm pleased you accepted this scholarship. I know you will make your island proud."

"Mahalo for this opportunity, sir."

"Please, call me *kumu.* It means 'teacher.' You will be my apprentice for the next four years. Monday through Friday, eight a.m. to five p.m. This is not just our schedule. This is our kuleana, our responsibility. Are you ready to commit your life to Spam?"

"Yes, Dr. . . . I mean, *kumu*," Anthony said, inspired. "Spam has given me and my people so much. I want to give back."

"That is pono. Spam has fed Chamorus and Hawaiians for generations. We are indebted to Spam. Reciprocity is an important value in Indigenous cultures. My name, Hoʻopilimeaʻai, means to be close to the food." He paused to let it sink in. "Before I give you the orientation tour, tell me what you know about Spam factories."

Anthony panicked. He was not mentally prepared for a pop quiz. He gathered his thoughts and recalled what he'd learned in school.

"The Spam factories and concentrated animal feeding operations moved underground a few years before the war. They feed the pigs soy and keep them healthy with antibiotics. When the pigs are at full weight, they're processed using the assembly-line approach. Workers are stationed at different points and trained to complete individual tasks. They rely on speed and volume to meet production goals. This method is very profitable—"

"Very good," Dr. Hoʻopilimeaʻai interrupted. "That is exactly what the textbook, which I helped write, teaches you. But here is your first lesson: *this method is flawed and failing.* The pigs have developed genetic disorders due to inbreeding, and the workers have contracted strange diseases. Hormel has stockpiled enough Spam to last a few more years, but they're running out. We're five minutes from midnight on the Spam doomsday clock. We're on the brink of mass riots, civilizational collapse, the Spam apocalypse."

Anthony gasped. He could not believe it. He could not imagine a world without Spam. He could barely imagine a world where a can of Spam would actually *expire.*

"Everyone in the Pacific will die of starvation," he trembled.

Dr. Hoʻopilimeaʻai put his firm hands on Anthony's shoulders. "I know it sounds like a dystopian science fiction story. But there's hope." He paused, dramatically. "The old Spam factories are based on Western principles. The plantation. Linear time. Cheap labor. Profit motive. *It's always been unsustainable.* But here, at the Spam Research and Development Center, we're creating a new way to process Spam."

He paused again, even more dramatically.

"*Here,* we're creating a Spam factory grounded in Indigenous cultural knowledge and guided by the most advanced technology and science. It'll be based on a spiral concept of time and a circular economy. It'll be sustainable and carbon neutral. It'll treat workers as essential and pay them a living wage. It'll be ancient and new. Most importantly, it'll be nutritious and ʻono."

Anthony's spirit lifted.

"Our mission," Dr. Hoʻopilimeaʻai continued, "is to create the perfect Spam that will feed our global ʻohana seven generations from now. Our kuleana is to create *The Forever Spam*™."

* * *

Dr. Hoʻopilimeaʻai led Anthony down another hallway until they reached an entryway with the sign "The Spam Ahupuaʻa." Dr. Hoʻopilimeaʻai took off his boots. Anthony did the same, then pulled out his pocket notebook.

"What does ah-who-poo-a-a mean?" Anthony asked, embarrassed by his pronunciation.

"Ahupuaʻa is an ancient Hawaiian environmental management system in which crops and trees—such as taro, sweet potato, breadfruit, and coconut—were planted alongside streams that flowed through valleys, from mauka, the mountain, to makai, the sea. At the muliwai, the estuary, fishponds were built and maintained. The ahupuaʻa is a symbol of Hawaiian stewardship and abundance. The word itself has kaona, or hidden meaning."

Anthony had been taking notes, hanging on every word. It was not until Anthony looked up at Dr. Hoʻopilimeaʻai that he revealed what was hidden.

"Ahu means shrine or altar. And pua'a means pig. Ahupua'a is the altar on which the pig was sacrificed as payment to the chief of the ahupua'a land. Thus, it is the perfect place to make The Forever Spam."

The underground Spam Ahupua'a was a circular, concrete structure divided into different rooms. An unpaved path curved around the exterior. The rooms were lined with one-way mirrors so that those walking along the path could observe without disturbing the workers within. Lights, electrical wires, and air-conditioning ducts wrapped around the structure before traversing down another hall to a maintenance room at the other end of the labyrinthine complex.

"Each room is an 'ili," Dr. Ho'opilimea'ai explained. "An 'ili refers to a subdivision of an ahupua'a. This first 'ili is called 'Pō.' This is where we genetically modify our pigs and artificially inseminate their eggs."

Anthony looked into Pō, where scientists were staring into microscopes, typing on computers, tapping syringes, and measuring beakers.

"We use genetic modification to create the perfect pigs for Spam production. At first we edited their genes to prevent any disorders. Then we went further. We compassionately edited their code so they no longer have nerve endings or eyes. This way, they do not feel pain or see anything that will cause them fear. We also modified their digestive tracts to function unidirectionally: they eat and absorb nutrients, but don't generate feces or urine, which makes them grow more efficiently. Our most innovative modification, however, was that we programmed every fertilized egg to generate a conjoined twin. Not only have we doubled the meat, but this way no pig will ever feel lonely. Our special pigs are patent pending."

The next 'ili contained large, egg-shaped cylinders, filled with a thick, florescent pink liquid. Floating in the middle of the incubator: conjoined pig fetuses. Handmaids dressed in pink frocks monitored vital signs.

"This is the 'Piko' room. The fetuses grow to full term in only two months."

"What's the liquid made of?" Anthony asked.

"A proprietary blend of Spam powder, Hawaiian pink salt, and desalinated water from Moana Nui, the ocean. Wai ola. Water is life."

The next 'ili included rows of raised cribs. Nurses dressed in pink mu'umu'u tended a group of eyeless newborns conjoined at their legs like a pig standing in shallow water and its perfect reflection. Without feet, they lied on their sides. Plastic tubes connected their mouths to feed buckets.

"This is the Māla room, where we feed and care for the pigs for three months. Since they can't stand up, the nurses flip them over every day so their bodies marble evenly."

"They're so quiet," Anthony whispered.

"Ah yes, I forgot to mention earlier. We engineered away their squeals."

Anthony noted this detail, then inquired: "What do they eat?"

"Let's go to the next 'ili, the 'Heiau,' and I'll show you."

The fat, conjoined pigs were placed atop large, flat volcanic stones, arranged in a circle throughout the Heiau room. Masked butchers, wearing pink smocks and holding stainless steel knives, mounted the stones.

"This is where we sacrifice the pigs and offer our gratitude."

Anthony watched the butchers carefully carve the pigs. Warm blood dripped down the stone, draining through floor grates.

"We save the blood and mix it with their ground bones and nutrients to use as feed. The cycle of life and death entwined. Every part of the pig, even the tails and ears, are used. Whole pig, artisanal Spam. Nothing wasted. Even the skin is used to make our boots."

Anthony could smell the next ʻili before they reached it. The ʻImu room. A large pit with hot stones. Chefs wearing pink aprons placed the butchered meat into the pit, then covered it with aluminum foil and more stones.

"ʻImu is the name for an underground oven. This is how my ancestors cooked pig. It infuses the flavor with earthy smokiness."

The final ʻili was the "Ipu" room, where the cooked meat was processed, enriched, preserved with natural additives, and hand-packed into BPA-free Spam cans. The special labels read: "The Forever Spam: Hand-Crafted with Aloha in Hawaiʻi."

Dr. Hoʻopilimeaʻai proudly pointed out: "Ipu is a gourd used to hold food, water, and medicine. There's an ʻōlelo noeau, a Hawaiian proverb: *Haumanumanu ka ipu ʻinoʻino, a misshapen gourd makes an ugly container.* It's a warning to parents: be careful with the body of a baby when you mold it, lest it be imperfect."

Anthony closed his notebook, amazed.

"The ipu is also used as a drum in hula." Dr. Hoʻopilimeaʻai smiled. "And I like to think that our Spam will make you want to dance."

* * *

They walked down another hallway to a sizable room with a test kitchen, dining area, sleeping pods, offices, and the most extensive Spam library in the world, with every monograph, dissertation, thesis, novel, short story, poetry collection, and biography ever written about the famous meat.

"I know what you're thinking," Dr. Hoʻopilimeaʻai coyly said. "The ahupuaʻa is amazing, but how does the Spam *actually taste.*"

He grabbed two spoons and two cans of Spam from the kitchen. They sat across from each other at a round table. "These are from the newest batch."

"The can is still warm," Anthony observed as he cupped his hands around it. "I've never had fresh Spam before."

Dr. Hoʻopilimeaʻai whispered an inaudible prayer to bless the food. ʻAmene. When they opened the cans, a scent of porky smokiness wafted through the room. Anthony scooped a spoonful of The Forever Spam into his mouth. Chewed it. Slowly, tenderly. Surrendered his tongue to the fatty miracle. Swallowed, sublime, spamscendent.

Anthony dreamed of hundreds—no, thousands—of Spam Ahupuaʻas being built across the Pacific, Asia, the Americas, Europe, Africa, and the Arctic. Once people eat The Forever Spam, all wars will end, and a new age of humanity will dawn: The Spamocene. The true meaning of "Spam" will be known: *Security Peace And Magic.*

"This is the most delicious Spam I've ever had," Anthony confessed, pieces of The Forever Spam stuck between his teeth.

* * *

From that day forward, Anthony dedicated himself to Spam. He arrived to work early and stayed late into the night studying in the library. He started his apprenticeship in Pō; then, after two months, rotated to the next ʻili. At the end of his first year, he completed the cycle. Everyone, from scientist to chef, adored Anthony. His humility, youthful enthusiasm, and intellectual curiosity were infectious. Conversely, he loved all the people who worked in the Spam Ahupuaʻa. And for the first time, his life had purpose. He *belonged*.

One Friday night, he was reading in the library. Everyone had gone home to their hotel rooms. The first hurricane of the season was blessing the island with rain and wind. Dr. Hoʻopilimeaʻai had assigned him to read a novel over the weekend, *For Whom the Spam Tolls,* by the obscure and underappreciated Chamoru author Craig Santos Perez. Bored by the unrealistic characters and allegorical plot, Anthony started to doze off.

Suddenly, a drop of water fell onto the book. Drip, drip. Anthony looked up to the ceiling and saw condensation forming on the air-conditioning duct. Curious, he left the book behind to follow the duct to the maintenance room. *That's strange,* he thought, *the door is ajar.* He turned on the light. Water was leaking from a ceiling panel. *Maybe I can fix the leak and impress Dr. Hoʻopilimeaʻai.*

He found a flashlight in the tool chest, then positioned the ladder that was leaning against the wall. After he removed the ceiling panel and climbed into the rafters, he heard water trickling. He shined the flashlight in all directions. Nothing. He tried again, slower. *There. What is that?* He moved closer to inspect. He waved away a dense tangle of spiderwebs and found something strange: a small lava tube in the rock wall.

He slithered his body through the wet, dark passageway. The sound of water grew louder. *I must be close,* he thought as a gush of wind moved through the tunnel. *Light. The opening is up ahead. Just one more push.*

He stood up, stretched, dusted off his clothes. He found the source: a majestic waterfall at the back of a massive cavern, made stronger by the hurricane rains seeping through the mountain range. Anthony had never seen a waterfall in person before, so he was too entranced to notice that it flowed into a robust stream, which coursed down the length of the cavern. He did not notice that standing torches were placed along the water, lighting rows of trees, plants, and thatched houses. He did not notice the pond at the opposite end of the cavern, fish glimmering. He did not notice the ancient petroglyphs visible on the cave walls: a story about disaster and resilience.

* * *

"Don't move," a stern voice commanded Anthony from behind. A sharp object pressed into his back. "Who are you? Where'd you come from?"

"My name's Anthony Ñålang," he quivered. "I came from the university."

"Do you have any weapons?"

"What? No. I'm just a student."

"Sit down. Turn off the flashlight." A figure holding a torch and a wooden paddle with shark teeth moved in front of Anthony. He could see only her face: round like the Mahealani moon, brown skin, wavy black hair. Her eyes: kind yet fierce.

"How'd you find us?"

"I was in the library. It started leaking. The hurricane. I found a lava tube. I didn't know anyone was down here. I'm sorry."

"Does anyone else know you're here?"

"No, I'm alone."

"Who's your 'ohana? What island you from?"

"I'm not from here. I'm from Guam. My parents died in the war. I'm an orphan."

"I'm sorry," she said. "You're a long way from Guam, Anthony. How'd you get here?"

"I got a scholarship for the Spam Research and Development Center. Dr. Ho'opilimea'ai's my kumu."

"Did you say Dr. Ho'opilimea'ai?"

"Yes, I'm his apprentice at the Spam Ahupua'a. He's trying to create an Indigenous eco-Spam. He's trying to save the world. It's written in his name: *to be close to the food.*"

She laughed, lowered her weapon.

"Uncle Kimo is a good storyteller. Yes, that's the *literal* meaning of his name. But the kaona describes people who follow the ali'i so they can eat closer to power. He's exploiting our culture for money."

"Uncle Kimo? Dr. Ho'opilimea'ai's your uncle?"

"He's my mom's cousin. My name's Nālani Ho'oulu. Welcome to the underground Waikīkī ahupua'a."

Before he could ask her more questions, she looked behind him and shouted: "No, don't hurt him! He's not . . ."

A blunt object struck the back of Anthony's head. Warm blood. Darkness.

<p style="text-align:center">*　　*　　*</p>

What a strange dream, Anthony thought when he woke up the next morning. *Thank God it's the weekend. I can eat Spam all day, recharge.* He tried to sit up, but grabbed his head in pain. He felt the woven mat against his skin beneath him. Saw the thatched roof above. He realized he was in a hut. In a secret cavern. Under the Ko'olau mountains. On the island of O'ahu. The most isolated place on earth. Far from home.

He stepped outside the hut. A ring of grow lights, embedded throughout the cave walls and powered by hydroelectricity from the waterfall, emanated like small suns to replicate the full light of morning. He tried to take in the entire terraced panorama: along the stream, plants with heart-shaped leaves growing in rows and rows of small wetland plots alongside banana, breadfruit,

mango, coconut, and other tropical trees he had only seen in history books. At the end of the stream, fishermen cast throw nets into the pond. Beyond, Anthony imagined, the stream continued through stone and sediment until it reunited with the trenchant ocean.

"How's your head?" Nālani asked.

Anthony turned to see her sitting on a mat with a wooden board between her legs and a carved pounding stone in her hand. He squatted next to her.

"It's sore. What happened?"

"One of our guards thought you're a spy from Hormel. I told him you weren't, but it was too late. If anyone asks, you're my cousin. I put aloe on your wound and a noni leaf over it. It'll heal. Here, drink this. It's kava. It'll help with the pain."

She passed him a coconut shell with a light brown liquid.

"No, thank you," he said, afraid of being poisoned.

"*Drink,*" Nālani insisted.

Anthony hesitantly sipped the elixir. His tongue tingled and his muscles relaxed. In case he had only a few minutes before the poison kicked in and killed him, he started asking Nālani questions.

"How many people live here?"

"About a hundred kānaka."

"How long have you been down here?"

"Since the war broke out twenty-five years ago. I was only three years old. Our 'ohana came to this cave for shelter."

"Where did all these plants come from?"

"We brought them. Roots and seeds. Shrimp, fish, and pigs. To grow and keep safe. Our kūpuna's canoe crops became our cave crops."

"In school, they taught us that Spam was the last food on earth. Why did they lie to us?"

"Remember, Hormel and Uncle Kimo wrote those textbooks. That's what they want you to believe. So you become dependent. So you never imagine eating anything else. It's Spamaganda."

"How did you find this place?"

"There's a series of other secret tunnels that lead to the surface. I can't tell you where they are. We knew their location from our mo'olelo, our stories."

* * *

"What are those?" Anthony asked, pointing to the heart-shaped leaves.

"That's kalo growing in the lo'i. We cook their leaves and corms. I have some here."

Nālani placed cooked pieces of purple kalo on the board, dipped her left hand into a wooden bowl filled with water, splashed it against the stone pounder in her right hand, then mashed the corms. A fluid, powerful stroke repeated in rhythm.

"This is poi," she said, gracefully twirling two fingers into the puttylike substance and scooping it into her mouth. "'Ono. Try."

Anthony once again hesitated because he had never eaten anything else in his entire life besides Spam. He clumsily imitated the motion she made with her fingers. The texture and taste was

difficult for him to process and describe. He did not want to offend Nālani, whom he was developing a crush on, so he tried to politely articulate what he thought about poi.

"It's definitely not Spam," he said, awkwardly.

Nālani laughed.

"Eat more," she challenged him. "You're going to need your strength this weekend. You're going to work in a *real* ahupua'a."

After finishing the poi, they joined a group in one of the lo'i. He helped them pull up the kalo and cut off the corm and leaves. Then they planted the cuttings, surrounded by mounds of mud, in a different, fallow lo'i.

"It's called the huli," Nālani taught Anthony. "Huli means *to turn*. New corms and new leaves will emerge. A revolution," Nālani said. "See the shoots? Those are 'ohā, offspring. That's where our word, 'ohana, comes from. 'Āina will nurture us for generations."

To show his own knowledge, Anthony replied, "Dr. . . . I mean, Uncle Kimo used the word 'āina. 'Āina means land, right?"

"Yes, but 'āina means so much more," Nālani emphasized. "'Āina is ancestor and relative. 'Āina is sacred. Aboveground, they only care about war, power, and profit. They desecrate 'āina. Here, we aloha 'āina. That's our true kuleana."

<p style="text-align:center">* * *</p>

They worked in the lo'i for hours. Wars continued to rage on the surface of the planet. Countless people died from violence, disease, and starvation. The Spam doomsday clock ticked.

Exhausted, Anthony lay down on a mat by the stream. Nālani sat next to him.

"Mahalo for helping us today," she said.

He nodded, then said with concern: "Dr. Ho'opilimea'ai will be expecting me at the Spam Ahupua'a on Monday. If I don't return, they'll search for me. They might find this place."

"Do you want to go back?"

After a moment of silence, he confessed: "I don't know. I want to stay here longer, learn more about the ahupua'a, about how to aloha 'āina. But I made a promise to Dr. Ho'opilimea'ai. He's been like a father to me." He paused. "What if we join forces? What if the two ahupua'a come together? What if we create a Forever Spam Poi to feed the world?"

"It's too dangerous," Nālani warned. "If Uncle Kimo and Hormel ever discovered us, they'd destroy the lo'i, burn all the kalo. They want to monopolize the food system, control our stomachs. Spam's the perfect weapon of mass consumption."

The grow lights changed color from bright orange to a dusky red, simulating sunset. Some people were picking ripe bananas and mangos for dessert. Others were singing and weaving mats and baskets from coconut fronds. A mother pig nursed several piglets under a breadfruit tree.

"If you decide to leave," Nālani continued, "I trust you'll never tell anyone about this wahi pana, this sacred place. If you stay, you can trust us to care for you as part of our 'ohana. Either way, we have to close the lava tunnel you found. You won't be able to come back."

She dipped her hands into the stream and cupped the water to her mouth. She gathered another handful and offered it to Anthony.

He drank the water from her hands. Cool, rejuvenating. Without the chemical aftertaste of the desalinated, treated, and bottled water he was used to. Without the infusion of Spam flavoring.

"Wai," he said.

"Yes. That's where our word waiwai comes from," she stated. "*Wealth.*"

Children, knee-deep in mud, played in the newly planted lo'i. New 'oha sprouted from the huli, their piko a portal to the future. A group danced hula by the waterfall. The drumming of the ipu echoed throughout the cavern. Nālani did not translate their chanting. Anthony could only make out a few words: *Papa, Wakea, Haloanaka.* He closed his eyes, listened.

"Tomorrow," Nālani whispered. "You have to choose, tomorrow."

Plates 17–21　From Sloane Leong, *Prism Stalker* (Portland: Image Comics, 2019).

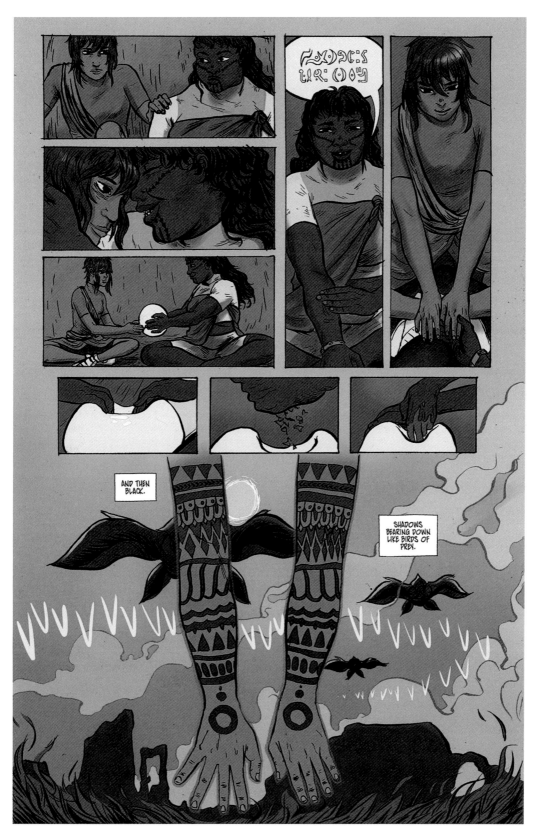

Plate 19

Plate 22 The greedy prince refuses to share with the frigate bird. From *Sina ma Tinirau,* written, directed, and produced by Vilsoni Hereniko, 2021. 2D animation.

Plate 23 The eel hides in shame, waiting for Sina to love him. From *Sina ma Tinirau,* written, directed, and produced by Vilsoni Hereniko, 2021. 2D animation.

Plate 24 Sina defends the eel/Tinirau against her brothers. From *Sina ma Tinirau,* written, directed, and produced by Vilsoni Hereniko, 2021. 2D animation.

Plate 25 Sina kisses the coconut/Tinirau and they lock eyes. From *Sina ma Tinirau,* written, directed, and produced by Vilsoni Hereniko, 2021. 2D animation.

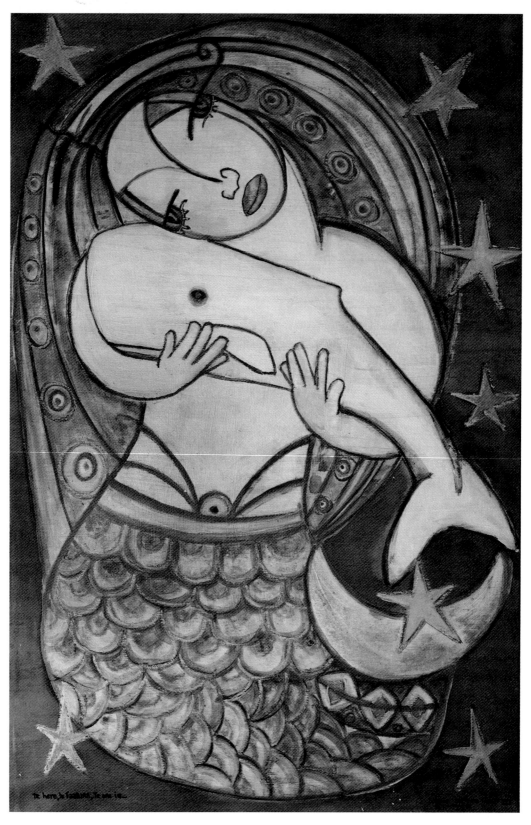

Plate 26 Sarahina Sabrina Birk, *Ia Ora Taaroa, Paraoa Iti ē* (*Greetings Taaroa, Little Whale*), 2020. Acrylic on plywood, 48" × 32".

Ko au tēnei

Marama Salsano

From
the inbetweeness
of earth and sky, Parekohe rises.
Below the shadows of Te Maunga, Ōhinemataroa
weaves and bleeds towards Te Moana-nui-a-Kiwa, then transforms
into waves that navigate Mātaatua, back, back, back, to the banks of Ngāi Tūhoe
where Hamua tend the ahi kā. Within Ruatoki, at Waikirikiri, the Akuhata whānau
rise and mihi to earth and sky. Swirling past Te Urewera, atop Maungahaumi, Paoa's mimi
flows to the ocean, carrying

t
ō
t
a
r
a

to Horouta,
foreshadowing
the aitanga of Māhaki.
Within the marshes of Te Karaka,
Te-whānau-a-Taupara build Takipu
so the calls of the Ruru may be heard
across the plains of Te Tairāwhiti

and beyond

Cyberspace Is an Island in Oceania

A Close Reading of "Te Kuharere Tapes" by @tekahureremoa

Marama Salsano

> Hinepūkohurangi drifted down. Let herself fall like the murmuring stone goddesses who chose to dwell in oceans. She was the taniwha who arrived with the mist and vanished with the rain. The glittery, liquid tresses of the first woman.

Cyberspace is an island in Oceania for Indigenous creatives: a dynamic place where whānau/family can connect, gain nourishment, and channel their realities into the wider networks of our world. In cyberspace, the mokopuna/grandchildren of my ancestor, Hinepūkohurangi, navigate as easily across digital waters as they might the boundaries of our iwi/tribe, or indeed the archipelago of islands that make up Oceania. She (Hine) is the source (pū) of mist (kohu) that descends from the sky (rangi), and along with Te Maunga, Hinepūkohurangi is the progenitor of my iwi, Ngāi Tūhoe—an Indigenous Māori[1] tribe located on the East Coast of the North Island of Aotearoa New Zealand, and from whose shores I choose to read and critique the world. From here, I examine within this essay the Instagram post "Te Kuharere Tapes," in which Ngāti Kahungunu and Ngāti Tūwharetoa storyteller Te Kahureremoa Taumata (2019a)—also referred to as @tekahureremoa—provides an extraordinarily creative and thought-provoking reaction to Pākehā[2] attempts at renaming Indigenous bodies. While twenty-first-century texts published on platforms such as Instagram may not sit easily within a traditional English literary curriculum, and indeed the novelty of these specific forms may well prove fleeting, the "everydayness" of online texts yields rewarding analysis opportunities.

This essay attempts to give thought and expression to my Ngāi Tūhoe whakapapa. Thus, in places where a *ng* might otherwise be written, the *g* has been dropped if it is a term I consciously attempt to use. For instance, "Māoritana" is used rather than "Māoritanga." Any omissions, inconsistencies, and/or misunderstandings may be attributed to this author alone, along with her ongoing research into her Tūhoetana and obligations to learn te reo Māori.

1. Māori: a generic name for the Indigenous people of Aotearoa.
2. Pākehā: a collective term often used to describe descendants of the European treaty partners to te Tiriti o Waitangi—the Māori-language version of the Treaty of Waitangi.

Names Matter!

The epigraph to this essay is an extract from a novel in progress that emerged as I contemplated narratives related to Indigenous names. Māori names, like Hinepūkohurangi, can carry the histories of iwi ancestors, natural and metaphysical places, and important events (Smith 1999; Henare 2001). In summary, Indigenous names matter! When my father was born, his name, Te Marama, was typewritten out of existence. He was recorded as Tamarama instead, and every official document from then on carried this name. And Tamarama may be a beautiful name for someone, somewhere. It just wasn't his name. My mother, on the other hand, was stripped of her name as an adult. When my mother applied for a birth certificate much later in life, the surname of her father, Tautau, was replaced with Hata—who was my grandmother's first husband. Although Hata died before my grandmother remarried and my mother was conceived, according to Births, Deaths & Marriages, Hata had miraculously, perplexedly, fathered a child. My mother's latest birth certificate sees her completely fatherless. One click is all it took to erase my grandfather from existence. One click to connect dead links. One click to replace whakapapa.[3] The renaming of Indigenous peoples, places, and things, along with the associated distortion of whakapapa, has been discussed extensively by Māori scholars, such as Ngāti Awa and Ngāti Porou academic Linda Smith (1999). Similarly, Indigenous researchers like Cherokee scholar Jace Weaver (2006, 6) have linked this renaming to the "colonial process," which "has always depended upon division and the power to bestow names." In Aotearoa, European explorers routinely renamed te ao Māori/the Māori world, and even street names continue to act as enduring reminders of colonial oppressors (Belshaw 2005). Yet, within Māori names lies the world (Henare 2001).

The world of Te Kuharere begins with a name. "Te Kuharere Tapes" (Taumata 2019a) is an Instagram post that comprises one main video or "tape," an accompanying outtakes video or a second "tape," and a written entry. @tekahureremoa (Taumata 2019b, para. 1) describes the character Te Kuharere Taumata as "Brooklyn's finest, baddest most unskilled yet aesthetically ready wrestler." To elaborate on the creation of Te Kuharere, @tekahureremoa (Taumata 2019a, para. 2) writes: "I swear I meet a new alter ego from inside my soul every bloody year. Here's the latest crazy bitch inside me Brooklyn's baddest wrestler TE KUHARERE (inspired by the misspelling of my name in the Levin newspaper). Te Kuharere means 'The flying thigh(s).'" The misspelling of Te Kahureremoa Taumata's name in the *Horowhenua Chronicle* occurred three and a half weeks prior to the Instagram post "Te Kuharere Tapes." Despite the correct spelling of Te Kahureremoa Taumata's name elsewhere in the news article, the following misspelling remained: "On Wednesday 170 preschoolers came to sing songs and hear stories and enjoy the antics of Te Kuharere Taumata who told a story about what heppend [*sic*] if you take a tree from the forest without asking permission" (Baalbergen 2019, para. 8). And although a full discussion of the *Horowhenua Chronicle* article is beyond the scope of this essay, given the negative connotations attached to the description of @tekahureremoa's performance as "antics" (suggesting infantile or foolish behavior), as well as

3. Whakapapa: a multifaceted term that has its roots within the cosmological relationship between Papatūānuku and Ranginui (earth mother and sky father). May be used to describe a person's genealogy, but also wider connections to traditional deities, ideas, and things.

an inattention to spelling in general, it is reasonable to surmise that, from the outset, the author had little inclination to edit meticulously. Interestingly, Taumata chose to name neither the specific newspaper nor the writer in her Instagram post. Instead, @tekahureremoa (Taumata 2019a) made room for Pacific people "inside her soul" to breathe: characters who possess their own mannerisms, diction, and life experiences. Taumata (para. 3) further explains that "everytime my name gets misspelled it's like they invent a whole new person. E.g. Te Kahurewarewa, Tekahureremoana, Taumata Tekahumata, Te Kahureretoa, Kahuteremoa . . . which I don't mind coz these people sound cool af [as fuck]." While colonial renaming is hardly new to Māori and Indigenous people who bear ancestral names, what is extraordinary is @tekahureremoa's whole-bodied response.

Indigenous Bodies

Writing about Indigenous existentialism, Ngāti Pūkenga academic Brendan Hokowhitu (2009, 107–108) states, "Everyday culture and traditional culture must form a composite of an Indigenous sense of self if a healthy Indigenous epistemology is to take hold. For Indigenous people (as with all people) there is nothing more immediate and everyday than the body." Hokowhitu (2009, 116) further considers the extent to which people view the Indigenous body and wonders: "Do we romanticise the Indigenous body as part of the pure-pre-colonial past, scarred and traumatised by the rupture of colonial invasion? Are Indigenous bodies anxiety ridden in the present, lost between the pure past and the impure present, racked by tears over the actions of others upon us? Do we feel cheated of the future? Does the birth of our children lack responsibility; that is, will we pass on to them as part of our bodily 'traditions', the tears of self-pity?" Taumata's (2019a) Instagram post is evidence that not all Indigenous bodies are interested in remaining scarred and traumatized by colonial invasion, including systemic renaming. Nor are we anxiety ridden and lost, nor wallowing in "tears of self-pity." Sāmoan writer Albert Wendt (2009, 98) maintains that the postcolonial body "is a body coming out of the Pacific. Not a body being imposed on the Pacific. It is a blend, a new development, which I consider to be in heart, spirit, and muscle, Pacific." In "Te Kuharere Tapes," Taumata (2019a) constructs an online body who, in heart, spirit, and muscle, is a Pacific body. In the everydayness of @tekahureremoa's world, Indigenous bodies are given oxygen and freedom to exist. They are "cool as fuck" and emerge from the waters of Oceania like never-before-imagined pou[4] that have the power to disrupt colonial publishing structures. Today, yesterday, and tomorrow, "Indigenous people want to tell our own stories, write our own versions, in our own ways, for our own purposes" (Smith 1999, 28). By publishing online, Indigenous artists and composers such as @tekahureremoa can choose to circumvent mainstream publishing channels and write histories that reflect our everyday experiences: "the mundane, habituated, and taken-for-granted daily routines that compose most of Native experience" (Biolosi 2019, 77). In cyberspace, Indigenous bodies have room to breathe.

Commenting on the static nature we sometimes imagine of our ancestors, Tongan writer Epeli Hau'ofa (2001, 23) says, "we've often put our traditions in cages, and so we try to do what we

4. Pou: support pillar for a traditional whare (building).

think our elders, the people in the past, did. And we trap our traditions there. We freeze them." Hauʻofa then asserts that "people in the past really lived very much like people in the present. There were always cultures mixing. Things were fluid, they were not frozen" (23). Similarly, @tekahureremoa—like many Māori and Indigenous artists, composers, and critics of our world—refuses to accept a view of our culture as frozen in the paleolithic past. @tekahureremoa symbolizes modern Māori bodies who acknowledge the fluidity of the waters we inhabit, pay close attention to the meaning and practices of our lives, and are driven to publish our Pacific realities online, on our terms, for our purposes. And it is this move away from mainstream publishing channels and into cyberspace that seems shocking to literati's "white castle" membership (Wendt Young 2019). Writing about her participation in the design of an online writing course in Philadelphia, Sāmoan writer Lani Wendt Young proposed that students be offered guidelines to online publishing. The response, she says, was like ushering in a "zombie apocalypse": "There was a consensus, among the English professors, editors and traditionally published authors (in other words, everyone but me) that by the end of the course, a person would know the basics of writing stories and have completed a portfolio of pieces to continue refining. But publish any of it? No" (11).

At this point, it is important to note that Lani Wendt Young's first book, *Telesā* (2012), was rejected by over thirty literary agents and publishers (Wendt Young 2013). Seemingly in response to this, on her blog *Sleepless in Samoa*, Wendt Young says, "if you are a Pacific writer with a dream to see your work in print—then maybe, self-publishing online is the answer" (2013, para. 4). She elaborates: "I am passionate about seeing more of our Pacific stories taken to a global audience and believe that digital publishing is an exciting avenue to make it happen—it's the fastest, cheapest and simplest way to get our stories to the world. Self-publishing makes it possible for the artist to be in control of every step of the creative process" (para. 2).

Cyberspace thus provides virtual spaces where Indigenous writers can control their own narratives, learn from established writers, and self-publish their work. At the launch of *Telesā*, Samoan and Tuvaluan poet laureate and academic Selina Tusitala Marsh described the novel in the following manner:

> Mills and Boon Pasifika style this novel is not
> it's more than corny romance set to a cliché plot
> it's contemporary mythology so that the next generation
> Relates to our pre-colonial stories in post-colonial fabulation
> . . .
> genealogy and story strung in the integrity of line
> Pacific epistemologies wrapped in passion sublime
> the unexpected plot turns allow our eyes to see
> into the fire's bluest flame of Pasifika sensuality.
> (quoted in Wendt Young 2011, para. 3)

Marsh introduces *Telesā* as an important piece of self-published, Indigenous fiction that points to the richness of English-language literature when written and read through Pacific eyes.

Producing, sharing, and discussing Indigenous work in cyberspace is another avenue for Pacific peoples to "write, paint, sculpt, weave, dance, sing, and think ourselves into existence. For too long other people have done it for us—and they've usually stereotyped us, or created versions of us that embody their own hang-ups and beliefs and prejudices about us. So we have to write our own stories!" (Wendt 2012, para. 45). And, it would seem, subsequently launch these stories into Oceania's waters, on our own terms.

Similarly, despite such ardent gatekeeping, @tekahureremoa (Taumata 2019a) seems uninterested in participating in an industry that is intent on curating Katherine Mansfield-esque slice-of-life stories of "refined" Kiwiana whiteness. Instead, Taumata produces a vibrant account of everyday life in Oceania, and, like many Indigenous creators in cyberspace, she too publishes her work online if, when, and how she chooses.

Everyday Pacific Worlds

In the first, main video of "Te Kuharere Tapes," @tekahureremoa's everyday world is on display from the outset (2019a). Indeed, we first meet the wrestler, Te Kuharere, standing in what appears to be Te Kahureremoa Taumata's living room. Additionally, after several outtake-type shots in the second video of "Te Kuharere Tapes," @tekahureremoa confesses, "Umm, sidenote: the neighbour came to the door while I was dressed up as Te Kuharere fili-filiming-filiming my videos. And it was, you know, it was what it was." Laughter ensues, as does the viewer's understanding that they are witnessing a very spontaneous and intimate snippet of her everyday life. About the production of the videos, Taumata (para. 5) states: "I was already wearing the moko[5] coz I had spent the morning [with] my SWIS [South Wellington Intermediate School] Army. I played guitar 4 their performance at the Intermediate Kapa Haka[6] festival out in Porirua. I could not stop thinking of this the whole drive home to do my next thing. I didn't even listen to music. I just thought about Te Kuharere all the way to Brooklyn." From this recount, it is clear that Taumata's Instagram post is a spontaneous venture. The video production appears to be last-minute: "I had a spare hour" (para. 4), with little prior planning involved: "I was already wearing the moko" (para. 5). Moreover, Taumata chose to create this video rather than eat "i legit skipped lunch to film this" (para. 2) and could think of little else while driving home immediately prior to production: "I didn't even listen to music. I just thought about Te Kuharere all the way to Brooklyn" (para. 5). And it is this immediacy and urgency to create and publish that the white walls of literature fail to comprehend.

Instead, white-castle gatekeepers—those who might find it "disturbing" that there are now "kazillions of people publishing their 13 crappy books online, books that haven't been edited" (Wendt Young 2019, 12–13)—would likely view Taumata's (2019a) Instagram post, or social media platforms in general, as universally "crappy" and "unedited." In the written component to her post, Taumata uses emojis, shorthand slang often used in social media like "coz . . . cool af . . . legit" (para. 3–4), and punctuation and grammar seem optional. But this is also the point of such

5. Moko/moko kauae: traditional wāhine (women's) chin adornment.
6. Kapa haka: a cultural group that practices and celebrates Māori performing arts.

a posting, to post in the moment, with urgency and immediacy. While contemplating the dilution of traditional Māori practices, or tikana,[7] Ngāti Kahungunu and Ngāti Porou constitutional lawyer Moana Jackson (2012, 93) maintains that "our jewelled fantasies are real . . . tikanga will always have strong and resilient roots giving shade to us, and to this hurt and troubled world." Thus, if Māori creatives are steadfast to their iwitana,[8] tikana, it seems, will protect our "jewelled fantasies," and literati "shade" thrown by white-castle gatekeepers (Wendt Young 2019) will not eclipse the taonga/treasures we create. Indeed, Wendt Young (2019, 27) points to the persistent privileging of literary whiteness, but also to the gradual erosion of the castle walls and the terror felt by white-castle gatekeepers who are suddenly confronted by their own irrelevance in cyberspace: "Finally, the digital era is challenging the status quo for what 'quality' literature is and who gets to define it. For so long it has been white cis het males' and then white females' standards of quality control. They decide who gets admitted to the castle and who is rejected. That paradigm is now threatened because anyone can publish. It terrifies those who, for so long, have been used to defining what GOOD means. Today the real gatekeepers are readers. And for many, their standards of quality are a bit different from those in the castle."

And yet, the kupu/word "different" implies that a singular Garden of Eden "standard of quality" exists from which every other standard is judged as "different," and that these differing standards must therefore prove their worthiness. Instead, it is argued here that such standards of quality are merely distinctive to the worlds from whence they come. So, while white-castle standards of quality will likely view @tekahureremoa's Instagram post as diametrically opposed to their own, in reality, the standards of quality within "Te Kuharere Tapes" (Taumata 2019a) reflect the unique world and values, such as immediacy, of social media platforms like Instagram. The paradigm shift Wendt Young (2019) alludes to when reading online texts is a shift to read beyond the only way that English language literature has been presented to Indigenous readers for hundreds of years. Despite the deceptively spontaneous nature of "Te Kuharere Tapes," in just the first few seconds of the main video, @tekahureremoa presents the viewer with an intricately developed world in which the wrestler Te Kuharere Taumata reigns supreme.

"Te Kuharere Tapes"

The first eleven seconds of the main Instagram video show Te Kuharere's first three poses and first three corresponding pieces of monologue (Taumata 2019a).[9] In the video, Te Kuharere is dressed in what appears to be a black, low-cut swimsuit. Red, tartan scarves or pieces of cloth are tied around the top of each thigh, and she wears long, thin, white earrings that resemble bone. Two feathers are inserted into a single topknot on the crown of her head, leaving the rest of her dark hair to cascade over her shoulders. A black band is wrapped around her neck, and the moko kauae on her chin remains from Taumata's previous engagement. In the medium-long shots throughout the video, the character of Te Kuharere stands in the middle of the frame, facing the viewer, with

7. Tikana/tikanga: customary Māori practices.
8. Iwitana/iwitanga: tribal ways of being and knowing.
9. For screenshots of the video depicting Te Kuharere's poses, see www.hawaiireview.org.

much of her face and torso slightly obscured. Fittingly, Te Kuharere's "flying thighs" seem to be highlighted by natural daylight. The first eleven seconds of "Te Kuharere Tapes" represent the diverse public, personal, and professional personas of the fictional character Te Kuharere Taumata.

At the beginning of the video, Te Kuharere comes into frame with an almighty stomp of one foot. Her hands are balled into fists on her hips, and the slightly low-angled shot, along with her erect stature and stern facial expression, suggests confidence and authority. This disposition continues as Te Kuharere stares directly at the viewer and asks brusquely, "Is there a problem here?" (Taumata 2019a). To a Māori viewer, this confrontational opening is somewhat puzzling; where's the mihi/greeting, we ask? However, upon reading the entire post, we recognize that this English-language question contrasts starkly with the frequent use of te reo Māori/Māori language throughout the videos. We thus assume that this rhetorical question is posed to a member of the wider, predominantly Pākehā, public. Te Kuharere's stance further supports this; one hip is positioned higher than the other, almost taunting or provoking a reaction from the viewer. The line is thus drawn. If you have a problem with this first impression of Te Kuharere, scroll on by. If, however, you do not have a problem, ka pai,[10] stay tuned. On this island in cyberspace, there are no passive, voyeuristic observers, only active and willing participants. For iwi such as Ngāi Tūhoe (n.d.), community participation is paramount; one has responsibilities to nurture ties to the land and people, which include learning about our culture, speaking te reo Māori, and actively participating in the permanency of Ngāi Tūhoe life. Te Kuharere's rhetorical question is therefore consistent with broader community expectations of iwi participation and might be read as a wero/challenge for Indigenous viewers to discard colonial thoughts and participate in life on our (iwi) terms. Indeed, Te Kuharere's clothing suggests both the hostile impact that te ao Pākehā/the Pākehā world has had on Māori, but also the demand for autonomy in all areas of a person's public and personal life. For instance, Te Kuharere's necklace is neither associated with traditional tāhei/neck adornment, nor does it seem a sensible ornament for a wrestler (it is after all a choker), yet it is a fitting symbol for Te Kuharere's public persona. That is, while the black choker might very well choke the life from Te Kuharere at some point, she wears it anyway. Both the consequences of wearing the choker and the choice to wear it in the first place are hers alone. Just as @te-kahureremoa's post might symbolize publishing autonomy, Te Kuharere too demands autonomy in her life, and she is willing to accept the consequences of her expression of mana motuhake,[11] dire as they may eventually be.

If the first pose represents Te Kuharere's public persona and demands for mana motuhake, the second pose represents Te Kuharere's personal persona and her grounding within te ao Māori. In the next sequence, Te Kuharere's arms are folded in a manner that is often suggestive of defensiveness in te ao Pākehā. Yet, this stance means so much more. In only a few seconds, Te Kuharere has moved from the Pākehāfied public sphere of her life into te ao Māori, and her stance is indicative of someone who is safeguarding her Māoritana.[12] The monologue Te Kuharere (Taumata 2019a)

10. Ka pai: used in this essay as a colloquial expression meaning "all good."

11. Mana motuhake: often translated as self-determination, responsibility, and autonomy.

12. Māoritana/Māoritanga: a term to describe broad similarities between iwi; expressions and understandings of being and living as Māori.

delivers in this pose is confident and measured: "Tēnā kōutou. Ko Te Kuharere Taumata ahau." Spoken entirely in te reo Māori, Te Kuharere's greeting to all who have chosen to stay ("Tēnā kōutou": Greetings to you all), and the subsequent offer of her name ("Ko Te Kuharere Taumata ahau": I am Te Kuharere Taumata), are clear statements of whakapapa and connection to her Māori viewers and Indigenous allies. Te Kuharere has enveloped her body with tō tātou reo Rangatira[13]—audible expressions of Māoritana. Additionally, Te Kuharere wears traditional Māori adornments such as feathers in her hair, a topknot, bone earrings, and moko kauae (indeed, later in the video, Te Kuharere wields a carved patu/club and strikes several kapa haka poses to the waiata/song "Raupatu" by te reo Māori metal band Alien Weaponry). The feathers that Te Kuharere wears are reminiscent of huia feathers worn by rangatira/leaders, while the extinction of huia birds reminds the viewer of the fragility of our world and how closely the past, present, and future overlap and repeat. When we neglect our responsibilities to Papatūānuku/earth mother, our forests are silenced. And when we neglect our responsibilities to te reo Māori and to each other, so too are our voices silenced. Te Kuharere reminds fellow Indigenous creatives that it is possible to carve out a sustainable existence both in real life and online, and that even in the "jewelled fantasies" (Jackson 2012, 93) of cyberspace, whakapapa can endure. Indeed, rather than relying on the "white castle of literature" for answers, Lani Wendt Young (2019, 35–36) suggests that the digital world can offer Indigenous creatives choice, autonomy, power, participation in literary conversations, and opportunities to critique the white castle: "The digital era means more choice. More power and control in our hands to write whatever we want to, breaking any or all of the literary rules, if that's what our story requires. It means the power to publish and distribute those stories, to have an impact on the conversation. To critique the structures that systematically smother us."

With the final pose, Te Kuharere completes the trinity of her existence. Alongside Te Kuharere's public and personal persona sits her professional persona as a wrestler. Predictably, in line with her chosen career as "Brooklyn's finest, baddest most unskilled yet aesthetically ready wrestler" (Taumata 2019b), Te Kuharere's professional stance and mannerisms are menacing and aggressive. Although Te Kuharere's body stands in the same general position as her public and personal personas, her professional persona has raised arms, and she uses her fingers to create two V symbols on both sides of her shoulders. In this manner, Te Kuharere's limbs emulate serpents. Te Kuharere Taumata thus intertwines te ao Māori and te ao tauiwi/the non-Māori world to transform into Oceania's Medusa of the wrestling circuit. Te Kuharere's monologue in this pose is, "Your local wrestler" (Taumata 2019a). With emphasis on the *s,* the sibilant sounds in this monologue evoke serpentine imagery, while Te Kuharere's clothing further supports her Medusa-like portrayal. That is, the scarves tied around Te Kuharere's thighs not only draw attention to her "flying thighs" and thus her name, but the red, white, black, and yellow tartan coloring of the scarves also conjures up images of festered gashes and pain. The scarves are visual deterrents for Te Kuharere's potential opponents and a reminder to the viewer that Te Kuharere is a force to be reckoned with in the wrestling arena. Taumata presents a character who incorporates wrestling tropes like thematic

13. Tō tātou reo rangatira: the language of our ancestors, our ancestral tongue.

costuming, dramatic posturing such as a stomping foot and balled fists, and aggressively delivered lines: "Is there a problem here?" These theatrics and tropes are recognizable to World Wrestling Entertainment (WWE) followers in Aotearoa New Zealand—many of whom are Māori, as evidenced by Māori Television's decision to present WWE Raw in both English and te reo Māori because "Māori audiences like wrestling (we simply do, not sorry 'bout it)" (Taipua 2018, para. 4).

Adding to this, Taumata's later image of Te Kuharere (2019b) could well be a publicity shot for the wrestler. The photo is well lit and is indeed "aesthetically ready" for promotional purposes. Ironically, in this photo, Te Kuharere's kneeling position on the ground indicates vulnerability, but also strength. That is, Te Kuharere expertly grips a taiaha/spear, sits upright with one hand on her hip, and her legs are spread, martial-arts style. And although Te Kuharere's seated stance with spread legs might nudge at colonial notions of decorum, Te Kuharere will not entertain such ideas. Instead, the wrestler ignores the camera and looks to the side, thus demonstrating her disinterest in the western gaze, while simultaneously exuding confidence in her ability to protect herself. Te Kuharere Taumata is fighting fit with a weapon at hand, and even the self-deprecating assertion that she is "most unskilled" is perhaps a mere ploy to distract opponents from her actual position as Brooklyn's "finest" wrestler.

In summary, from the first eleven seconds of "Te Kuharere Tapes," Taumata (2019a) presents viewers with a character who has little desire to engage with those who choose not to engage with her. In a similar vein, Lani Wendt Young (2019, 22) wonders: "Why should I mourn the supposed decline of an industry that didn't make room for me anyway? A structure that either erases my existence or is directly hostile towards people like me and other marginalised people is not one I want to prop up." Wendt Young further asserts that "a monocultural literature is a problem" (19). But so too is a monocultural, overarching genre that favors the written word over any other form, especially when forms such as "Te Kuharere Tapes" are as evocative as they are fleeting, yet possess the ability to prioritize the lives of Indigenous and minority creatives and viewers. For Pacific peoples, cyberspace allows our everyday realities, or indeed our tīpuna/ancestors, to be recorded, reimagined, or rebirthed. In a keynote address in te reo Māori at the He Manawa Whenua conference, Ngāi Tūhoe scholar Rangi Mataamua states, "Heoi, ahakoa nō hea tātau, ko tātau ko te wai, ko te wai ko tātau" (2017, 5). My translation of this statement is: "Wherever we are from, we are water and water is us." Immediately prior to this statement, Mataamua reminds us of the numerous ways that we are connected to water—i.e., via the waterways, channels, lakes, springs, and oceans that make up the islands of Aotearoa. He then presents the duality of the phrase "Ko wai koe" (5), which is often one of the first statements made when Māori meet. Generally translated as "Who are you?," the phrase, as Mataamua points out, can also mean, "You are water." Humans are physiologically made of water and are connected to water for our survival. Indeed, Indigenous people of Oceania are influenced by and connected to the ocean regardless of our physical proximity to the sea (Hauʻofa 1998). Water flows through the heart, spirit, and muscle of Indigenous bodies; our world is the ocean and the ocean is us. Cyberspace is therefore a virtual island in Oceania that does not need castle moats because—in the words of eminent Pacific scholar Teresia Teaiwa—"we sweat and cry salt water, so we know that the ocean is really in our blood" (quoted in Hauʻofa 1998, 392). As Pacific people, we can choose to dwell in oceans with our tīpuna, vanish

in the mist that descends on our maunga/mountains, or arrive in a rain of zeros and ones in cyberspace. So, let the monocultural castle of literature tremble within its physical walls of same-same-sameness and let digital publishing in cyberspace cast Aotearoa's fleet of storytelling waka into Te Moana-nui-a-Kiwa and beyond. This is the legacy of Te Kuharere's "flying thighs."

Works Cited

Baalbergen, Janine. 2019. "Māori Storyteller Te Kahureremoa Taumata Entertains Levin Preschoolers." *Horowhenua Chronicle*, September 11. https://www.nzherald.co.nz/wanganui-chronicle/horowhenua-chronicle/news/article.cfm?c_id=1503788&objectid=12266769.

Belshaw, K. J. 2005. "Decolonising the Land—Naming and Reclaiming Places." *Planning Quarterly* (December): 7–9. https://www.qualityplanning.org.nz/sites/default/files/Decolonising%20the%20Land.pdf.

Biolosi, Thomas. 2019. "Racism, Popular Culture and the Everyday Rosebud Reservation." *Journal of the Native American and Indigenous Studies Association* 6, no. 1:77–110.

Hauʻofa, Epeli. 1998. "The Ocean in Us." *Contemporary Pacific* 10, no. 2:392–410. https://www.jstor.org/stable/23706895.

———. 2001. "A New Oceania: An Interview with Epeli Hauʻofa." Interview by Juniper Ellis. *Antipodes* 15, no. 1:22–25.

Henare, Manuka. 2001. "Tapu, Mana, Mauri, Hau, Wairua: A Māori Philosophy of Vitalism and Cosmos." In *Indigenous Traditions and Ecology: The Interbeing of Cosmology and Community*, edited by John Grim, pp. 197–221. Cambridge, MA: Harvard University Press.

Hokowhitu, Brendan. 2009. "Indigenous Existentialism and the Body." *Cultural Studies Review* 15, no. 2:101–118.

Jackson, Moana. 2012. "Hui Reflections: The Power in Our Truth, the Truth of Our Power." In *Kei Tua o Te Pae Hui Proceedings: Changing Worlds, Changing Tikanga—Educating History and the Future*, edited by Ani Mikaere and Jessica Hutchings, pp. 87–93. Ōtaki: Te Wānanga o Raukawa and New Zealand Council for Educational Research. https://www.nzcer.org.nz/system/files/Hui%20Proceedings_Web.pdf.

Mataamua, Rangi. 2017. "He Manawa Whenua." In *He Manawa Whenua Conference Proceedings: Indigenous Centred Knowledge—Unlimited Potential*, edited by Leonie Pihama, Herearoha Skipper, and Jillian Tipene, pp. 4–6. Hamilton: Te Kotahi Research Institute. https://www.waikato.ac.nz/__data/assets/pdf_file/0019/321904/HMW-Conference-Proceedings-Inaugural-Issue_FINAL.pdf.

Ngāi Tūhoe. n.d. *Being Tūhoe*. Accessed June 2, 2023. https://www.ngaituhoe.iwi.nz/being-tuhoe.

Smith, Linda. 1999. *Decolonizing Methodologies: Research and Indigenous Peoples*. Otago: University of Otago Press.

Taipua, Dan. 2018. "WWE Superstars go Māori." *The Spinoff*, February 23. https://thespinoff.co.nz/atea/23–02–2018/wwe-superstars-go-maori/.

Taumata, Te Kahureremoa (@tekahureremoa). 2019a. "Te Kuharere Tapes." Instagram post and video, October 6. https://www.instagram.com/p/B3RQWSAp3V-/.

———. 2019b. "Brooklyn's finest, baddest most unskilled yet aesthetically ready wrestler Te Kuharere Taumata." Instagram photo, October 6. https://www.instagram.com/p/B3RQ2gepFIv/?igshid=7z8lzc99oj8g.

Weaver, Jace. 2006. "Splitting the Earth: First Utterances and Pluralist Separatism." In *American Indian Literary Nationalism*, edited by Jace Weaver, Craig Womack, and Robert Warrior, pp. 1–89. Albuquerque: University of New Mexico Press.

Wendt, Albert. 2009. "Tatauing the Post-Colonial Body." *SPAN: Journal of the South Pacific Association for Commonwealth Language and Literary Studies* 62, no. 2:83–101.

———. 2012. "A Pacific Living Legend—Professor Albert Wendt." *Creative Talanoa*, October 15. https://creativetalanoa.com/2012/10/15/a-pacific-living-legend-professor-albert-wendt/.

Wendt Young, Lani. 2011. "A Kind of Sex in the City Meets Hex in the Bush . . . Ancient Mythology Meets Teenage Biology." *Lani Young: Stories from Oceania*, December 17. https://laniwendtyoung.co/2011/12/17/a-kind-of-sex-in-the-city-meets-hex-in-the-bush-ancient-mythology-meets-teenage-biology/.

———. 2012. *Telesā: The Covenant Keeper*. Auckland: OneTree House.

———. 2013. "So You Want to Publish a Book?" *Sleepless in Samoa* (blog), *Lani Wendt Young—Author*, January 25. http://sleeplessinsamoa.blogspot.com/search?q=publishing+online.

———. 2019. "Stories from the Wild: Reading and Writing in the Digital Age." *ReadNZ*. https://www.read-nz.org/advocacy/nzbc-lecture/.

Black Milk

Tina Makereti

The Birdwoman came into the world while no one was watching. It was her old people who sent her, the ones who hadn't chosen to make the transition, who stayed in their feathered forms, beaks sharp enough to make any girl do what her elders told her.

"It's time," they said. "They're ready."

But was she?

There were things the people needed to know. But first she had to make her way into their world. She watched for a long time from her perch, trying to figure the way of them. They seemed so crude and clumsy to her—so slow with their lumbering bodies, their plain, unprotected flesh— no wonder they took plumage from her own kind, or made poor copies with their fibres. Their movements pained her—she would need to slow her own quickness, calm the flutter of wings, the darting of eyes that had protected and fed her all her wild life.

She saw what kind of woman she would be. She could keep some of her dignity if she held her head high, wore heavy skirts that fanned out and trained behind her, if she corseted in the unprotected flesh and upholstered it with good tailoring. A fine tall hat, or elaborately coiled hair beset with stones that caught the light. She had seen women such as this, glided past them on the wind. They saw her too, but didn't point and call out like the children. They saw and took note in silence, sometimes lifted their chins in acknowledgement. She saw spiraled markings on some of those chins, dark-haired women, and thought she could read meaning there. Though this was a rare sight, and though she needed to blend in, she decided she should mark herself this way too, so that the ones who needed to would recognise her.

So she came into the world when no one was watching, only just grown enough to be a birdwoman rather than a birdgirl. Then she moved through the forest to where the people lived. On the outskirts of the settlement, the men saw her first. They removed their hats and looked everywhere but into her eyes, for there was something piercing in her manner that made them uncomfortable. She walked past them towards streets lined with houses, alarmed that without wings the dust gathered itself to her and stayed. How did they stand it, the people with all their gravity and filth?

The women were less circumspect. They looked her up and down from their doorways, and made assumptions about where she came from and what kind of woman she was.

Previously published: Makereti, Tina. 2017. "Black Milk." In *Black Marks on the White Page,* edited by Witi Ihimaera and Tina Makereti, pp. 160–166. Auckland: Penguin Random House New Zealand. (First published in *Granta,* May 4, 2016, https://granta.com/black-milk/.)

"Looking for someone, dear?" called Eloise, who had survived four stillbirths and adopted every stray child in town.

"Perhaps she's in the wrong place," said Aroha to Eloise, loud enough for the Birdwoman to hear. "Are you lost, dear?" Aroha was all right once you got to know her, but she was not an easy woman to get to know.

The Birdwoman thought about how to answer these questions, and the only answer that came to her was politely.

"I am fine, thank you, but I am wondering if there might be a place for me to stay. Can you recommend a house?"

The women were disarmed by her directness.

"Mrs Randall takes in lodgers," said Eloise. "Aroha, take her to Mrs Randall's, will you? I have this lot to account for. No knowing what might happen if I leave them to their own machinations." Eloise was always using words that were too big for the meaning she intended.

Aroha's sullenness couldn't withstand the faint glow that emanated from the Birdwoman. Her hair seemed luminous and so marvellously soft that Aroha wanted to reach out but couldn't, for who knew what protection a woman such as this carried, seen or unseen? She'd never been so close to anyone quite so meticulous and, frankly, shiny. It was only moments before she found herself telling the stranger all the news of the town, including even her most delicious gossip.

There was a reason no one had been watching, the Birdwoman learnt, even though there were sentries on every hill. They were too busy watching each other and their firearms, too busy grappling with the ways of war, which, no matter how many times they went through it, could not be made intelligible. She knew they noticed her strangeness but no one had the energy to concern themselves about it.

Before now, she had only known them as the clumsy ones who took the small and fluttering bodies of her kin for food and feathers, even beaks and talons. And though it had sorrowed her, she knew there was a balance to it. The people called their greetings and gave their thanks, but they hunted. It was an old deal made right at the beginning: her line would be sacrificed to theirs. But the gods gave them two gifts to cope with the hurt—abundance, and a lack of other predators.

She got used to their ways. She helped. There were people to organise and mouths to feed. She kept her clothed dignity, but didn't mind rolling up her sleeves. And time passed. And the wars ended, but then even more people were hungry, and she didn't know if the old ones had been right after all—could she really do anything to help? Her sleeves remained rolled up, and she saw everything that had caused her family to send her to the ground—how they struggled, these landwalkers, her upright naked friends, how they hurt themselves like little children who had not yet learnt how to hold a knife safely or run without tripping.

<p style="text-align:center">* * *</p>

She had been so busy with the people and their wars that she didn't notice until it was done. They never took her hunting, they'd seen her disapproval and didn't want to anger her. But one day they emerged from the forest with empty hands, nothing to offer their children.

"It's the rats," a man said.

"It might be the cats," Eloise nodded toward the friendly feral at her feet.

"It's the white man," this was an old koro who was known to shake his stick and rant about the changing world. "They take them for their museums. Put them under glass to stare at. I saw it when I went over there as a boy on the ships . . ."

"Āe, āe, koro," the young ones rolled their eyes. They'd heard about the ships, the ships. But that was long ago. Before all the wars. The wars hardened them, and made them so tired.

"They trade in them. Take them by the hundreds."

No one wanted to hear this part. No one wanted to believe it. But she heard.

"It doesn't matter what happened to them now. There's none left to take. Haven't seen a huia since I was a boy."

Could it be that she had been gone so long? Could it be that she hadn't noticed the voices of her elders fading? Would she be stuck in this place with these fleshy fools forever? No. They weren't ready. How could they understand the gifts of her kind when they couldn't even restrain themselves or others? All that killing.

So she left, just as swiftly as she had come. She wandered between villages, her anger turned inwards, devoured by her grief. She forgot herself.

It was a dark place she got into. She no longer held her head high, no longer dreamed of the future. Despair sat on her shoulders where her wings should have been. Darkness consumed her, the quivering lip of a dying abalone, grease in the barrel of a gun. Sometimes she did not see or hear any birds for weeks.

Then, one day, she saw him, his great figure hunched so that he looked like one of hers, hair on his head shimmering in the way of the tūī. When he moved, she thought she heard the whispered scrape of feather against feather. He came slowly, in a considered fashion, was heavy limbed, but when he turned a certain way—it was enough.

"Lady," he said, and bowed.

He was a dark-feathered mountain. He was the shape of her nights. He was ink spilt in a pool of oil, volcanic rock, onyx eyes. The black enveloped them. There had been so many long days, she had seen so many things she didn't want to see. Lady, he said, and she liked the way the word curved around her and gave her a place to rest.

They had many children.

She had no time to remember herself then.

"Mother," the children would call, "we're hungry. Mother, we're cold, help us." Their mouths open with constant needs and demands. She was kept busy from the start of the day to the end.

They worked hard together to grow the children. It was easier for her to forget the guilt-ache and shame of where she had come from, how she had let it get so bad, how she didn't help her people. Better to let her children grow up in her husband's world, without the burden of her knowledge. She settled on this as the right path, though her husband would sometimes look sidelong at her, as if considering some puzzle he couldn't figure.

"Wife, sometimes you seem very far away," he said one day.

"I am here, husband, look at me. I am always here." But he was not convinced.

"Yes, your body is here, but I see when you leave. It is like you are up there somewhere."

Even in a marriage, there is only so much you can hide. Or share.

"You can tell me about it, if you wish," he said.

"Sometimes I miss my family, but then I think of the children." That had been her answer. Focus on the children.

It was difficult, then, when one by one the children began to lose their way.

She watched them leave, sooner than she wished, on their own journeys of peril. But when her youngest son showed signs of following the same path, she took him aside.

"There's something I should have told you kids long ago." Her son stooped so that she could whisper in his ear. She told him where she had come from, about her own kind, how there were so few left. Their gifts. The covenant they had had with his father's people. She told him how she had been sent a long time ago, and the telling was like an unravelling of all the things she had seen: the wars and despair, the museums and grief, the long, dark nights and the joy of making children.

"You were hope made real," she told him. And she hoped it wasn't too late, hoped that the knowing would help him, hoped that the story would make him stronger than he knew how to be.

Her boy saw a world that was not what he thought it was. He saw many things that he hadn't known possible before. He only had one question.

"Why didn't you tell us? Why didn't you tell everyone?"

She thought how she should have opened her mouth when she kept it closed. How silence doesn't help anything. But would they have heard her? Maybe she didn't give them the chance.

"Perhaps I should have spoken sooner. Perhaps not. It is time when it is time," she said, and placed her hand on her son's shoulder.

The unravelling of her story was an ending. The darkness came flooding back in. This time it wasn't bleak or hurtful, it was a flash of curved beak in velvet night. Black milk. The depths of Te-Kore-the-place-before-night. More inviting, more liquid than you ever expected black to be. Darkness that holds all of light in it. Home, she thought, and she heard the movement of feathers through air.

Artist Statement: An Interview with Sosthène Desanges

Conducted by *ku'ualoha ho'omanawanui, Joyce Pualani Warren, and Cristina Bacchilega*

What (or who) inspired you to become a writer?

Desanges: Reading.[1] Without a doubt, reading encouraged me to write. Going to a concert is a great night out but it can be a bit frustrating. When you see musicians on stage, you realize playing air guitar is insufficient. You want to learn to play, so you borrow an instrument from a friend and he or she shows you how to play an E note. I became a writer like others became musicians, by trying.

What (or who) are some of your influences for your writing?

Desanges: I read the classics quite late, mostly English authors. I am particularly fond of tales and fables. I love Roald Dahl as an example. However, I was inspired by nineteenth-century literature, when romantic art was at its height. I admire stories where the narrative leads to emotion and where emotion leads to thought. Victor Hugo and Alexandre Dumas are my favorite authors.

What inspired you to write Ash & Vanille? How did you end up conceptualizing it as a five-part series?

Desanges: The south Pacific Ocean is fascinating. It inspires dreams. I wanted to tell what it has meant to me since my childhood. I wanted to talk about the lights, colors, and the epic story of its people who crossed oceans, about this poetic mix of postcard and a harsh reality. And I wanted to do it through a pure adventure story, an initiatory journey in the tropics.

Ash & Vanille is about the ocean gathering people, friendship, and mana. . . .

It is a long odyssey through ancestral imaginary islands. There are so many people and communities to discover, so many characters and the links between them, and so many things that happened to them. A series of five was needed to cover it all.

And above all, the Oceanian (notion of) time is unique. Even if we are talking about a fictitious Oceania, one thing is certain: in this distant era, time was not the same. Time was not punctuated by the metal noise of industry and the madness of modern times. It is a different time.

1. Desanges's responses were translated from French by Laura De La Vega.

It was a time that escaped hours and seconds, vast, mineral, relaxed, and difficult to measure. A time that existed for people from the past.

I wanted to return to the Oceanic way of life and take the time to write this story and for the reader to take their time reading it.

What is your definition of fantasy?
Desanges: Fantasy is a more recent name given to the world's most ancient literature. The Greek Pantheon or the Aboriginal Rainbow Serpent are collections of tales where reality meets fiction. The *Iliad* and the *Odyssey,* the epic of Gilgamesh . . . This is pure fantasy. In France, this literature was considered for a long period only for children.

Yet, perhaps this genre does depict our world, but it acts as a filter on reality that draws colors and emotions invisible to our eyes. You cannot paint a genuine portrait of reality by using the tools within it. You need to put it aside and go beyond. To illustrate war, Picasso painted Guernica, and Tolkien wrote *The Lord of the Rings.* Fantasy is to literature what expressionism is to painting. I see the genre as a genuine and demanding read.

What role do you see fantasy playing in Pacific literature (especially with your work)?
Desanges: Languages remain alive as long as new generations are appropriating, transforming, and transmitting them. If not, they are likely to disappear. This concept holds for stories too. The tales of the imagination are common in traditional cultures of the Pacific; unfortunately, modern times have noticeably weakened (the method of) oral transmission. Many have been lost. Writing is a way to revive a world that is about to be forgotten; obviously it is a sensitive subject, because behind all of this lies the question of cultural identity, which is a complex issue and likely to create misunderstandings.

Regarding *Ash & Vanille,* I did a lot of research for my work. But I'm not a historian. A historian is a scientist, collecting data and checking the accuracy of facts.

A writer concentrates on the nature of emotions and desires to express a vision. I believe a historian serves the past, and a writer the future.

This genre of literature is an effective way to revive myths and legends, to rejuvenate them and allow new generations to adopt them culturally.

How does your fantasy writing counter outside (western) stereotypes of Melanesia or the Pacific? How has that affected who your readers are?
Desanges: It is true, there are a lot of clichés about the Pacific. They often come from the early writing of explorers. Images of cannibals or vahines were shown via movies, and this fueled the imagination of westerners. It is like a postcard of course. . . . But in my opinion, it isn't that bad because clichés are everywhere really. What comes to mind when you think about Egypt, Peru, or China?

Stereotypes of the Pacific are very powerful. However, instead of resisting them, I prefer to utilize them. I try to move the perspective of the reader by giving a soul to "cannibals" and faults to "vahines."

I speak of a Pacific from the past. Yet, despite various works, research, and theories, no one fully knows what the ancestral Pacific was like. As its content became unclear over 200 years. The first evangelists contributed to this loss of memory. We can imagine ancestral history went through evolution and change. It is a black hole for historians. But for writers, obviously it is a blank page to be diligently filled in.

How do Pacific constructions of fantasy speak to broader, global traditions of fantasy?
Desanges: Peoples of the Pacific exist as a collective. Legends clearly show that a cultural unity prevails among all islanders, from one side of the Pacific to the other. Stories found vary little, if at all; they are universal. The Maui legend of the stolen fire secret is found in Prometheus. A tale common amongst all peoples of the Pacific. Apart from Australia, I know of very few fantasy novels that are set in the Pacific. This is possibly due to the fact that the Pacific consists of multiple islands spread over a large area. It is still largely unknown, I believe. Perhaps in the future interest will develop in this part of the world.

Do you see any similarities or differences between Melanesian representations of fantasy and other Pacific representations of fantasy?
Desanges: I am not an expert to answer this question. As in all parts of the world, each has its specialties. I can see a difference in the structure of stories. Where Polynesian tales are complete with a beginning, a middle, and an end, we can notice that in certain Kanak tales there are short-cuts in the structure that conceal part of the story as if it is still a taboo subject. It is as if an element is missing. Without this key point in the story, it is impossible for the uninitiated to understand the meaning. It could be a method to pass on a tale to only those able to understand.

What else would you like people to know about your work?
Desanges: I think these stories are essential. The world was built on stories. We often need to tell ourselves stories to wake up every morning, to keep smiling, and to go out every day. Stories are windows through which we glimpse the possibility of other lives that could be ours. They unite us, they allow us to bond and inspire us. I suggest they can make us better. This is the conviction I write with.

"A Crossing in Dark Waters" from *Ash & Vanille*

Sosthène Desanges

Translated by Peter Rawlingson

Ash plunged into the darkness and disappeared. The others could see nothing, just hear the water close around his body with a sinister sound.

A few moments later, he had passed the last stone outcrop, the one on which a demon-faced turtle had appeared to him. Despite the fright he had felt that day, he was now almost reassured when he thought about it. It was only rock, even if his memory still held the image of that monster.

But once he had left the last outcrops of solid ground behind, he sank into the depths of darkness. The sea opened under him like a gaping mouth, and an unknown anguish embraced him. How far did the night go in these nameless abysses? What beasts still unknown to human eyes were crawling in them? He tried not to think about it. His heart was beating so fast. At the bottom, there were surely some forgotten TO' beings, who were still swarming there. He turned around to try to see his friends . . . Their torch no longer shone. They had gone. Waiiao itself was no longer an island, but a slightly darker spot.

He tried not to think of anything because he felt in his soul that fear could bite him more than any other creature, and that he would then turn around. But alas, his mind hated emptiness, and the questions were like his war club. The further he sent them, the stronger they came back. He tried to imagine what those creatures could see from the depths and he thought that the moon was not favorable for him. His swimming body on the surface was the only thing that disturbed the silence and calm of the sea. He stopped swimming and listened. It seemed to him that he felt movements around him. He had the impression that things were moving, lifting columns of water from the depths.

"You don't have to do what you're doing, son of Nakash. You don't have to!"

In his terror, Kaahl's voice seemed unreal to him.

"I'm just a condemned old bone. I don't care anymore about where I spend my eternity. But you . . . If you have to die, why not choose to spend your last hours in the dry, surrounded by your friends? Why not enjoy your body of flesh and blood once again and the moments that you have

Originally published in French: Desanges, Sosthène. 2014. "Traversée en eaux sombres" [A crossing in dark waters]. In *Ash & Vanille: Les guerriers du lézard* [Ash & Vanille: The lizard's warriors], ch. 17. Noumea: Les Trois Chouettes Éditions.

left? You know this fight is doomed . . . A thousand giants! How can you defeat a thousand giants? No one can do that."

Ash felt his willpower weaken.

"They'll arrive and trample the Clan huts with the children inside. They'll uproot the trees from the mountain where you hunt and turn them into spears with which they'll dislodge the Vaaï like chicks from their nests."

These words slapped him harder than the cold wind that had risen.

"No . . ." he said.

"They'll flatten the forest right up to the Sea Clan borders and nothing that lives there will remain standing. They'll flatten the Fish-Men's stockade and kill them all, even the most valiant among them. . . ."

"No, no . . ." said Nakash's son again. "I don't want to. . . ."

"They'll set fire to everything that grows, and the birds will end up falling from the sky, tired or hungry . . ."

"No, no, no, no!" shouted Ash.

Ash was seized by an invincible anger. An anger that he had never felt before and which seemed to him to come from the depths of time, from Tarsham's era, when "Light was only a child on his knees, between fear and darkness."

He pushed ahead into the open liquid night under him and swam, and swam, and swam, and swam . . . descending into the depths where terror could find secret paths into his imagination. "Nooo!" he shouted again furiously into the faces of the creatures of the shadows. And it seemed to him that he saw them flee and return to the void in which they were born.

Hiti, the Return of the Navigator

Ra'i Chaze

Translated by Mahinatea Shea McCallum

Once upon a time, the island of Tahiti was called Tahiti Nui Māre'are'a, "The Great Tahiti of the golden mist." Tahiti Nui Māre'are'a was a beautiful island with many mountains and hills. Between them were magnificent valleys in which ran streams, rivers, and torrents. At times, she was simply called Hiti. Nowadays, we call it Tahiti.

In the olden days, in memory of their island, the Mā'ohi[1] would carry with them its name during their travels. Several locations used to be called Hiti: Pitcairn, Ra'iātea, Taha'a, and Ma'areva (the Gambier Islands).

In those days, a chief and great Tahitian navigator had left his island with his whole tribe. He had crossed the ocean and had arrived in Hawai'i, where he took the name of Hiti. After some time, he had a son. In memory of his island, he named him Kahiki, which means Tahiti in Hawaiian.

Hiti longed for one thing: to return to Tahiti Nui Māre'are'a. But he would not leave without his son. He knew he had to wait for Kahiki to grow older and gain enough physical strength and learn the necessary navigation knowledge for such a long voyage.

Hiti gathered his tribe and shared his upcoming plan. He offered to whomever wished to to embark with him on the voyage.

"But we must, first of all, get ourselves and our children ready. We must farm the land and allow the children to grow strong and intelligent."

During Kahiki's childhood, the clan enjoyed peace and prosperity. Wherever you set your eyes, you saw banana trees, sugar cane, and taro[2] fields swing in the wind. Pigs and chickens grew in numbers. There were so many children that it was hard to keep track of how many of them there were. They were well-fed, strong, and resistant.

When they became teenagers, the elders started to teach them the art of navigation and javelin throwing. Several of them became bold warriors. They learned to sail along the coast, and to align with the zenith star of Tahiti, also known as 'A'a. They sailed from island to island throughout the Hawaiian archipelago.

Previously published: Mahinatea Shea McCallum, trans. 2021. *Hiti, the Return of the Navigator*. Air Tahiti Nui. Originally published in French: Chaze, Ra'i. 2020. *Hiti, le retour du navigateur*. Tahiti.

This book is the first of a book series about the adventures of Hiti and his crew. The illustration *Encountering the Great Pahua* by Tafetanui Tamatai is accessible at www.hawaiireview.org.

1. Polynesian Natives.

2. Traditional Polynesian staple food (*Colocasia esculenta*); the flower, leaves, stems, and roots are edible.

They were taught about the colors of the seabed: when its color would go from deep blue to green, a coral reef was near. Drifting wood was a sign of a nearby island, floating seaweed revealed a coral shoal. The young sailors learned that clouds colored with emerald or jade green were only reflecting the lagoons of islands still too far for the eye to see. To be a good navigator, you had to observe everything around you, from the birds fishing in the morning and returning at nightfall, showing sailors the way to their island home. Or, how the clouds would have different odd shapes as they got caught at the top of an island, and parts of them fragmented and drifted away with the winds.

The sailing school was led by Hiti himself, helped by all of the aito[3] of the sea who had traveled with him from Tahiti Nui Māre'are'a. Kahiki and the other teenagers had learned a lot from them. But Hiti, most importantly, wanted them to know that navigating successfully could only happen when one is in harmony with nature. The young people discovered that the way to survive on the ocean, as on solid ground, required constant harmonious adaptation to the surroundings, without which the voyage was doomed to fail.

Recognizing the swells became a habit. The ones that were regular, long, and curved had their origin in an island. They knew now that when the stars were hidden by heavy clouds, one had to feel the swell, paying attention to the highs and lows, until the stars would appear again.

The departure day had arrived at last. The double canoes were ready. Food supplies were ready and stored in their assigned space: bananas, sweet potatoes, taro, pigs, and chickens, and also the cooked and bamboo-preserved goods. At the very back end of the canoe, an altar had been built to call onto the Creator.

Hiti was proud of his son, and he was proud of all these children as they had become strong powerful warriors and voyagers. Most of all, he was happy to see how well they lived in harmony with nature on the land. They had traveled short distances between the Hawaiian islands, but the real test was about to happen, on the ocean.

The tribe members who had decided to stay behind had gathered on the beach to say their farewells.

The pahī[4] were now sailing on the great ocean. They followed the coast, and the inhabitants stared at them for a long time. Then, they slowly disappeared on the horizon.

Kahiki got closer to his father. He needed to feel his presence. With his father by his side, he knew all would be well.

Hiti was scanning the ocean, which was slowly becoming as dark as the coming night. Hiti noticed his dad was watching intently a certain shadow under water. A gigantic shadow.

"Father, is it a whale?"

"Indeed it is, as big as a motu, like a tiny island."

"Should we move away from it?"

"We will keep our distance until we know which side is its tail and which is its head. One hit from that tail and the pahī will be shattered. If we remain in front of its head, it will not see us. We must, therefore, sail along beside it."

3. Courageous, brave; warrior, hero, conqueror.
4. Ship, boat, double canoe, traveling canoe.

"There it is, I see its tail!"

In that same instant, the whale hit the ocean's surface with its tail, just like children hit the water to call onto the waves.

"It's a friend. It is calling out to us," said Hiti.

He knocked on the side of the pahī and the whale began to sing. Hiti blew in his pū shell.[5] The whale responded to his call with another song.

"What is it saying, Dad?"

"Listen!"

The young man took a deep breath. He opened his heart to receive the whale's song and listen in his spirit.

"I am your friend. I will escort you all the way to Tahiti Nui Māre'are'a. It is the whale song. It is the ocean's song. It is the song of the rain over the sea. The dolphin and the turtle are my companions."

"Father, I can hear the whale's song. It sounds like a lament, a cry of love. The dolphin and the turtle are its companions. Rain is coming."

Hiti turned his eyes toward the horizon. He saw a pa ua moving across the waters: a dark thick wall of water rising from the sea to the sky, parallel to the horizon. The rain-preceding wind, moved powerfully by the pa ua,[6] was growing stronger.

The night was now dark. One could not see a thing around. The rain and the clouds were hiding all the stars. The seamen were paying attention to the swells and trying to feel their movement. It is the only way to find your way when the sky is hidden. The rain came and the rain left. The night settled quietly, a night without wind or stars. The canoe traveled according to the swells and currents. Watch teams were rotating through the night. Feel the sea. Feel the swell. Feel the highs and the lows.

Morning was almost there when Venus, called in Tahiti Ta'urua horo i te po'ipo'i,[7] stood above the horizon. It is the first star to be seen at night, and the last to be seen before dawn. The navigators knew now her position in the sky.

Not a gust of wind. Only the swell, the currents and the oars were moving the canoe forward.

Kahiki could feel a stronger current than the ones before. He got closer to Hiti and noticed he was paying attention to it. He was listening to it, feeling it, with his whole body, from head to toe.

"This is not a normal current. I think it is the current of the pāhua."[8]

"The giant pāhua?"

All of a sudden, Kahiki saw it:

"Over there, right ahead!"

One could see the top half of the pāhua against the sky while its second half was under water.

5. Sea conch used as a wind instrument.
6. Wall of water that travels across the sea.
7. Venus who runs toward the morning.
8. Tridacna clam.

"The giant pāhua will swallow us just like it swallowed many of our ancestors. Row harder!" yelled Hiti. "Turn around and row the opposite way, as hard as you can, the pāhua is trying to swallow us."

They all hurried to their assigned area. They succeeded at staying in place, but they were losing ground. Hiti was starting to worry, as the current was getting stronger and stronger. He knew the time would come when all would be lost. They would end up swallowed whole by the giant pāhua.

Hiti had forgotten about their companion the whale. He saw it circle the pahī and jump high above water.

Each time it crashed in the water, it would create huge powerful swirls, little by little moving the pahī away from the giant pāhua.

The pahī was finally far enough from the threat for its crew to feel safe. The dolphin jumped with joy. The turtle swam circles around the pahī, raising one of its legs in the air as a gesture of aroha.[9] They were safe!

The trip was going well once more. The sails, swollen with the trade winds, were helping the canoes glide on the slick ocean's surface.

One could hear the world breathe.

The seafarers were enjoying this sweet peaceful time when, all of a sudden, the sun turned dark. What was happening? No one knew what was going on, except for Hiti. He cried out:

"It's the sky monster!"

A huge bird was hovering over the sailors, hiding the sun. Only his piercing eyes, shining like little fires, could be seen.

"This bird can only die at the hand of a warrior from Tahiti. Therefore, all warriors, be ready for the strike."

The dark bird flew down a few times toward the canoes, ripping some sails with its wings, breaking the masts of others. He then chose his prey. Hiti could sense it. It was him or the bird. Only one could become the winner.

The bird was ready to dive straight for Hiti, who was standing tall on the canoe's deck. When the bird came close enough to him, the great warrior thrusted his spear into the bird's throat. Other sailors threw their spears, piercing the bird's wings and his heart. His remains were dispersed on the ocean.

Hiti had given the fatal last blow. But he had gotten hurt also. His eyes had been injured by the bird's beak.

The tahu'a[10] came by his side to bring him healing. Before embarking, the doctor had prepared an ointment made with young yellow leaves from the Tamanu[11] tree to soothe eye pains. It was just not strong enough to heal Hiti. The beak held a poison, and the poison was now traveling through Hiti's body. He was trembling with fever.

Hiti was nearing death, and the tahu'a was powerless. Kahiki was holding back his tears. He had to remain strong. Hearing the dolphin wailing, he looked down and saw that he was not alone. Swimming along him was a whole school of dolphins.

9. Love, compassion.
10. Priest, witch doctor, healer, medicine man.
11. Ballnut or nyamplung (*Calophyllum inophyllum*) tree.

They were swimming really close to each other. The seamen lowered Hiti into the ocean, even though he was feverish. The dolphins surrounded him. For three days and three nights, they carried him, hugged him, talked to him, and moaned along his side.

At the dawn of the fourth day, Hiti was healed. His men helped lift him back onboard, where he rested for another twenty-four hours.

Distracted by their suffering and shaken by the painful events, the sailors had let the pahī drift from its route. No one wanted to worry Hiti as he needed all the rest he could get.

The turtle decided it was its turn to help.

"Listen up, navigators! You must find the rainbow hidden in a cloud; it is through that rainbow that your pahī will reach Tahiti Nui Māre'are'a."

It started to rain and it didn't stop for fifteen days. The sailors did not see one single rainbow. They were soaked and freezing cold.

When it finally stopped raining, Hiti watched the clouds and saw a small blue opening, slowly getting wider.

He searched for a rainbow in a cloud and at last found it. It was small and almost colorless. Hiti set sail toward it. Kahiki noticed seaweed on the ocean's surface and, farther out, he saw clouds. The clouds were in a still clutter. Some were moving forward. It was the island of Tahiti.

The eye could only see clouds, but the ocean landscape had already changed. Hiti observed all the beauty the sea was offering all around him. A sky blue with serenity. A sea of blinding beauty. Winds that filled the sails. The great canoe was gliding on a blue velvet ocean.

"Yes, we are close to Tahiti, he exclaimed."

Loud screeching cries were suddenly heard. Hiti turned around and saw a flock of black birds flying toward them.

It was the sky monster's family. At first, it just seemed like a dark cloud lost in the blue of the sky. But as it was getting closer, he could see huge jagged wings.

Hiti grabbed his spear and yelled:

"We shall fight together. These birds may only be defeated by warriors from Tahiti. We must face them together! They came to avenge their father. Be strong, fearless warriors!"

The sailors were exhausted after weeks of facing storms. They were soaked to the bone. They had had very little rest and were suffering from the cold.

Facing this huge flock of threatening birds was impressive and scary but the men knew they could defeat it. They were Tahitian warriors. They doubled in courage and yelled in unison:

"Not one of us will perish! We will fight until the very end!"

This is how Hiti, his son Kahiki, the aito, and all of the children who had grown up learning their ancestors' ways and art of sailing were able to reach Tahiti, despite all the monsters and obstacles met on this trip from Hawai'i to Tahiti.

They won the battle against the sky monsters. They landed in Tahiti, the island cherished by their fathers. Tahiti Nui Māre'are'a, the Great Tahiti of the Golden Mist.

2140AD

Robert Sullivan

Waka reaches for stars—mission control clears us for launch
and we are off to check the guidance system
personally. Some gods are Greek to us Polynesians,
who have lost touch with the Aryan mythology,
but we recognize ours and others—Ranginui and his cloak,
and those of us who have seen *Fantasia* know Diana
and the host of beautiful satyrs and fauns.

We are off to consult with the top boss,
to ask for sovereignty and how to get this
from policy into action back home.
Just then the rocket runs out of fuel—
We didn't have enough cash for a full tank—
So we drift into an orbit we cannot escape from
Until a police escort vessel tows us back

and fines us the equivalent of the fiscal envelope
signed one hundred and fifty years ago.

They confiscate the rocket ship, the only thing
all the iwi agreed to purchase with the last down payment.

Previously published: Sullivan, Robert. 1999. "2140AD." In *Star Waka,* p. 7. Auckland: Auckland University Press.

Ocean Birth

Robert Sullivan

With the leaping spirits we threw
 our voices past Three Kings to sea—
 eyes wide open with ancestors.

We flew air and water, lifted
 by rainbows, whales, dolphins thrashing
 sharks into birthways of the sea's

labour: Rapanui born graven
 faced above the waves—umbilical
 stone; Tahiti born from waka:

temple centre of the world;
 Hawai'i cauled from liquid
 Fire: the goddess Pele churning

land from sea: born as mountains;
 Aotearoa on a grandmother's
 bone—Maui's blood to birth leviathan;

Samoa, Tonga, born before
 the names of the sea of islands,
 before Lapita clay turned to gourd,

before we slept with Pacific
 tongues. Chant these births Oceania
 with your infinite waves, outrigged

Previously published: Sullivan, Robert. 2005. "Ocean Birth." In *Voice Carried My Family*, pp. 36–37. Auckland: Auckland University Press.

waka, bird feasts, and sea feasts,
>Peruvian gold potatoes,
>>Sing your births Oceania.

Hold your children to the sky
>And sing them to the skyfather
>>In the languages of your people.

Sing your songs Oceania.
>Pacific Islanders sing! Till
>>Your throats are stones heaped as temples

on the shores for your ancestors'
>pleasure. PIs sing! to remind
>>wave sand tree cliff cave of the songs

we left for the Moana Nui
>a Kiwa. We left our voices
>>here in every singing bird—

trunks like drums—stones like babies—
>forests fed by our placentas.
>>Every wave carries us here—

every song to remind us—
>we are skin of the ocean.

The Wind through Stars

Sloane Leong

Previously published: Leong, Sloane. 2019. "The Wind through Stars." In *The Alloy Anthology: Electrum*, edited by Der-Shing Helmer and Kiku Hughes, pp. 169–181. Ascend Press.

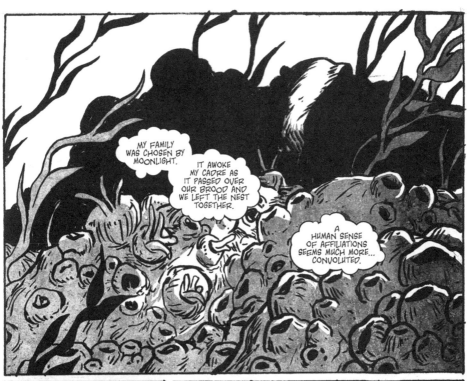

Drawing from the Margins

Speculating Pacific Diasporas across Discipline, Genre, and Form

Joyce Pualani Warren

The tensions and resolutions of the first volume of Sloane Leong's graphic novel *Prism Stalker* (2018) are teased out through the protagonist's encounters with limits: be they corporeal, physical, familial, emotional, or psychological. As Vep, a climate refugee, makes her way across various planets and communities, the text's use of Indigenous speculation places pressure on the reader's understanding of the presumed limits of Indigeneity and diaspora, creating parallels between the physical margins on the page and Vep's transcendence of the limits placed upon her senses and physical body. In both the body of the text and the body of the protagonist, movements toward, within, and beyond the margins come to represent Indigenous defiance of the limits imposed by settler colonial epistemes; in turn, movement, particularly diaspora, becomes a literary representation of Indigenous corporeal resilience and the potential to rework and overcome the discursive and epistemological violence that settler colonial frameworks and their attempts to limit, to literally box in, Indigenous abundance enact.

This essay asks us to consider margins as a site of theoretical and discursive potential in three contexts: discipline, genre, and form. These considerations allow us to speculate what each of these fields might gain from Indigenous revelations and imaginings of what lies beyond the margins. Margins are often thought of as sites of demarcation and exclusion, as boundaries that mark the end or limits of what is constituted as belonging in the center, in the spaces within the margins. But in the context of Indigenous Pacific constructions of wonder and the fantastic, particularly Indigenous speculative fiction, the margins become sites of potential. More specifically, that potential is realized in movements toward, along, and beyond the margins that constitute our understandings of kinship, reconciliation, and sovereignty. What might the discipline of Pacific studies gain if we interrogated the themes and locations that seem to have codified the field over the last half century, and embraced the diasporic peoples and communities that have existed in the margins of academic inquiry? In comics and graphic novels, the marginal space between panels, also known as the "gutter," exists as a liminal epistemological and visual space within which the imaginations of the author and the reader mediate the text's passage of time and space. What might this genre, one with anti-Indigenous and racist roots, gain if we imbued that space between the margins with Indigenous knowledge and theory?

309

The theoretical and discursive potential of movement toward, along, and beyond methods of containment finds an analogue in the historical, current, and future waves of Indigenous diasporas within and beyond the Pacific. Indigenous Pacific constructions of wonder are expressions of knowledge and belonging. Indigenous constructions of the fantastic, the speculative, and futurisms represent living and thriving beyond the boundaries of what settler colonial epistemologies, ontologies, and temporalities deem limits. In this way, diaspora comes to represent Indigenous refusals of settler colonial political, cultural, and literary containment. In the same way that the speculative fiction genre infuses every narrative with boundless possibilities, the lived realities of diasporic communities continually generate new methods of maintaining ties to place-based structures of culture, kinship, and knowledge.

In theorizing diasporic movement as a form of Indigenous resilience, belonging, and abundance, this essay takes a bit of a circuitous, perhaps spiral, journey of its own. Just as Indigenous Pacific peoples are rooted to and routed through our umbilical connections to our various home islands,[1] I write this essay through my diasporic, Black Kanaka Maoli perspective:[2] rooting my argument in the discipline of Pacific studies and its diasporic evolutions, and routing it through observations of Indigenous encounters with the comics genre, to arrive at an understanding of *Prism Stalker* as a literary representation of diasporic Indigeneity as liberatory and affirming.

Diasporic Movements beyond the Margins of Pacific Studies

As Pacific studies has coalesced into a formal field since the mid-twentieth century, formative texts have come from a range of disciplines. A sampling of this array might include Albert Wendt's attention to literature's transformative political and spiritual potential in the field-defining "Towards a New Oceania" (1976), Epeli Hau'ofa's insistence on a nuanced articulation of the intimacies between the region's islands and rejection of settler notions of economic and political dependence and development as represented in his canonical "Our Sea of Islands" (1994), Linda Tuhiwai Smith's revolutionary reframing of the discourse of academic research and knowledge production in *Decolonizing Methodologies* (1999), and Teresia K. Teaiwa's attention to the ways Pacific peoples and environments must navigate the enmeshed imperial legacies of militarism, tourism, and patriarchy in "bikinis and other s/pacific n/oceans" (1994). These and many other foundational texts cover a range of disciplines and themes, attending to the experiences, knowledges, and needs of Indigenous communities as they exist within Oceania.

While the aforementioned canonical texts represent a disciplinary and discursive variety, they all reveal different facets of similar struggles for political independence across Oceania. Pacific studies' disciplinary commitment to expressions of sovereignty is also apparent in Pacific literatures, as Wendt emphasizes that "our literature began and gained euphoric power and mana within and alongside the movements for political independence in our region" (1995, 3). Political independence is woven into the realist and postmodern traditions of Pacific literature, particularly

1. See Anesi et al. (2021).
2. Anesi et al. (2021); Warren et al. (2021); Warren (2021).

in canonical texts: in novels such as Vincent Eri's *The Crocodile* and Wendt's *Pouliuli,* and the poetry of Grace Mera Molisa and Haunani-Kay Trask.

For as much as formative Pacific studies texts have focused on the populations and politics located within Oceania, there has been much attention paid to the dynamism and exchange made possible by the voyaging traditions within the region. The long history of advanced navigational practices and knowledges has been studied in multiple contexts, including Vicente Diaz's work on Micronesian seafaring vessels and technologies (e.g., 2011) and Kealani Cook's study of Hawaiian voyages across Oceania (2018). Alice Te Punga Somerville's *Once Were Pacific* (2012) explores the contours of Māori and broader Pacific kinship through multiple contexts of diaspora within Aotearoa and the Pacific. Tēvita O. Kaʻili's *Marking Indigeneity* (2017) reveals how diasporic Tongan populations in Hawaiʻi both maintain and adapt their understandings of time, space, and community. Katerina Teaiwa's *Consuming Ocean Island: Stories of People and Phosphate from Banaba* (2014) details how colonial capitalist desires led to the removal of Banaba's natural resources and the relocation of its peoples to Fiji. Te Punga Somerville, Kaʻili, and Katerina Teaiwa illustrate the dynamism and resilience of diasporic Pacific populations *within* the Pacific. While both Diaz and David Chang (2016) have used voyaging as a lens to examine Indigenous Pacific experiences with populations in North America, as a whole, the field of Pacific studies has, until relatively recently, paid comparatively less attention to those diasporic communities established beyond the physical boundaries of Oceania.[3]

These twin pillars of *movements toward* political sovereignty and *movements across* our vast moana seem to hold up many of the frameworks that make up the discipline of Pacific studies. Yet, in both instances, disciplinary considerations of these movements seem contained within the physical limits of Oceania. But, what opportunities for political, intellectual, and cultural affirmation and regeneration might we perceive if we acknowledged and interrogated the boundless potential for our diasporic kin and communities to develop the discipline further?[4] Diasporic Pacific women offer us two examples of diasporic kinship and community as a methodology that transcends disciplinary and physical margins to expand the mana of the aforementioned understandings of Pacific studies.

3. A notable exception to this is Diaz and Kauanui (2001). In their introduction to the special issue "Native Pacific Cultural Studies on the Edge," coeditors Diaz and Kauanui employ the metaphors of the edge and the canoe to theorize the relationships between Native, Pacific, and cultural studies. Lea Lani Kinikini Kauvaka's "Berths and Anchorages" (2016) is a nuanced and ambitious engagement with Diaz and Kauanui, and takes up the metaphor of the canoe as a way to recenter conversations of Pacific cultural studies within Oceania.

4. Pacific studies undoubtedly developed in academic and community spaces within Oceania from the mid-twentieth century until the present. Examples of this include programs, departments, and publications rooted in the University of Papua New Guinea, the University of the South Pacific, the University of Hawaiʻi, the University of Guam, and various universities in Aotearoa. Since the late twentieth century, many scholars educated in these spaces have rerooted themselves in institutions and communities in places such as the continental United States, while a subsequent wave of diasporic scholars have come to intellectual maturity there as well. For example, the University of California, Los Angeles, and the University of Utah currently have faculty specializing in Pacific studies across a range of departments. For a discussion of diasporic concerns with and contributions to the field of Pacific Islander studies, see Anesi et al. (2021) and deGuzman et al. (2011).

Diasporic Pacific women have continued to use collaborative methods as a way to center the concerns of diasporic populations, which exist mostly in the margins of Pacific studies. In the pivotal forum "Black and Blue in the Pacific: Afro-Diasporic Women Artists on History and Blackness," Teresia Teaiwa, Ojeya Cruz Banks, Joy Lehuanani Enomoto, and Courtney-Sāvali Leiloa Andrews (2019) push readers to consider diaspora's significance in multiple contexts. They use their embodied knowledges and expertise in literary, visual, and performing arts to center not just the Indigenous Pacific diasporic experience, but also point to the sea as a site of confluence of multiple forms and waves of diaspora. In their consideration of both Black and Blue—African and Pacific—diasporas, the authors reveal the importance of diasporic kinship ties to individuals and communities, as well as disciplines such as Pacific studies, global Black studies, and Native studies.

A second example of this diasporic Pacific women's branch of the genealogy of Indigenous diasporic analysis is the collective Hinemoana of Turtle Island, whose members include Liza Keanuenue Williams, Lani Teves, Fuifuilupe Niumeitolu, Maile Arvin, Kēhaulani Vaughn, and Natalee Kēhaulani Bauer. The collective's online publications range from book and film reviews to discussions of the Indigenous presence in U.S. civil rights struggles. As their name suggests, this collective situates itself as an Indigenous Pacific effort that acknowledges its presence in Indigenous North America. This avowal of Indigenous accountability to the communities and lands on which we reside when away from home is telling, but even more significant is the group's insistence on the diaspora as a site of Oceanic endurance, survival, and vibrancy. Their website notes the U.S. Department of Interior's ongoing attempts to form a potential government-to-government relationship with Kānaka Maoli as a motivator for the site's formation. They declare that this site is, thus, "a space for acknowledging, reflecting on and building other modes of Indigenous recognition in and beyond Oceania."[5] In addition to being a collective comprised of diasporic Indigenous Pacific women then located on the U.S. West Coast, Hinemoana of Turtle Island also connected with Honolulu-based Nolu ʻEhu: A Queer Nesian Creative Collective. Taken as a whole, this site and its publications then position the diaspora as both a wahine and a queer space to imagine, articulate, and encourage Indigenous Oceanic cultural and political sovereignty.

As these two examples show, the late twentieth and early twenty-first century have seen the emergence of a distinctly diasporic thread of contemporary Pacific studies, woven by wāhine who insist on recognizing multiple, overlapping heritages and relationships to people and place. In this tradition, Sloane Leong's *Prism Stalker* extends this arc of diasporic Pacific studies, as its form and content reroot and reroute Indigeneity through its centering of diasporic experiences and concerns, such as climate refugees, language loss, and militarism. As the latter part of this essay will show, these themes are most clearly articulated in moments where Vep, the female protagonist, encounters other women. This embodied understanding of diasporic sovereignty and resilience are all the more significant when one considers how the text's movements beyond margins, forms,

5. "About," More than Two Minutes, https://morethantwominutes.wordpress.com/about/.

and limits is itself a transgression of the marginal position in which the comics genre has histori-
cally attempted to place Indigeneity.

Indigenous Sovereignty beyond the Limits of the Comics Genre

At first glance, the comics and graphic novel forms and their expressions across subgenres such as
the superhero and the space odyssey seem ready-made for Indigenous explorations of sovereign
futures within and beyond the times and spaces of settler/colonial occupation. Each of these cat-
egories, particularly their speculative and fantastic expressions, are often built on their desires for
times and spaces of transgressive potential. And the current visibility of Indigenous authors and
authors of color within the genre, such as Leong, would seem to confirm this. Yet, even in a
moment when publishing powerhouses like Marvel are producing comics series like their *Indige-
nous Voices* and moviegoers are supporting the box office behemoths of adaptations like Marvel's
Black Panther and DC's *Aquaman*,[6] or when DC's imprint Vertigo is responsible for Mat Johnson's
stirring graphic novel *Incognegro* (2008), there exists within the publishing and fandom commu-
nities a deep-rooted, long-standing resistance to Indigenous presence.[7] In this section, I explore
the historical marginalization of Indigenous and people-of-color communities, and emphasize
how Indigenous refashioning of the genre reveals a refusal of settler/colonial limits of not just
genre, but also epistemological understandings of time, space, and sovereignty, which come center
stage in Leong's text.

The comics genre, from which the graphic novel develops, is unequivocally steeped in expres-
sions of white, heteropatriarchal, colonial desires that at best subjugate and at worst erase Indige-
nous and ethnic bodies. In North American contexts, one can look to early comics that define the
white male hero in opposition to his racialized opponent or subordinate. When *The Lone Ranger*
series first appeared in 1948, the titular character was a white man, in contrast to the many con-
temporary sources that now affirm a Black man, Bass Reeves, was the inspiration for this character.[8]
His sidekick, an Indigenous man who is variously Comanche or Potawatomi, is named Tonto. In
Spanish, "tonto" means foolish or stupid, a trait played up in early portrayals of this sidekick in
comics and radio versions. In the same decade, Marvel produced the *Captain America* spinoff
Young Allies (1941), which featured Whitewash Jones, a character in blackface, displaying the
stereotypical signifiers of large lips and eyes, and described as being able to "make a harmonica
talk" and "also [being] good on de watermelon!" While Tonto and Whitewash Jones are racial-
ized tropes caricatured as sidekicks, series like *Batman* created the racialized other as a villain in
characters like the axe-wielding "tricky Chinaman." As these brief examples show, in early North

6. While I applaud the film's use of Oceanic Indigeneity as a way to imagine this superhero, it does at times conflate
and misconstrue various Oceanic communities in service of the film in ways that I, as an Indigenous Pacific person and
scholar, attest need more nuance.

7. See Reid (2014).

8. For an analysis of the historical entanglements of genre and race in this example, see the HBO adaptation of the
graphic novel series *The Watchman* (2019), which opens by rooting Bass Reeves's blackness and heroism in a larger
conversation of racial violence and the massacres of Black bodies in Oklahoma's race riots.

American contexts, the comics genre represents Indigenous and ethnic bodies as problems, as opposition to be overcome in the service of white male colonial domination and the resolution of the narrative.

The comics genre's early representation of Indigenous and ethnic bodies as oppositions to the resolution of white heteropatriarchal desires of fictional worlds has an analogue in the related field of political cartoons, which cast these same bodies as problems to be solved by the erasure of Indigenous sovereignty and the affirmation of settler colonial policies and institutions. During the late nineteenth century, U.S. political magazines and newspapers consistently used anti-Black tropes to caricature Hawaiian monarchs like King Kalākaua, Queen Kapiʻolani, and Queen Liliʻuokalani as infantile, lewd, unintelligent, and lascivious, and therefore unfit to rule Hawaiʻi, leaving the island nation in need of U.S. imperial intervention (Warren 2019; Warren et al. 2021). These same tropes continue to be deployed against Indigenous Pacific people by settler colonial governments well into the twenty-first century. In 2013, Aotearoa publications the *Marlborough Express* and *The Press* included anti-Māori cartoons by Al Nisbet. Nisbet's images portrayed Māori as a drain on the nation's social resources, taking advantage of free-meal programs in schools in order to spend their money on alcohol, cigarettes, and lotto tickets at the expense of caring for their children. These two brief examples show us that the related forms of cartoons, comics, and graphic novels have historically been used to undermine Indigenous sovereignty, especially in the Pacific, and that legacy has continued into the present moment, when these forms have relied on stereotypes to present Indigenous populations as social problems to, in Nisbet's example, be called out and critiqued by the white male gaze and solved by stricter implementation of white settler colonial governmental policies.

These static and limiting representations of Indigenous and ethnic bodies can also be theorized as examples of the comics and graphic novel genre's inherent concern with a static understanding of time and space that rests on Indigenous containment by settler colonial epistemological limits. One of the earlier, field-defining texts, Scott McCloud's *Understanding Comics: The Invisible Art,* draws on Will Eisner's description of comics as "sequential art" (1993, 2). McCloud then goes on to describe six types of transitions between panels, each of which rests upon the sequential, ordered relationship of time and space within and between panels, in order to give the panels meaning. McCloud's text undoubtedly offers a wealth of knowledge of the genre. Yet, as an Indigenous scholar who is invested in understandings of time and space that move beyond linearity, I see this reliance on sequence and order in understanding of the formal elements as an analogue to the previous discussion of the attempts to limit, order, and subjugate Indigenous and ethnic bodies in the content of early texts in the field.

With their reliance on sequence and order to make meaning, comics and graphic novels become the ideal genre to critique and resist settler colonization, which often deploys notions of order and progress to justify the appropriation of resources and the disenfranchisement and displacement of peoples. Indigenous comics creators in North America and Oceania have recognized the potential within the genre to refashion settler epistemological limits of time and space, and adapted it in service of movements toward cultural and political sovereignty. Gord Hill, creator of *The 500 Years of Resistance Comic Book,* sees the genre's privileging of images as a format especially

useful in reaching multiple generations and "rais[ing] the levels of historical understanding" (2010, 6) for Indigenous peoples. As its title suggests, Hill's text attempts to narrate a counterhistory, and to affirm Indigenous presence and agency for over five centuries. Related to Hill's emphasis on recovering agency and rewriting historical narratives, Arigon Starr's *Super Indian* series also rejects settler teleologies of a static and vanishing Native. Volume 1 of *Super Indian* opens with images of a bare-chested, loincloth-clad "mighty Native warrior" whose return and "sacred quest" is "foretold" by "the ancient ones" (2012, n.p.). This gentle yet strong warrior epitomizes the doomed and romanticized Native that American popular culture perpetuates in order to keep Native peoples firmly in the past. Yet, the final text box in the opening page of Starr's series proclaims, "Unfortunately . . . That warrior and his story are told in another comic book." Starr's contemporary, dynamic superhero, Super Indian, is a rejection of the nebulous yet comforting vanishing Native, and an affirmation of Native modernity. Similar to Hill's reclamation of Indigenous agency from settler histories and teleologies and Starr's rejection of static, vanishing, and welcoming Natives, Michael Lujan Bevacqua and Jack Lujan Bevacqua's comic book *Makåhna* draws on Chamorro history and spirituality to trace an arc of Indigenous survival and community from the past to our contemporary moment. *Makåhna*'s ability to remind contemporary Chamorro readers of their connections to Fu'una, the goddess who gave life to Guam's land and people, especially in the wake of decades of settler colonial military appropriation of the islands' land and resources, exemplifies Hill's call for the genre to "raise the levels of historical understanding" for Indigenous peoples. Hill, Starr, and the Bevacquas illustrate that Indigenous comics often craft their own sense of history and temporality, and resist settler colonialism's rigid, linear narratives.

Simultaneous to the rejection of settler notions of time and history within Indigenous comics is the insistence on Indigenous solidarity that moves beyond the boundaries of settler-imposed understandings of space and Indigenous community. As with other literary genres, Indigenous creators of comics and graphic novels navigate across and draw inspiration from global communities and schools of thought. Michael Yahgulanaas's *Red: A Haida Manga,* merges stories and culture of the Haida people, from islands off the coast of what is known as British Columbia, with Japan's manga style of comics and graphic novels. Yahgulanaas's text is a remarkable feat of illustration and storytelling, but beyond that, it attests to contemporary Indigenous art and literature that move beyond the local and have the power to reshape and indigenize long-standing genres and techniques. Global Indigenous encounters within the comics and graphic novel genres can move beyond form and technique, and be found in moments of inspiration, inception, and encouragement. For example, Starr's *Super Indian* series' "humble origins began in a Brisbane, Australia Indigenous Theatre Workshop" (2012, n.p.). Alongside these examples of global Indigenous communities as spaces for encounters and inspirations, we can see within Indigenous comics a resistance to more tangible and cartographic understandings of space. For example, Hill's *500 Years of Resistance* focuses on Indigenous peoples in Canada, but also includes resistance in what would come to be known as the United States and Mexico. This affirmation of Indigenous kinship and resistance across settler colonial cartographic and governmental ideas of space again helps us trace a strand of Indigenous comics that resist settler colonial epistemes.

As these brief examples show, contemporary Indigenous comics and graphic novels indigenize the genre through both their form and content. The result is a strand of Indigenous resistance that embraces movements across time and space, resisting the history of anti-Indigenous and anti-ethnic attitudes that marginalize these writers, readers, and communities within comics, graphic novels, and cartoons, and simultaneously creating a time and space of Indigenous storytelling that exist beyond the boundaries of settler/colonial histories, and making space for Indigenous sovereignties and imagining alternative Indigenous futures.

Drawing from/through the Margins: Diasporic Time and Space

Prism Stalker's refusal of the comics genre's historical location of Indigeneity on the margins is mirrored in the text's refusal of margins within its literal form. The absence of margins and closure between panels produces a uniquely diasporic construction of time and space. Within the text, time and space are mediated by the diasporic Indigenous body, whose identity and history are only fully understood through memories and relationships with land and communities with which that body maintains deep connections even in its absence. While in our world time and distance away from one's homelands—how far or how long one has been gone—can be erroneously viewed as a lessening of one's Indigenous identity, within *Prism Stalker,* Indigenous connections to the land become portable and resilient, flourishing wherever Indigenous bodies endure.

Leong's text unfolds within an Indigenous temporality that is both wholly unique to the fictional world of *Prism Stalker* and in step with actual Indigenous Pacific constructions of time. For Kānaka Maoli and other Pacific Islanders, time is a genealogical construct that is only fully realized through the relationships between humans, gods, and the environment (Kameʻeleihiwa 2009; Warren et al. 2021).[9] Oceania is vast, and its cultures are diverse, with many different understandings of time (see Māhina 2004). Among them is the notion of spiral time, which stands in stark contrast to the linear time of European and American settlers. Taken together, these genealogical and spiral elements produce a temporality that allows the Indigenous body to (re)experience moments across time and space, each iteration producing a slight variation of the ever expanding spiral. These moments of return are represented in the text by Leong's imbuing of the margins, or the gutter, with the potential to find and make meaning that resists the limits of settler notions of time and space, particularly through images of diasporic kinship and community.

From the opening of its first issue, the *Prism Stalker* series disrupts notions of linear temporality and assumptions of an Indigeneity fixed to a particular place. The first pages move between the memories of the as yet unnamed, diasporic, adult protagonist, Vep, as she recalls the home planet of her childhood, Inama. While the panels contain images of a purple, pink, and orange landscape that is nearly indistinguishable from the similarly hued bodies of its inhabitants, the dialogue superimposed across this memory of a homeland comes from Vep's mother, who, along with her tribe, was forced to leave years ago. The rest of issues 1–5 are set in the contemporary moment,

9. For an illustration of the spiral, corporeal, genealogical, and divine elements of time, see Robyn Kahukiwa and Patricia Grace's text and images of "Te Pō" in this collection.

yet the series begins with a memory of home, narrated by a person removed from that memory by a great time and distance. Vep's childhood memories become a new experience now that she is old enough to understand the regret and anguish in the words she hears her mother whisper to an aunt during prayers: "We were cowards once, you and I" (2018, issue 1, n.p.; **Plate 17**). Because the reader is also not yet oriented in the space and time of the text, upon first reading, it is not clear that the events and dialogue of the opening page exist in a different time and place than the rest of the series. As the reader rereads the text, this knowledge is revealed similarly to how Vep's remembering and burgeoning understanding of her mother's words cause her to re-experience her memories of home from abroad. As the text unfolds, it returns multiple times to the tensions around diaspora and Indigenous resistance first introduced by Vep's mother. Thus, the reader's own body and memories become involved in the text's construction of a spiral temporality that centers diasporic, Indigenous bodies as mediators of time and space and agents of resistance.[10]

While the content gradually reveals how Indigenous bodies and temporalities resist the imposition of linearity as a tool of colonization, the form again reveals this from the opening page. In addition to the act of remembering as resistance in the opening, the text resists linear chronology through its absence of page numbers. The only numbering contained in volume 1 is to designate issues 1 through 5; the digital version contains only the required Kindle location numbers, which are not included in the text itself. When asked about the lack of numbering, Leong has noted that she prefers not to number them to allow "for some fluidity with how you perceive the story or sometimes gives the impressions of looping in a way. [*Prism Stalker*] is a very circular story of learning and unlearning."[11] The process of "learning" and "unlearning" is illustrated in moments when diasporic Indigenous bodies, particularly their sensory experiences, push the limits of perception and reality within the text, which simultaneously prompts the reader to question the rigidity of settler colonial epistemes in our own world.

As previously mentioned, the series opens with images of the Indigenous Inaman Sele tribe on their home planet, the coloring of the two suggesting a fluidity between them. This contrasts with the diasporic Vep's relationship to the planet on which she currently resides. There, the natural world becomes a manifestation of the colonial project of surveillance and confinement. Gone is the fluid, nearly symbiotic relationship between people and the environment; in its place is a tenuous, nearly claustrophobic setting. As shown by Vep's crouching body and worried expression as she contorts and climbs along a winding path, here she is often "hunted. Tricked. Trapped" (**Plate 18**). The panels here are arranged to emphasize that confinement, with smaller panels imposed over the larger one, effectively squeezing Vep through their placement above and below her. In addition to the layout of the panels, her physical location is literally beneath one of the captors, who walks along the path under which Vep takes cover to escape surveillance (**Plate 18**). Vep emerges from this moment of hiding and crouching when she meets an older Inaman woman and participates in a ritual that affirms her body's link to the expansive, fluid, symbiotic characteristics of space on Inama (**Plate 19**).

10. For an understanding of the term, see DeLoughrey (1999).

11. Correspondence with author, May 21, 2020.

In this ritual, the Indigenous body becomes a medium for storytelling, remembering, and resistance, through its unique ability to remain tied to its homelands even in the diaspora. The two embrace each other and the older woman uses materials Vep has gathered to prepare a richly pigmented mixture evocative of the warm purple and coral hues of Inama (**Plate 17**). This mixture is used to record Vep's story and memories of home, displacement, and resilience. The ritual takes place in eight similarly proportioned panels on the top half of the page (**Plate 19**). These panels are laid over a larger image that comprises the entire page: Vep's arms as they exist on the current planet, but superimposed over her childhood memory of the day their captors came and took her tribe from Inama. The gutter, the space between the panels of the contemporary time and space, is filled with the potential, kinship, and endurance of another time and space, the past upon which these panels are layered. Even across the time and space of diaspora, Vep's arms seem to blend into the natural world of Inama within her memory: the purple grass seeming to spread beneath her splayed fingertips, the orange of the sky complementing the warm tone of her skin. Her childhood memory of their captors is also articulated in images of nature; without a reference point for the unnatural vehicles in which they traveled, she remembers thinking the captors arrived on something akin to "birds of prey," resulting in large avian figures looming in the sky (**Plate 19**). This Inaman practice of corporeal storytelling appears similar to the Polynesian art known variously as tātau, kākau, moko, or uhi. Motifs that replicate the natural world are placed on the body in order to tell a story and to affirm kinship ties to people, places, and environment. The yellow *v*'s stretching across the horizon are mimicked in the geometric shapes on Vep's arms; the curves placed near the crooks of her elbows are reminiscent of the wings of the birds in the sky; the circles on her hands are similar to what looks to be a green sun; and even the rich purple pigment is redolent of the purple grass just beyond her fingertips.

The tactile, visual, and dynamic elements of this corporeal storytelling function as a form of intergenerational resistance toward diasporic language loss. Adult members of the Sele tribe, who likely remember Inama and the events of their removal with more clarity than Vep and her contemporaries, are now "quarantine[d]" away from the youth like Vep, who is told it is "important for [her] social health to move beyond [her] base traditions" (issue 1, n.p.). While these bearers of language, history, and culture are effectively silenced as an imperial form of Indigenous erasure, the younger generation simultaneously speaks its own form of silence. Vep and other imperial subjects are forced by the Sverans to "sing" to their captors' eggs as part of the birthing process— a job deemed too dangerous for the already dwindling Sveran population to perform. Vep observes that while the Sverans "kept us from our mothers. Now our family language is broken," they also used that silence to perpetuate the project of imperial expansion as the next generation of Sverans "grow fat off our stolen voices" (**Plate 20**). Thus, her observation that "snaring a tongue is a clever trap" refers both to the confinement of the older speakers of the Inaman language and the forced labor of the younger generation (**Plate 20**). The storytelling ritual Vep undergoes now functions as a method of intergenerational resistance of silence and of recovery of multiple forms of Indigenous agency and voice. While the Inaman language may now be "not much more than soothing sounds" to Vep, her body's pictorial telling of the Sele experience comes to stand in for the absence of oral and aural understanding (**Plate 21**). The ritual becomes a way for the older woman to

speak and for Vep to understand, even if no words are spoken. Her body thus becomes a site for Indigenous storytelling that affirms connections to land and community, effectively circumventing the time and space of captivity and erasure.

This ritual is not simply the replication of a practice from their homeland, but a diasporic iteration that incorporates and modifies traditional elements to produce a new way of understanding and perpetuating Indigenous relationships and identity across time and space. Vep recognizes and to some extent understands, but does not necessarily speak, the Inaman language. During the ritual, the older woman speaks to her in Inaman, which is represented in the text by blue glyphs that are differentiated from the standard English used by Vep and others. The textboxes that narrate Vep's memory of that day and also the images on her arms are rendered in what appears to be a common language, represented in the text as standard English. In addition, the motifs on Vep's arms are richly hued, gradated, and temporary, where some older Inaman women such as the one in the ritual appear to have more permanent, dark, monochromatic markings consistently placed across their cheeks, noses, and chins. Vep's markings are not a reproduction of the glyphs of the Inaman spoken language, nor the predominantly triangle-shaped markings of the older women. Instead, they incorporate both: curves and circles placed alongside the more angular and geometric shapes. Vep's body tells the story of the events that triggered her people's diaspora, while the motifs may reflect the diasporic adaptation necessary to continue to remember and resist the colonial force behind those events: she doesn't have access to the plants of her homeland, but finds something suitable and still manages to tell the story of her continued tie to that homeland. In telling the story, she remembers and perhaps relearns some things, but also rearticulates them through a multilingual form that is only possible through the resilience of her diasporic body and its adaptation and affirmations across time and space.

Speculative Movements and Diasporic Futures

With its attention to the potential beyond the margins of discipline, genre, and form, a significant portion of this essay has been dedicated, unavoidably, to discussion of the historical and discursive construction and maintenance of those margins. Yet, in closing this essay, I allow myself the room to speculate and imagine how those intangible margins, which contour so much of our lived and remembered existences and realities, may be overcome by, paradoxically, returning to and sifting through them. What functions do those margins actually perform? Are they truly as rigid and narrow as we are led to believe? What speculative potential might we encounter if we viewed those margins not as linear sites of demarcation and exclusion, but as spiraled paths along which we might travel as we backed into futures that moved not between but beyond the ideas of an Indigeneity fixed in time and space? Leong's tale is set in a speculative future in a time and space beyond the Pacific, but the realities of her protagonist's existence are eerily similar to our own. She is an Indigenous climate refugee forced into the diaspora, compelled to join a military-adjacent institution and become an agent of colonization of other peoples in order to provide a better life for her family, all the while experiencing the traumas of language loss and eroding kinship ties. Vep's story is that of countless contemporary Pacific Islanders. And like her,

many of us are fighting to maintain our sense of self and community by looking to both the past and the future.

In keeping with the idea of looking to the past to guide our movements into the future, I close this essay with questions similar to those posed in its opening. What would it look like for Pacific studies to focus on the diaspora? What might we, as a discipline, but more importantly as a people, gain if we thought of diasporic futurity? What new understandings of the formal aspects of comics and graphic novels might be revealed if more readers and creators recognized the speculative and transgressive potential contained within and beyond the margins and other in-between spaces carved out in Indigenous and diasporic texts? Rather than thinking of diasporic Pacific Islanders as those who are no longer rooted to the lands, waters, and skies of their homelands, we should recognize them as fecund offshoots making roots in new times and spaces. And revealing routes for Indigenous futures comprised of cultural and political sovereignty. In each of these contexts, and many more, the margins come to represent not the realities of confinement and exclusion, not the lack of a connection to an ever-receding time and space, but the limitless, dynamic potential that is found only in the many movements that produce diasporic abundance.

Works Cited

Anesi, Juliann, Alfred P. Flores, Brandon J. Reilly, Christen T. Sasaki, Kēhaulani Vaughn, and Joyce Pualani Warren. 2021. "(Re)centering 'Pacific Islanders' in Trans-Pacific Studies: Transdisciplinary Dialogue, Critique, and Reflections from the Diaspora." In "Interventions in Pacific Islands Studies and Trans-Pacific Studies," special issue, *Critical Ethnic Studies Journal* 7, no. 2. https://manifold.umn.edu/read/ces0702–12/section/85160da6-fa3d-4025-b43f-edf8244d4c3c.

Chang, David. 2016. *The World and All the Things upon It: Native Hawaiian Geographies of Exploration*. Minneapolis: University of Minnesota Press.

Cook, Kealani. 2018. *Return to Kahiki: Native Hawaiians in Oceania*. Cambridge: Cambridge University Press.

deGuzman, Jean-Paul, Alfred Peredo Flores, Kristopher Kaupalolo, Christen Sasaki, Kēhaulani Vaughn, and Joyce Pualani Warren. 2011. "The Possibilities for Pacific Islander Studies in the Continental United States." In "Transoceanic Flows," special issue, *Amerasia Journal* 37, no. 3:149–161.

DeLoughrey, Elizabeth. 1999. "The Spiral Temporality of Patricia Grace's *Potiki*." *ARIEL: A Review of International English Literature* 30, no. 1:59–83.

Diaz, Vicente M. 2011. "Voyaging for Anti-Colonial Recovery: Austronesian Seafaring, Archipelagic Rethinking, and the Re-Mapping of Indigeneity." *Pacific Asia Inquiry* 2, no. 1:21–32.

———. 2016. "In the Wake of Matå'pang's Canoe: The Cultural and Political Possibilities of Indigenous Discursive Flourish." In *Critical Indigenous Studies: Engagements in First World Locations*, edited by Aileen Moreton Robinson, pp. 119–137. Tucson, University of Arizona Press.

Diaz, Vicente M., and J. Kēhaulani Kauanui. 2001. "Native Pacific Cultural Studies on the Edge." *Contemporary Pacific* 13, no. 2:315–342.

Hau'ofa, Epeli. 1994. "Our Sea of Islands." *Contemporary Pacific* 6, no. 1:148–161.

Hill, Gord. 2010. *The 500 Years of Resistance Comic Book*. Vancouver: Arsenal Pulp Press.

Ka'ili, Tevita O. 2017. *Marking Indigeneity: The Tongan Art of Sociospatial Relations*. Tucson: University of Arizona Press.

Kame'eleihiwa, Lilikalā. 2009. "Hawai'i-nui-akea Cousins: Ancestral Gods and Bodies of Knowledge Are Treasure for the Descendants." *Te Kaharoa* 2:42–63.

Kauvaka, Lea Lani Kinikini. 2016. "Berths and Anchorages: Pacific Cultural Studies from Oceania." *Contemporary Pacific* 28, no. 1:130–151.

Leong, Sloane. 2018. *Prism Stalker: Volume One*. Portland: Image Comics.

Māhina, 'Okusitino. 2004. "Art as *tā-vā* 'Time-Space' Transformation." In *Researching the Pacific and Indigenous Peoples: Issues and Perspectives*, edited by Tupeni L. Baba, 'Okusitino Māhina, N. Carmago Williams, and Unaisi Nabobo-Baba, pp. 86–93. Auckland: Centre for Pacific Studies, University of Auckland.

McCloud, Scott. 1993. *Understanding Comics: The Invisible Art*. New York: William Morrow.

Reid, Robin Anne. 2014. "'The Wild Unicorn Herd Check-In': The Politics of Race in Science Fiction Fandom." In *Black and Brown Planets: The Politics of Race in Science Fiction*, edited by Isiah Lavender III, pp. 225–240. Jackson: University Press of Mississippi.

Smith, Linda Tuhiwai. 1999. *Decolonizing Methodologies*. Otago: University of Otago Press.

Starr, Arigon. 2012. *Super Indian: Volume One*. West Hollywood: Wacky Productions Unlimited.

Teaiwa, Katerina. 2014. *Consuming Ocean Island: Stories of People and Phosphate from Banaba*. Bloomington: Indiana University Press.

Teaiwa, Teresia K. 1994. "bikinis and other s/pacific n/oceans." *Contemporary Pacific* 6, no. 1:87–109.

Teaiwa, Teresia, Ojeya Cruz Banks, Joy Lehuanani Enomoto, and Courtney-Sāvali Leiloa Andrews. 2019. "Black and Blue in the Pacific: Afro-Diasporic Women Artists on History and Blackness." *Amerasia Journal* 43, no. 1:145–192.

Te Punga Somerville, Alice. 2012. *Once Were Pacific: Māori Connections to Oceania*. Minneapolis: University of Minnesota Press.

Warren, Joyce Pualani. 2019. "Reading Bodies, Writing Blackness." *American Indian Culture and Research Journal* 43, no. 2:49–72.

———. 2021. "Blackness Is Life in Hawai'i and Oceania." Mauna Kea Syllabus Project. *Hawai'i Review*, July 31. https://www.maunakeasyllabus.com/.

Warren, Joyce Pualani, Keith Camacho, Elizabeth DeLoughrey, and Evyn Lê Espiritu Ghandi. 2021. "Genealogizing Pō: The Relational Possibilities of Blackness in the Pacific." *Ethnic Studies Review* 44, no. 3:7–16.

Wendt, Albert. 1976. "Towards a New Oceania." *Mana* 1, no. 1:49–60.

———, ed. 1995. "Introduction." In *Nuanua: Pacific Writing in English since 1980*, pp. 1–8. Honolulu: University of Hawai'i Press.

Artist Statement for "Padil o (the Paddle)"

Emelihter Kihleng

> I call upon Soumadau en Sapwalap, Soumadau en Sokehs, ngehi kadkadekedek kohla, break out and don the sturdiest of the te otanga (I-Kiribati warrior costume), take the strongest, most solid-looking war club (there are hundreds of them) and recite a ngihs, then smash open the crates, one by one, freeing the ancestors.

In 2019–2020, I served as the inaugural curatorial research fellow for Oceania at the Museum am Rothenbaum—World Cultures and Arts (MARKK) in Hamburg, Germany. As part of the museum's "major repositioning and decolonization process," the fellowship was intended for an emerging scholar, preferably from former German colonies of the Pacific, to conduct archival research on the Hamburg South Seas Expedition (1908–1910) collection and connect this research to their "origin society," which, for me, is Pohnpei Island in the Federated States of Micronesia.

On one of my first trips to MARKK's off-site storage facility, I expected to see some of the dipwisou kesempwal, precious things, up close and personal, but was told that most, if not all, of the objects on my long list taken from the illustrated index cards were inaccessible and may no longer exist. I was also informed that many of the objects burned in a fire during WWII. I went into the bathroom and cried. I cried for our lost heritage, for broken expectations and hopes, for mehn Pohnpei. On that same day, I kept scanning the shelves filled with "objects" from throughout Oceania and saw a padil en kepir, a dance paddle, from Pohnpei, without an inventory number. I sensed that it felt my presence, called out to me, and I later wrote "Padil o" about this discovery.

My visits to the storage facility brought out many emotions. I felt anxious, profoundly sad, and angry. While I felt privileged to have the opportunity to see my heritage from Pohnpei up close, something most Pohnpeians will never get to do, I was also somewhat scared. I was afraid to reawaken their feelings, their spirits, which, after a hundred years of isolation, away from their kin, their peneinei, their keinek, must have made them numb. The dipwisou kesempwal had allowed themselves to become mere "objects" as a means of survival. I was afraid to reawaken them when I knew that I would eventually leave them behind. Like cherished family members, I didn't want to spend too much time with them, to love and become attached to them knowing I would have to abandon them and subject them to the pain of becoming "objects" again.

I became enraged by the cruelty of colonialism and its legacy, the futility and insincerity of efforts to decolonize within museum structures and staff, and the blatant way in which storage

facilities remain behind-the-scenes showcases of forsaken imperial loot. I imagined myself as an "object," new to the museum, homesick, foreign, craving affection, and then being left on a shelf—or worse, in a crate, with other lonely "objects" from other islands also far away from home. I kept myself afloat through fantasizing about truly decolonizing the museum, saving the ancestors, setting them free to wreak havoc on our former colonizers, to dance, feast, sing, and find their way home.

Padil o (the Paddle)

Emelihter Kihleng

first time at Fischbek
Jeanette and I comb through the aisles
packed and piled high with objects
Ozeanian
precious, rare, many
horded, stolen, purchased
gifted even . . . lonely
oh so very lonely
isolated, surrounded only by dust
other lonely canoes, bowls, baskets
spears, more spears, fish hooks
missing the caress of Island hands

collected objects
some in crates
some somewhere
burned in the fire
most MIA
undocumented objects

we look through drawers
Tapakiste 1 and 2
Kleidmatte für Männer from Fais
Kleidmatte from Truk
Kleidmatte für Frauen from Santa Cruz
we look at the Regale
I see your nting
recognize your designs
we are kin
you without a number

like the Lien Rohnkitti without a name
you called my name
and led me to yours, a title
Joumadau
Soumadau
Soumadau en Sapwalap
your nting carved into black painted
breadfruit wood
whitened with lime
dated Mei 1910
Not (Nett)

when you arrived at this museum
you had a fellow padil, now lost
you must have been in mourning for years
did you smell me coming?
ready to pick you up
and dance with you again.

Artist Statement for *Sina ma Tinirau*

Vilsoni Hereniko

I first heard a version of this story when I was a young boy growing up on Rotuma, Fiji, where I was born and raised for the first sixteen years of my life. My father was an avid storyteller and told me many folktales (what were called myths and legends then) that fired up my imagination.[1] His oral tales sustained me, kept my hungry imagination fed, and made me dream of a life more interesting and fulfilling than the one I was living. Unlike the romantic view that life on a small Pacific island was like living in paradise, my reality was the opposite. As the youngest of eleven children, I was often hungry. There were times when I was so hungry I thought I would die. Our main source of protein was the ocean, but the fish there had to be caught. With no supermarkets anywhere, feeding a large family with three decent meals a day was not an easy task. Coconut flesh saved my life many a time, as did coconut water. For me then, the coconut tree, especially its coconuts (which Rotumans, like Hawaiians, call niu), was indeed the tree of life.[2]

On the internet, one can see several versions of *Sina ma Tinirau*,[3] often titled *Sina and the Eel* or similar.[4] Also, there are several written versions of this tale with similarities and differences. In

1. I pay tribute to the influence of my father's storytelling on me most keenly in the opening scene of my narrative feature film *Pear ta ma 'on maf: The Land Has Eyes*, which can be seen here: https://vimeo.com/531376357. I should also add that the scene of the protagonist's father being hauled before the western court on the island for the alleged charge of stealing coconuts is based on an actual incident that happened to my father. Of course, he was innocent!

2. Apart from the animated short film on the origin of niu based on this screenplay, I have recently completed another short film called *A Niu Way* (2021) that was commissioned by PIC (Pacific Islanders in Communications) about how the pandemic enhanced my interest in niu and caused me to weave baskets using coconut leaves again, as well as become an advocate for niu as a food and water source in Hawai'i. I am therefore working with three Hawaiian directors to make a documentary on cultural practitioners and their relationship with niu in Hawai'i. I'm also a cofounder of NIU NOW!, a growing movement to promote the return of niu culture in Hawai'i. *Sina ma Tinirau* received funding from the European Research Council (ERC) Starting Grant No. 803302, Indigeneities in the 21st Century.

3. For Rotumans, Sina was a very beautiful woman, especially in legends and songs. See Churchward (1940, 311). A very handsome man, Tinrau or Tinirau, was much used in poetry and legends as the proper name of the prince or hero. See Churchward (330). Variations of these two names, such as Hina or Tinilau, can be found in several other Polynesian languages and cultures.

4. I also wrote a version of this oral tale as an illustrated children's book titled *Sina & Tinilau*, which was published in 1997. When Bess Press in Honolulu was interested in reprinting this book in the 1990s, after I moved from Fiji to Hawai'i, a reviewer killed this project by saying that my version was not authentic because it was not the original version. Epeli Hau'ofa (2008) calls this "history beginning with the arrival of Europeans," and, may I add, beginning with the written word. The so-called original version is always the one that was first written down, and of course almost always by a non-native person. What happened before this, when stories were passed down orally? Were they fossils, unchanged by teller, time, or context?

some versions, the eel is a Fijian prince and therefore darker skinned than Sina, a name that means "white" in Samoan but implied in Rotuman. Growing up on Rotuma, I was aware that those with fair or light skin looked down on those with darker skin. In the 1950s and right up to the 1980s, Rotumans believed Fijians were an inferior race. In fact, when one of my brothers married a Fijian, my mother disowned him. And when I wanted to marry a Fijian, a sister with whom I was close to bawled her eyes out.[5] How could I bring shame to the family, she wailed! For her and those of her generation and older, marrying a Fijian was humiliating! Fortunately, things have changed today: so many of my nieces and nephews are now married to Fijians. They have many children who are part-Rotuman and part-Fijian. And they move easily from one language and culture to another.

I do not believe that we can point to any specific version of this tale and claim it to be the original, and that any version that deviates from that is false.[6] Just because a version had the benefit of having been written down or made into a short film does NOT mean that there weren't other versions circulating before it. We would never know the date when the first oral telling actually took place. And maybe we should not want to know, because what is important is not who told it first, but the enduring truths about the human condition that are hidden in the narrative. These truths we should keep, even as we develop the characters and deepen their connection to each other as well as the natural and supernatural world they inhabit. This is what I have done in this version. This is the reason for a beginning and an ending that cannot be found in any other version.[7]

Why is a man cursed to become an eel? This is a question that versions on the internet do not answer. In my version, it's because he is overfishing the lagoon, taking more than he needs. This is a lesson on conservation that needs heeding. When I was on Rotuma five years ago, the lagoon in front of my house there had hardly any fish. People have become selfish, greedy, thinking only of today, and not tomorrow.[8] In all existing versions up to this point, the story ends once the coconut tree (the gift) is realized. My version frees up the man in the tree. It also challenges Sina to see beyond and beneath looks, the color of skin, and to love unconditionally. In the past, Polynesian

5. My plays *A Child for Iva* and *Sera's Choice* (1998) are about racial prejudice, by Rotumans against Fijians and by Fijians against Indians, respectively. This is a theme that continues to be of interest to me.

6. Also see an interview with Albert Wendt (Wendt and Hereniko 1993), where he agrees with this sentiment.

7. I have always wondered why no explanation was given in any of the versions as to why the prince was cursed to become an ugly eel. Also, ending the story with the coconut tree does not resolve the relationship between Sina and Tinirau, and I wanted to speculate about how the lovers could be together again without destroying the meaning of the oral tale as I had heard it for the first time. But to maintain the integrity with my understanding of my culture, a happily ever after as in western fairy tales needs to be complicated. This is why the story ends with the symbolic representation of the frigate bird following the lovers, which can be read as either searching to punish them or endorsing their actions. The ending then becomes another beginning, informed by the past, which is before us. In Lilikalā Kameʻeleihiwa's words, "the future is always unknown, whereas the past is rich in glory and knowledge" (1992, 22–23). And this is where an imagined future, fantasy, becomes relevant!

8. Some families now have refrigerators, and there are freezers on the island, allowing people to store the fish they catch instead of sharing them with the rest of the households in the village. More importantly, the conservation practices of old, such as forbidding overfishing or enforcing embargoes on certain fish or forbidding fishing during certain times of the year, are no longer practiced.

men provided for the women; today, many a Polynesian woman is providing for her man. This anomaly in the story needs updating, so that it does not perpetuate and endorse patriarchy and outdated notions of masculinity. This is what informs this updated intervention.

A note about the world of the unseen. In this version, the story of Sina and Tinirau is bookended by the presence of the frigate bird, a symbol of the supernatural world.[9] This version suggests that there is a reality beyond the human that influences and shapes our lives, whether or not we are aware. This is definitely the reality of Rotuman beliefs, and I believe of Oceanic peoples, Indigenous peoples, and many peoples from other cultures as well. In this version, I also wanted to suggest not only that ultimately it is the supernatural world that prevails, but also that history is more circular than linear.[10] Sina and Tinirau, for example, may think that by eloping or running away they'd resolve all their problems and live happily ever after. This story does not end happily ever after, but suggests that as a couple they are still accountable to the supernatural world, in which case, as in the beginning, the ancestors may want to teach them a new lesson.

As an Indigenous storyteller in the twenty-first century, navigating a present-future that is still riddled with racism and racial disparity, I have an opportunity to seek wisdoms inherent in oral tales of the past and to refashion them in ways that address the concerns of the present. This is how Indigenous stories can remain relevant and vital. My hope is that my version of this oral tale about the origin of the coconut tree will draw attention not only to the importance of the tree of life (niu) for Oceanic peoples (and why in places like Hawai'i a niu culture that once thrived needs to return), but also to the importance of LOVE, especially unconditional love. This is the kind of love that changes people: not only for the one who loves but also for the one who is loved.

Works Cited

Churchward, C. Maxwell. 1940. *Rotuman Grammar and Dictionary*. Sydney: Australian Medicine Publishing Company.
Hau'ofa, Epeli. 2008. *We Are the Ocean: Selected Works*. Honolulu: University of Hawai'i Press.
Hereniko, Vilsoni. 1997. *Sina & Tinilau*. Suva: Institute of Pacific Studies.
———. 1998. *A Child for Iva* and *Sera's Choice*. Suva: Institute of Pacific Studies.
———. 1999. "Representations of Cultural Identities." In *Inside Out: Literature, Cultural Politics, and Identity in the New Pacific*, edited by Vilsoni Hereniko, pp. 137–166. Lanham, MD: Rowman & Littlefield.
———, dir. 2004. *Pear ta ma 'on maf: The Land Has Eyes*. Honolulu: Te Maka Productions.
———, dir. 2021. *A Niu Way: Coconut Trees, the Virus, and the Vision*. Honolulu: Te Maka Productions and Pacific Islanders in Communications.
Inia, Elizabeth. 2001. *Kato'aga: Rotuman Ceremonies*. Suva: Institute of Pacific Studies.
Kame'eleihiwa, Lilikalā. 1992. *Native Land and Foreign Desires*. Honolulu: Bishop Museum Press.
Wendt, Albert, and Vilsoni Hereniko. 1993. "An Interview with Albert Wendt: Following in Her Footsteps." *Manoa* 5, no. 1:51–59.

9. In the distant past, Rotumans believed that spirits of the dead could enter animals and birds, especially the frigate bird and owl, transforming them into guardian spirits. This they called *tu'ura*. See Inia (2001).
10. I have written about this circular view of history before in Hereniko (1999).

Sina ma Tinirau

Vilsoni Hereniko

OVER BLACK

> STORYTELLER
> *Hanuj,*
> *Hanujakia rogrog on Sina ma Tinirau.*
> I'll tell you a story about Sina and Tinirau.

EXT. OPEN OCEAN—DAY

A FRIGATE BIRD flies toward us above a BLUE OCEAN. Drawing near, its six-foot wingspan increases in size.

The bird's beak points downwards.

The frigate HOVERS in the wind, its eyes SURVEYING the scene below.

> STORYTELLER
> Once upon a time, frigate birds were guardian ancestors. From their lofty place in the sky, they could see when a human was overfishing and when a storm was coming!

EXT. LAGOON—DAY

TINIRAU, a DARK-SKINNED MAN, 20s, is FISHING from inside an outrigger canoe OVERLOADED WITH FISH.

Inspired by an oral tale from Rotuma.

 STORYTELLER
 On the day of this story, Tinirau was being greedy
 again.

Tinirau pulls in one more fish on his fishing line when suddenly he hears the FLAPPING of wings as the frigate bird SWOOPS IN.

Tinirau grabs the legs of the bird. They STRUGGLE. Will Tinirau give the bird a fish?

But Tinirau must have everything and refuses to concede to the bird.

The frigate ejects a blob of POOP on Tinirau's face.

As Tinirau wipes off the bird poop, the frigate grabs the fish, ascends, and disappears.

 STORYTELLER
 Oh, Tinirau was a very greedy man!

The canoe CAPSIZES.

 STORYTELLER
 So the ancestors cursed him to become an eel!

INT. OCEAN—CONTINUOUS

DEAD FISH everywhere, floating around Tinirau. Tinirau frantically tries to grab everything floating around him. As he grabs one fish then another, his human body MORPHS into that of a BLACK EEL.

The eel curls up as it descends to the bottom of the sea, uncurls and then swims toward a coral colony, where it curls up tightly in shame.

 STORYTELLER
 Now Tinirau had to wait, and wait, and wait,
 for Sina to love him.

A large shark swims by and blackens our view.

EXT. VILLAGE—ROTUMA—DAY

BIRD'S POV

A VILLAGE by the sea consisting of a dozen thatched houses surrounded by lush vegetation. One of the houses is on a STONE FOUNDATION and is bigger than the rest. This is the chief's house.

> STORYTELLER
> Long ago, on the island of Rotuma in Fiji, there
> lived a girl called SINA. Song composers compared
> SINA's beauty to the light of a full moon.

EXT. SINA'S HOUSE—DAY

SINA is a 16-year-old girl. She has FAIR SKIN, brown eyes, and long black hair.

Sina appears from inside her house carrying a wooden spear. She surveys her surroundings before rushing into the woods.

INT. FOREST—DAY

Several pigs look up as Sina approaches. They squeal and scatter.

Sina CHASES the pigs carrying her spear.

> STORYTELLER
> Sina carved weapons from the hearts of trees, hunted
> wild boars, and befriended sharks.

EXT./INT. OCEAN—DAY

Sina DIVES into the ocean deep.

Sharks swim toward Sina.

> STORYTELLER
> Oh, Sina loved PLAYING with sharks.

Sina hears someone WHISTLING. She looks everywhere but can't see anyone. She turns and swims away.

> STORYTELLER
> But one morning she met a stranger!

Sina hears whistling again.

Sina turns to stare right into the eyes of a black eel.

> EEL
>
> *Han tei, sei ta 'ou asa?*
> What's your name?

Sina pushes the eel away in disgust!

> SINA
>
> *Aah!*
> *Ewww!*
> *Ka 'ou asa maf raksa'a?*
> Is your name UGLY?

Sina tries to flee from the eel.

> TINIRAU
>
> *Han te'. Se re tape'. Gou pua' ta sirien my 'os*
> *temamfua ha' vahia gou. Kepoi ka ae la 'oaf se gou,*
> *ma gou la keleag lelei hoiak.*
> Oh, come on . . . Be nice to me! I took more from the
> ocean than I needed and now I'm cursed. Only Sina's
> love can change me back into a prince again.

Sina ROLLS her eyes.

> SINA
>
> *Ka 'ae maf raksa' ta sirien!*
> But you're so ugly!

> TINIRAU
>
> *Po'e 'ae hake gou pa' kele!*
> Because you think I'm just an eel.

Sina giggles.

> SINA
>
> *Ka sei 'ae?*
> What are you then?

<div style="text-align: center">TINIRAU</div>

Fa sau te'
A prince!

<div style="text-align: center">SINA</div>

'Otou asa Sina. Sian te' 'ul fis ka keleag lelei pau.
I'm Sina. I have light skin. And I'm beautiful!

<div style="text-align: center">TINIRAU</div>

Gou le Tinirau. Le' 'on Tui Fiti.
I'm Tinirau. Son of a Fijian chief.

The eel becomes BIGGER as he swirls up and around Sina before LOOMING LARGE above her.

<div style="text-align: center">TINIRAU</div>

Ka 'ae 'oaf se gou?
But do you love me now?

<div style="text-align: center">SINA</div>

Kepoi ka 'ae la jen 'ou aga ma posema.
If you stop being greedy, then maybe.

The eel WINKS at Sina. Sina reaches out to touch the eel's chin.

Sina giggles.

Sina and the eel lock eyes.

<div style="text-align: center">STORYTELLER</div>

Sina lingered because the eel was fun.

The eel winks a second time. Sina giggles again.

EXT. SKY—DAY
The wind picks up as hundreds of FRIGATE BIRDS fly low above Sina's village.

Sina's brothers are on the roof of their house trying to tie down the thatch. They stare after the frigate birds, worried.

Lightning strikes followed by thunder.

INT. SINA'S HOUSE—MOMENTS LATER

Sina's brothers wait anxiously for their sister to return home.

Sina appears, her face flushed with excitement.

> STORYTELLER
> When Sina told her brothers that a big black eel
> was flirting with her, they were very angry. They
> asked her if she could lure the eel to shore so they
> could meet him.

Sina's house shakes in the wind.

EXT. SINA'S HOUSE—DAY

Sina appears in the doorway. She SITS ALONE on the steps outside her house, looking concerned for the eel.

The wind blows Sina's hair as she worries about the eel waiting for her. What will she do?

INT. OCEAN—DAY

The eel PUSHES his neck further out from his hole in the coral and whistles. The eel searches for signs of Sina. Where is she?

The eel swims out of his hole and into the open sea.

INT. OCEAN—CONTINUOUS

The eel sees Sina playing with the sharks. He waits for the sharks to leave.

Sina pretends to swim away, knowing the eel will follow.

Sina TURNS around, her beautiful long hair swirling around her face, and eggs him on with an outreached hand.

EXT. BEACH—DAY

Sina's hand CARESSES the eel's chin. The eel grows BIGGER.

Hiding under the trees above the shoreline, Sina's brothers observe the lovers. And bide their time.

EXT. BEACH—DAY

Dark clouds. Raindrops.

Lightning strikes. The thunder roars in the distance. But the lovers are so into each other they don't care.

The eel has grown VERY BIG by now. It stands erect before Sina, its head towering above her.

The eel whistles again! Sina giggles with excitement.

Suddenly, Sina sees her brothers. She GASPS.

The brothers charge toward the lovers, their WEAPONS raised to kill.

Sina SCREAMS as she throws herself in front of the eel.

The rain, lighting, thunder, and sounds of killing and screaming turn the day into night.

EXT. BEACH—DAY—MOMENTS LATER.

The storm has subsided. Silence, except for the gentle lapping of waves on white sand.

Sina lies prostrate on the sand, her face to the side, heartbroken. She can't speak.

> EEL
> *Ka 'ae oaf se gou ne igke'?*
> Do you love me, Sina?

Sina nearly chokes with emotion. She reaches out to caress Tinirau's face.

> SINA
> *Gou kat 'inea ra ta te.*
> I don't know. I'm so confused.

EXT. OPEN AIR—DAY

Sina hugs close to her heart the head of the eel.

> EEL
> *Ae la hoa' gou se 'ou hanue ta.*
> Take me home with you.

Sina cradles the eel's head in her arms, tears rolling down her cheeks. She must hurry home. She can see her house now.

Sina STUMBLES. Lands on the ground with a thud. Looks around for a place to hide the eel's head.

<div align="center">

EEL

Ma fam 'otou filo' heta ma niu huut la fup.
Bury my head and a NIU tree will sprout.

</div>

Sina digs a hole in the ground using a digging stick.

EXT. HOUSE COMPOUND—MOMENTS LATER

<div align="center">

EEL

Niu hu teis la 'esao pau se 'ae.
Use every part of me to sustain yourself.

</div>

She digs a hole near her house and buries the eel's head.

<div align="center">

EEL

Soa' 'otou niu heta ma 'ae la rae se 'otou maf
he rua ma 'otou nuj heta. Ko 'otou nuju ma iom
'otou tan heta. 'Ae la re tape' ma 'itarua la kom nuj.
Husk my coconut and you'll see two eyes and a
mouth. Open my mouth and drink my juice.
And when you do, you'll be kissing me.

</div>

INT. EARTH—CONTINUOUS

The spirit world of dead ancestors welcomes the head of the eel with an ancient chant.

EXT. HOUSE COMPOUND—DAY

Sina keeps watch above ground, waiting to see if the eel's words will come true.

MONTAGE

—Small ROOTS emerge from the mouth of the eel below ground.

—A RED flame morphs into a stem, then SHOOTS out of the earth before Sina's eyes.

—The new shoot KEEPS MORPHING until it becomes a LONG, SLENDER TRUNK.

—GREEN LEAVES appear at the top of the tree.

—Among the leaves, clusters of fruit cling to each other.

NIU'S POV

Sina and her brothers stare at the tall tree before them. They marvel at its hanging fruit.

SINA'S POV

Her younger brother climbs up the coconut tree. He twists a coconut from the cluster and releases it.

The coconut lands on the ground and rolls to rest at Sina's feet.

EXT. COCONUT TREE—NIGHT

A FULL MOON above the coconut tree. Everyone is asleep.

Sina approaches the tree, carrying in her hand the green coconut and a digging stick that looks like a spear.

> STORYTELLER
> When everyone was sleeping, Sina snuck out
> to husk the coconut and to look for the eel's
> two eyes and mouth.

Sina digs into the ground with her stick. She husks the coconut.

She sees TWO EYES AND A MOUTH.

With a sharp shell, she pokes into the mouth of the coconut. The opening releases a red flame of mana.

Then Sina raises the coconut to her mouth and SUCKS its sweet refreshing nectar. The sounds of Sina KISSING Tinirau fills the air. Satisfied, Sina places the coconut down by the tree.

She sits back on her tucked feet and stares at the tree.

Sina CARESSES the tree's trunk and rests her sad face against it.

STORYTELLER
Oh, how Sina longed to see Tinirau again!

The tree SHAKES, causing Sina to fall back on her hands in shock.

Suddenly, Tinirau EMERGES out of the trunk of the tree, wearing an elaborate costume made of leaves.

Tinirau's even more handsome than he was before.

* * *

TINIRAU
(to Sina)
Ka ʻou asa maf raksaʻa?
Is your name UGLY?

Sina GIGGLES.

SINA
Tinirau! Tinirau! TINIRAU!

Sina jumps up and grabs Tinirau's hand with joy.

She leads him away from her brothers sleeping in the house.

They head toward the sea, where they first met.

EXT. OPEN AIR—CONTINUOUS

The moon HOVERS above the ocean, a night rainbow around it.

Moonlight on the water creates a path that leads toward the moon in the sky.

Their backs to us, SINA leads Tinirau toward the moonlight, LAUGHING all the while.

The lovers disappear into the sea.

The frigate bird appears to follow the couple, then seemingly flies inside the full moon.

OVER BLACK

STORYTELLER

Ma ta' ma maria' ma ofsia,
And that is the end of my story!

FADE TO BLACK.

Artist Statement for *Ia Ora Taaroa, Paraoa Iti ē (Greetings Taaroa, Little Whale)*

Sarahina Sabrina Birk

When I began sketching this work devoted to Taaroa, the sperm whale, a gift from our Creator (**Plate 26**), I had in mind what Vaihei Paepaetaata wrote about the French government's impending destruction of the whale stones of Tahua Reva in Tautira. These rock formations immortalize the faces of paraoa (whales) in the cliffs facing Tea Fā Pass. I had also just read the tragic story of *Moby-Dick,* where I discovered the giant white whale defending its family against the unscrupulous cruelty of European whalers.

This magnificent white whale, Taaroa, was revealed to me in a vision, crossing the Pacific Ocean, a living deity for our nūnaa (Tahitian people), embodying love of family and intelligence while accompanying his Tahitian clan on their travels throughout the Pacific Islands, demonstrating an intimate kinship between our nūnaa and the paraoa nūnaa (whale people). The words "Te here, te faatura te ora ia" are on the painting to underscore this kinship. Our intimate relationship was destroyed through colonialism beginning with the arrival of Spanish conquistadores in the Americas, followed by explorers, whalers, pirates, and missionaries, looting, massacring, and oppressing the Native peoples everywhere they went.

After thousands of years of communion shared with our nūnaa, paraoa were slaughtered in terrible conditions by European intruders. Foreign whalers benefited from the friendly trust the paraoa had of our people. The paraoa were killed by harpoons, struggling and drowning in their own blood, experiencing horrific suffering. When father whales tried to defend their families, they were killed as well. This is how whole clans of whales, who had experienced a respectful kinship relationship with our nūnaa, were massacred by whalers. The ocean, the primary marae for our people, was covered, drenched by the blood of our atua Taaroa, and I can only imagine the distress, sorrow, and incomprehension of the paraoa and mokorea of our nūnaa.

I imagine that the very beautiful melodies—called siren songs—that the whalers on those foreign ships heard were the songs of our mokorea (mermaid-like sea creatures that accompanied the paraoa), who attracted the whalers to dangerous reefs to prevent them from attacking their children, our paraoa. This is how Taaroa, paraoa iti ē, finds itself in the arms of a siren, who represents our mokorea.

Sperm whales are very rare in our waters since the massacres by whalers in the eighteenth century. Nevertheless, since the government's intention to dynamite the stones representing the paraoa of Vaiufaufa on Tahua Reva in Tautira, a small pod of a dozen whales have come, and are seen from time to time off Tautira. Ia ora Taaroa, paraoa iti ē.

Contributors

Māhealani Ahia is a Los Angeles–born Kanaka ʻŌiwi scholar, activist, songcatcher, and story-keeper. Her writing, theater, film, and performance from University of California, Berkeley, University of California, Irvine, and University of Hawaiʻi at Mānoa empower her Indigenous feminist decolonial creations, and her commitment to community education and access informs her editing for the *Hawaiʻi Review, ʻŌiwi: A Native Hawaiian Journal,* and the Mauna Kea Syllabus Project.

Cristina Bacchilega is professor emerita of English at the University of Hawaiʻi at Mānoa. A settler of color in Hawaiʻi, she has focused her research on wonder tales (*Postmodern Fairy Tales: Gender and Narrative Strategies; Fairy Tales Transformed? Twenty-First-Century Adaptations and the Politics of Wonder*) and the translation and adaptation of traditional narratives in colonial and decolonial projects (*Legendary Hawaiʻi and the Politics of Place: Tradition, Translation, and Tourism*). She coedited *The Penguin Book of Mermaids* with Marie Alohalani Brown (2019) and *Inviting Interruptions: Wonder Tales in the Twenty-First Century* with Jennifer Orme (2021).

Michael Lujan Bevacqua is from the Kabesa and Bittot clans from Guam. He is a cochair of the decolonization-focused organization Independent Guåhan and, with his brother Jack, runs the Guam Bus, a creative company that publishes children's books, comics, and other learning materials for Chamoru history, language, and culture.

Sarahina Sabrina Birk is Tahitian, Jewish, French, and English. She was born in Santa Barbara, California, and raised in Huahine, French Polynesia. Her art is child inspired, colorful, and full of magic and love, expressing stories of ancient Tahitian legends, gods, dreams, visions, family, and animals. Her first art show was in 1989 in a French café in Nantes. She has since done shows in Tahiti in art galleries, in the streets, in the local prison, and in Tahiti's parliament when she was a member of the sovereignty party from 2004 to 2013. View her art on Facebook at Sarahina Art.

Elizabeth Ua Ceallaigh Bowman is an independent scholar and political organizer who has worked for One Campaign Michigan and the governor of Guam. Past projects include the CHamoru oral narrative website Hongga Moʻna and essays on CHamoru ecosovereignty (coauthored with Michael Lujan Bevacqua), and Mary Wortley Montagu's translation (into English) of a Turkish lyric.

344 Contributors

Marie Alohalani Brown, professor of religion at the University of Hawaiʻi at Mānoa, is the author of *Ka Poʻe Moʻo Akua: Hawaiian Reptilian Water Deities* and *Facing the Spears of Change: The Life and Legacy of John Papa ʻĪʻī;* and coeditor with Cristina Bacchilega of *The Penguin Book of Mermaids.*

Alexander Casey is a PhD candidate at the University of Hawaiʻi at Mānoa. His publications can be found with NineStar Press, the *Indiana Review, Steam Ticket Literary Magazine, Hawaiʻi Review,* and *Sonora Review.* He would get more writing done if there was not a cat in residence on his keyboard.

Raʼi Chaze is Polynesian, born and raised in Tahiti. After living in the United States for about ten years, she returned home. Living in Tahiti, she is constantly rediscovering her country and writing about it. Her first novel, *Vai, ou la rivière au ciel sans nuage,* was published in 1990. To this date, she has published many books, and has participated in many collective works in France, Canada, Morocco, Hawaiʻi, and Aotearoa New Zealand.

Sosthène Desanges was born in 1972. He is a novelist from New Caledonia. He had been studying people and traditions from the Pacific for years before writing *Ash & Vanille: Les guerriers du lézard,* a high-fantasy novel, the first of five volumes of a saga that takes place in an imaginary Oceania. He wrote it in French and self-published it in New Caledonia. The success of the novel won it a government prize and funding for a translation into English, with the aim of finding a U.S. publisher. He is also the co-author of a comic strip series called *Frimeurs des îles* (ten albums published) and the screenwriter of a short TV series. He is currently working on collecting and writing old Kanak tales, and also working on the third volume of the *Ash & Vanille* series.

Joy Lehuanani Enomoto is a Kanaka Maoli mixed-media artist and community organizer living in Honolulu, Oʻahu. Her work engages ancestral memory, climate justice, and other social justice issues currently affecting Pacific peoples. She is currently the executive director of Hawaiʻi Peace and Justice, an organization committed to creating a demilitarized and de-occupied Hawaiʻi and Pacific.

Solomon Enos is a Native Hawaiian artist who aspires to visually translate the traditional stories of his ancestors, and to further extrapolate them into the genres of sci-fi, fantasy, and futurism. He believes there is a wealth of wisdom to be shared at a time when new ways of thinking and feeling are needed. Crucially, he prioritizes the need to share his visual offerings as a way to build consensus around interpretations of ancestral imaginings, and most of his art thus takes the form of questions rather than statements. Underlying all these motivations is his desire to inspire other Native artists to take up the work of decrypting the rich imaginations of their ancestors.

Pono Fernandez: He hoa kōkoʻolua ka ua Pōʻaihale o Kahaluʻu, he hoa kūpaʻa ke ʻaʻaliʻi kū makani a he hoa ʻinau ke koa kū haʻaheo. He noiʻi nōwelo kēia i ka lei laeʻula e hoʻomali nei i nā moʻolelo hulu kupuna. He aloha nō a he aloha.

Nicole Kuʻuleinapuananioliko'awapuhimelemeleolani Furtado received her PhD in English from the University of California, Riverside, and is a current UC president's postdoctoral fellow at the University of California, Santa Cruz. She works at the intersection of critical Oceanic studies, visual culture, Indigenous feminisms, and speculative aesthetics.

Sofia Kaleomālie Furtado is from the island of Oʻahu. In Spring 2023, she earned her bachelor of arts degree in music and communications at the University of Hawaiʻi at Mānoa. Sofia frequently experiments with digital art inspired by the aesthetics of Hawaiian futurism and influenced by her Hawaiian-language learning.

Nō Ngāti Toa Rangatira, nō Ngāti Raukawa, nō Te Āti Awa a **Patricia Grace.** Kei ngā whenua o ōna tūpuna a ia e noho ana, e pātata ana ki tōna mārae i Hongoeka, i Plimmerton. E whiti ngā paki roa, e rima ngā kohinga paki poto, e hia kē ngā pukapuka mā te tamariki kua titoa e ia. He huhua ng tonu whakanui kua uhia ki a ia mō āna tārainga kupu i roto i ngā tau, i Aotearoa, i tāwāhi anō. Kua uhia ia ki ētahi Tohu Kairangi Whakamānaa mō te Mātākōrero, e Te Whare Wānanga o Te Ūpoko-o-Te-Ika-a-Māui i te 1989 me te World Indigenous Nations University i te 2016. **Patricia Grace** is Ngāti Toa Rangatira, Ngāti Raukawa, and Te Āti Awa and lives on ancestral land in close proximity to her home marae at Hongoeka Bay, Plimmerton. She is the author of seven novels, five short story collections, and several children's books. She has won numerous prestigious awards for her work over the years, both nationally and internationally. She received honorary doctorates in literature from Victoria University of Wellington in 1989 and from the World Indigenous Nations University in 2016.

Andrea Nicole Grajek is an illustrator originally from Guåhan currently wandering the CHamoru diaspora in the United States.

A native of Rotuma, **Vilsoni Hereniko** is a professor, playwright, and screenwriter, as well as a stage and film director. He teaches at the University of Hawaiʻi's ACM: The School of Cinematic Arts. His narrative feature film *The Land Has Eyes* premiered at the Sundance Film Festival and screened at more than thirty international film festivals. It also won several awards, including Best Dramatic Feature at the Toronto ImagineNATIVE Film + Media Arts Festival. *Sina ma Tinirau,* his first animated film, has won five awards, including Best Short at the 2022 Berlin Independent Film Festival and the 2022 Los Angeles International Film Festival. In 2022, he received a Star of Oceania award in Film, Media, and the Arts in Hawaiʻi.

He haku mele, he kaha kiʻi, a he wahine kiaʻi aloha ʻāina ʻo **kuʻualoha hoʻomanawanui,** aʻo he kumu moʻolelo Hawaiʻi i ke Keʻena Pelekania i UH Mānoa. He Luna Hoʻoponopono nō ʻo ia no ka puke ʻŌiwi: A Native Hawaiian Journal. Ua paʻi ʻia kāna puke mua, ʻo *Voices of Fire, Reweaving the Literary Lei of Pele and Hiʻiaka* i 2014. Ua hānau ʻia ʻo ia i Kailua, Koʻolaupoko, Oʻahu, a hānai ʻia i Wailua Homesteads, Olohena, Puna, Kauaʻi. Nunui kona aloha iā nā mauna i lei ʻia i ka noe.

346 Contributors

Kathy Jetñil-Kijiner is a writer, performer, and climate activist of Marshall Islander ancestry—jowi eñ ao ke Ri-mae, im ña juon ledrik in Aur, Jaluit, Likiep, Ebon, im Namdrik. She was born in the Marshall Islands, raised in Hawai'i, and is currently based in Majuro, the capital city of the Marshall Islands.

Kahala Johnson is an Indigenous politics, futures, and gender and sexuality studies scholar at the University of Hawai'i at Mānoa. Their research focuses on genderqueer and poly decolonial love, and their dissertation, "A Night Slippery with Echoes," examines decolonized futures of the Hawaiian Kingdom. Previous publications involving *Kumulipo* include "Placed in the Middle: Serving Mana Māhū Maoliness for the Gods in a Wā of Cosmic Emergence" as well as "A Breath of Ea: Submergent Strategies for Deepening the Hawaiian Diaspora" in *Shima Journal*, co-authored with Māhealani Ahia.

Nō Ngāti Porou a **Robyn Kahukiwa,** nō Te Whānau-a-Ruataupare me Te Whānau-a-Te Ao, i Tokomaru. Kua moe anō ki roto o Te Arawa. Kei te Takutai o Kapiti a ia e noho ana. He auau tonu te whakaatu a Robyn i āna mahi toi, ā, kei ngā kohinga maha—tūmatanui, tūmataiti, āna toi e iri ana, i Aotearoa me tāwāhi. Kua tuhi pukapuka anō ia mā te tamariki, nāna ngā kōrero me ngā whakaahua o roto, tae atu ti ēnei: *The Toroua and the Mauri Stone, Kehua, Mauri Ora, Paikea* me *Ngā Atua.* Nāna anō ngā whakaahua o *Oriori* (nā Roma Potiki ngā kōrero), i puta i te 1999 me ērā o *The Standing Strong House,* nā Reina Kahukiwa ngā kōrero. **Robyn Kahukiwa** is Ngāti Porou, Te Whānau-a-Ruataupare, and Te Whānau-a-Te Ao of Tokomaru Bay, and is affiliated to Te Arawa by marriage. She lives on the Kapiti Coast. Robyn exhibits frequently, and her work is in public and private collections in New Zealand and overseas. She has written and illustrated a number of children's books, including *The Koroua and the Mauri Stone, Kehua, Mauri Ora, Paikea,* and *Ngā Atua.* Robyn also illustrated *Oriori* (with text by Roma Potiki), published in 1999, and *The Standing Strong House,* written by Reina Kahukiwa.

Emelihter Kihleng is a poet, curator, and teacher who has lived and worked in Pohnpei, Federated States of Micronesia, Guåhan (Guam), Honolulu, Hawai'i, Aotearoa New Zealand, Europe, and now Denver, Colorado. In 2019, she was the inaugural curatorial research fellow for Oceania at the Museum am Rothenbaum—World Cultures and Arts (MARKK) in Hamburg, Germany. In 2023, she is the Mellon Fellow for Oceanic Arts at the Denver Art Museum.

Aaron Ki'ilau is a PhD student and instructor at the University of Hawai'i at Mānoa, assistant director of the Writing Center, editor-in-chief of the *Hawai'i Review,* and an editor for *'Ōiwi: A Native Hawaiian Journal.* He researches comedy and satire, music, and Hawaiian literature in English. Aaron is also a pianist, violinist, and composer.

Victoria Nalani Kneubuhl is a Hawai'i playwright and author. She has written plays, short stories, novels, living-history programs, and television documentaries. Her anthology, *Hawai'i Nei: Island Plays,* and her three mystery novels are published by the University of Hawai'i Press. In

1994, she was the recipient of the prestigious Hawai'i Award for Literature and, in 2006, she received the Eliot Cades Award for Literature.

Bryan Kamaoli Kuwada is a big brown guy with long hair who teaches Mo'olelo 'Ōiwi, Hawaiian and Indigenous literatures, at the Kamakakūokalani Center for Hawaiian Studies at the University of Hawai'i at Mānoa. He also takes photos, writes some fiction and poetry, surfs as much as possible, and deeply loves those he is in pilina with.

Sloane Leong is a self-taught cartoonist, illustrator, and writer of Hawaiian, Chinese, Mexican, Native American, and European ancestries. In prose, illustration, and comics, she engages with visceral futurities and fantasies through a radical, kaleidoscopic lens, the extrapolation and hybridization of ecologies within speculative frames, and the violent cultural structures of our world and others, both micro and macro. She has several graphic novels: *From Under Mountains, Prism Stalker, A Map to the Sun,* and *Graveneye.* Her fiction has appeared in *Dark Matter Magazine, Apex Magazine, Fireside Magazine, Analog, Realm Media, Snaring New Suns,* and many more publications. You can find more of her work at https://sloanesloane.com.

Caryn Lesuma is an assistant professor of English at Brigham Young University–Hawai'i, where she also serves as an associate director for the Center for Learning and Teaching. Her research interests include young adult literatures of Oceania (YALO) and place-based pedagogy and rhetoric. She has published essays on contemporary adaptations of Pacific folklore and place-based composition pedagogy.

Nai'a-Ulumaimalu Lewis is a multidisciplinary professional with deep roots in art, culture, community, and conservation. She blends contemporary expressionism with Indigenous identity and focuses on engaging, empowering, and supporting the most socially vulnerable and often marginalized. Nai'a is the founder of Salted Logic, an Indigenous women-led media collective; Nai'a also serves as director of Big Ocean, a network of the world's largest marine-managed areas. Born and raised in O'ahu, Hawai'i, she holds a bachelor's degree in journalism from the University of Hawai'i at Mānoa and worked for almost ten years at the Papahānaumokuākea Marine National Monument.

Tina Makereti is the author of *The Imaginary Lives of James Pōneke* (2018), *Where the Rēkohu Bone Sings* (2014), and *Once upon a Time in Aotearoa* (2010), and coeditor of *Black Marks on the White Page* (2017). Her short story "Black Milk" won the 2016 Commonwealth Writers Short Story Prize, Pacific region. Tina teaches creative writing at Te Herenga Waka Victoria University of Wellington.

Selina Tusitala Marsh (ONZM, FRSNZ) is the former New Zealand poet laureate (2017–2019) and has performed poetry for primary schoolers and presidents (Obama), for queers and queens (HRH Elizabeth II). She has published three critically acclaimed collections of poetry, *Fast*

Talking PI (2009), *Dark Sparring* (2013), *Tightrope* (2017), and award-winning graphic memoirs, *Mophead* (2019) and *Mophead TU* (2020), dubbed as "colonialism 101 for kids." Professor Tusitala Marsh calls herself a Pasifika artist-academic. She teaches Pacific literature and creative writing at the University of Auckland, Aotearoa New Zealand.

From Kula, Maui, in the ahupuaʻa of Aʻapueo, **Brandy Nālani McDougall** is the author of two poetry collections, *The Salt-Wind, Ka Makani Paʻakai* (2008) and *ʻĀina Hānau/Birth Lands* (2023). Her book *Finding Meaning: Kaona and Contemporary Hawaiian Literature* (2016) is the first extensive study of contemporary Hawaiian literature and the winner of the Beatrice Medicine Award. She is an associate professor of American studies (specializing in Indigenous studies) at the University of Hawaiʻi at Mānoa and the Hawaiʻi poet laureate for 2023–2025. She lives with her keiki in Kalepōhaku in the ahupuaʻa of Waikīkī.

Kapiliʻula Naehu-Ramos is a Maui-born and Molokaʻi-raised artist of Filipina, Borincua, Portuguese, Chinese, and Hawaiian descent. She is a Molokaʻi High School graduate currently attending Princeton University, where she is majoring in the practice of art. She aspires to continue to empower people and raise consciousness through art, servicing all cultures and backgrounds.

Jocelyn Kapumealani Ng is a queer multidimensional creative of Hawaiian, Chinese, Japanese, and Portuguese descent. The fluidity of her art blends award-winning spoken word poetry, special-effects makeup, theater performance, photography, and fabrication to navigate themes of queerness, Indigenous culture, womxn issues, and the representation of underrepresented narratives.

Lehua Parker is an author, editor, and educator who writes speculative fiction for kids and adults, often set in her native Hawaiʻi. A graduate of the Kamehameha Schools and trained in literary criticism, she is an advocate of Indigenous voices and a frequent presenter at conferences and symposiums. Connect with her at www.LehuaParker.com.

Craig Santos Perez is a Chamoru writer and scholar from Guåhan (Guam). He is the author of five collections of poetry and the coeditor of five anthologies. His monograph, *Navigating Chamoru Poetry: Indigeneity, Aesthetics, and Decolonization,* was published by the University of Arizona Press in 2021. He is a professor in the English department at the University of Hawaiʻi at Mānoa.

Born in Niue, painter and poet **John Pule** moved to New Zealand with his family in 1964. He began writing in 1980 and has since published two novels: *The Shark That Ate the Sun* (1992) and *Burn My Head in Heaven* (1998). He began painting in 1987.

Tiare Ribeaux is a Kanaka Maoli interdisciplinary artist and filmmaker. Her work employs storytelling and visual narrative to center social and ecological imbalances while imagining more regenerative futures. She explores how both our bodies and the technologies we use are entangled with the environment, and aims to recenter Indigenous narratives.

Marama Salsano is of Ngāi Tūhoe, Te-Aitanga-a-Māhaki, and Ngāti Porou descent. She is a māmā to three tamariki, toi Māori artist, high school English teacher, and doctoral candidate at the International Institute of Modern Letters at Victoria University in Wellington, New Zealand. Marama has an MA in creative writing from Victoria University and an MA in Māori cultural studies from the University of Waikato. Her creative writing has been recognized in national fiction competitions and has been published in various anthologies and literary journals.

Born and raised in Hawai'i, **Lyz Soto** is a poet of Ilocano, Visayan, Hakka, German, English, and French descent. Her spoken arts show, *Her Bodies of Stories,* debuted in Honolulu in 2016; her book *Translate Sun/Son/Sum* was published in 2017 by Finishing Line Press; and she was the dramaturg and director for *She Who Dies to Live* in 2019.

Terisa Siagatonu is an award-winning poet, teaching artist, mental health educator, and community leader born and rooted in the Bay Area. She is a Kundiman Fellow and a 2019 Yerba Buena Center for the Arts 100 List Honoree. Terisa's writing blends the personal, cultural, and political in a way that calls for healing, courage, justice, and truth.

Robert Sullivan belongs to the Māori tribes Ngāpuhi (from Kāretu and Omanaia) and Kāi Tahu (Karitāne). His collections of poetry include *Captain Cook in the Underworld, Shout Ha! to the Sky,* and the best-selling *Star Waka.* He coedited three major anthologies of Pacific and Māori poetry. His PhD thesis, "Mana Moana," examines the work of five other Indigenous Pacific poets. His eighth collection, *Tūnui/Comet,* was published by Auckland University Press in 2022.

Dan Taulapapa McMullin is a poet and painter. Their book *The Healer's Wound: A Queer Theirstory of Polynesia* (2022) was published by Pu'uhonua Society and Tropic Editions of Honolulu, and was launched as part of the Hawai'i Triennial 2022. Their collection of poems *Coconut Milk* (2013) was on the American Library's Rainbow List of Books of the Year. Taulapapa is currently working on a novel, *Malepe.*

Nicholas Thomas is a Fellow of Trinity College, Cambridge. His books about art and history in the Pacific include *Hiapo* (2006), co-authored with John Pule. Over 2018–2019, he cocurated "Oceania" with Peter Brunt for the Royal Academy of Arts and the Musée du quai Branly—Jacques Chirac.

Kristina R. Togafau is a Western Shoshone-Samoan poet scholar pursuing a PhD in English at the University of Hawai'i at Mānoa. Currently residing on Piscataway land, they're continuing their research and creative work on Pasifika diaspora in the continental United States, Indigenous posthumanism, and speculative science fiction.

Briana Koani U'u is a graduate of the University of Hawai'i at Mānoa's English MA program. No Waikāne mai 'o ia, she is from the ahupua'a of Waikāne and currently resides in Honolulu. She is a teacher at Wai'anae High School.

Joyce Pualani Warren is a diasporic Black Kanaka Maoli. She is assistant professor in the Department of English at the University of Hawaiʻi at Mānoa, where she teaches Native Hawaiian, Native Pacific, and ethnic American literatures. Her research interests include Pō, blackness in the Pacific, mana wahine, feminisms, Indigenous futurisms, and literary nationalism.

Maualaivao **Albert Wendt** has published many novels, including *The Mango's Kiss,* and collections of short stories and poetry. The recipient of many prizes and honors, he is internationally regarded as one of Oceania's major writers. He was pro-vice chancellor of the University of the South Pacific and professor of English at the University of Auckland, and held the citizens' chair at the University of Hawaiʻi. He lives with his partner, Reina Whaitiri, in Auckland, Aotearoa New Zealand, and continues to write and paint.

Steven Winduo writes poetry, short stories, newspaper commentaries, fiction— including children's books—and nonfiction. He lives and writes in Papua New Guinea and teaches Literature at the University of Papua New Guinea. His scholarly interests include pan-Pacific literature, folklore and folk knowledge systems, and critical theory and cultural studies in Oceania.

Brittany Winland is a PhD candidate and instructor at the University of Hawaiʻi at Mānoa. Her main research interests are ecocriticism and ecocomposition, queer theory, posthumanism, and contemporary fiction—particularly climate fiction and queer speculative narratives. Originally from West Virginia, she is her happiest self surrounded by mountains.

Qianqian Ye is a Chinese artist, creative technologist, and educator based in Los Angeles. Trained as an architect, she creates digital, physical, and social spaces exploring issues around gender, immigrants, power, and technology. She currently teaches at the University of Southern California and Parsons, and serves as the p5.js lead at the Processing Foundation.